Above Scotland **Cities**

The National
Collection of Aerial
Photography

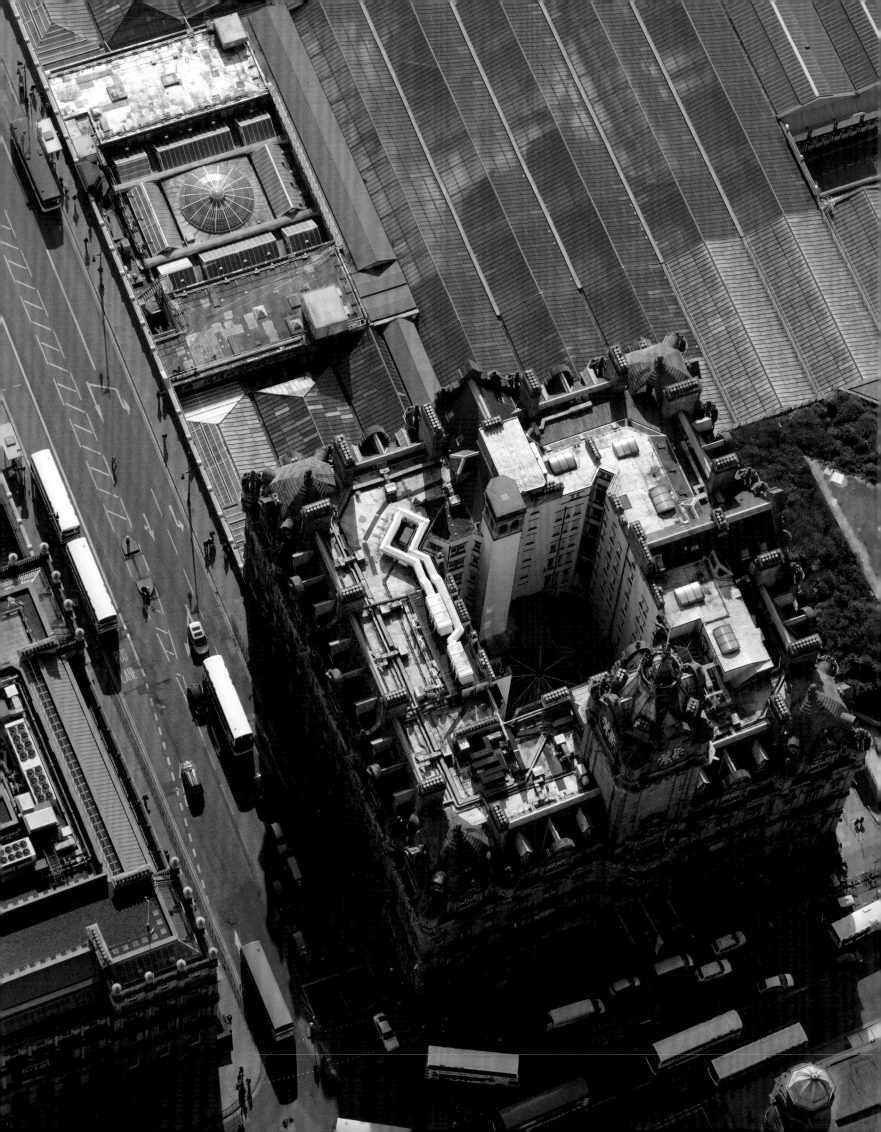

Rebecca M Bailey, James Crawford and Allan Williams

Above
Scotland
Cities

The National
Collection of Aerial
Photography

Royal Commission on the
Ancient and Historical Monuments
of Scotland

Published in 2010 by the
Royal Commission on the Ancient and
Historical Monuments of Scotland.

Royal Commission on the Ancient and
Historical Monuments of Scotland (RCAHMS)
John Sinclair House · 16 Bernard Terrace
Edinburgh EH8 9NX

telephone +44 (0)131 662 1456
info@rcahms.gov.uk · www.rcahms.gov.uk

Registered Charity SC026749

British Library Cataloguing-in-Publication Data.
A catalogue record for this book is available from
the British Library.

ISBN 978 1 902419 65 7

The quote in the first paragraph of page 9
is taken from *The Worlds of Patrick Geddes* by
Philip Boardman.

Frontispiece: A procession of colourfully-roofed
buses winds past the iconic edifice of Edinburgh's
Balmoral Hotel – originally opened in 1902 as the
North British Hotel. **RCAHMS 2010** DP075889

Designed by Dalrymple
Typeset in Brunel, Frutiger and Minion
Printed in the UK by Beacon Press

Royal
Commission on the
Ancient and
Historical
Monuments of
Scotland

Contents

Born amidst the fiery clamour of the industrial revolution, modern cities created a new way of living, laying out giant maps of rapidly growing and competing architectures that surrounded – and often demolished – ancient cores grown organically over centuries. Pictured here in 1937, central Glasgow's great street canyons are ordered in a vast geometric grid

AEROFILMS 1937 53587

Introduction

On 18 October 1909, a special cable to the *New York Times* reported that Charles Lambert – a pupil of aviation pioneer Wilbur Wright – "left the Juvisy Aerodrome at 4.36 o'clock in a Wright machine, flew across Paris to the Eiffel Tower, circled it, and returned to his starting point, arriving safely at 5.25". As the first ever aeroplane flight over a city, Lambert's stunt caused an obvious sensation – and for one young Paris student watching from the window of his apartment, it was a spectacle never to be forgotten. Charles Edouard Jeanneret – better known as the iconic pioneer of Modernist architecture Le Corbusier – was entranced. In his 1935 book *Aircraft*, he summed up his youthful excitement at the unique possibilities offered by the aerial view: "The airplane carries our hearts above mediocre things, enabling human beings to glance down like Gods upon the worlds they have made." Years later, he jumped at the opportunity to experience it for himself. "It is as an architect and town planner – and therefore as a man essentially occupied with the welfare of his species – that I let myself be carried off on the wings of an airplane … to which end I directed the pilot to steer over cities."

From the air, you can read a city. Urban stories are patterns and codes, puzzles best cracked by obtaining distance and height. At street level, cities are bewildering concepts, their true forms obscured by noise, chaos and an excess of detail. But by looking down from above, perpetual motion slows to stillness. Framed by their ancient landscapes, city origins that date back not thousands but millions of years become suddenly, strikingly, clear. Massed rooftops can be viewed like geological strata, architectural timelines of social, economic and political history.

For almost as long as pilots have circled high over the spires, towers and steeples of cities, photographers have been alongside, capturing the bird's-eye view and bringing it back down to earth. In the National Collection of Aerial Photography, held by the Royal Commission on the Ancient and Historical Monuments of Scotland, a near century of aerial imagery comes together. Dating from the 1920s to the present day, these photographs represent unparalleled records of change, visual biographies of the nation's constantly evolving urban environments. Every city's story is one of growth, loss, prosperity, hardship, resilience and renewal. But none is quite the same. From the fortified volcanic rocks of Edinburgh and Stirling and the mineral coast of Aberdeen, to the trader river-plains of Inverness and Dundee and the manufacturing machine of Glasgow, unique tales emerge of communities, their landscapes and their architecture. These are tales of castles and cathedrals, royalty and religion, war and politics. There are medieval markets and custom-built New Towns, renaissance merchant ports and smoky, monolithic factory-lands. Modernist motorways crash through grand Victorian street plans, tower blocks rise and fall, industrial wastelands are repurposed for living and leisure. The stories go on; the urban fabric never stops shifting. And all the while, what Le Corbusier called "the airplane eye" stares down – recording from on high the fascinating lives of our restless cities.

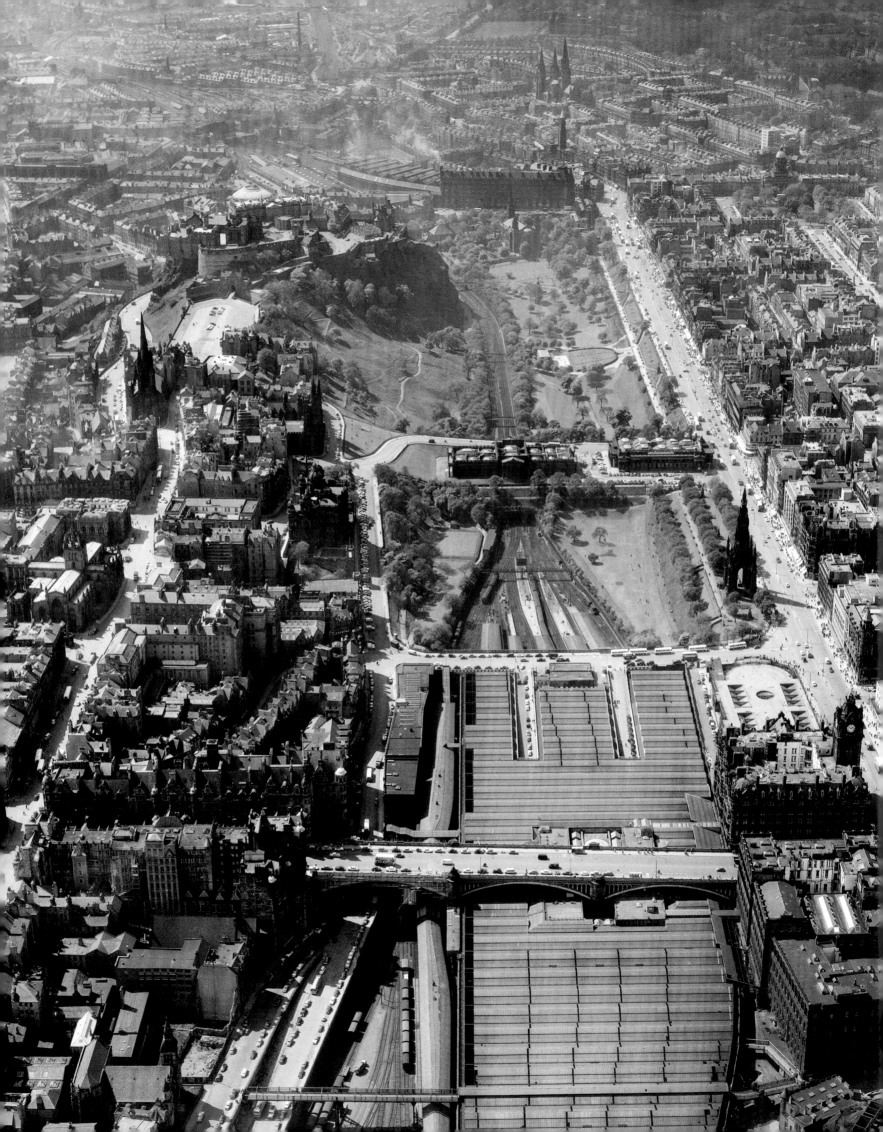

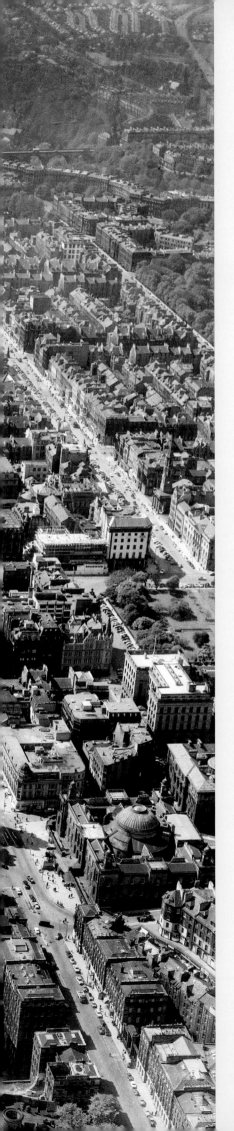

Edinburgh

In late nineteenth century Edinburgh, on a narrow cobbled street near the top of Castlehill's maze of dark wynds, a man could often be seen leading curious groups into a doorway at the foot of an imposing tower. Through a castellated portal, this excitable guide would rush his parties up five flights of stairs to a turret with a small, open gallery some 80ft above the ground. "Perhaps you wondered why I hurried you up here from the street?" the man would ask. "Simply because the exertion of climbing makes one's blood circulate more rapidly, thus clearing fog out of the brain and preparing one physiologically for the mental thrill of these outlooks."

The man was Patrick Geddes – a visionary scientist, educator and thinker, and the father of modern town planning – and the building was his 'Outlook Tower', an innovative mixture of observatory, museum and civic laboratory that showcased his unique philosophy for understanding the world in which we live.

Geddes wanted to expand minds that were constrained at street level by narrow lanes, looming buildings and everyday bustle. The immediate visual experience offered by his Tower was a view of the city and the surrounding landscape from above. But Geddes believed that the roof-top contained many more 'outlooks', views that encompassed geography, economics, anthropology, engineering and – crucially – the past and the future. As his visitors looked east to the volcanic bulk of Arthur's Seat, he would tell them that they were seeing the world through the eyes of a geologist. By staring down the Royal Mile's ridgeback of sixteenth century 'skyscrapers', they became architects and historians. With this knowledge and understanding of Edinburgh in place, they could go on to consider another horizon, an 'outlook' that was unseen – the province of the town planner, the landscape and the city *as it could be*. The future.

Geddes was so inspired by the rich panoramas from his Tower – now better known as the Camera Obscura – that he devised theories of city life and development that are still seen as cutting-edge today. "I have found no better a site for such a tower than here in Edinburgh", he said. "Not even from the heights of London or Paris, nor from the historic pinnacles of Athens or Constantinople, is there so complete a view of the natural and social world."

What makes Edinburgh so special – and allowed Geddes such a varied visual appreciation from Castlehill – is the complex relationship between its natural and built form. Clinging to spectacular topography, the dramatic townscape is revealed clearly, showing how buildings fit into the city structure, and offering a direct contrast between the organic growth of the enclosed Old Town and the planned openness of the New Town.

Edinburgh preserves in stone a unique physical timeline of the history of urban planning. Whereas in many cities the medieval core is slowly eroded, demolished and replaced, in Edinburgh it was fossilised, left behind as a slum city. The Old

Town, constrained for centuries by the landscape, had grown upward and on top of itself. A strict social hierarchy situated the wealthy at the top of towering tenements – the world's first high-rises – while below street level, pinhole passageways led down to the filthy dwellings of a literal 'underclass'. This unique form of urban congestion made for intense overcrowding and squalor, but also created a melting pot of academics, merchants, clerics, aristocrats and professionals, whose radical new philosophies and ideologies coalesced in debating chambers and Old Town taverns. It was in this febrile atmosphere of intellectual revolution – known as the 'Scottish Enlightenment' – that the map of the city was first redrawn.

In the mid eighteenth century, over a hundred years before Geddes and his Outlook Tower, the Lord Provost, George Drummond, gazed out from the high vantage point of his chambers to the indistinct horizon of the future. A New Town was needed to supplement the overflowing Old, and, surveying the open lands to the north, Drummond proclaimed there would rise "a splendid and magnificent city".

It is a testament to the conviction and self-belief of Edinburgh's civic architects that this vision was so fully realised. Constructed in stages over a period of a hundred years, the New Town spread across the glacial landscape as a model of structured urban planning, a grand aristocratic quarter laid out in a sumptuous grid of airy streets, squares, crescents and formal gardens.

These two Towns made the core of modern Edinburgh. But, as Geddes recognised from on high, they represent more than just that. Set opposite each other like two pages of an open book, they tell the enduring story of the development of a unique urban environment, a treasured city of the world in which geology, history and architecture have combined in remarkable harmony.

The development of modern Edinburgh is a tale of two towns. From the pinnacle of Castle Rock, the medieval Old Town's heaped mass of buildings has grown erratically downhill, while across a glacial valley dominated by the carapace roof of Waverley Station, the Georgian New Town is a model of ordered, geometric planning.
AEROFILMS 1961 A87711

A white turret poking out above the sky-high tenements of Castlehill, the Outlook Tower was occupied by Patrick Geddes in the mid 1890s, at a time when the Old Town was at perhaps its lowest ebb – reduced to a decaying slum, blighted by disease. Geddes' plan, starting with the construction of the five-storey co-operative flats of Ramsay Garden and continuing with the 'sociological laboratory' of his Tower, was to reoccupy and rehabilitate the Old Town, transforming it into a vibrant cultural and academic quarter. Although the idea never truly caught on, Geddes' intervention saw many old buildings at the summit of the High Street restored or saved from demolition.
RCAHMS 2009 DP062383

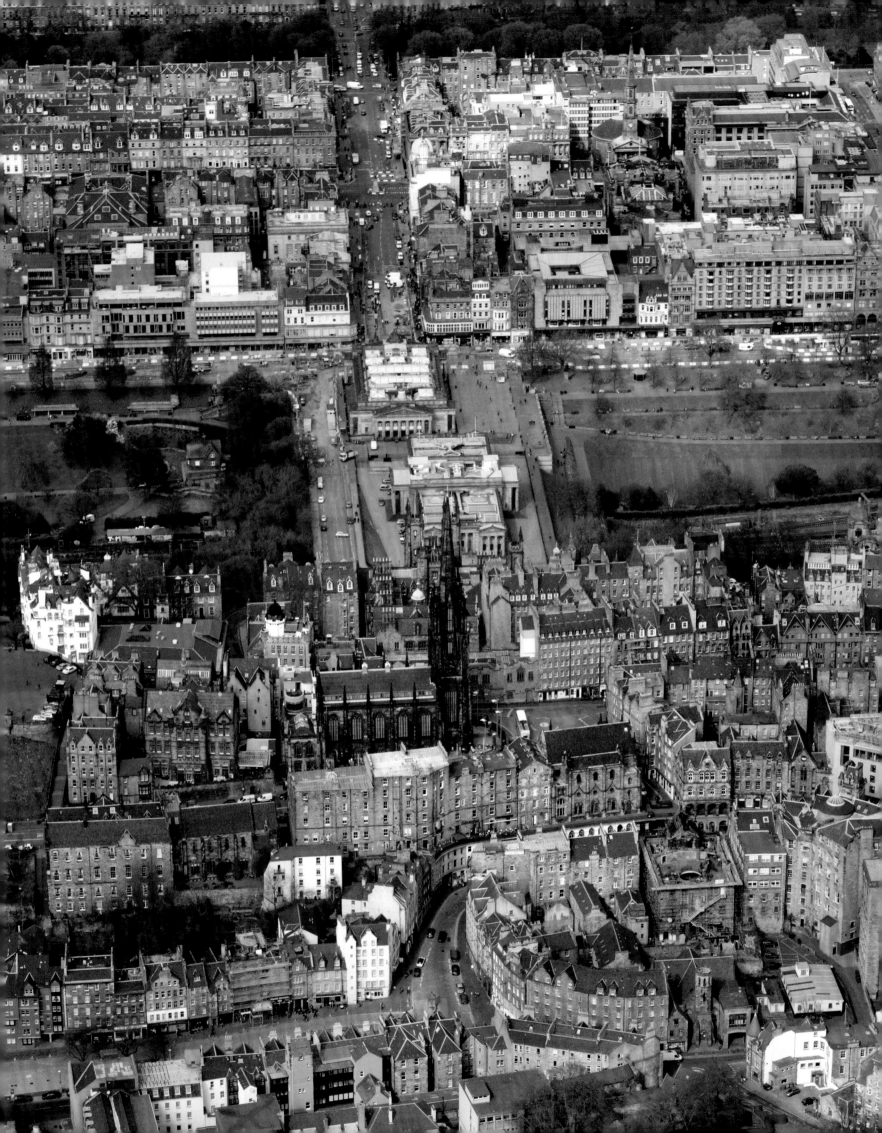

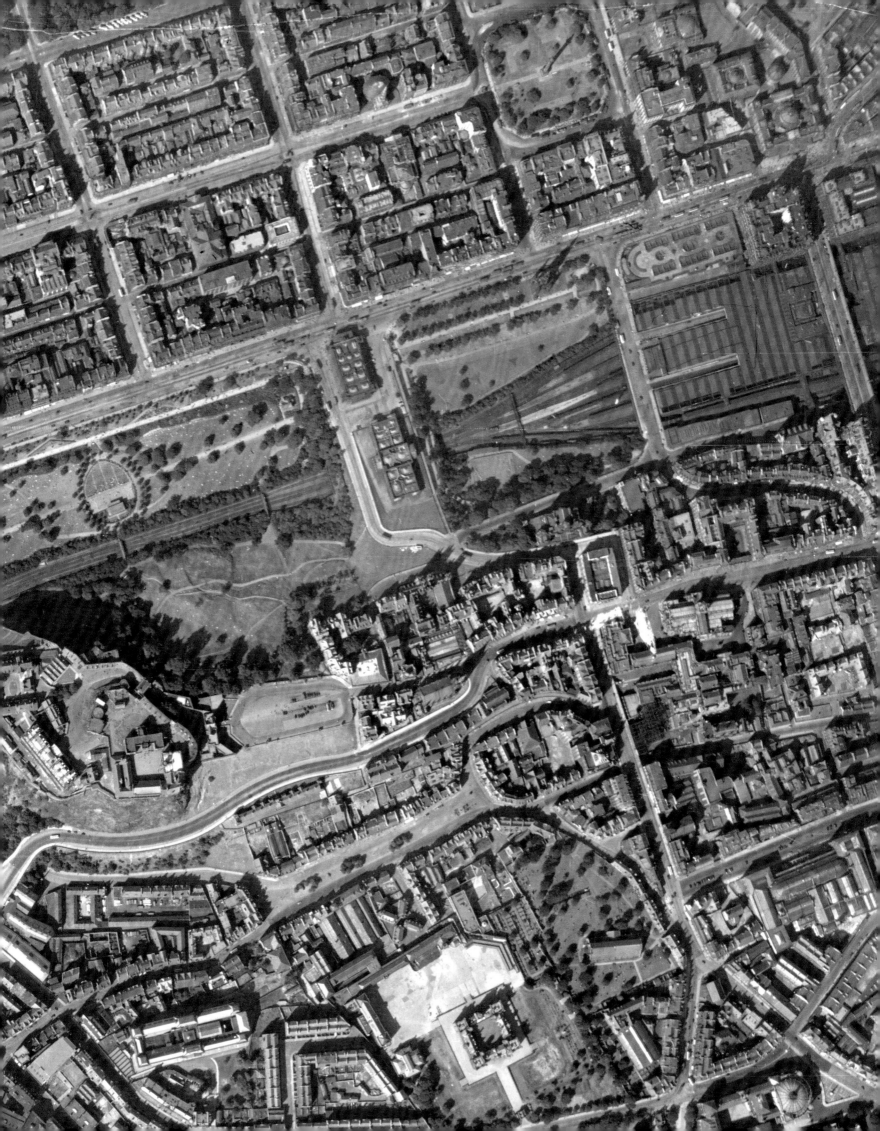

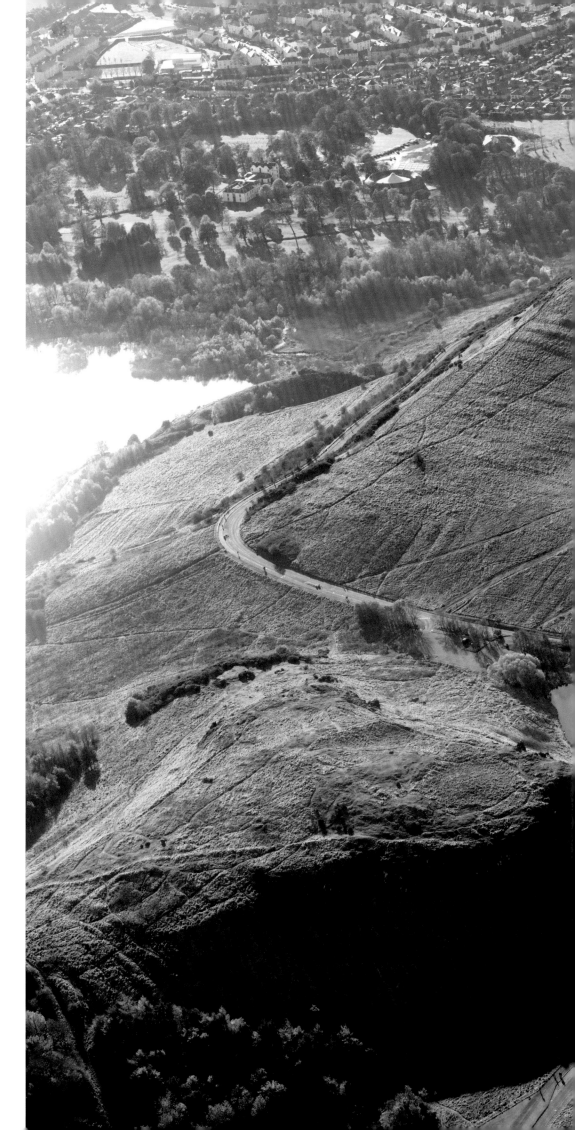

PREVIOUS PAGES

In the view from above, the draughtsman-
ship of an eighteenth century town planner
is shown in near perfect physical realisation.
In 1766, an unknown 22-year-old architect
called James Craig produced the winning
design for the first New Town. Its simple
grid layout of primary and secondary
streets, with civic squares at each end, was
elevated by its use of Edinburgh's natural
topography. The two exterior streets –
Princes Street and Queen Street – were
created with outward-facing buildings on
one side only, allowing the former views
over the valley to the great bulk of the
Castle, and the latter a panoramic prospect
out to the Firth of Forth and the distant
hills of Fife.

RAF 1947 006-001-000-246-C

RIGHT

The destiny of a city is often shaped long
before the arrival of man. The origins of the
modern Edinburgh landscape can be traced
back over 350 million years to a volcanic
system running through Scotland. Over
two million years ago, the glaciers of the
last ice age eroded and sculpted great heaps
of igneous rock, producing the distinctive
basalt fist of the Castle Rock, and the huge
central landmark of Arthur's Seat. Before
the city was even a concept, there was a
human presence on the slopes of Arthur's
Seat, with the earliest evidence dating to the
fifth millennium BC and the discovery of
flint and stone tools. Today, the remains of
many early settlements are still visible. Here,
picked out by a low winter sun, the outline
of a pre-historic fort emerges directly
above the loch on the summit of Dunsapie
Crag, while the dark lines running across
the hillside have been formed by medieval
rig-and-furrow cultivation.

RCAHMS 2008 DP049951

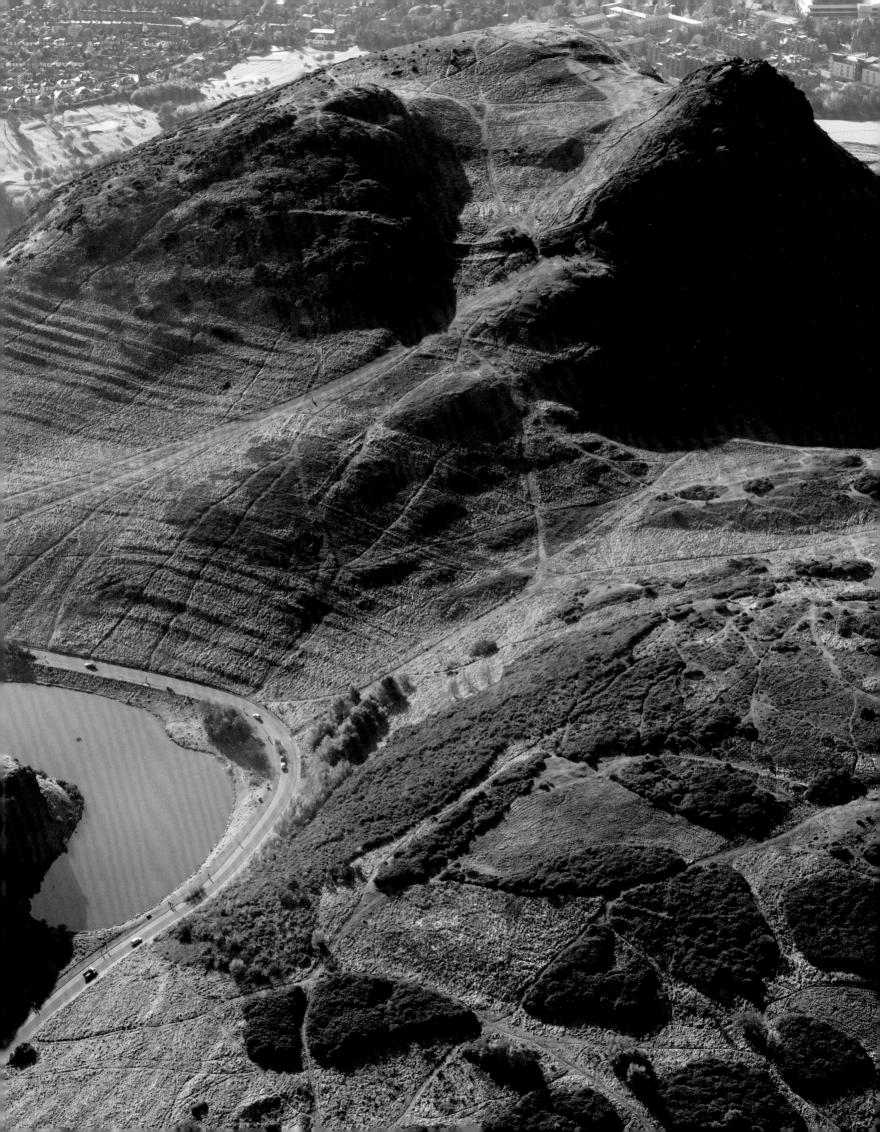

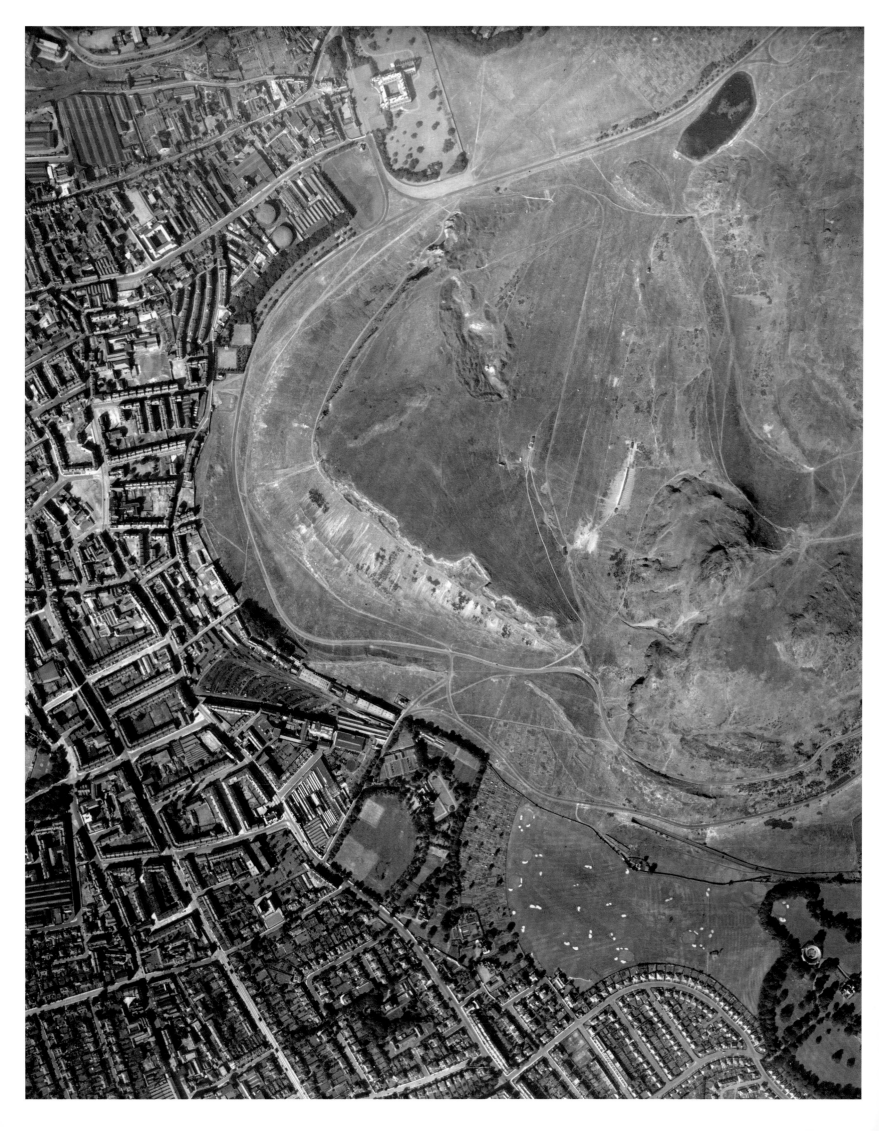

The buildings of Edinburgh's Southside bend against the great arc of Salisbury Crags – almost as if it is the ancient geology that is pushing its way into the city rather than the other way round. In 1949, the Abercrombie Plan proposed a major inner ring road encircling the Old Town and blasting through the Southside. The idea of the ring road was perpetuated by the Buchanan Plan of 1972, a vision that was stuck in limbo for decades – and ultimately never implemented. Also unexecuted was a major redevelopment of the University properties in the area. The long period of planning uncertainty saw the area slip into disuse and decay.

RAF 1947 006-001-000-244-C

Behind Arthur's Seat, a wide plain of patchwork fields stretches to meet the horizon, while Edinburgh is half-hidden by the clouds of smoke that earned it the Scots epithet 'Auld Reekie'. Seen here in 1941, it is remarkable to consider how small the city still was in the mid twentieth century. In the foreground, the Royal Botanic Gardens and Inverleith Park are sitting almost on the urban periphery.

RAF 1941 006-003-000-234-C

Neo-classical structures decorate the shallow summit of Calton Hill, while across a glacial valley filled with the housing, railways and industry of the Old Town's tail, shadows emphasize the natural monument of Salisbury Crags. Directly below the sheer face of the basalt cliffs is the huge Holyrood Brewery – now the site of the Scottish Parliament.

AEROFILMS 1972 A232121

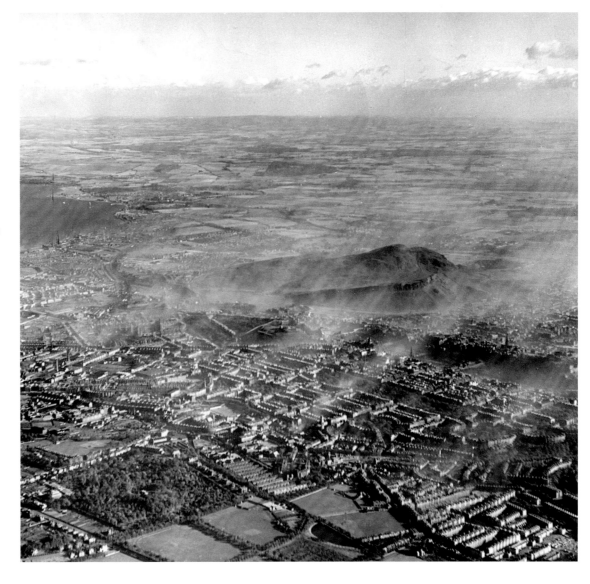

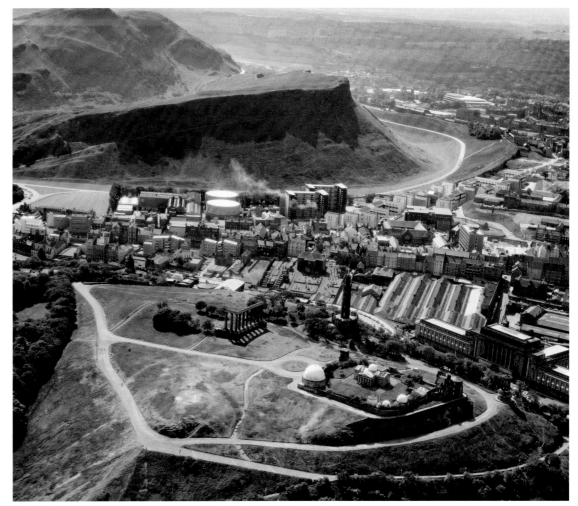

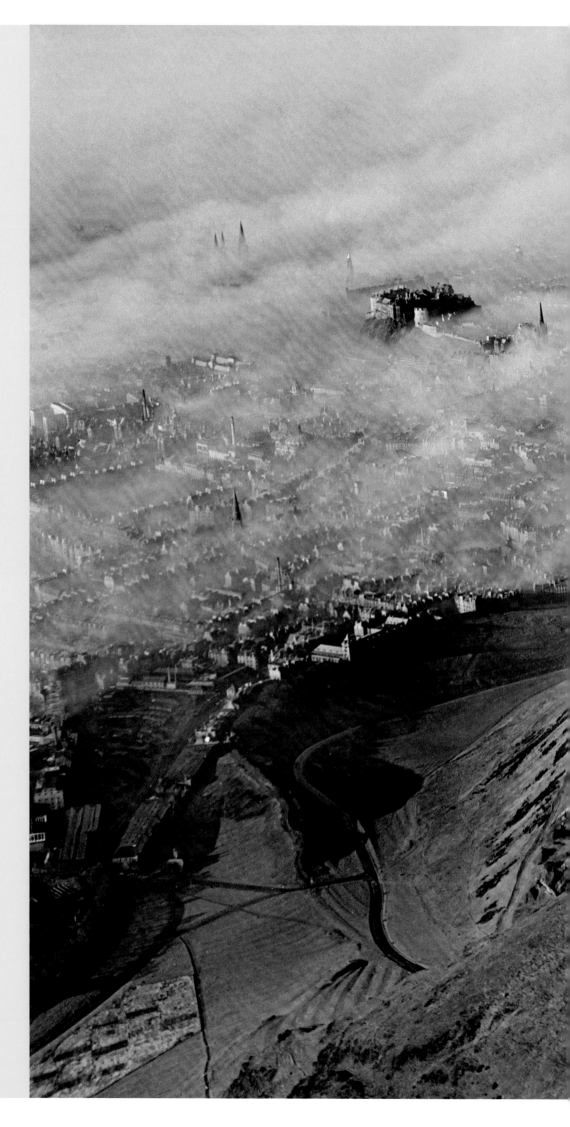

For a long time power and influence in Edinburgh were determined by height. Here, with the city wreathed in thick mist and smoke, the cornerstones of society rise into clear air – the military, religion and government. Below the imposing fortress of the Castle, church steeples stud the skyline, while in the lee of Calton Hill, Thomas Tait's brand-new St Andrew's House positively sparkles with monolithic, Art Deco authority.

AEROFILMS 1949 R12112

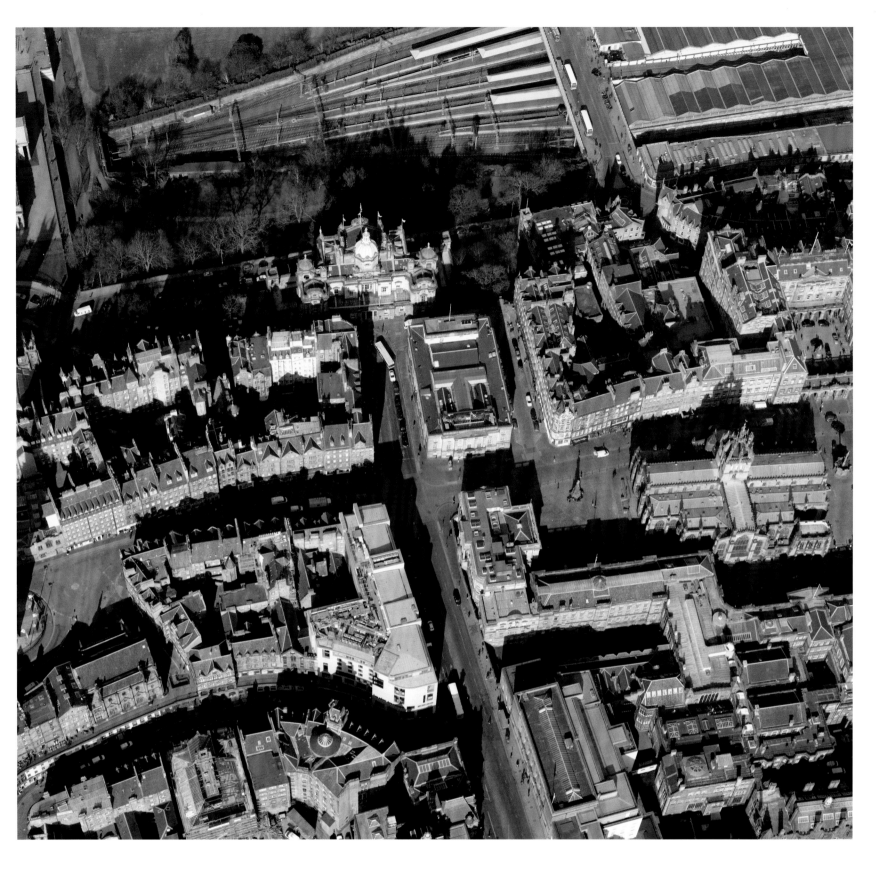

One of the many 'outlooks' promised by Patrick Geddes from his Castlehill tower, the critical junction of the Lawnmarket, the High Street and George IV Bridge, draws together some of the most important buildings, personalities and events in the history of the city. Below the dark, gothic steeple of James Gillespie Graham and Augustus Pugin's Tolbooth Church, public hangings of the likes of bodysnatcher William Burke once took place. On the high cusp of the Mound, two great nineteenth century temples still stand. One – William Playfair's New College and Assembly Hall – housed the fledgling Free Church, while the other – Robert Reid, Richard Crichton and David Bryce's Bank of Scotland Headquarters – remains a grand tribute to trade and commerce. At the centre of the junction, looming seventeenth century tenements rub shoulders with the twenty-first century Hotel Missoni, while opposite, the Signet Library and the High Court of Justiciary surround the fourteenth century High Kirk of St Giles. In every rooftop, street and stone, history and architecture meet.

RCAHMS 2010 DP075935
RCAHMS 2010 DP075936

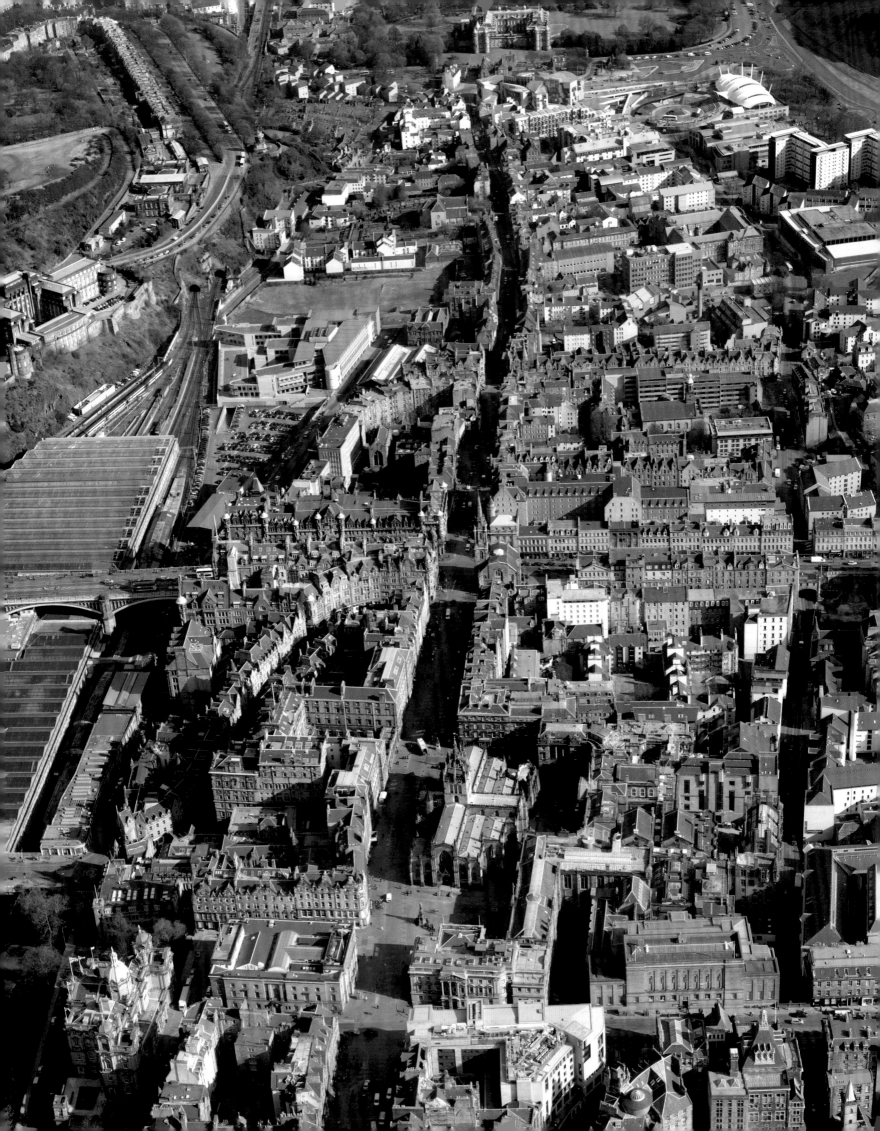

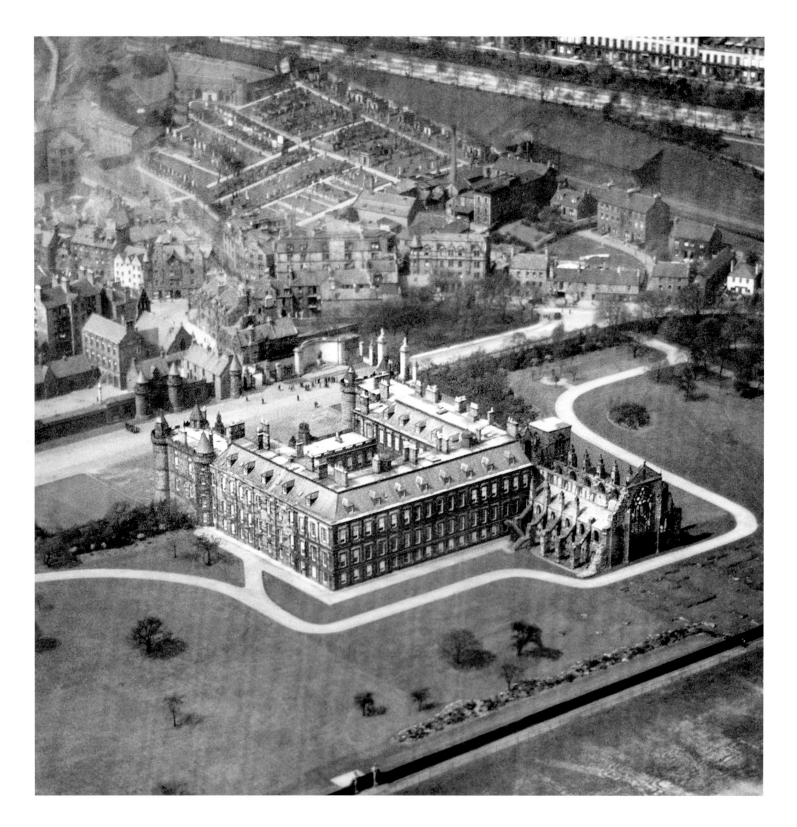

Picked out in shadow, the Royal Mile descends through a cavernous funnel of 'skyscraping' tenements towards Holyroodhouse and the Parliament building. Adopted as Scotland's capital in the late fifteenth century, Edinburgh's long development, combined with its precipitous landscape, gave little scope for expansion to reflect its new status and royal patronage.

RCAHMS 2010 DP075922

With space at a premium, Edinburgh's noblemen often built their houses outside the city walls, and there was no room for the grand designs of the Kings of Scotland, who took up residence in Holyroodhouse, a Palace built onto a twelfth century Abbey at the foot of the Canongate, an independent burgh until 1856. Pictured here in 1927 by Aerofilms – one of the earliest commercial aerial photography companies in the world – the Palace originally dates back to the sixteenth century, but was reconstructed in both the seventeenth and nineteenth centuries.

AEROFILMS 1927 17718

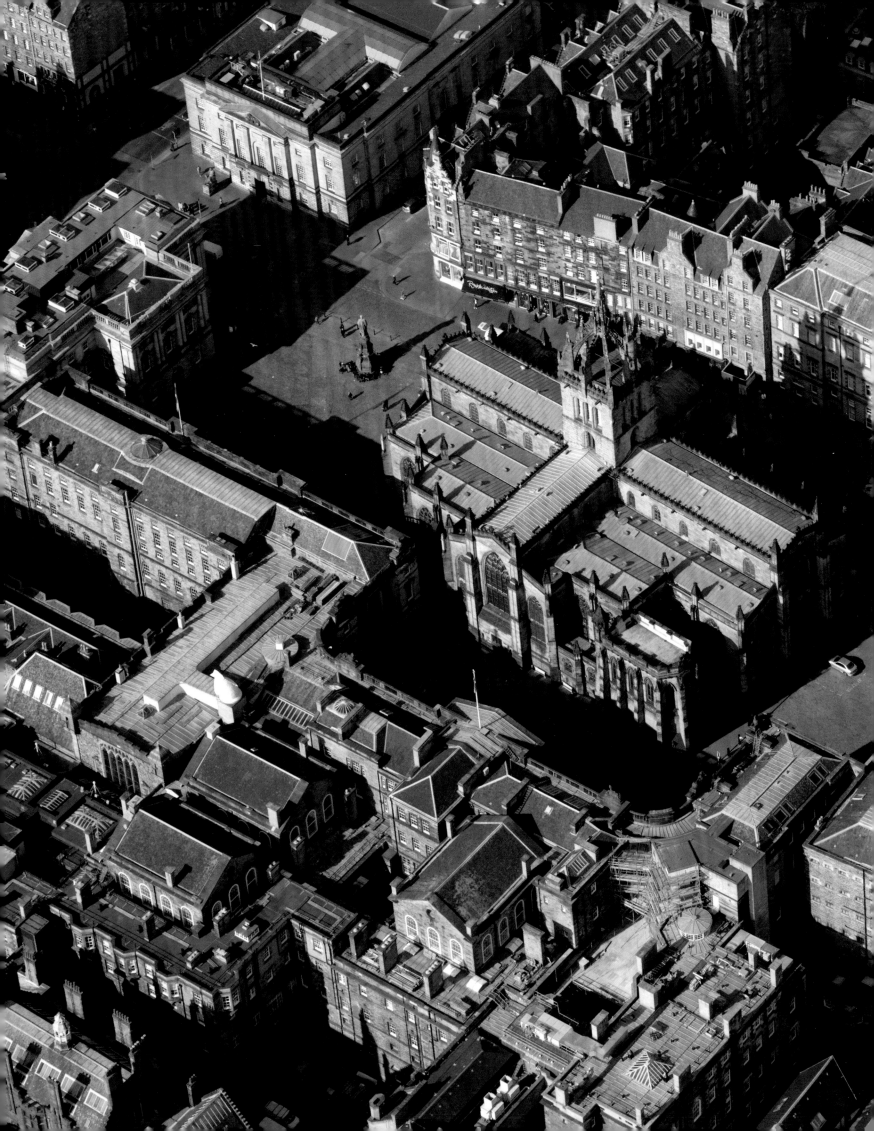

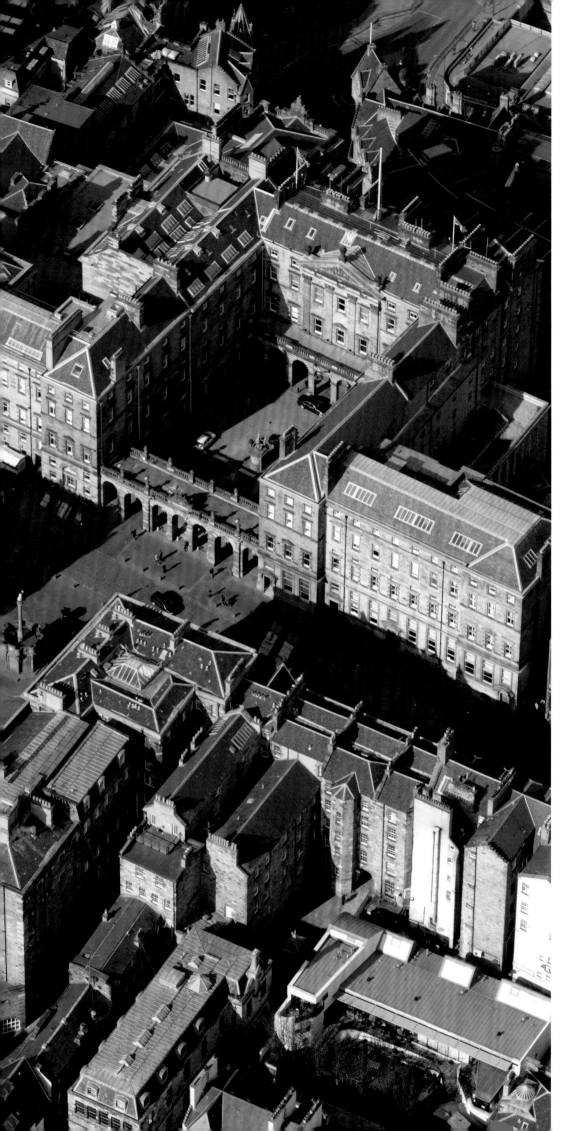

For almost a thousand years St Giles'
High Kirk has been at the physical and
spiritual heart of Edinburgh. First founded
in the twelfth century, the building that
remains today has been continually shaped,
moulded and rebuilt by history. Severely
damaged by fire during an English raid in
1385, its reconstruction over the coming
century saw the creation of the distinctive
Crown Spire in 1500. In the mid sixteenth
century, the incendiary preaching of John
Knox in the pulpit of St Giles' put the
church at the epicentre of the Reformation,
but over the following 200 years it endured
a period of disrepair and decay. At the
outset of the nineteenth century it was
largely obscured from public view by the
many merchant booths that filled the Old
Town's central plaza – some even built
up against the side of the church itself. In
1829 the exterior was almost completely
refaced and remodelled by William Burn,
and, between 1871 and 1883, William Hay
restored the interior to its original single
space, removing the partition walls created
during the Reformation. The last addition
was the Thistle Chapel, designed by Robert
Lorimer and completed in 1911.

RCAHMS 2010 DP075931

While Arthur's Seat rises over Edinburgh as a permanent reminder of the city's violent geological origins, and the Castle sits high as a symbol of fortified, military beginnings, Calton Hill was developed as a tribute to a more refined age. As the New Town spread across the glacial landscape below, the rounded summit of the Hill became the canvas for a sequence of neo-classical monuments advertising Enlightenment Edinburgh's dream of becoming a 'Modern Athens'. Now surrounded by Thomas Tait's Art Deco-inspired St Andrew's House and modern hotel and leisure complexes, Patrick Geddes' description of Calton Hill, "with its strange medley of monuments", as a "museum of the battle of styles and a permanent evidence showing how the town planners of one generation cannot safely count on continuance by those of the next", seems particularly prescient.

RCAHMS 2008 DP051311

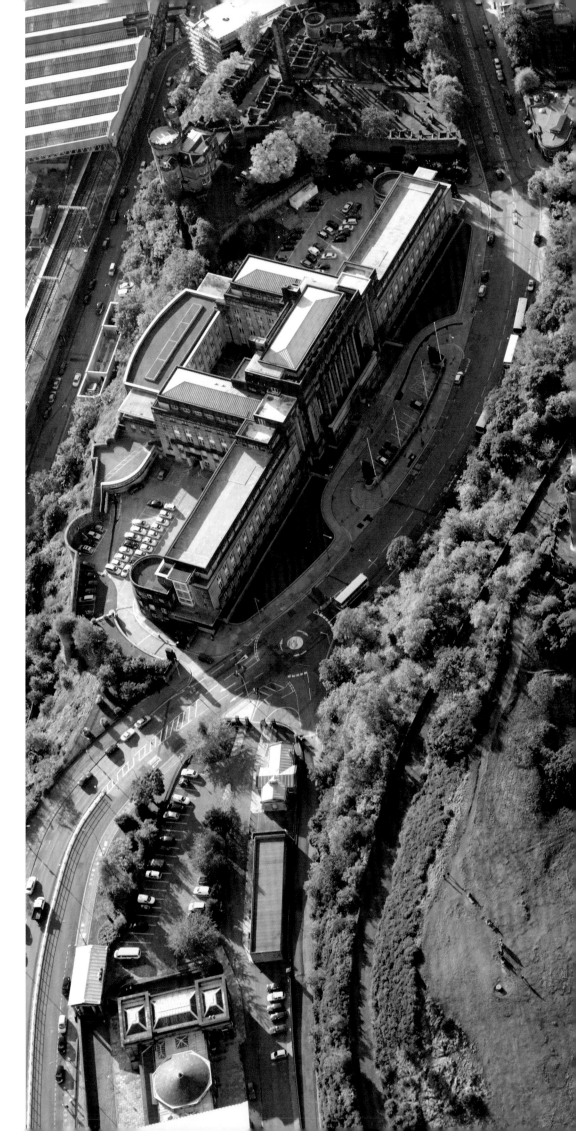

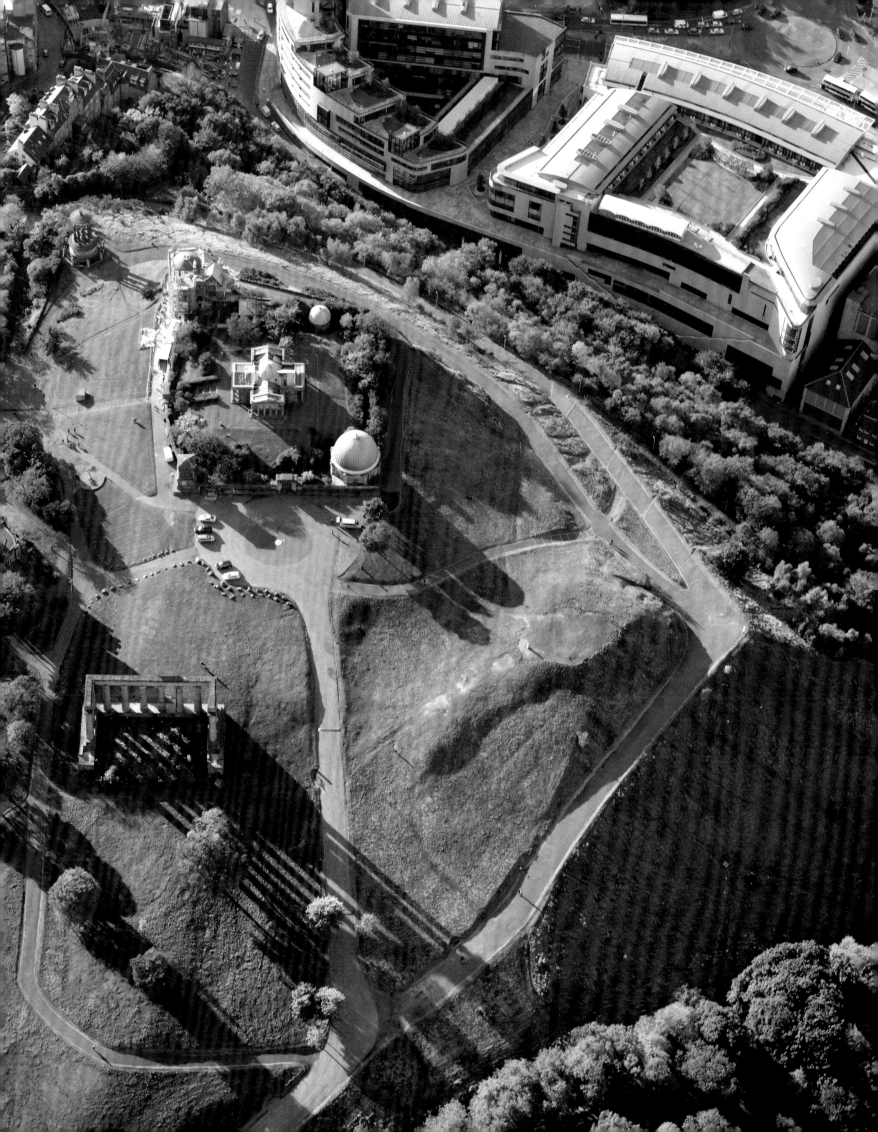

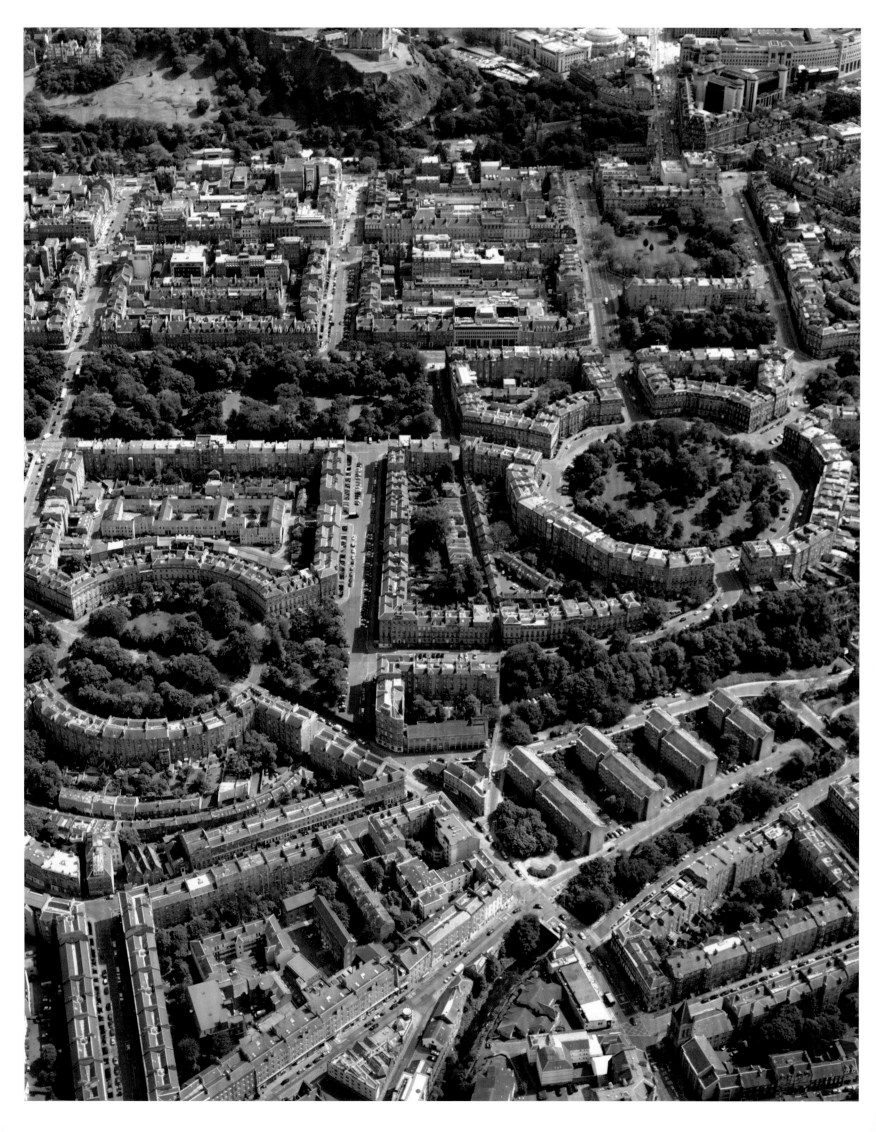

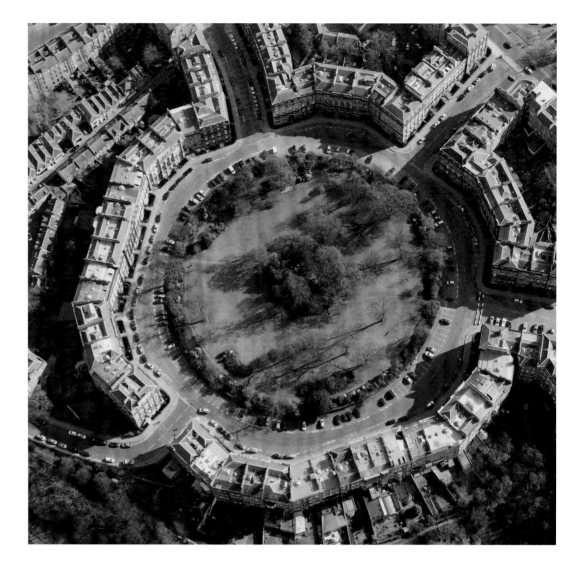

As the New Town spread north, east and west from James Craig's original grid plan, the ambition and elegance of the street layouts increased accordingly. The scale was gargantuan, with tall palace fronts rising to line wide, sweeping crescents and circuses of neo-classical Georgian and early Victorian grandeur.

RCAHMS 2007 DP033378

Built for the Earl of Moray from 1822, James Gillespie Graham's Moray Place is a stunningly baroque circus. By far the largest in Edinburgh, its buildings were specifically designed to do justice to its scale, with great columned palace facades gazing out across the central gardens.

RCAHMS 2010 DP075869

Completed in 1823, Royal Circus marks the western end of the northern New Town, which runs from Drummond Place in the east along the wide parade of Great King Street. Originally planned by Robert Reid and William Sibbald between 1801 and 1802, it was William Playfair who completed the final, detailed design of the grand Circus.

RCAHMS 2010 DP075873

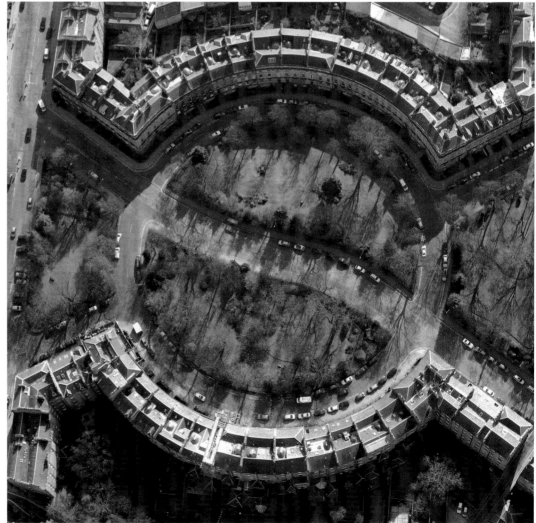

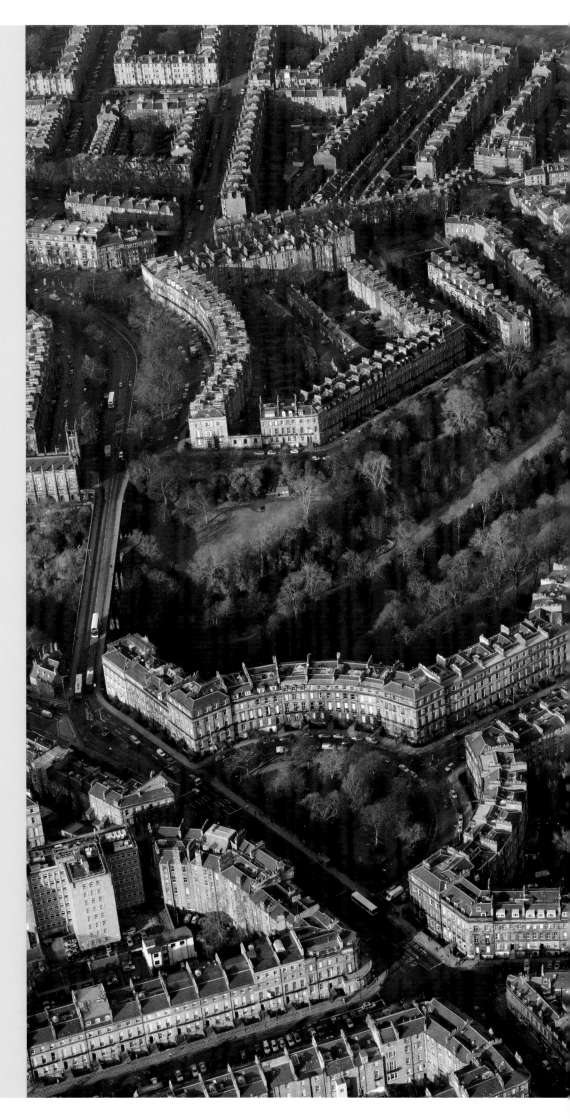

Even today, the visionary Enlightenment planning that created the New Town is astonishing in its boldness. Constructed over a period of 100 years from the late eighteenth century, an ambitious architectural dream became a monumental reality. Designed as a grand, aristocratic suburb, its completion caused an exodus of the wealthy from the medieval Old Town, leaving behind a slum city occupied only by the poorest citizens.

RCAHMS 2009 DP054820

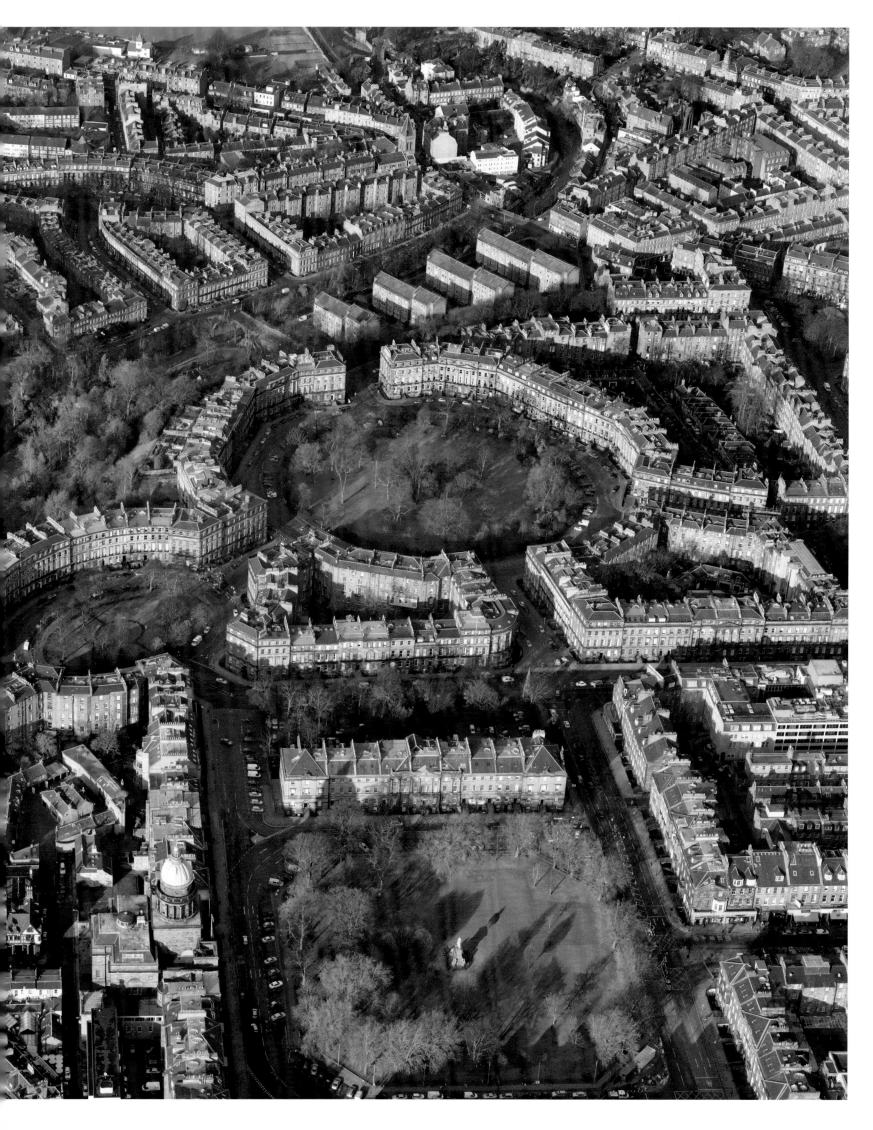

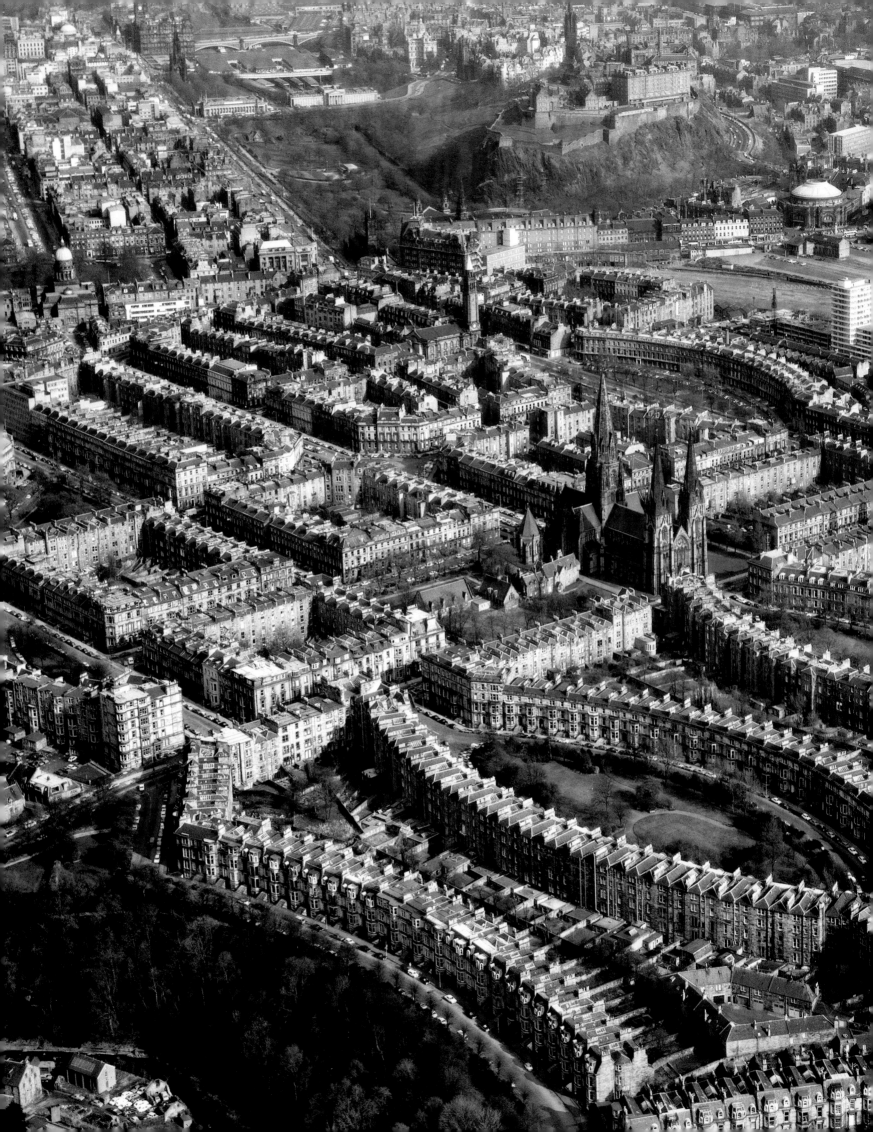

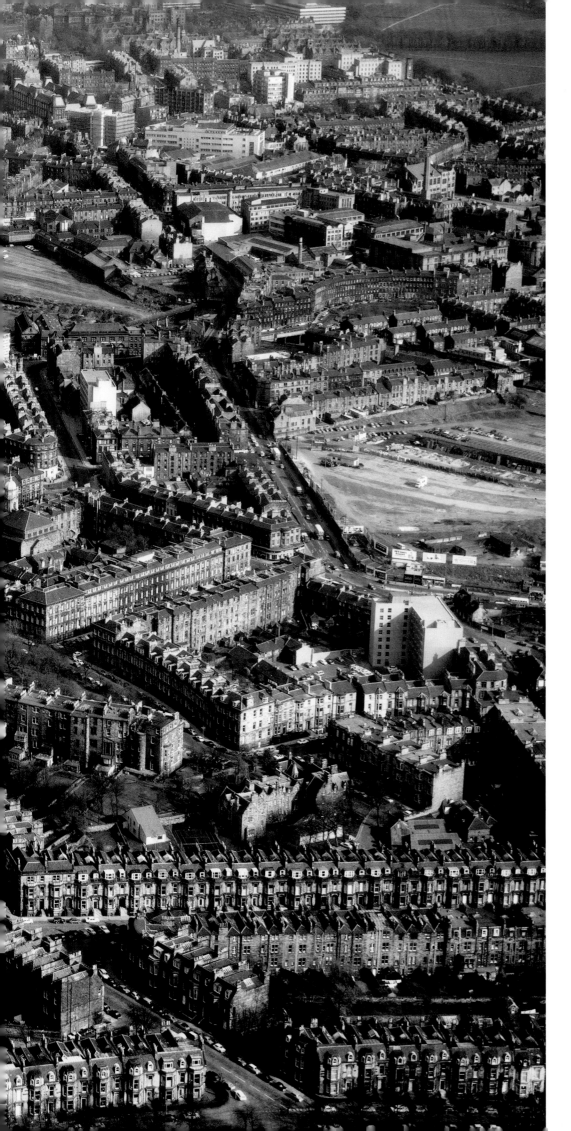

Centred on the giant spires of St Mary's Cathedral, the western New Town was the last phase of Edinburgh's second city to be developed, finally reaching completion in the 1880s. Echoes of James Craig's original block grid system continue before the layout opens up elaborately into the ellipses of Grovesnor, Landsdowne, Glencairn and Eglington Crescents. In this image, taken in 1972, the classical city meets the modern, as, beyond the sweep of Atholl Crescent, the cleared land of the former Caledonian railway station is overlooked by the multi-storey Canning House.

AEROFILMS 1972 A222966

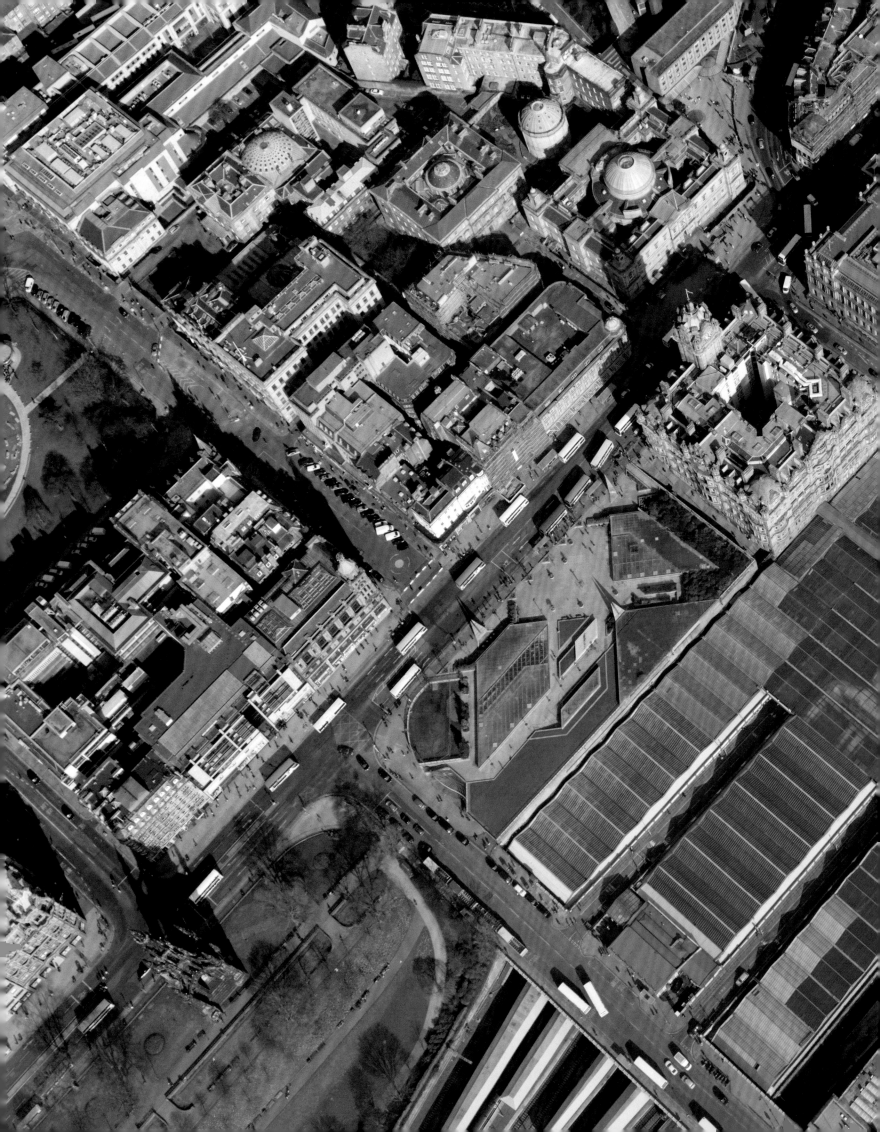

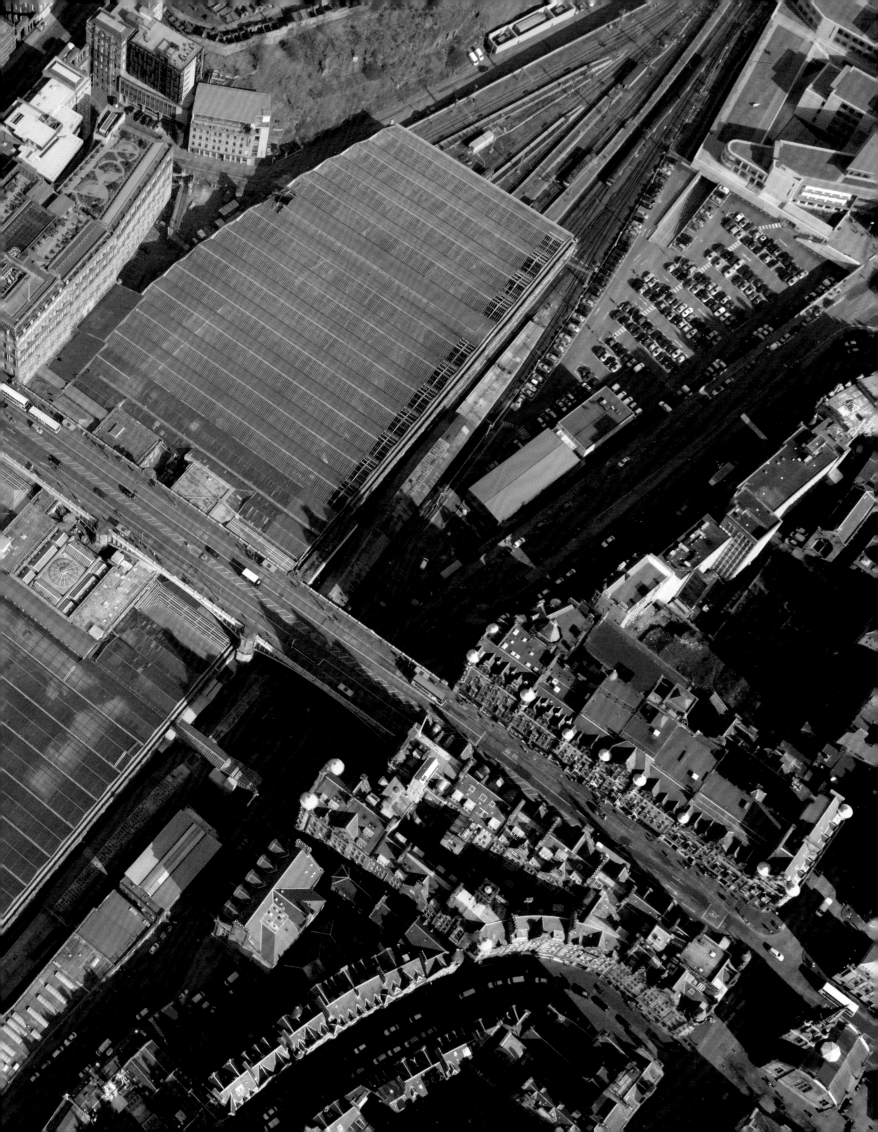

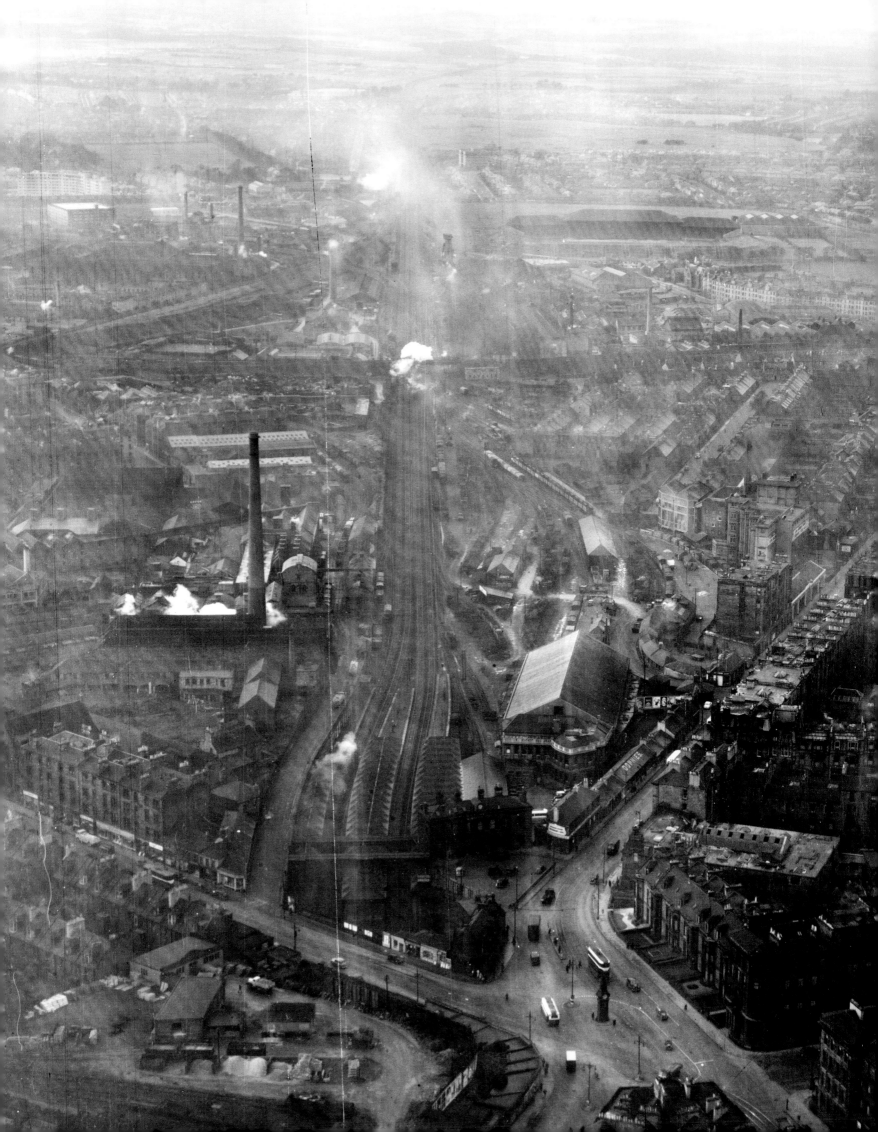

LEFT

In the mid twentieth century, the legacy of the Victorian era clearly remained. Post-war Edinburgh was still a slave to iron and steam, its urban landscape carved up by busy railway lines, with cavernous stations pushing apart the city centre. Here rail tracks arrow straight out of Haymarket past the tall chimneys of the Caledonian Distillery towards the distant fields of West Lothian.

RAF 1951 006-001-000-102-C

TOP AND BOTTOM RIGHT

The now demolished Caledonian Station curves outwards from the baroque facade of its attached hotel, while, at the other end of Princes Street, the North British Hotel hangs over the vast expanse of Waverley Station. According to one Victorian architectural journal, "railway termini and hotels are to the nineteenth century what monasteries and cathedrals were to the thirteenth century. They are truly the only real representative buildings we have."

RAF 1951 006-001-000-112-C
RAF 1951 006-001-000-073-C

PREVIOUS PAGES

Filling the valley between the Old and New Towns, it is clear to see the impact of Waverley Station – and the railway in general – on the shape of central Edinburgh. First built in 1844, the Station displaced the old Fruit and Vegetable Market, which moved north to become Waverley Market. In the 1980s the Market, which once operated open stalls on the valley floor, was resurrected as a state-of-the-art subterranean shopping centre based on the American mall model.

RCAHMS 2010 DP075884

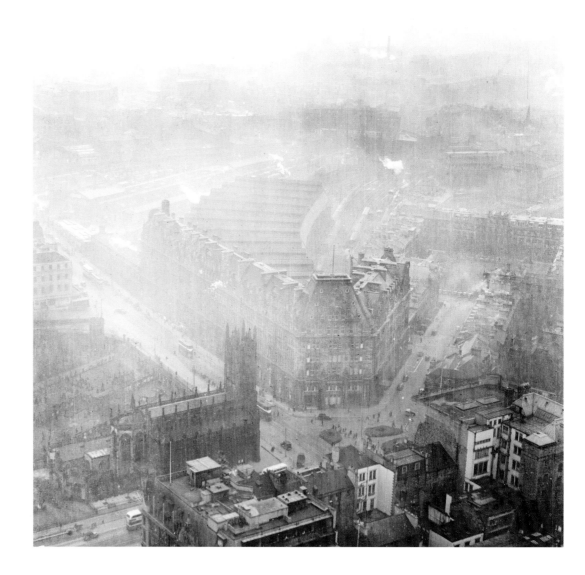

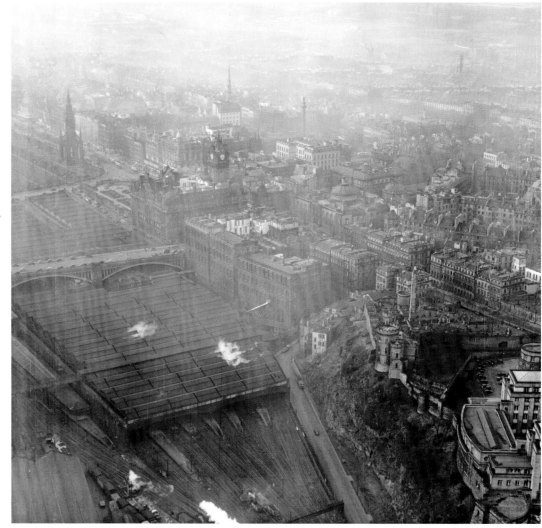

The primary point of entry into Scotland for centuries, Leith has been a trading nexus, a frontier port, a merchant town and was twice fortified as a city with its own parliament. The grand architecture of its early boom years – churches, townhouses and merchant palaces – is mostly long gone, but, with the derelict land of the docks now reclaimed for modern flats, offices and leisure complexes, the area is in the midst of a wholesale, post-industrial transformation.

RCAHMS 2010 DP075955

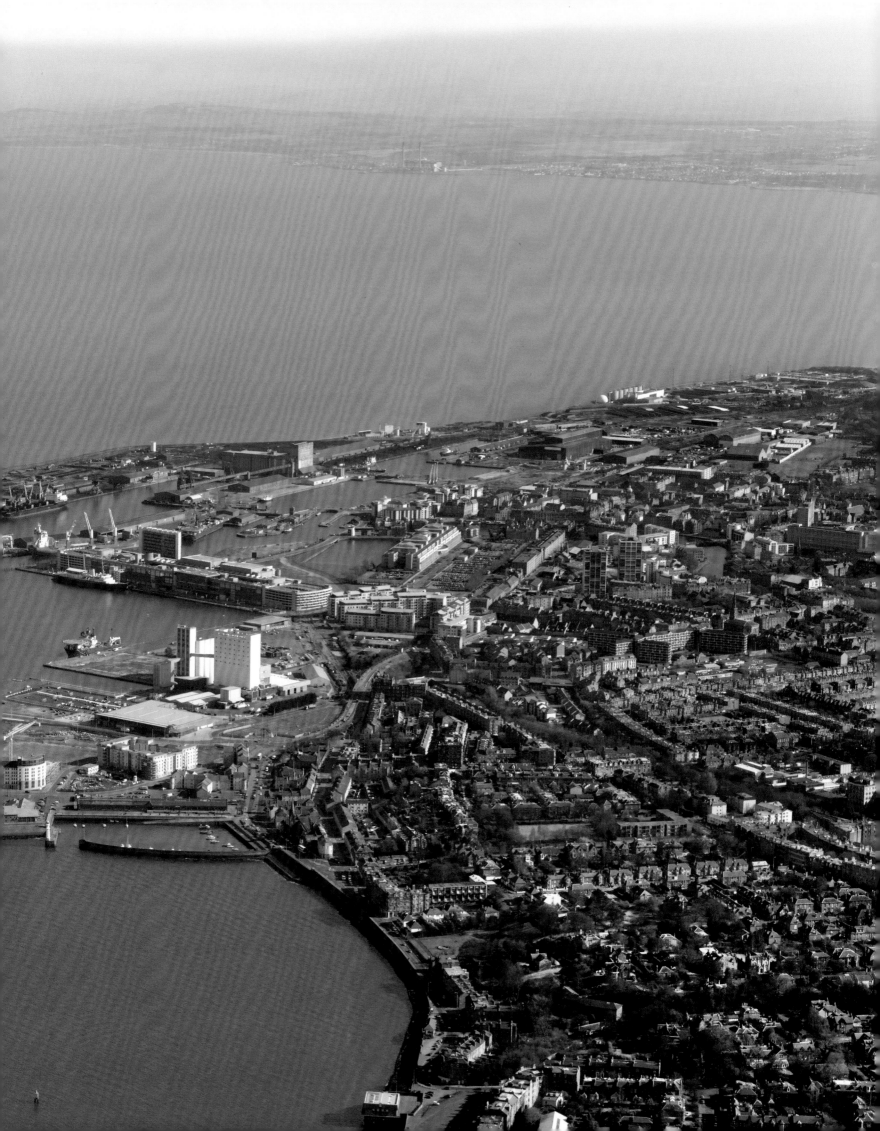

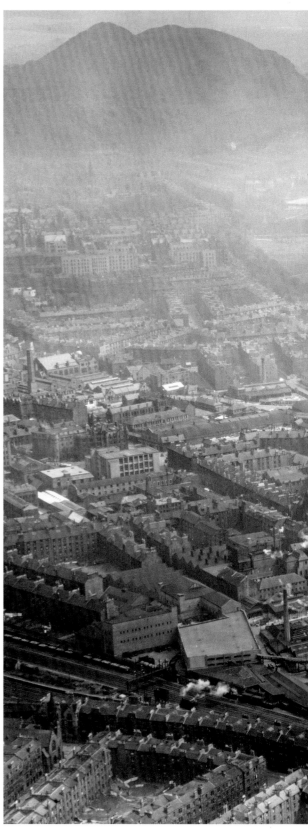

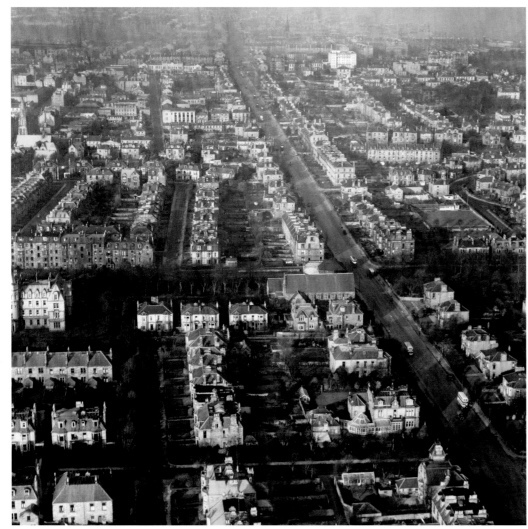

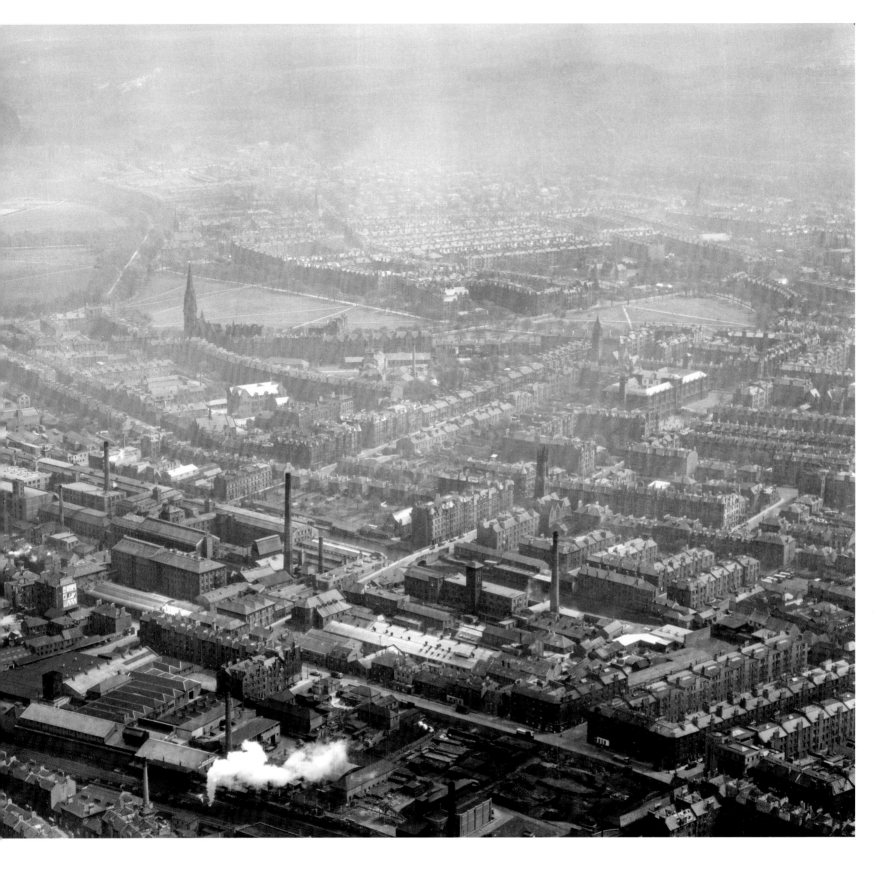

TOP LEFT

Throughout the Victorian era, Edinburgh's expansion beyond the confines of the Old and New Towns was rapid and relentless. Here the hierarchy of housing is clear, as the villa estate of Merchiston meets the tenements of Polwarth, with the poorest housing pressed against the industrial canal.

RAF 1951 006-001-000-088-C

BOTTOM LEFT

On Edinburgh's Southside, villa estates stretch as far as the eye can see, their bulky facades multiplying out across both sides of the wide artery of Craigmillar Park.

RAF 1951 006-000-001-021-C

ABOVE

Fountainbridge was once one of the heartlands of industrial Edinburgh. Pictured here in 1951, huge breweries and factories are pressed between the canal and the railway, while close-packed workers' tenements surround on all sides.

RAF 1951 006-000-001-022-C

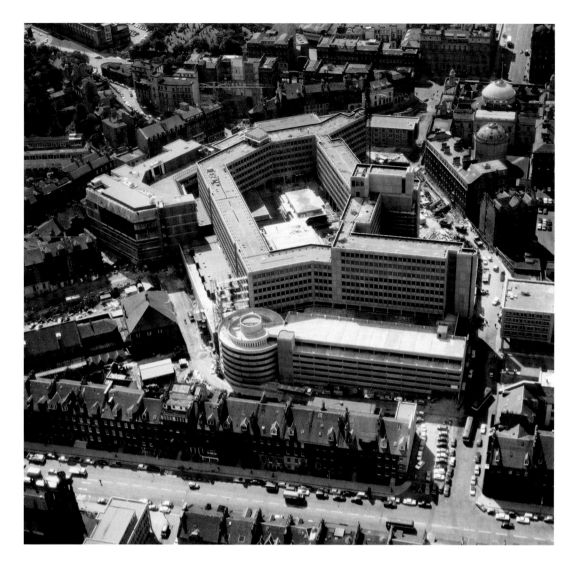

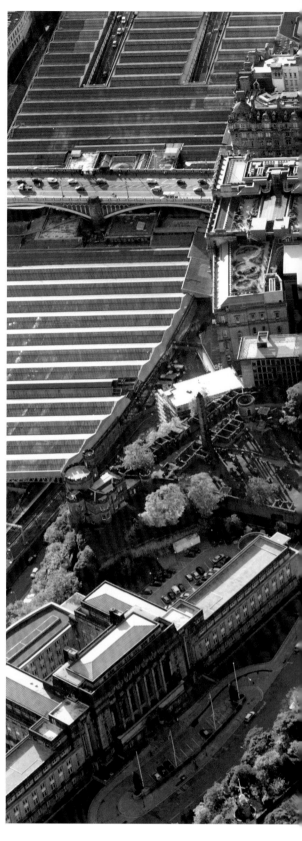

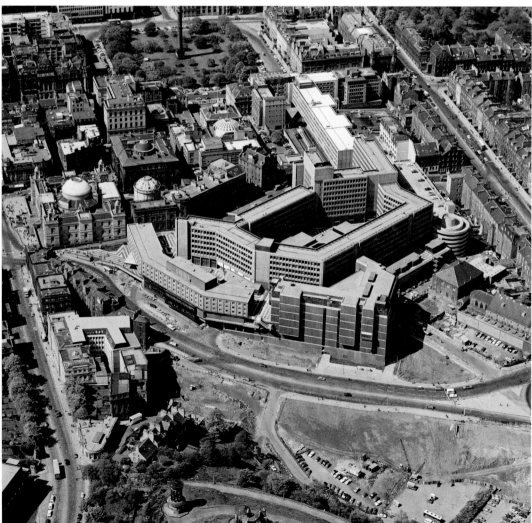

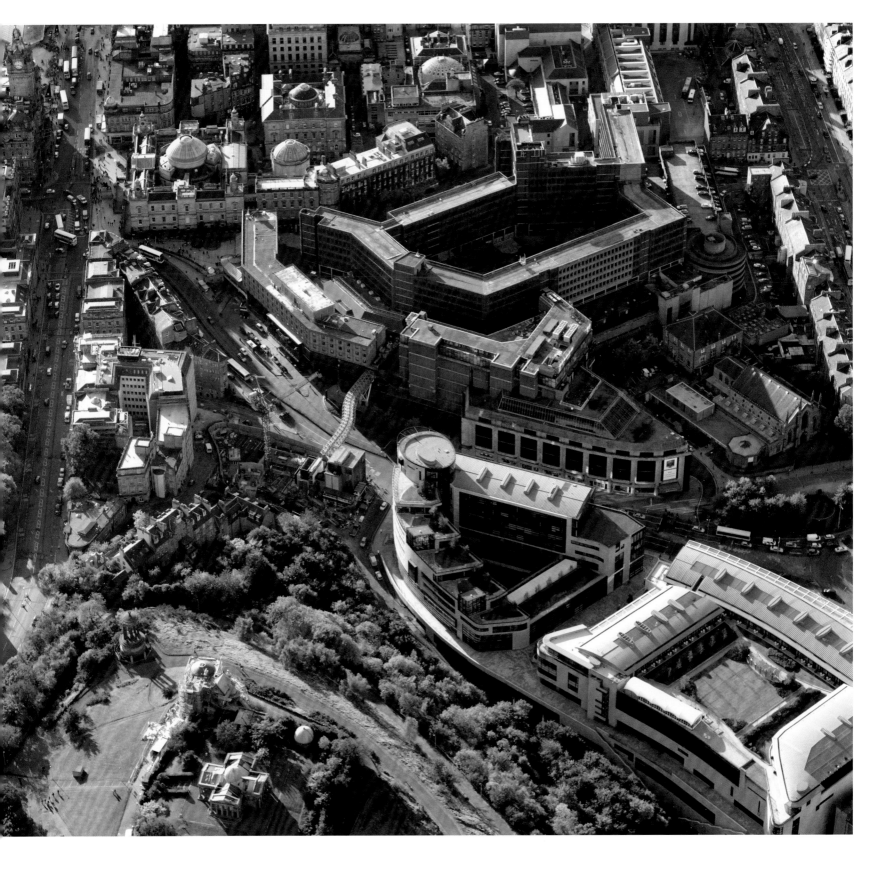

The multi-functional, megastructural complex which includes the St James Shopping Centre and the former Scottish Office headquarters of New St Andrew's House, emerged with brutalist Modernism into the east end of James Craig's New Town.

AEROFILMS 1972 A232120

Expansion of the complex – which was first completed in 1970 – continued into the following decades. In this image, housing at the top of Leith Walk has been cleared to allow the addition of Sir Basil Spence, Glover & Ferguson's John Lewis store, a sweeping curve of sandstone and glass built in 1987.

AEROFILMS 1975 290876

Still a dominant, brooding presence on the fringes of the Georgian New Town, the 1970s complex looks set for demolition in the coming decade, with the area to be re-imagined as the 'St James Quarter', a multi-level galleria containing hotels, shops, offices, restaurants, galleries and continental-style public spaces.

RCAHMS 2008 DP051312

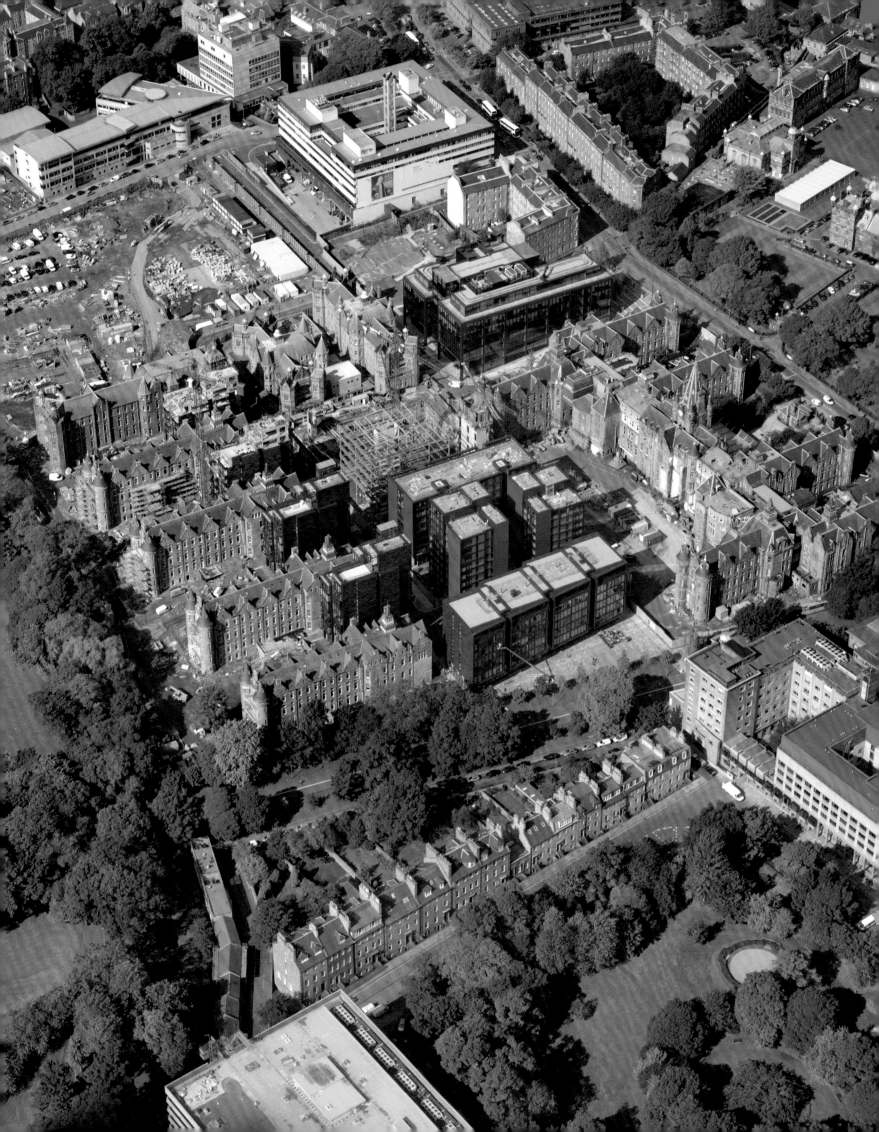

Architect David Bryce reputedly consulted Florence Nightingale in creating his 1870 design for a new Royal Infirmary of Edinburgh. Working in a baronial style, Bryce devised four separate medical pavilions with the intention of maximising the amount of light and air that could enter the wards. With the relocation of the Infirmary to a greenfield site on the outskirts of the city in 2002, the old Victorian hospital is currently being redeveloped by Norman Foster as 'Quartermile' – an urban community of housing, shops, hotels and public spaces that intends to integrate modern architecture into the core of Bryce's original building.

RCAHMS 2008 DP049312

Flats emerge on land reclaimed from Leith Docks. Housing is just one aspect of the 'Western Harbour' vision for the redevelopment of the old port, which envisages creating nine new interconnected waterfront villages on 144 hectares of brownfield land – an area larger than the entire Georgian New Town.

RCAHMS 2010 DP075951

The award-winning University of Edinburgh Informatics Forum was designed to house a faculty that brings together research into artificial intelligence, cognitive science and computer science. Opened in 2008 – on a site which had lain empty since the 1970s when it was first cleared for redevelopment – the state-of-the-art building is founded on the sustainable ideals of long life and adaptability.

RCAHMS 2008 DP051318

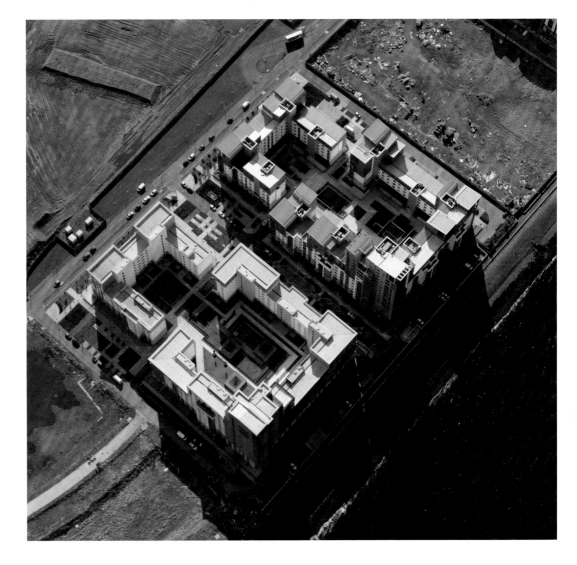

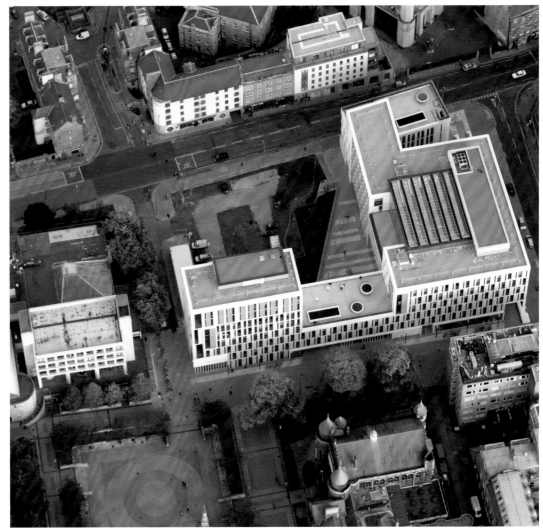

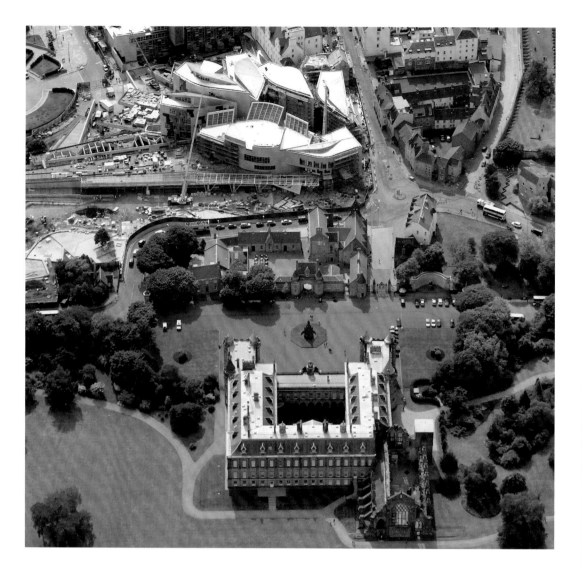

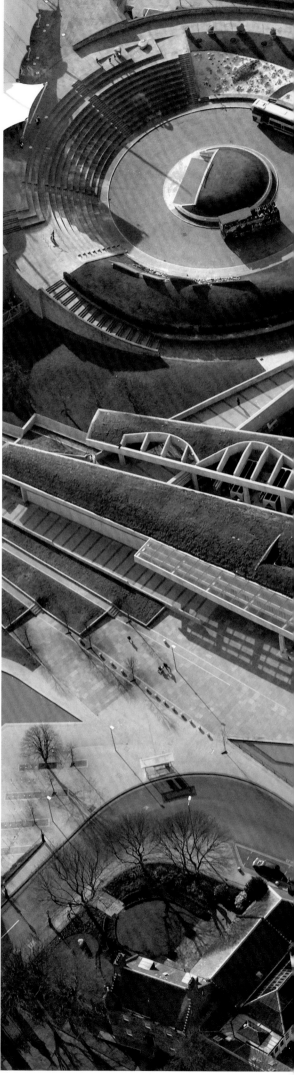

Seen from above, Catalan architect Enric Miralles' bold vision for the new Scottish Parliament appears as an elegant mesh of overlapping shapes and forms. Symbolism played a major role in the location choice – positioned at the foot of the medieval spine of the Royal Mile, and opposite Holyroodhouse, seat of royal power for centuries, the parliament emerged from the brownfield site of a formery brewery, reinvigorating a post-industrial landscape that had been in decline for decades. A controversial project from the outset, response to the building has been polarised, yet the critical reaction is almost universally positive. As the *Architectural Journal* put it, here was "a Celtic-Catalan cocktail to blow minds and budgets, it doesn't play safe, energetically mining a new seam of National Romanticism refined and reinterpreted for the twenty-first century".

RCAHMS 2004 DP007329
RCAHMS 2007 DP025693

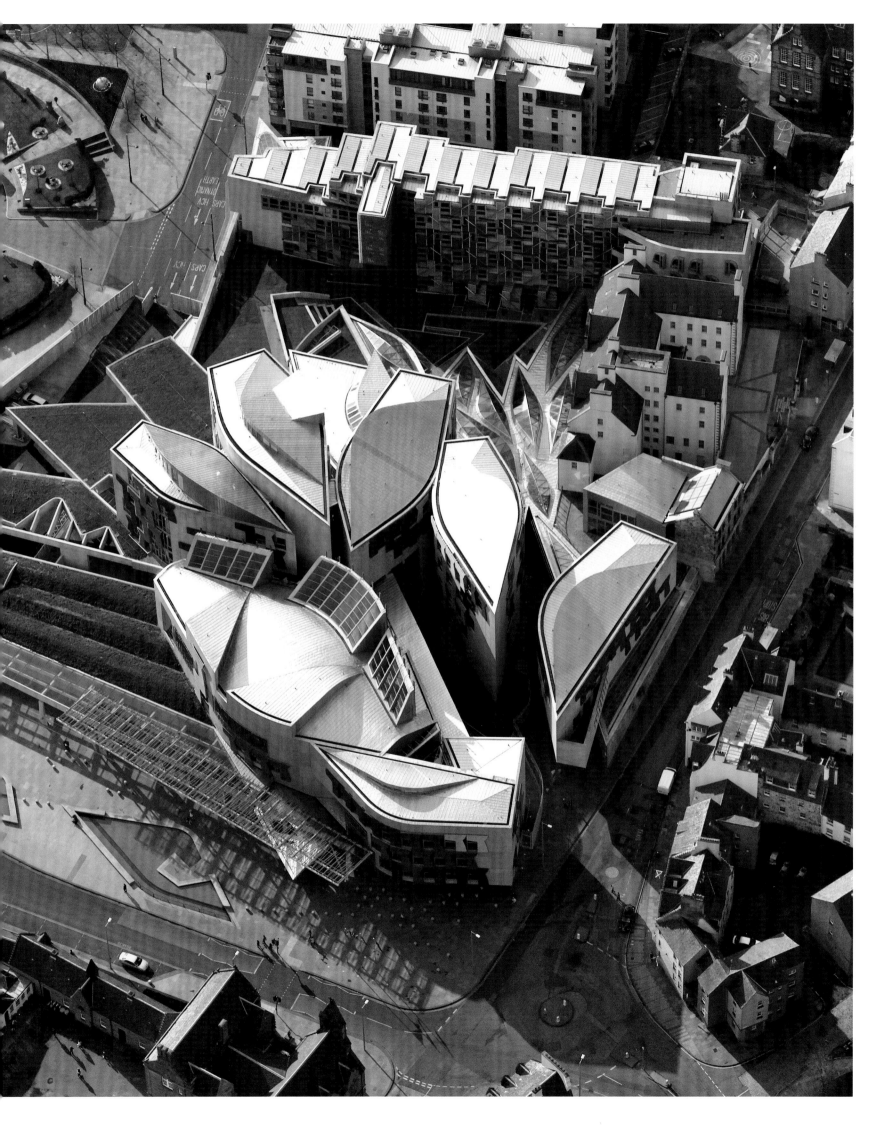

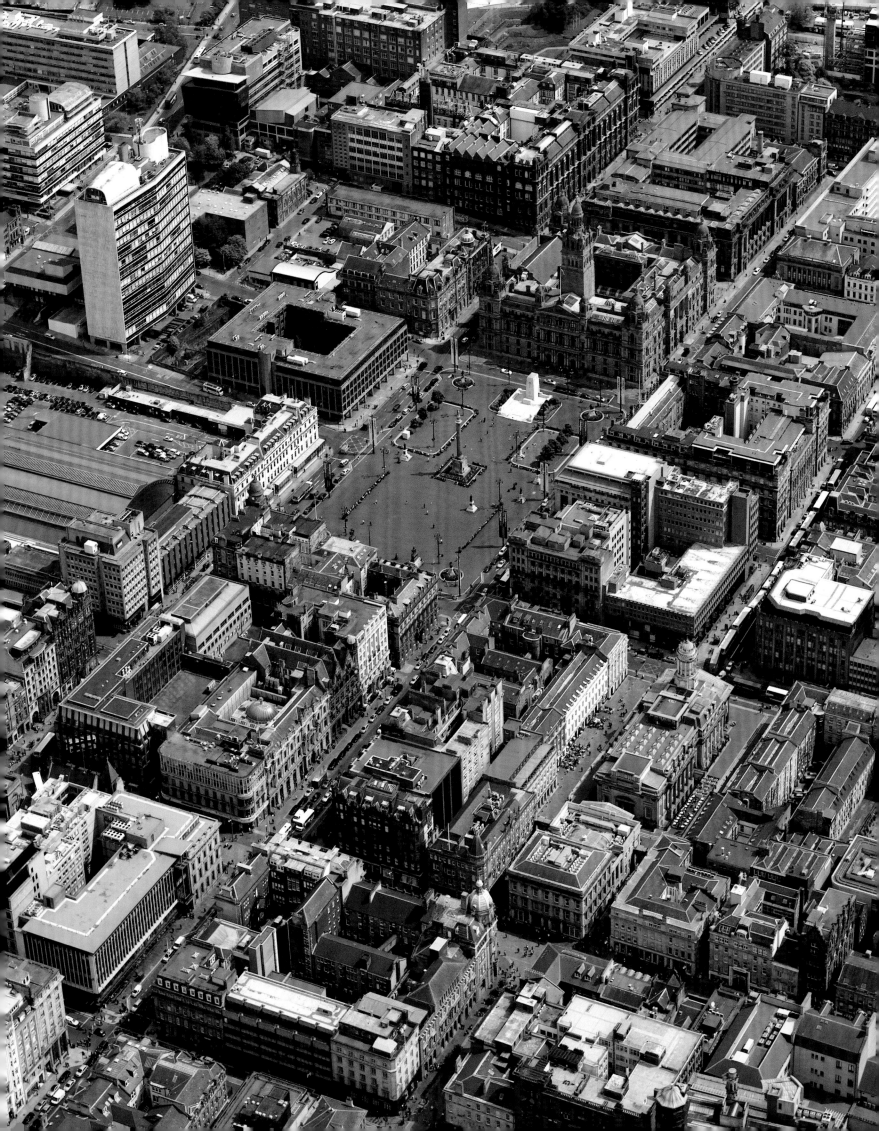

Glasgow

On 8 October 1883, the *Glasgow Daily Herald* gave a breathless report of the ceremony to lay the foundation stone for the new City Chambers Building. "The arches, the Venetian masts, the statues in the square, the numerous flags and decorations exhibited on hotels and business premises, the brilliant uniforms of the military and the vari-coloured attires of the tens of thousands assembled – all these combined presented a spectacle excelling in magnificence and interest anything that has been witnessed in the city of Glasgow within the memory of living man." Swollen with pride, Lord Provost Ure preached a gospel of civic religion to a crowd of some 60,000 disciples packed into George Square. "The magnificent mass which is soon to rise where we now stand is the citizens' own, to be bought with their money, to be dedicated exclusively to their uses, to pass under their executive control. Could there, therefore, be found a surer index of this people's devotion to its municipal institutions, and faith in their permanence?"

Although it took five years for the Chambers to grow into Glasgow's cityscape, on completion public enthusiasm remained undimmed. When opened by Queen Victoria in 1888, over 400,000 citizens walked transfixed through their glorious new temple of civic power, its colossal edifice matched by its startlingly opulent interior, with marbled staircases and glowing galleries reached through a Romanesque entrance hall bearing an intricate mosaic of the city's coat of arms. The grand structures that Glasgow built to enrich its urban environment, from the vast civic Chambers to the cultural palace of Kelvingrove, were not commissioned on beneficent whims of merchant princes as in renaissance Venice, nor were they philanthropic gifts from wealthy industrialists as in Manchester and Liverpool. Instead the city and its people were acting as one, part of a bold municipal experiment that carried with it the echoes of the city-states of ancient Greece.

For the Second City of the Empire, the workshop of the world, scale was everything. The new Chambers buildings sat within a geometric grid plan that was unique in Britain, with huge banks, merchant houses and shipping headquarters advertising imperial importance through lavish architectural symbolism, and street names like Virginia, Jamaica, St Vincent and West Nile referencing the worldwide reach of trader Glasgow. Tobacco and cotton had elevated it to the international stage and, as Victoria reached the throne, a certain rebellious spirit shared with the New World was ingrained in its fabric.

By this time Glasgow was already on its way to becoming one of the greatest manufacturing machines the world had ever seen, a city of iron and steam, fire and steel. With unrelenting industrial growth it acquired a dense gravity all of its own, drawing workers in their hundreds of thousands from the Highlands and Lowlands, and across the sea from Ireland. The wealthy moved west to build districts of imposing terraces on the slopes of Blythswood Hill and Park Circus, while

landscapes of factories and tenements marched along the riverside and out across the city. Although the Victorian engine room burned white hot, in the overcrowded slums of the worker army, disease and suffering were endemic. The city pioneered an ambitious programme of civic improvement, tearing down the worst housing – and the fabric of the Old Town in the process – to create new streets lined with 'Improvement Trust' tenements, but greater challenges were still to follow.

In the twentieth century, war, depression and industrial decline picked Glasgow apart piece by piece. It was the mothballing of the city on a grand scale, the great machine dismantled. Challenged by the social and economic fallout, post-war planners followed the blueprint of Modernist architecture to slice through the civic fabric of the nineteenth century, bringing a near Victorian vigour to the task of reconstructing the urban landscape. Modernist dreams of elevated motorways, skyscraper skylines and the 'house as a machine for living' became a Glasgow reality. Tenements were re-imagined as tower blocks, vertical 'hanging-gardens' that reached high over Glasgow, but often survived less than half a century before their demolition and consignment to history.

In the 1980s, it was a cultural initiative to re-invent the post-industrial city that stimulated an urban renaissance. The 'Glasgow's Miles Better' campaign promoted Clydeside's art, architecture and environment, envisioning a new future focused on enterprise, education and tourism. The selection of the city as European Capital of Culture in 1990 recognised this rich heritage and provided further impetus to the process of rebirth and renewal.

Today, new icons have risen to dominate the Glasgow skyline, from the sparkling aluminium shells of the Armadillo to the clean arc of the Finnieston Bridge. In this dynamic modern landscape the confident echo of the civic body that once built its own, monolithic Chambers remains – that robust belief in the power of culture, design and architecture to reinvigorate a city and its people.

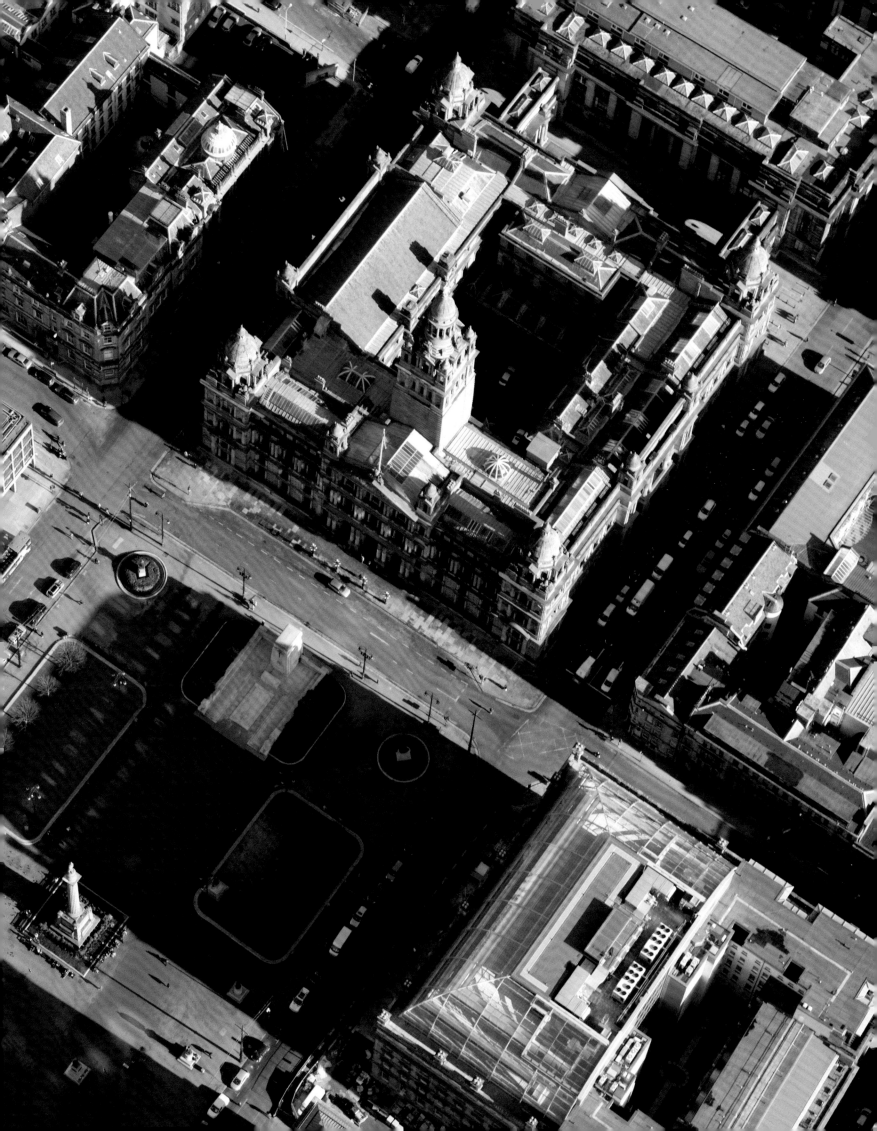

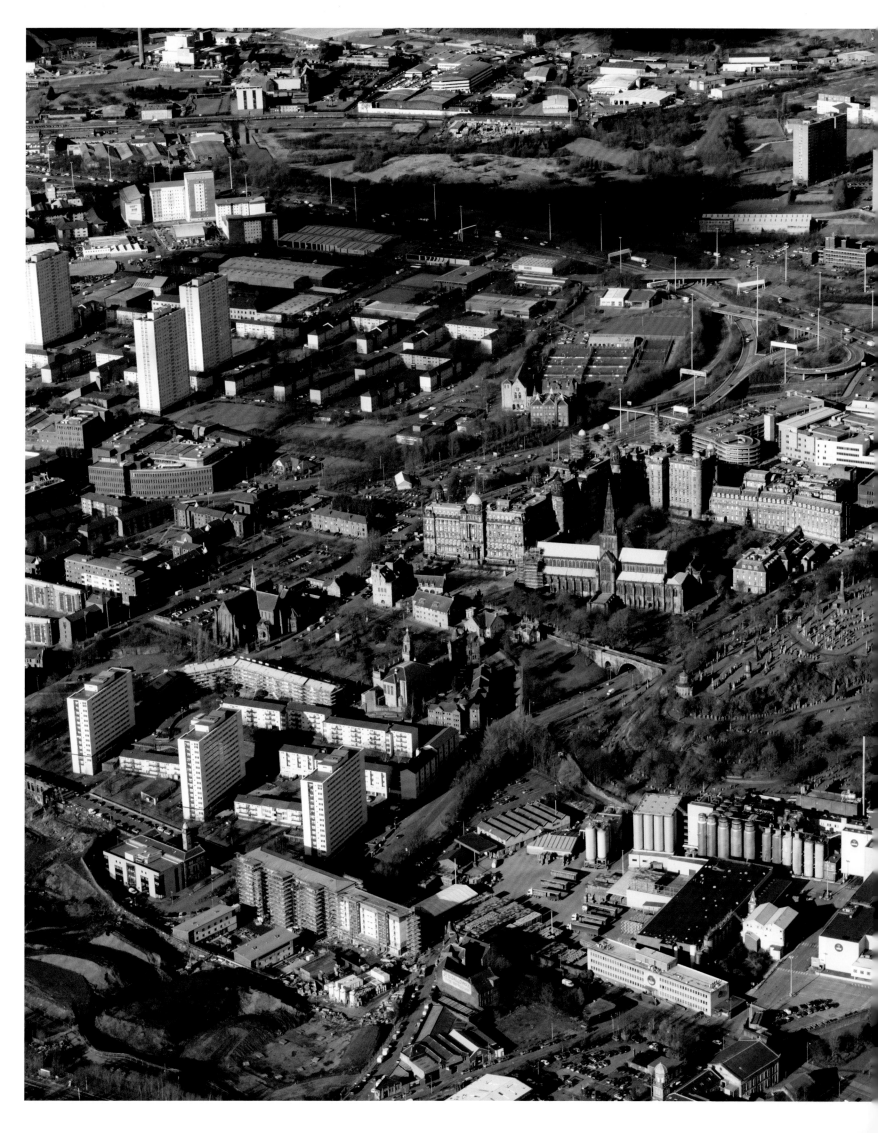

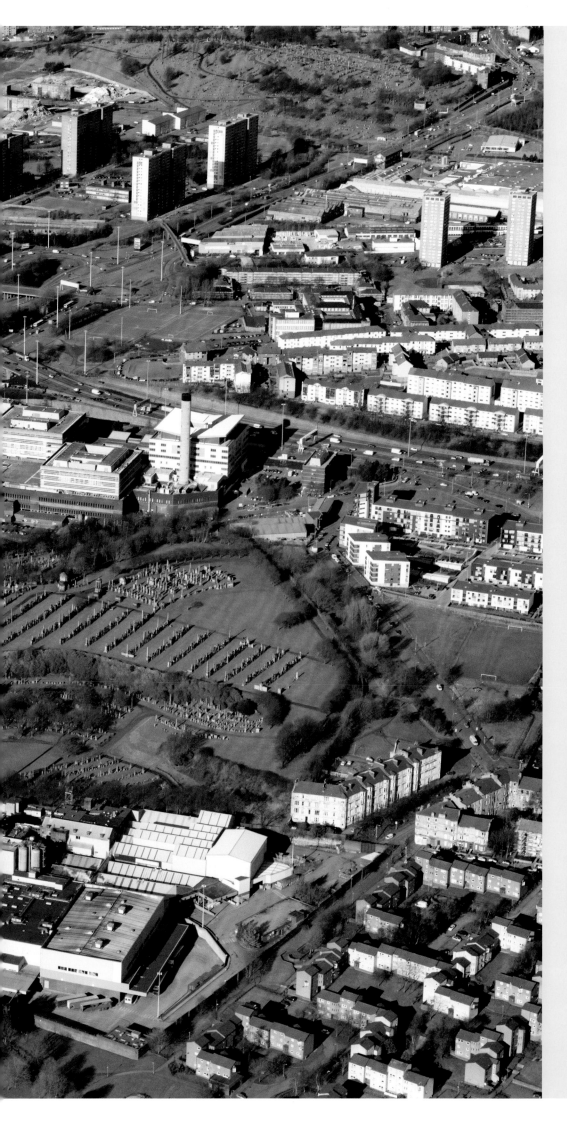

The origin point of the city of Glasgow is surrounded by modern development as motorway slip roads, high-rise housing, factories and the angular bulk of the Infirmary close in on the dark, gothic grandeur of the Cathedral. Dating from the thirteenth century, the Cathedral dominated the summit of medieval Glasgow – a small, hilltop settlement on the site of St Mungo's sixth century church and seventh century grave. Gradually, the modest town extended downhill towards the Clyde, before the trading boom of the seventeenth and eighteenth centuries transformed the civic fabric. As merchants created a new city to the west, the old High Street and Upper Town descended into decay and squalor, and the Cathedral became an increasingly isolated figure on the fringes of a rapidly expanding urban environment. The Necropolis, Victorian Glasgow's great garden cemetery – reputedly modelled on the Père Lachaise in Paris – now seems a potent symbol of the ultimate decline of the first city.
RCAHMS 2010 DP075386

FOLLOWING PAGES

As the medieval city – the original 'dear green place' – was redeveloped and its older fabric eroded, industrial Glasgow thrived round the old core in a dense landscape of tenements, factories and smoke. "The great city dims the autumn sky with its canopy of smoke", wrote Hugh Macdonald in 1853. "The pestiferous smoke from certain works in the northern quarter of the city, notwithstanding their gigantic chimneys, seems to have thrown a blight over the face of nature." The city as vast manufacturing machine – the 'workshop of the world' – had arrived.
AEROFILMS 1934 45887

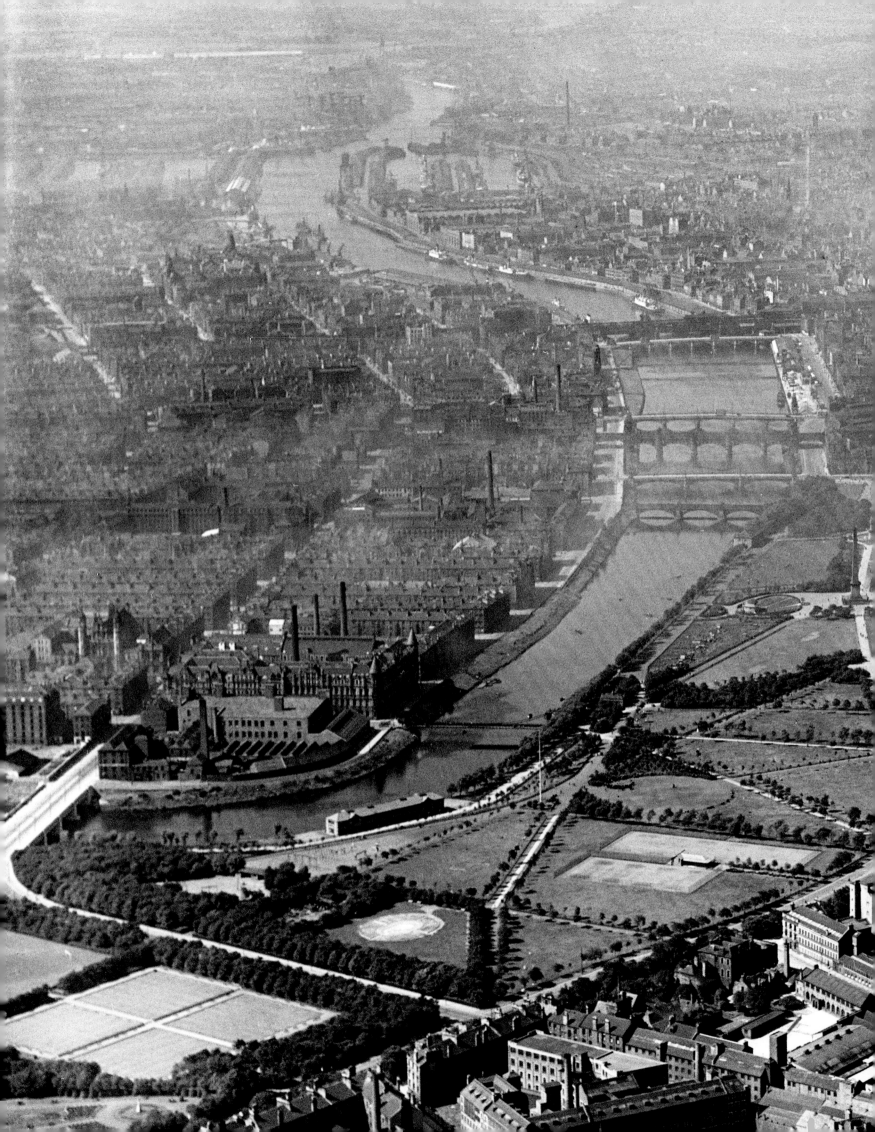

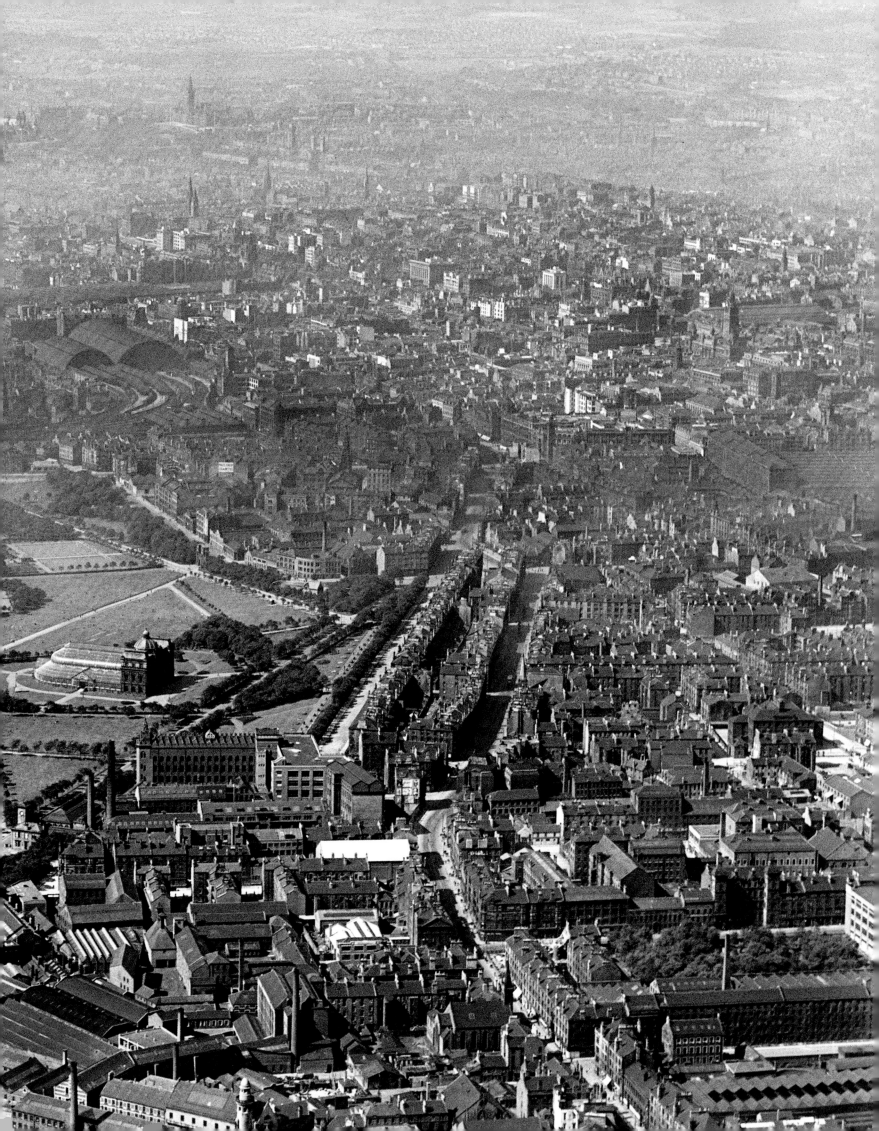

As heavy industry colonised the banks of the Clyde, housing for the worker army developed in parallel. At Scotstoun the raised embankment of an arterial railway line divides the crammed ranks of tenements from row upon row of shipyards and engineering works pressed tight against the riverside. A new vessel can be seen emerging here from a busy gang of cranes and a huge, criss-cross lattice of scaffolding at the Clydeholm Shipyard of Barclay Curle & Co. On Dumbarton Road, a long procession of trams runs east towards the city centre.

RAF 1950 006-001-000-026-C

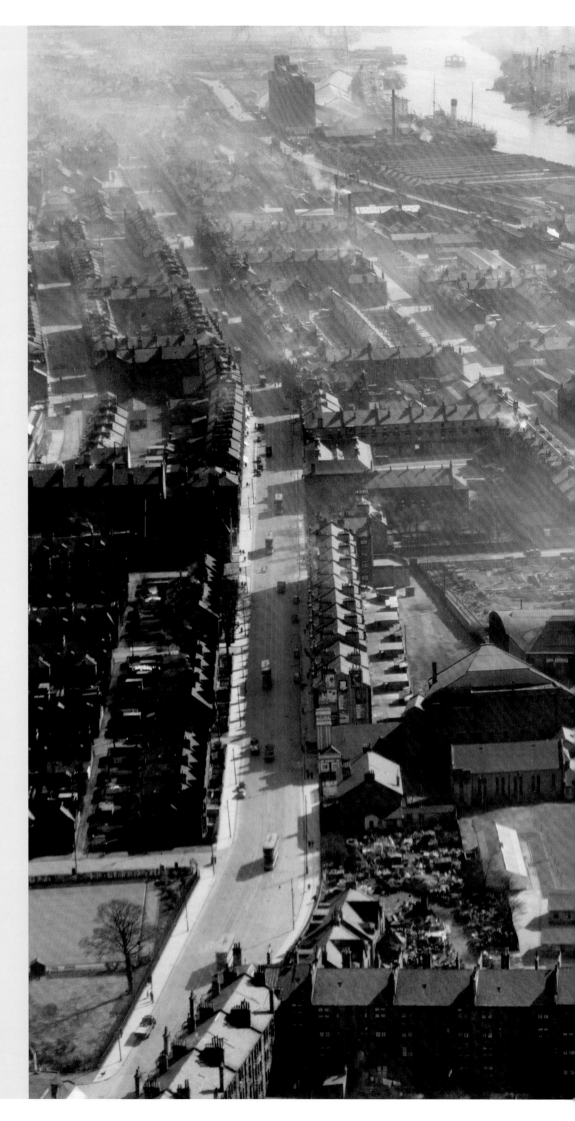

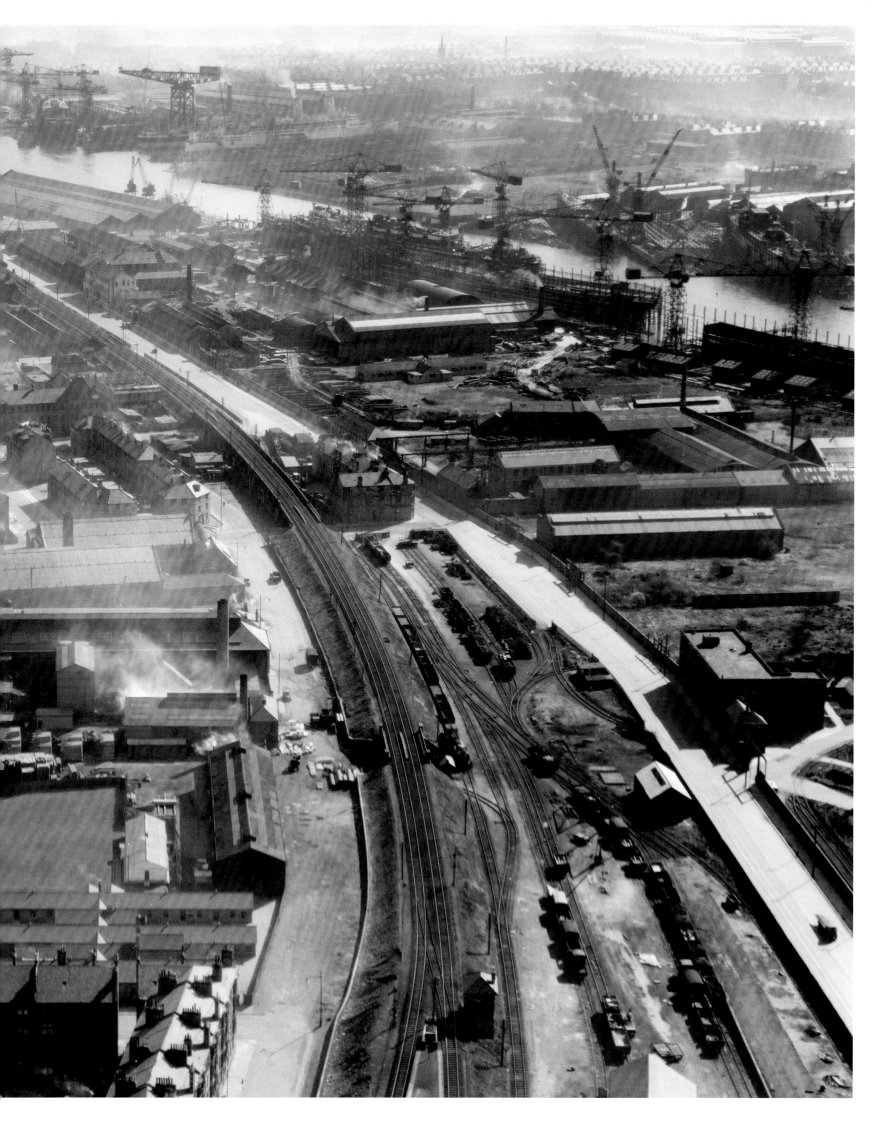

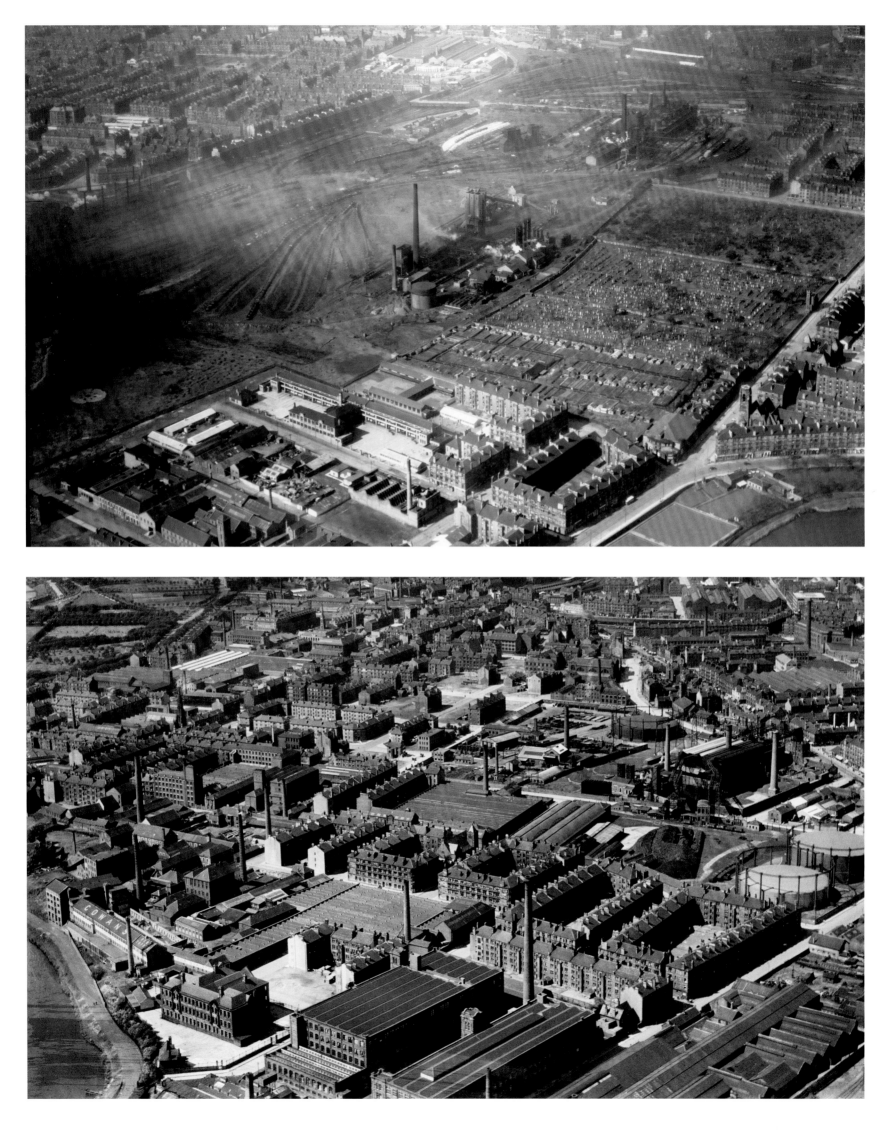

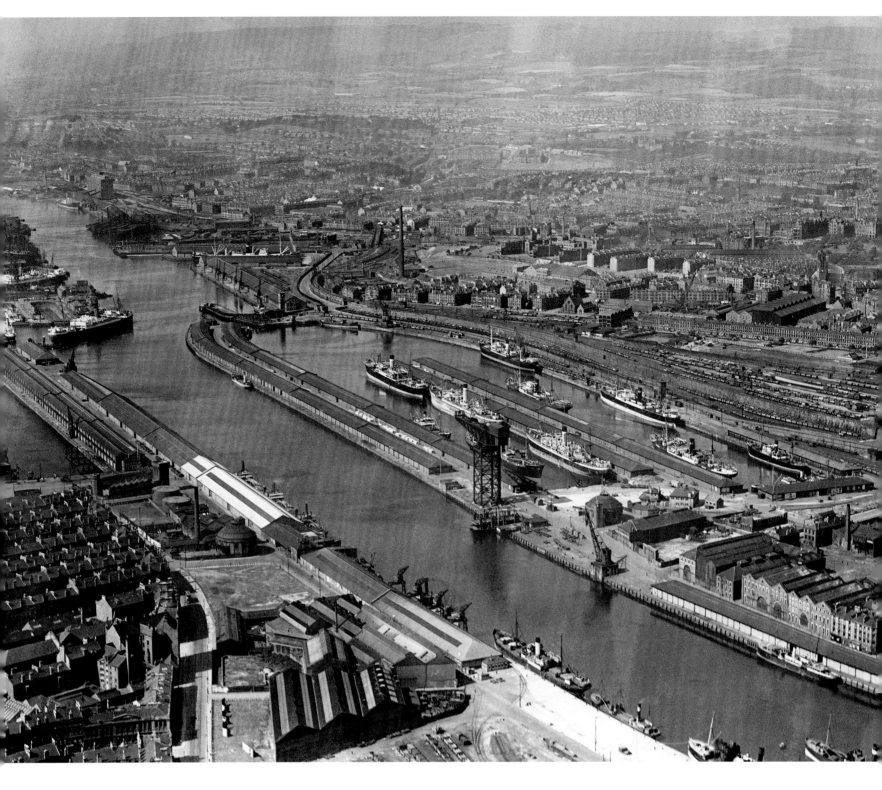

TOP LEFT

While the original Necropolis was land-scaped beside the looming medieval sentry of Glasgow Cathedral, the cemetery's southern incarnation had as its attendant monument the colossal dark hulk of the Govan Ironworks – an appropriate symbol in the industrial heartland of the city. Established by William Dixon in 1839 as the first ironworks in Glasgow, its five giant blast furnaces were in their day a constant, fiery presence on the skyline, earning the popular nickname 'Dixon's Blazes'.

RAF 1950 006-000-001-035-C

BOTTOM LEFT

An array of chimneys rises above the ridged roofs of cotton spinning and weaving fac-tories and the nearby squares of tenements in Dalmarnock. Originally a settlement that had grown up to the east of Glasgow, Dalmarnock was transformed during the industrial revolution into a manufacturing village, a textile machine absorbed by the rapaciously expanding city.

AEROFILMS 1936 50834

ABOVE

Dominated by the iconic industrial monument of a Titan cantilever crane, the Queen's Dock at Finnieston – the first of Glasgow's large docks – was built between 1872 and 1880 to cope with the huge volume of mercantile and industrial traffic operat-ing on the Clyde. The crane was erected in 1932, one of six Titan strongmen working the river, and was used to transfer every-thing from boilers to locomotives between ships and the quayside.

AEROFILMS 1934 45891

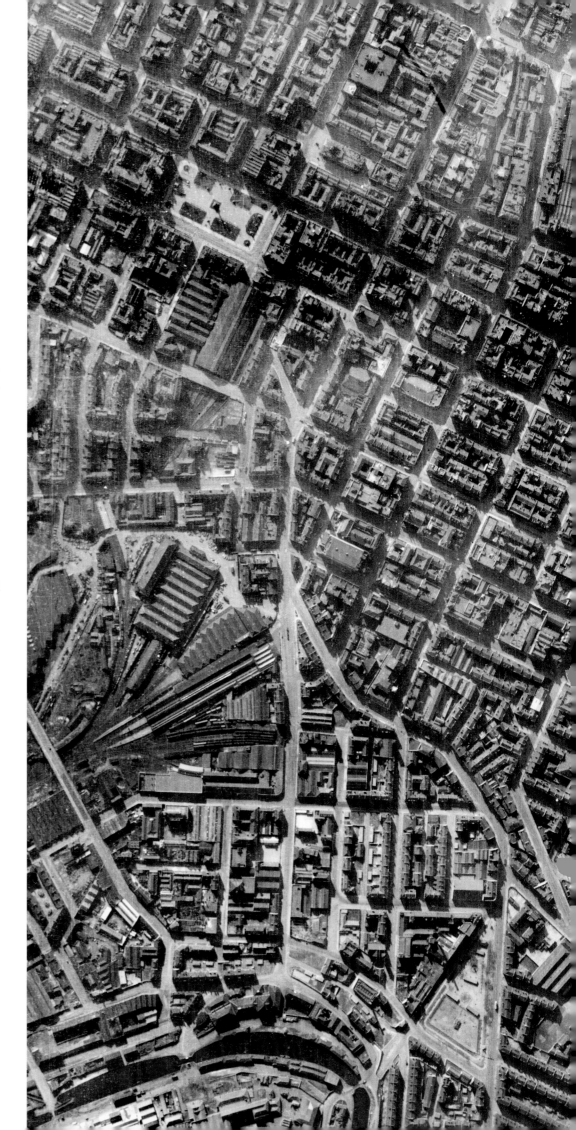

RIGHT

Taking its cue from the Merchant City's original eighteenth century grid, throughout the 1800s Glasgow's geometric streetplan – unique in scale in Britain – multiplied west across the slopes of Blythswood Hill in ordered rows of open-ended building blocks. Pictured here in 1948, Glasgow was still a city powered by coal and steam, its transport networks dominated by the Victorian infrastructure of the railways, river steamers and electric trams. In the coming decades, the automobile would arrive in the city in unprecedented numbers on the Modernist conduit of the motorway, profoundly altering the urban fabric once again.

RAF 1948 006-001-000-301-C

FOLLOWING PAGES

While the city remains true to the grid pattern, individual blocks in the commercial centre become microcosms of architectural development, their buildings mutating in a clash of forms and styles often separated in conception by hundreds of years.

RCAHMS 2005 DP009545

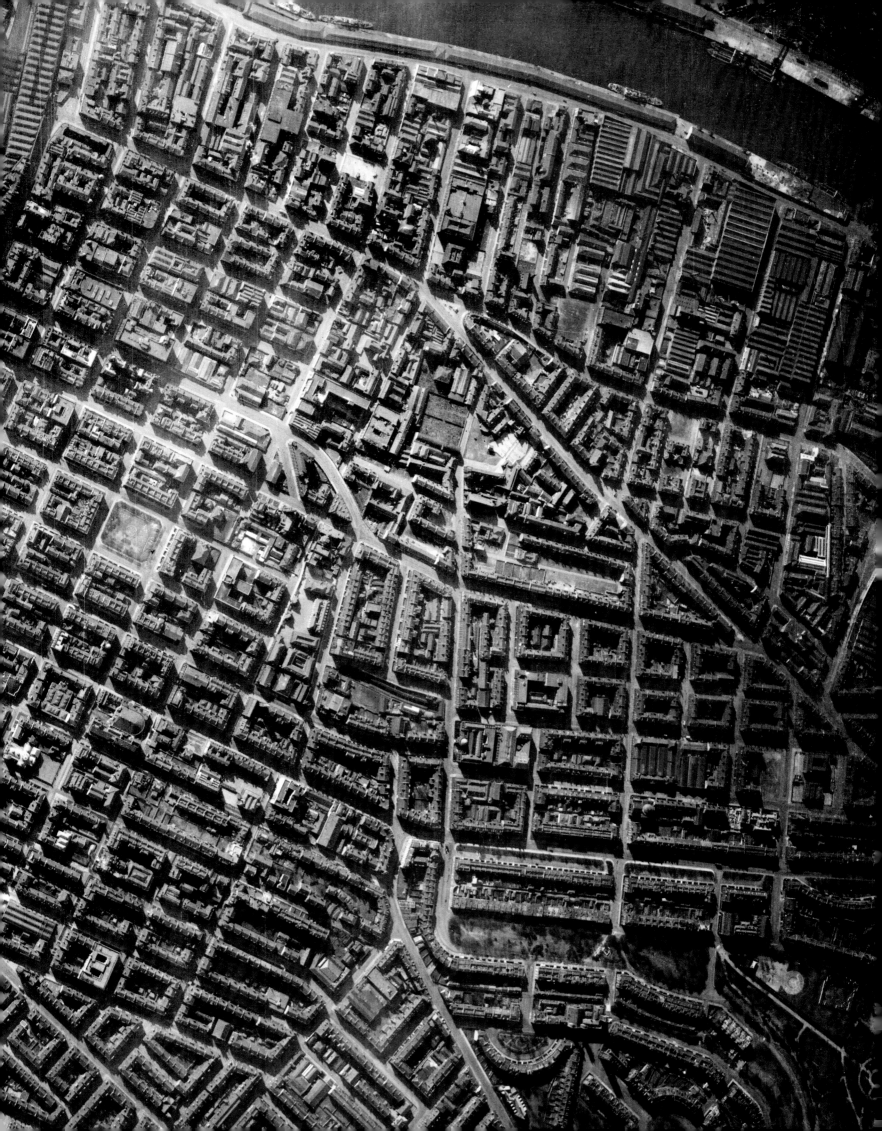

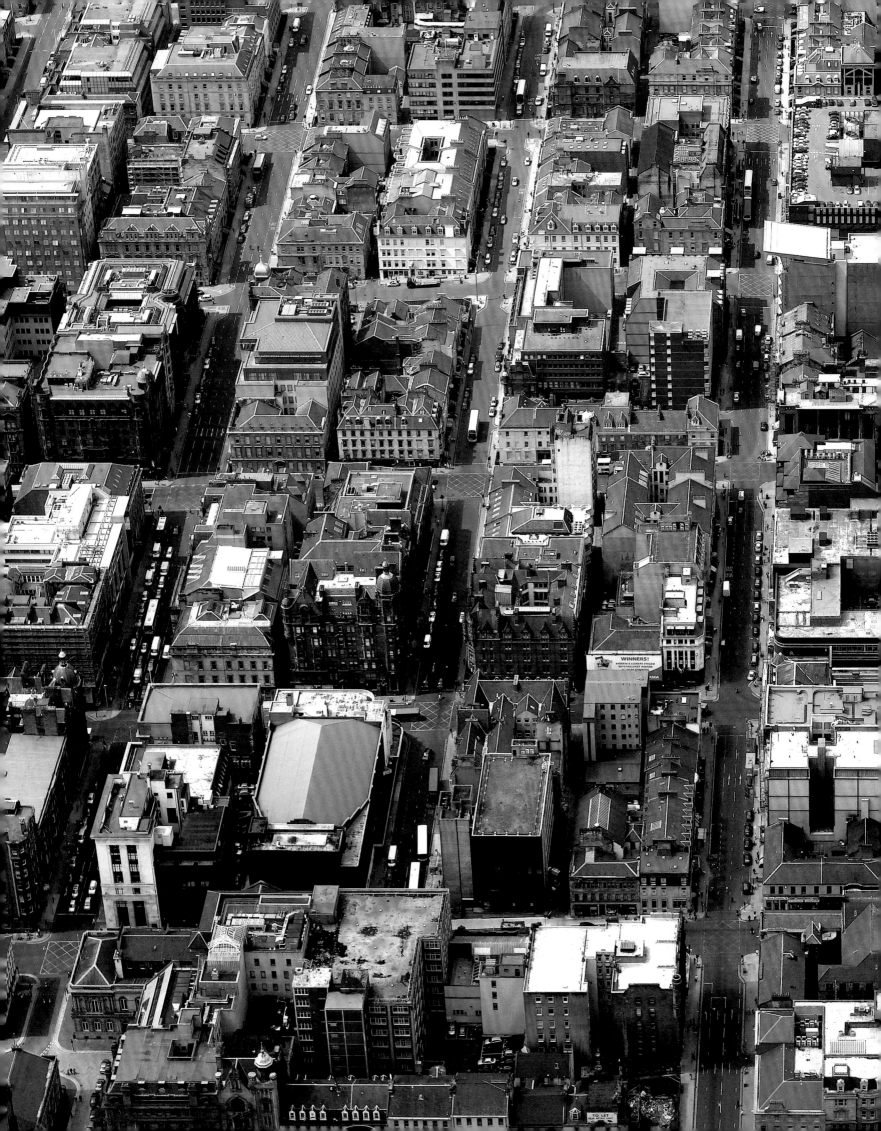

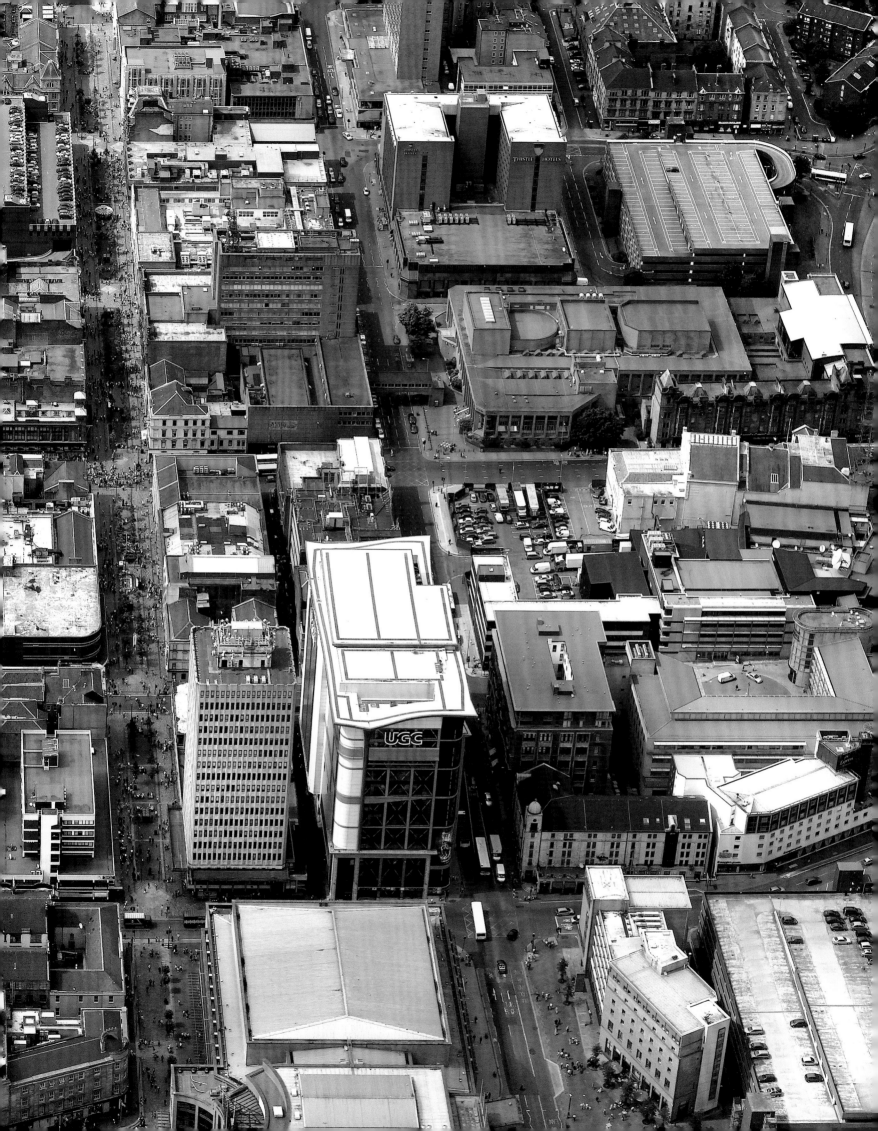

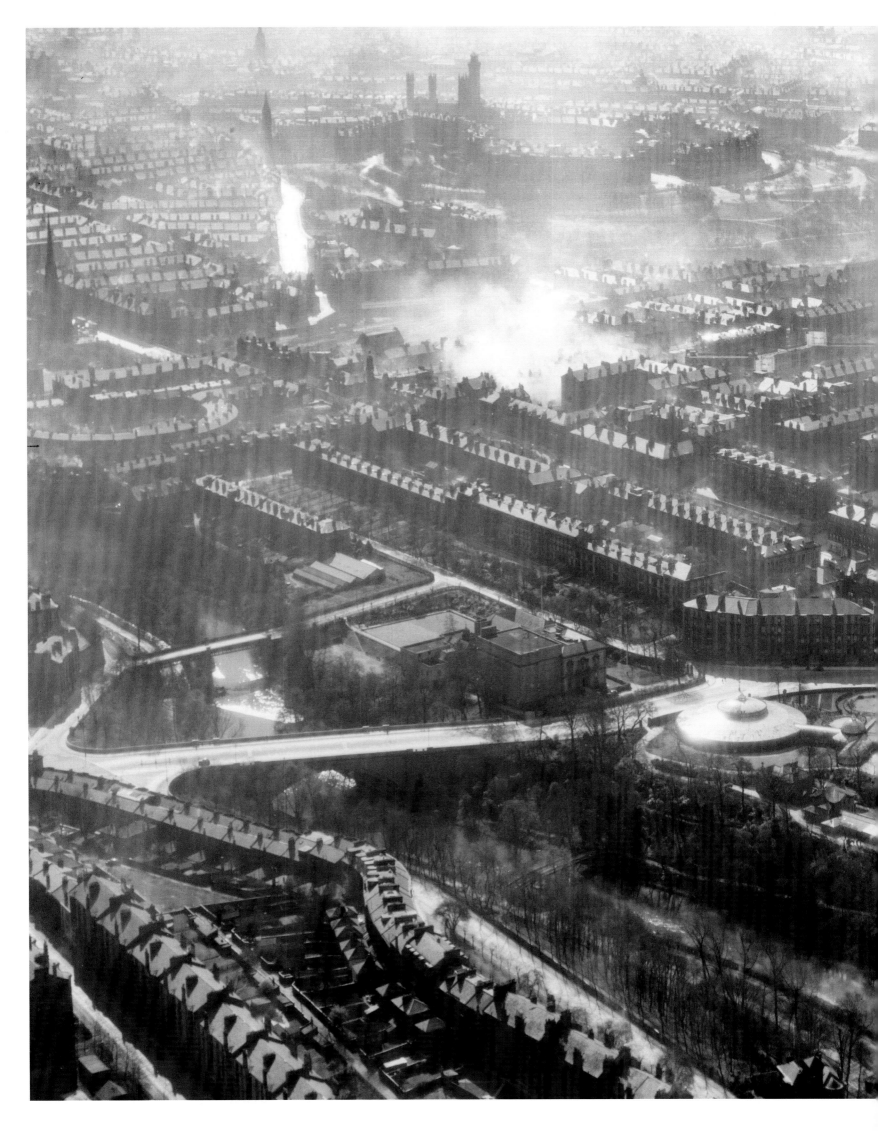

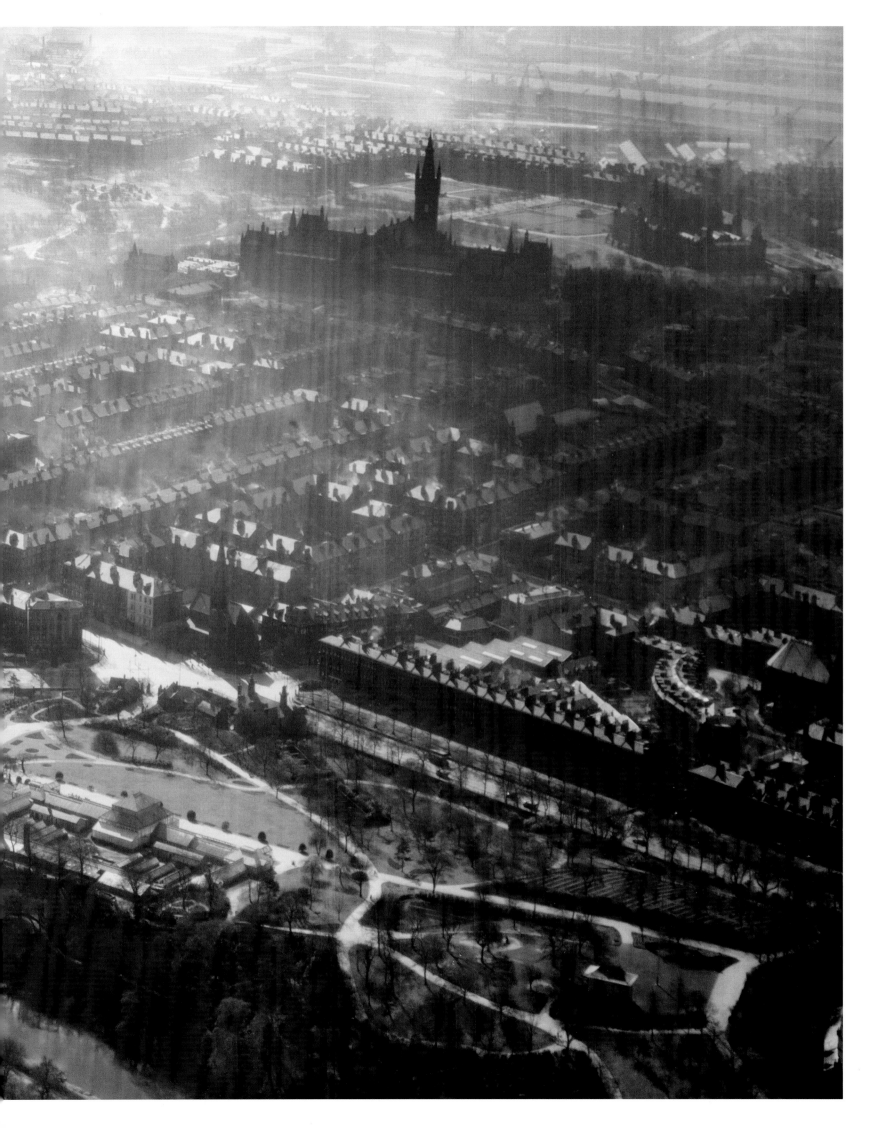

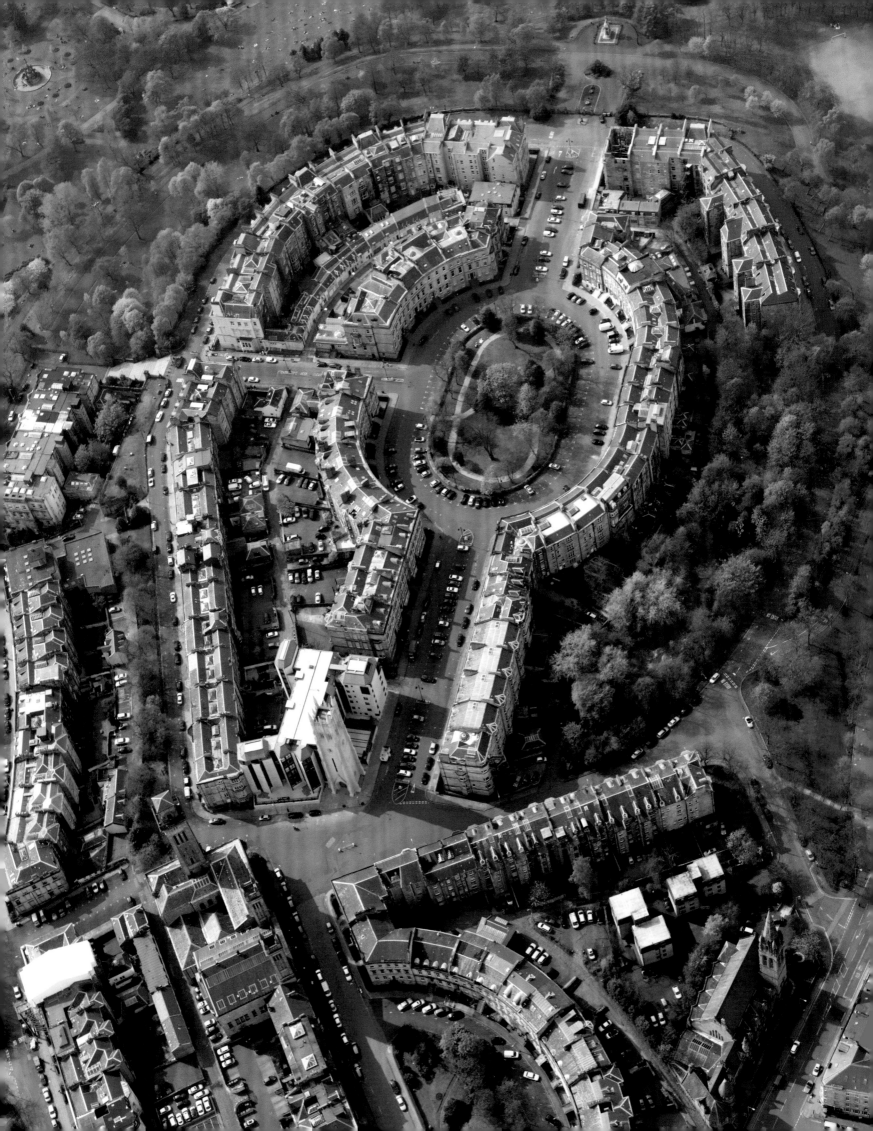

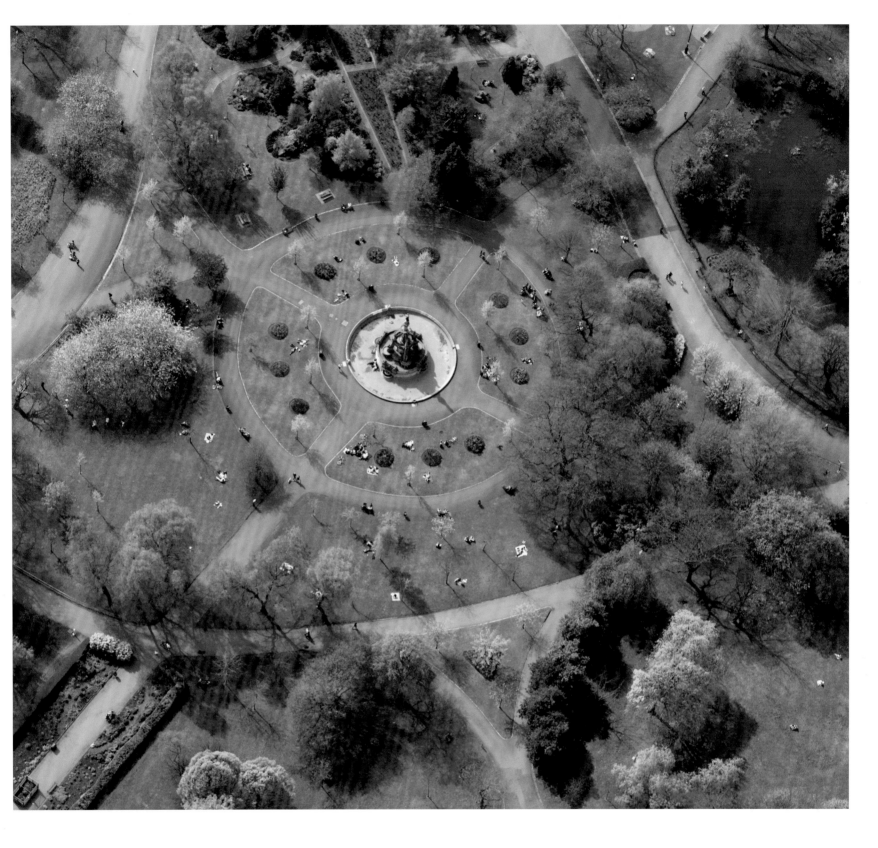

From the colossal gothic silhouette of Glasgow University to the broad boulevard of Great Western Road, a monumental Victorian city suburb emerges out of the smog. Massed ranks of tenements and terraces advance in ordered file across the open countryside of Hillhead and Kelvinside, creating a grand, aristocratic quarter of honey-coloured, sandstone dwellings.

RAF 1950 006-000-001-039-C

LEFT

Architect Charles Wilson created the Park district between 1855 and 1863, a grandiose classical townscape of contoured, sweeping terraces surrounding a lavish central circus. Set on a hilltop above the green valley of the Kelvin, the delicate curves of the Park plan are offset by the striking verticals of the towers of Trinity College and Park Parish Church.

RCAHMS 2009 DP064680

ABOVE

Below the terraces of the Park district the flamboyant sculptures of James Sellar's 1872 Stewart Fountain celebrate the achievements of Lord Provost Robert Stewart of Murdostoun. Stewart was a municipal hero, a man whose determination led to one of the Victorian era's greatest engineering endeavours, the Loch Katrine Water Works.

RCAHMS 2009 DP064673

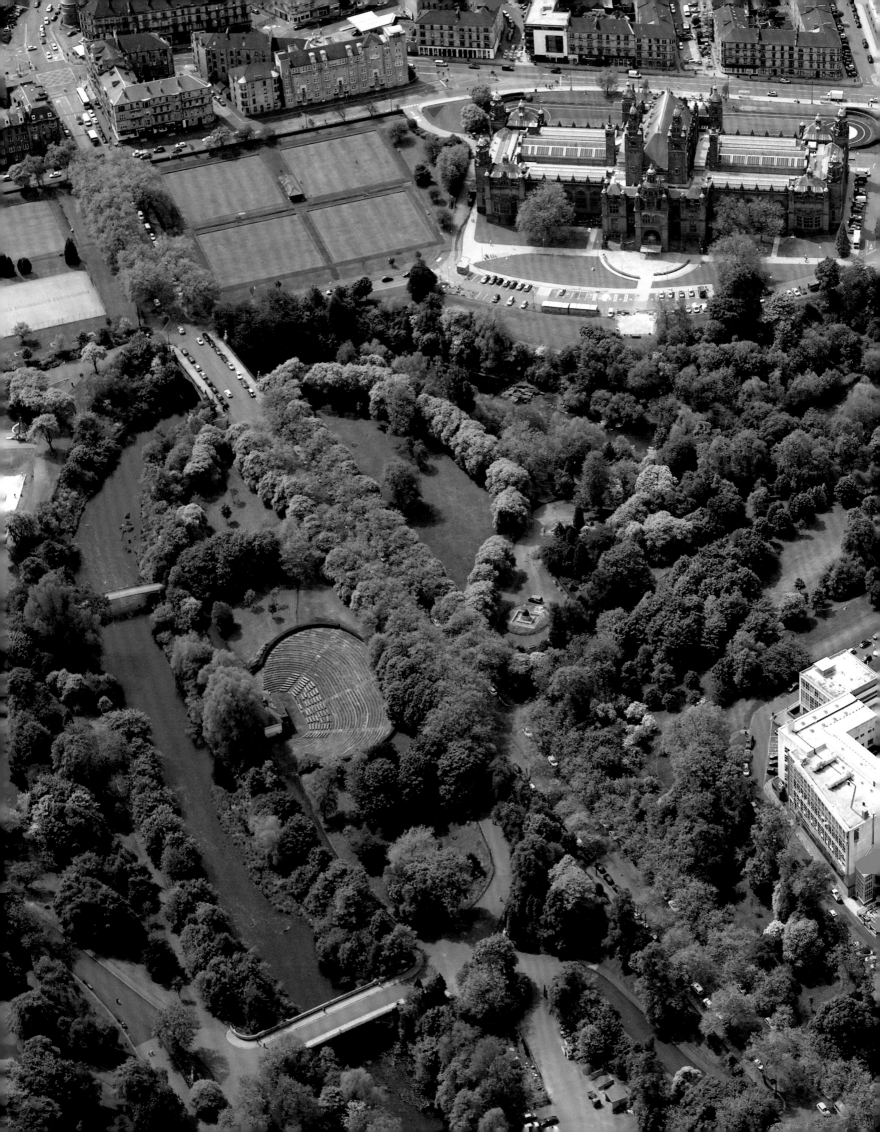

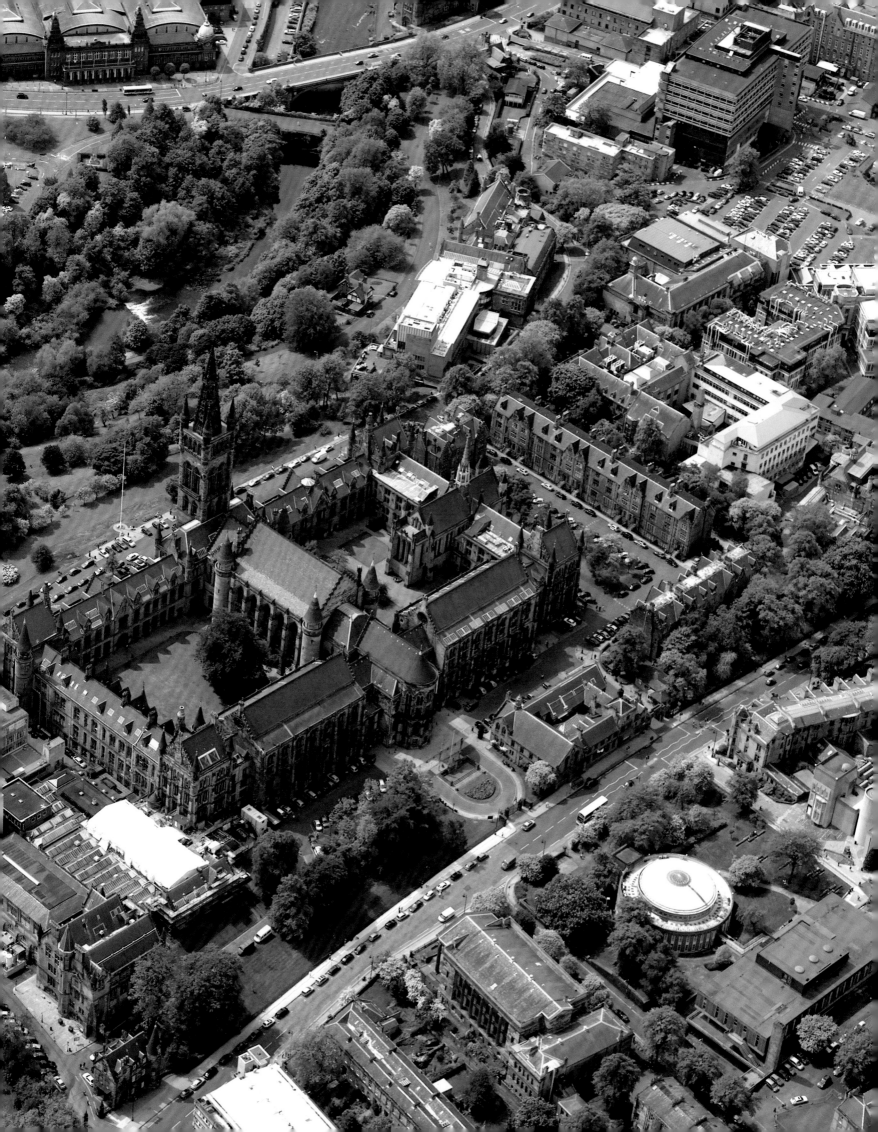

Two Victorian icons face each other across the Kelvin. In the nineteenth century city, monumentalism came to dominate design, with a building's perceived greatness a matter of both style and scale. Built between 1866 and 1886, the colossal gothic edifice of George Gilbert Scott's Glasgow University transformed Gilmorehill into a homage to the dignified medieval townscapes of northern Europe – a deliberate counterpoint to what many Victorians feared was the all-consuming, utilitarian architecture of the factory-lands of heavy industry. In the valley below, Kelvingrove Art Gallery and Museum emerged in 1901 as an enormous, carved baroque slab of deep-red sandstone. Funded by subscription and the proceeds from the 1888 Exhibition, Kelvingrove was intended as a response to London's South Kensington Museums, a permanent, public palace of art, advertising the cultural sophistication of Glasgow to the world.

RCAHMS 2006 DP015695

RIGHT

Originally located on the High Street as the Physic Garden of Glasgow University, between 1838 and 1842 the Botanic Gardens moved to a much larger plot established on Great Western Road. The Kibble Palace, seen here undergoing major restoration work, was the magnificent centrepiece of the Gardens, a cathedral of wrought iron and glass that was initially used for staging grand Victorian concerts and events before being repurposed in the 1880s to predominantly house exotic plants. First built in 1863 for John Kibble for his home at Coulport on Loch Long, the Palace was dismantled, transported up the Clyde by barge, and reassembled in the Botanics in 1871. After more than a century of use, work began in 2004 to repair the structure's corroded ironwork, with the glasshouse reopening to the public in 2006.

RCAHMS 2005 DP011624

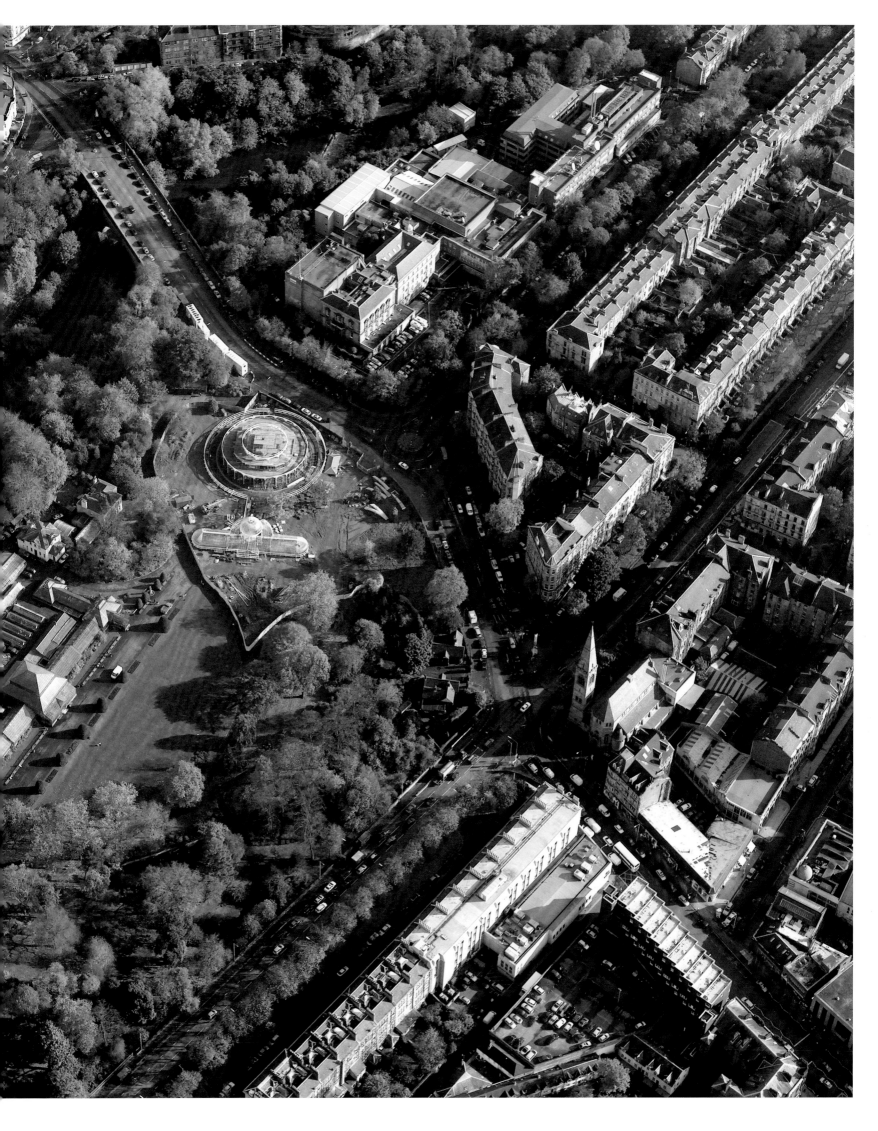

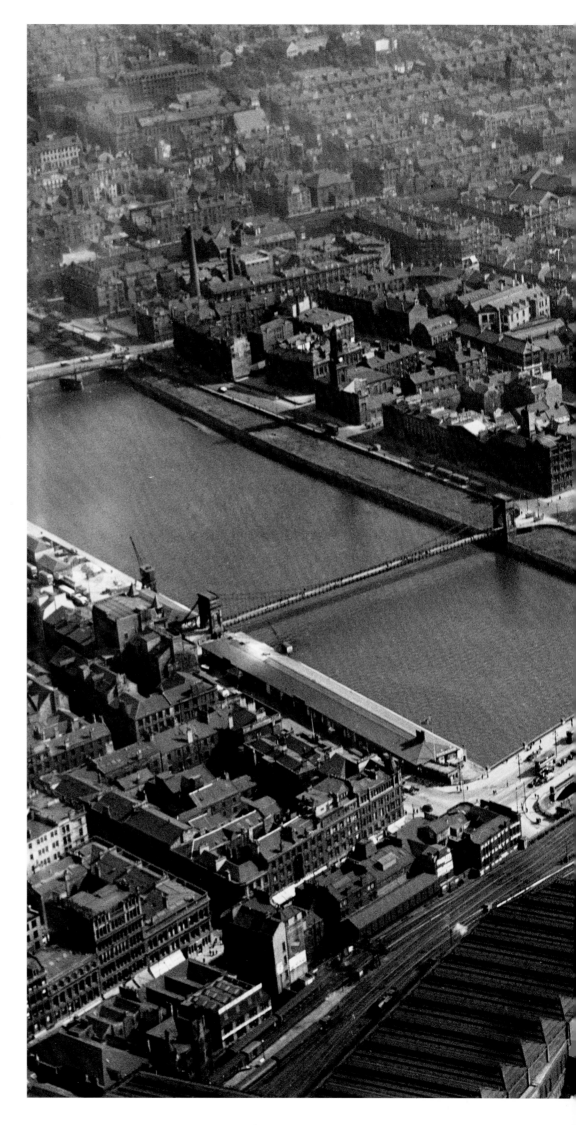

In the late nineteenth century, with the railway coming to dominate large tracts of the industrial cityscape, competition between rival operators was fierce and uncompromising. Denied access rights to the City of Glasgow Union Railway's St Enoch Station, the Caledonian Railway Company's emphatic response was to buy a huge slice of inner-city land from Bridge Street on the south bank across the river into Gordon Street. The result was Glasgow's imposing Central Station. Built between 1876 and 1879, the station and its tracks sliced through tightly packed rows of worker tenements to create a new crossing of the Clyde on a daring, wrought-iron girder bridge. The construction of a second bridge in 1905 brought a network of additional tracks into Central Station, making its forceful entry-point for a time the widest railway-over-river bridge in Britain.

AEROFILMS 1935 48777

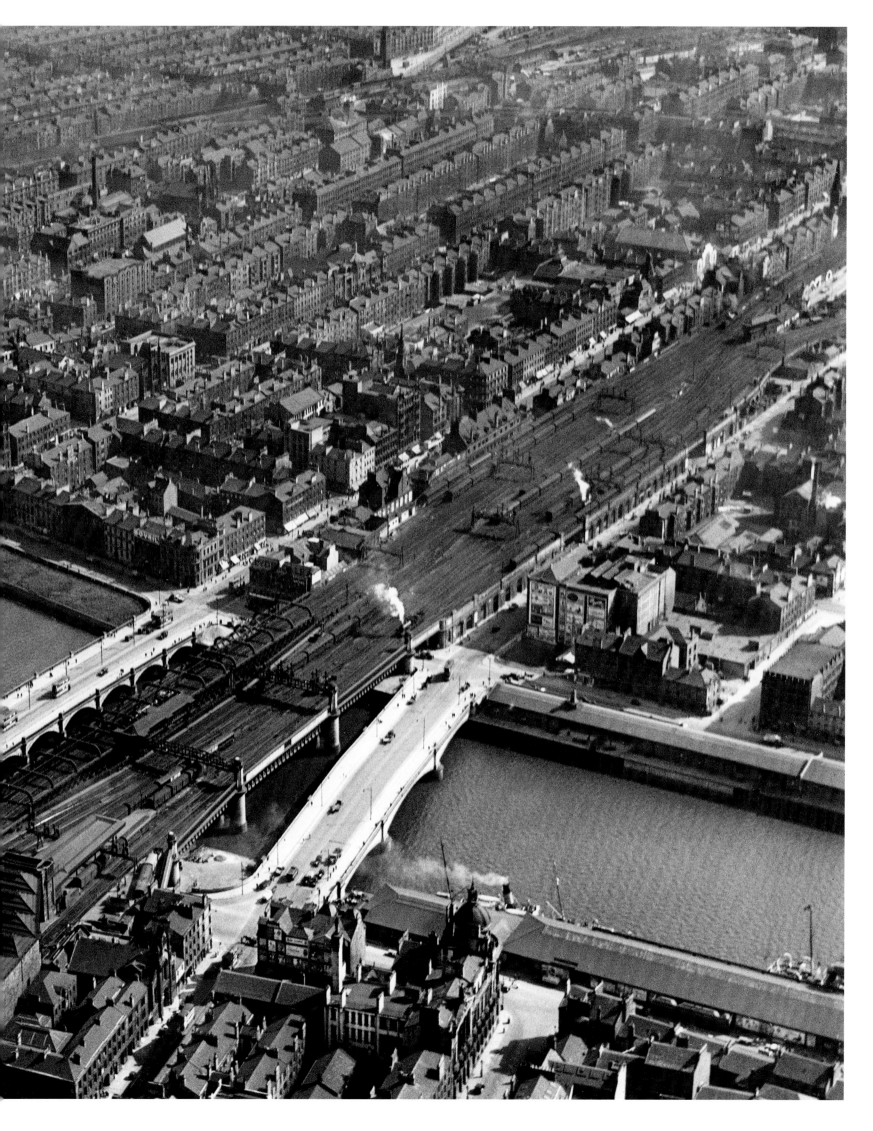

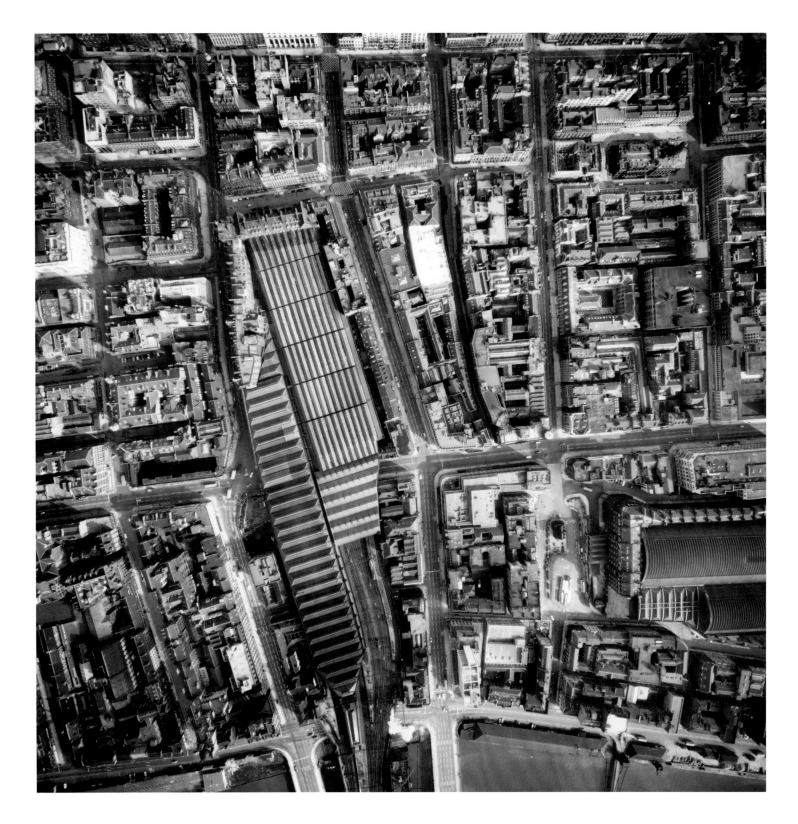

The roofs of the two rival stations push their way into the city, breaking up the ordered grid layout. Wrapped in a narrow facade around Central Station's blocky, ridged roofs, Robert Rowand Anderson's Central Hotel was designed as a refined, five-storey homage to northern Europe, dominated by the corner-piece of its huge, Germanic clock tower. Just a block away along Argyle Street, St Enoch Station was opened by the City of Glasgow Union Railway in 1873 and extended at the beginning of the twentieth century, operating twelve platforms beneath its vast glass and iron arches.

RAF 1966 006-000-001-045-C

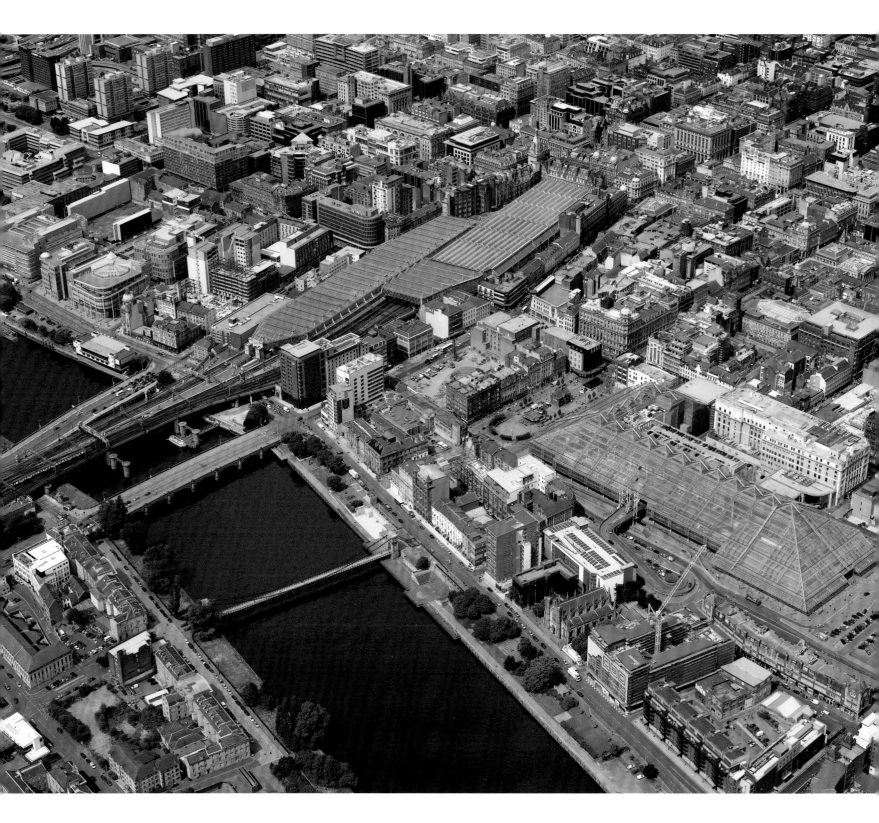

In 1947, following the nationalisation of the rail network, control of both stations passed from the London, Midland and Scottish Railway Company to British Railways. In the 1960s, Richard Beeching, chairman of British Railways, produced his report into the 'reshaping' of the entire rail network, slashing services on cost and efficiency grounds. St Enoch Station was an early casualty of the report, closing on 27 June 1966, after which it was used as a city centre car park. In 1989, the site was strikingly regenerated as a pyramidal, glass-roofed shopping centre. Although the closure of St Enoch made Central Station the main railway hub, the 1960s also saw the demolition of the girders of the original 1878 bridge – today the tall cylinders of its granite piers are the only visible remains.

RCAHMS 2005 DP009548

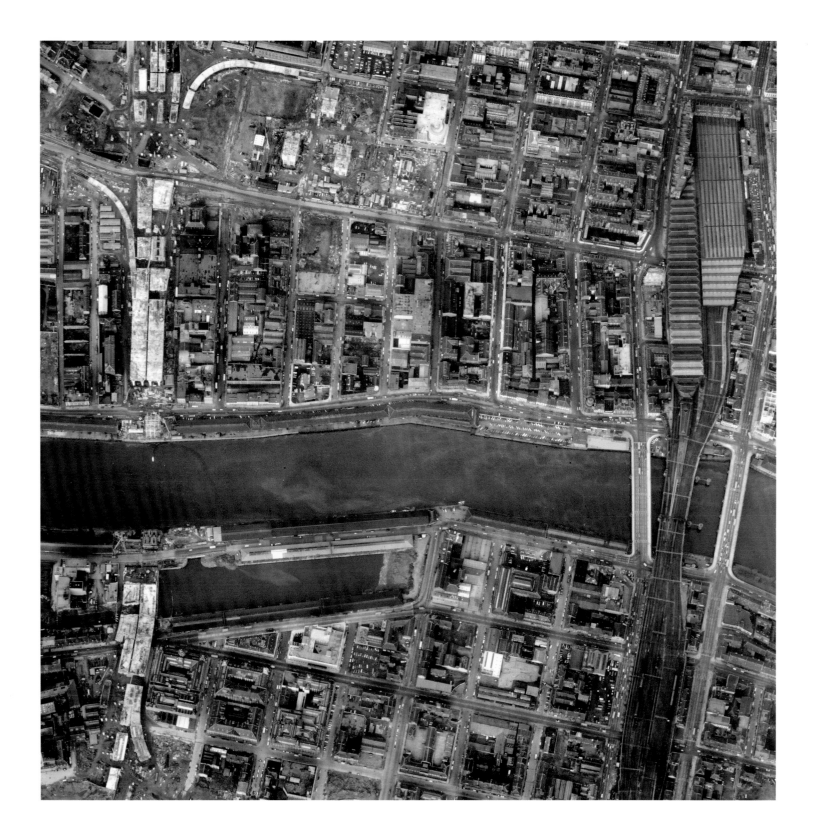

Downriver from the urban stamp left behind by the Victorian railway invasion, the twentieth century vision for a Modernist cityscape emerges in a line of monumental concrete building blocks. Pictured above under construction in 1968, the Kingston Bridge was part of the Glasgow Inner Ring Road, an elevated motorway designed to completely encircle the city centre. By 1972 half of the Ring Road's circumference was complete, but, soon after, construction was halted and in 1980 the plan was formally abandoned amid concerns over the dramatic physical impact of the road networks. Nevertheless, the motorway had transformed Glasgow, creating a vast, city-sized sculpture of bridges, flyovers, sliproads and stilts that had carved through and soared over the streetplans of previous centuries.

RAF 1968 006-000-001-047-C

RCAHMS 2007 DP032355

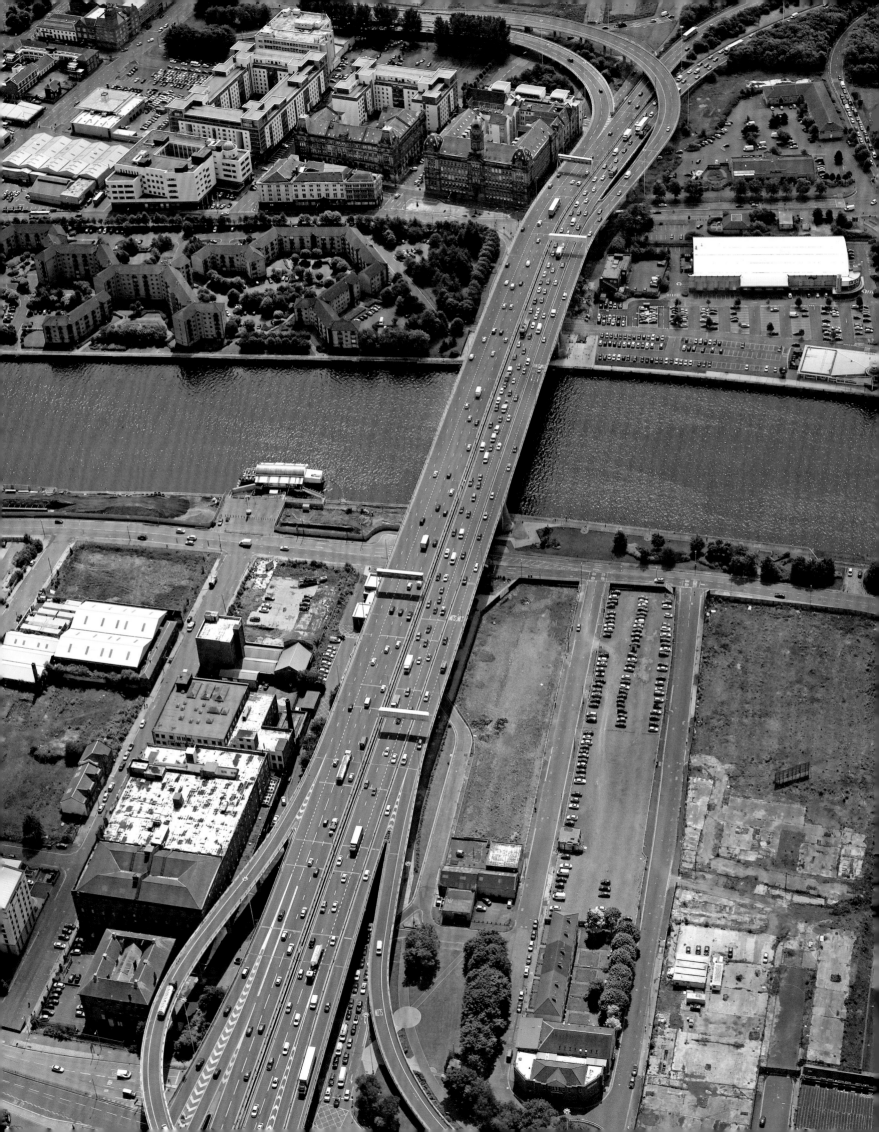

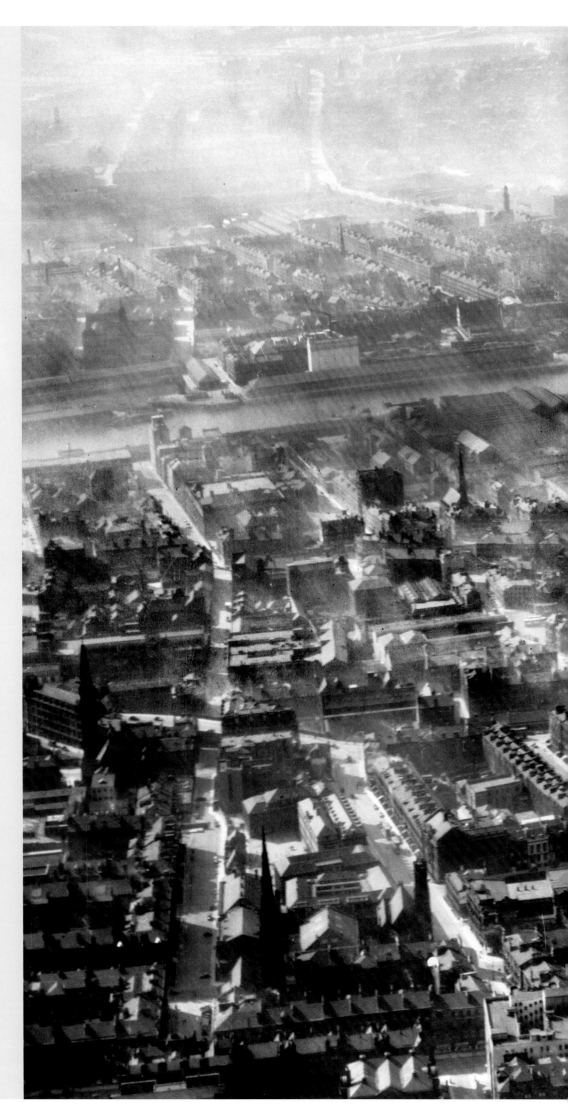

Rising in a great arc above the industrial landscape of Pollokshaws, the Port Eglinton viaduct – here still an exposed superstructure of steel box girder beams – will carry the wide motorway carriages of the M74 Completion Project over a network of surface streets and rail lines.

RCAHMS 2010 DP075345

RIGHT

Pictured here in 1950, the central Glasgow districts of Anderston and Finnieston are a dense maze of housing and businesses cloaked in the smoke of factories and tenement coal fires. In the immediate post-war period, with industrial decline already beginning to pick apart the economic heart of the city, and nineteenth century housing straining under the weight of increased overcrowding, the Bruce Plan – named after the City Engineer – proposed the near total reconstruction of central Glasgow. In 1959, most of the inner city was scheduled for conversion to this Modernist utopia – split into 29 'Comprehensive Development Areas'. Although the vision, which would have seen the creation of an entirely new city, was never fully implemented, the Bruce manifesto still fundamentally changed Glasgow. It was the City Engineer who first proposed the monumental Inner Ring Road, and by the late 1960s, the M8 was laying its broad concrete tracks straight through the centre of the landscape photographed here.

RAF 1950 006-000-001-050-C

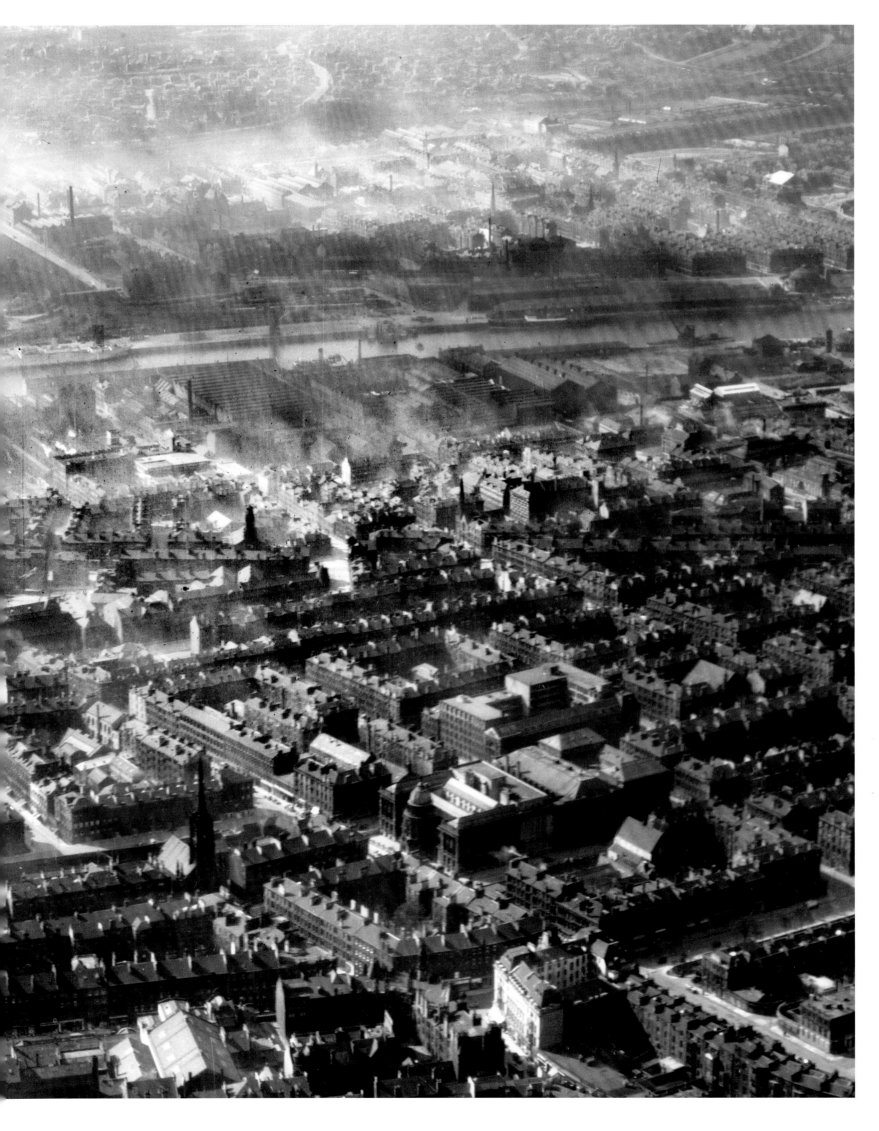

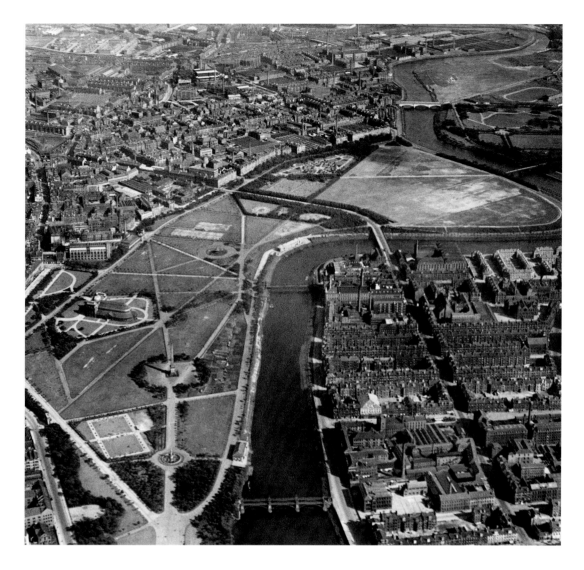

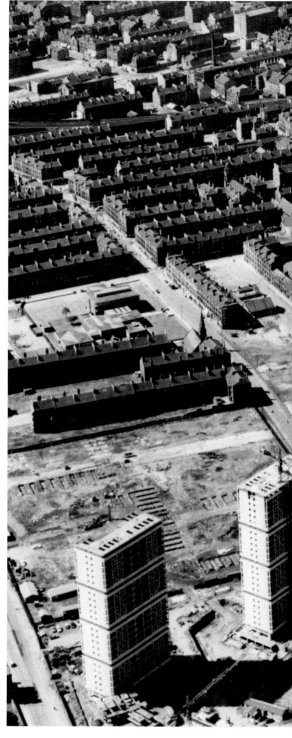

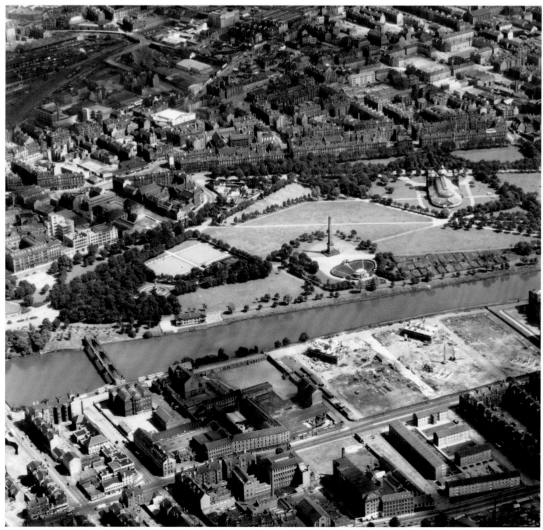

TOP LEFT AND BOTTOM LEFT

In 1928, the contrast between Glasgow Green and the crammed worker community of Hutchesontown is stark. First cleared in 1870, less than a century later the district was designated a 'Comprehensive Development Area'. In 1960, tenements have been demolished and foundations are emerging for a new form of living – the high rise.

AEROFILMS 1928 22173
RAF 1960 006-000-001-052-C

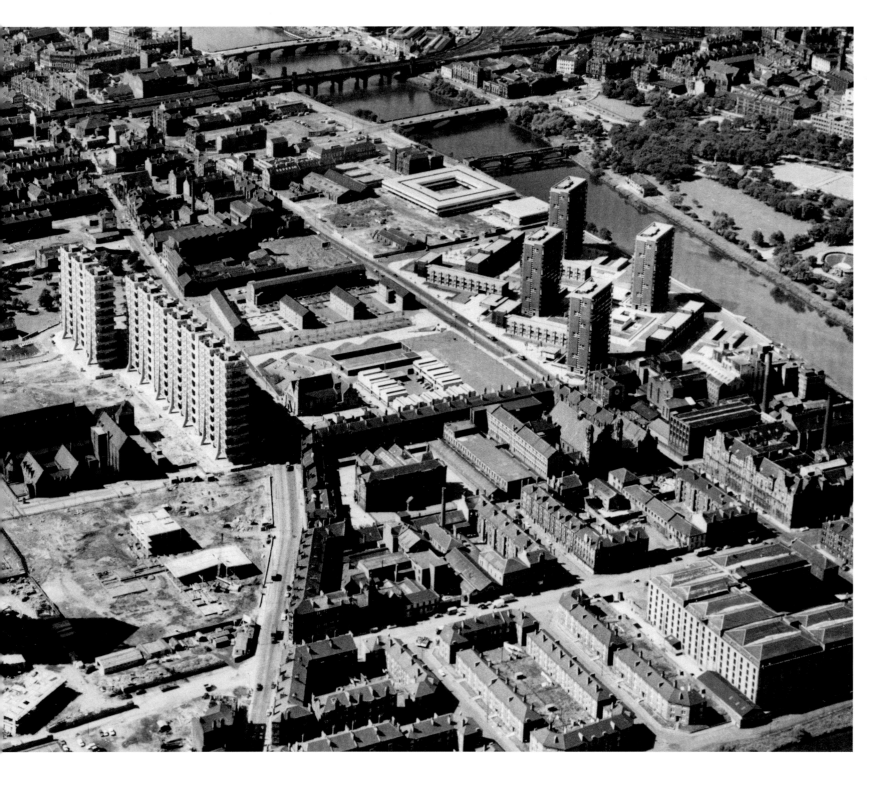

ABOVE

"The airplane eye reveals a spectacle of collapse", wrote the iconoclastic French architect Le Corbusier in 1935. "Cities with their misery must be torn down. They must be largely destroyed and fresh cities built." It was Le Corbusier's Unité d'Habitation in Marseille – his 'machine for living' – that was the major inspiration for Sir Basil Spence's Hutchesontown C development in the Gorbals – seen here in the centre of the picture. Vigorously pursuing the

Modernist vision, Glasgow's planners did indeed set about tearing down the old city, erecting vast, concrete-slab towerblocks on the rubble of the nineteenth century tenements. Yet less than 30 years later, this brave new world was branded a failure – Spence's utopian 'hanging gardens' were brought crashing back to earth by the demolition charges of a new generation of developers.

PLANAIR 1965 SC676678

FOLLOWING PAGES

The Gorbals is currently undergoing yet another transformation – a new vision for the area's redevelopment mixes privately owned and social housing with a range of public services and leisure facilities. Most intriguingly, a clause inserted in all building contracts demands that one per cent of any project's total building costs be set aside for art, a deliberate attempt to create a culturally rich civic environment.

RCAHMS 2005 DP009515

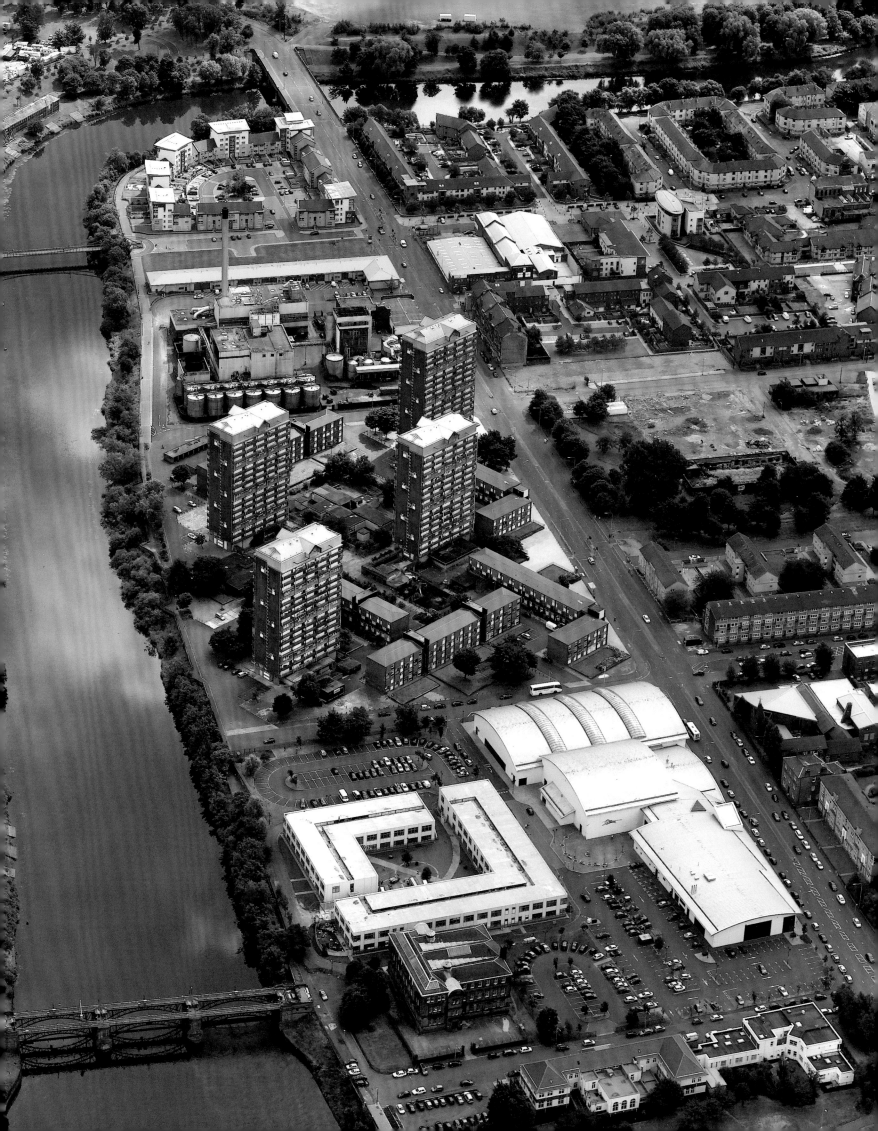

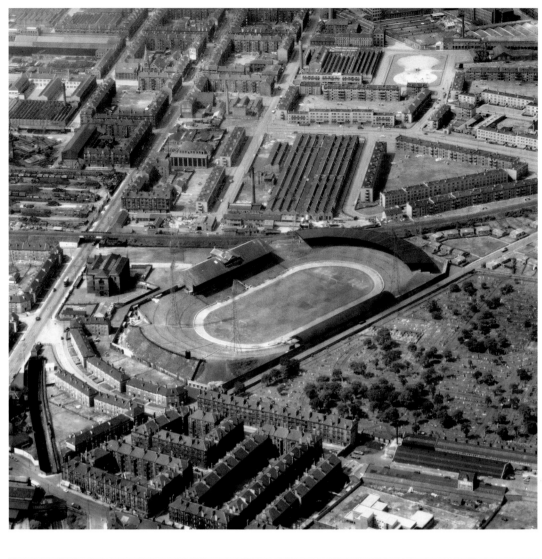

In 1887, in St Mary's Church Hall in Glasgow's East End, a meeting convened by Marist monk Brother Walfrid to look at ways to tackle the problems of social deprivation among the Irish immigrant community, inadvertently resulted in the formation of Celtic Football Club. Walfrid and a group of volunteers built the original Celtic Park in 1888. In 1892, after a huge increase in annual rent, another army of helpers was corralled to construct a replacement stadium across the street on the site of a disused Parkhead brickworks. Today the 60,506-capacity stadium – still standing on the 1892 site – is the largest football ground in Scotland.

RAF 1960 006-000-001-055-C
RCAHMS 2005 DP009535

Formed in 1872 by a group of rowing enthusiasts, Rangers Football Club at first enjoyed an itinerant existence, playing on the public pitch at Flesher's Haugh on Glasgow Green, Burnbank and Clydesdale Cricket Ground in Kinning Park. The Club moved to Ibrox in 1887, taking up a pitch immediately to the east of the current stadium. The site of modern Ibrox was occupied from 1899 and the first notable development came in 1929 with the construction by celebrated stadium architect Archibald Leitch of the tall, renaissance red-brick stand on Edmiston Drive – with 10,000 seats, the largest and most lavish that had ever been built. Leitch's stand remains today as a Category B listed building incorporated into the modern redevelopment of Ibrox, now a 51,082-capacity all-seater stadium.

AEROFILMS 1927 19495
RCAHMS 2008 DP043966

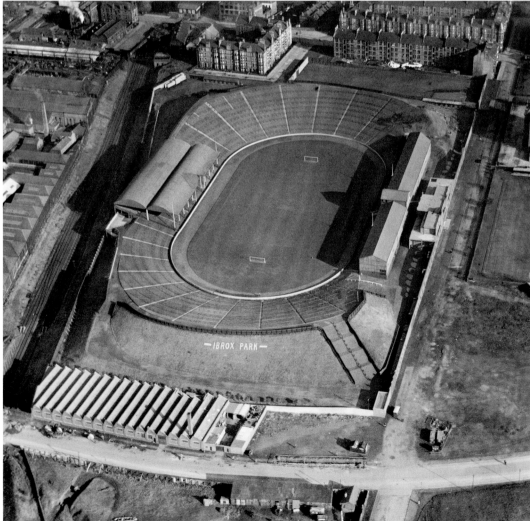

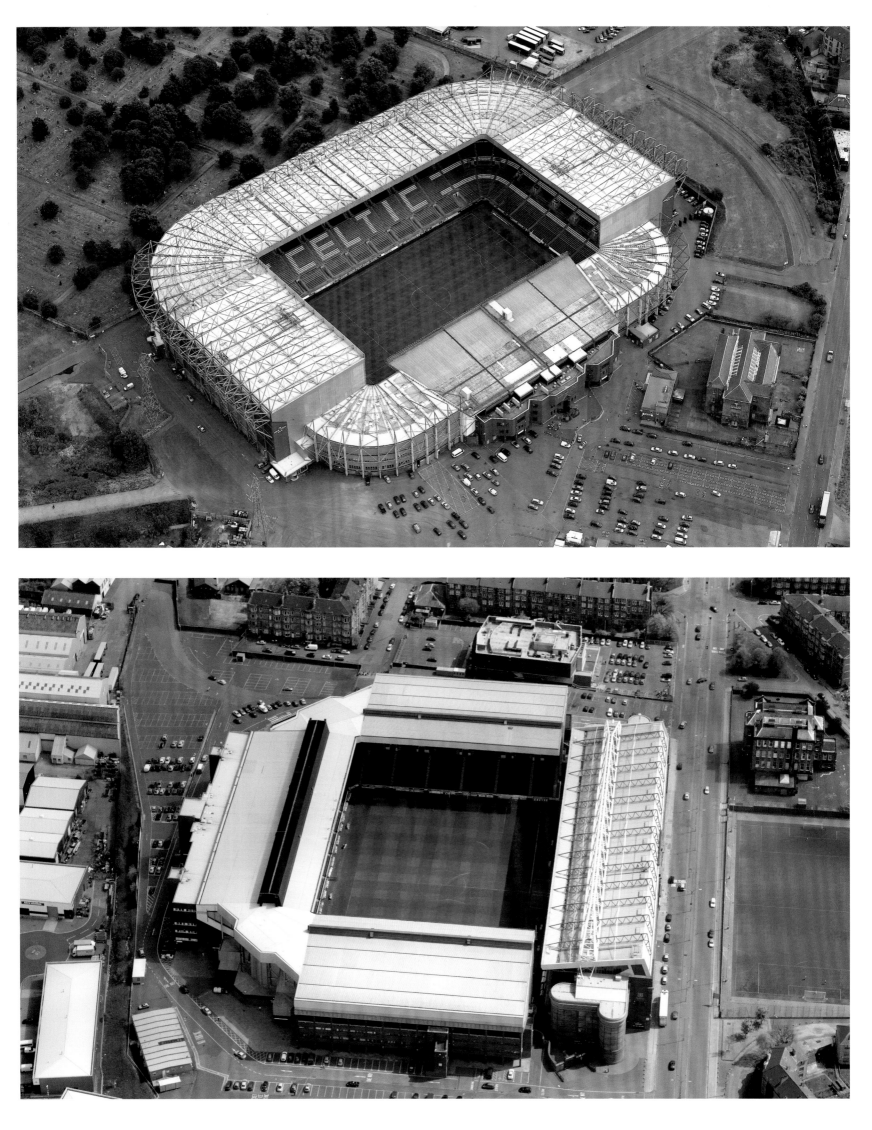

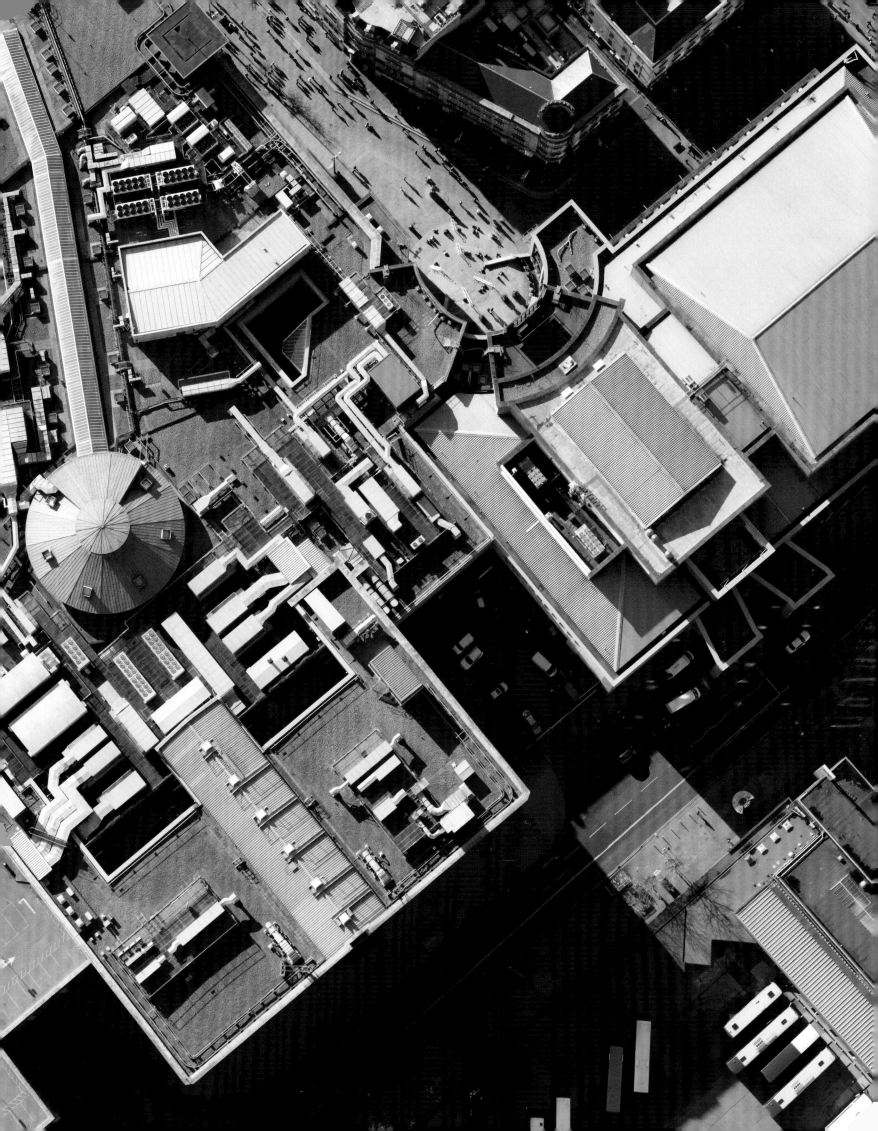

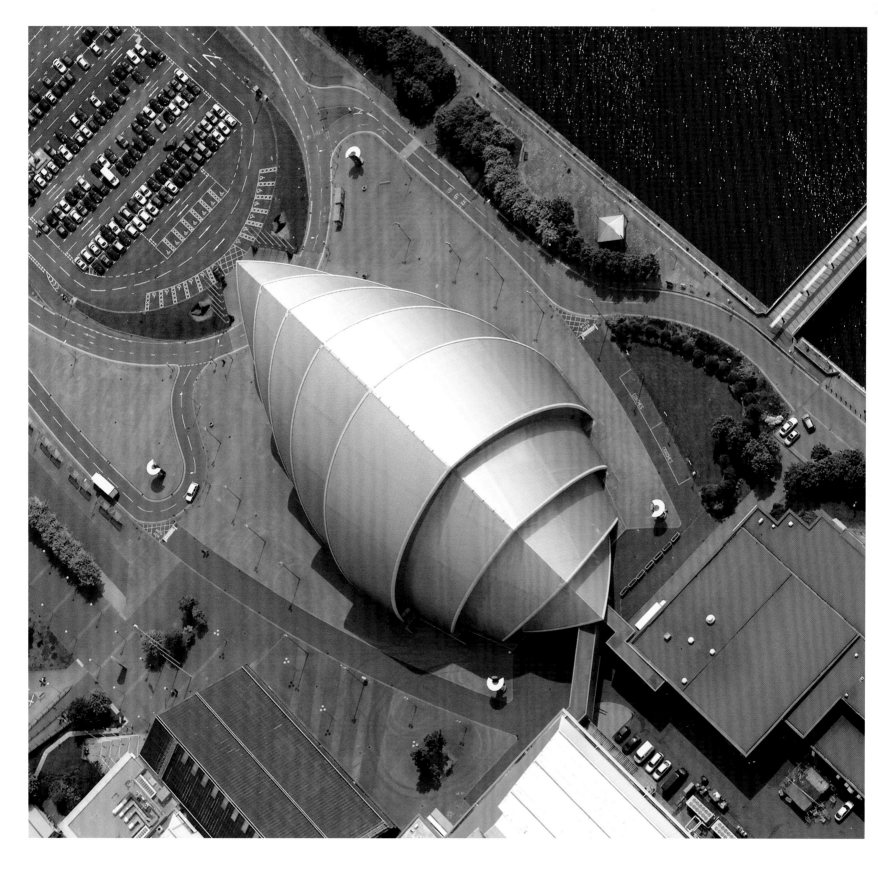

PREVIOUS PAGES

From above, the architecture of the city is
reduced to an abstract collage of shapes, colours
and forms. At the summit of Buchanan Street,
air-conditioning units surround the glass atrium
of the shopping complex; the concrete geometry
of a carpark sits alongside the roof of Queen
Street Station; and the Royal Concert Hall backs
on to a depot of yellow, rectangular bus roofs.

RCAHMS 2010 DP075361

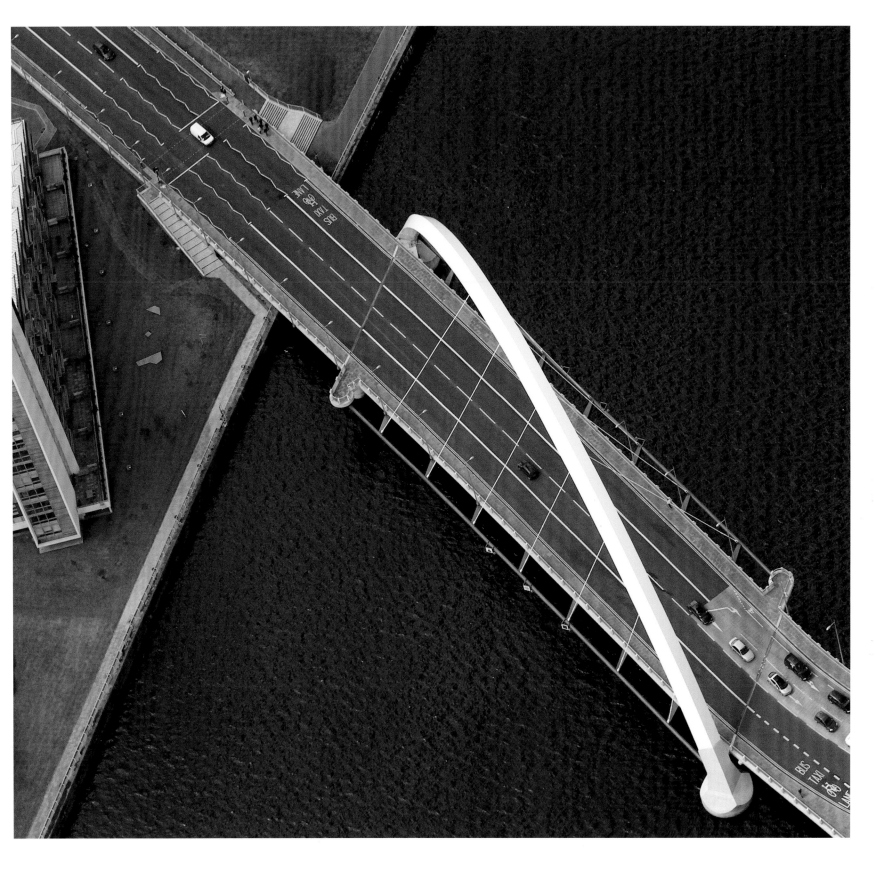

LEFT AND ABOVE

As cities grow and evolve, new architectural icons rise to define the character of their civic landscapes. In Glasgow, the colossal, overlapping, aluminium-clad shells of the Clyde Auditorium – nicknamed the Armadillo – and the striking white-concrete arch of the Finnieston Bridge have emerged as two of the latest, dominant urban sculptures – symbolic modern monuments to a city's design-led, cultural renaissance.

RCAHMS 2006 DP015689
RCAHMS 2007 DP032346

City of Culture, experiment in Modernist utopia, 'workshop of the world', King of Cotton, Tobacco Empire, ecclesiastical haven, 'dear green place' – Glasgow is a combination of all of these and more, a vast, rippling fabric moulded by centuries of growth, change and – often wholesale – redevelopment.

RCAHMS 2010 DP075388

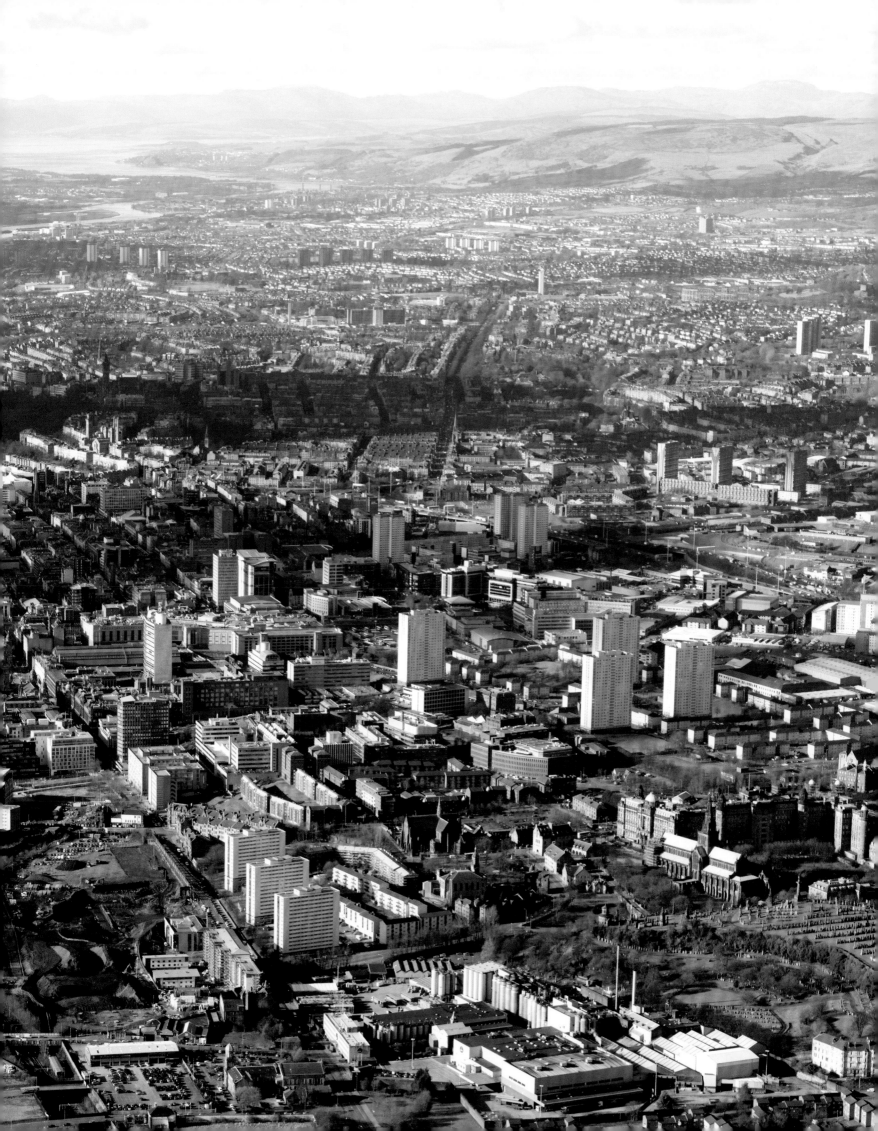

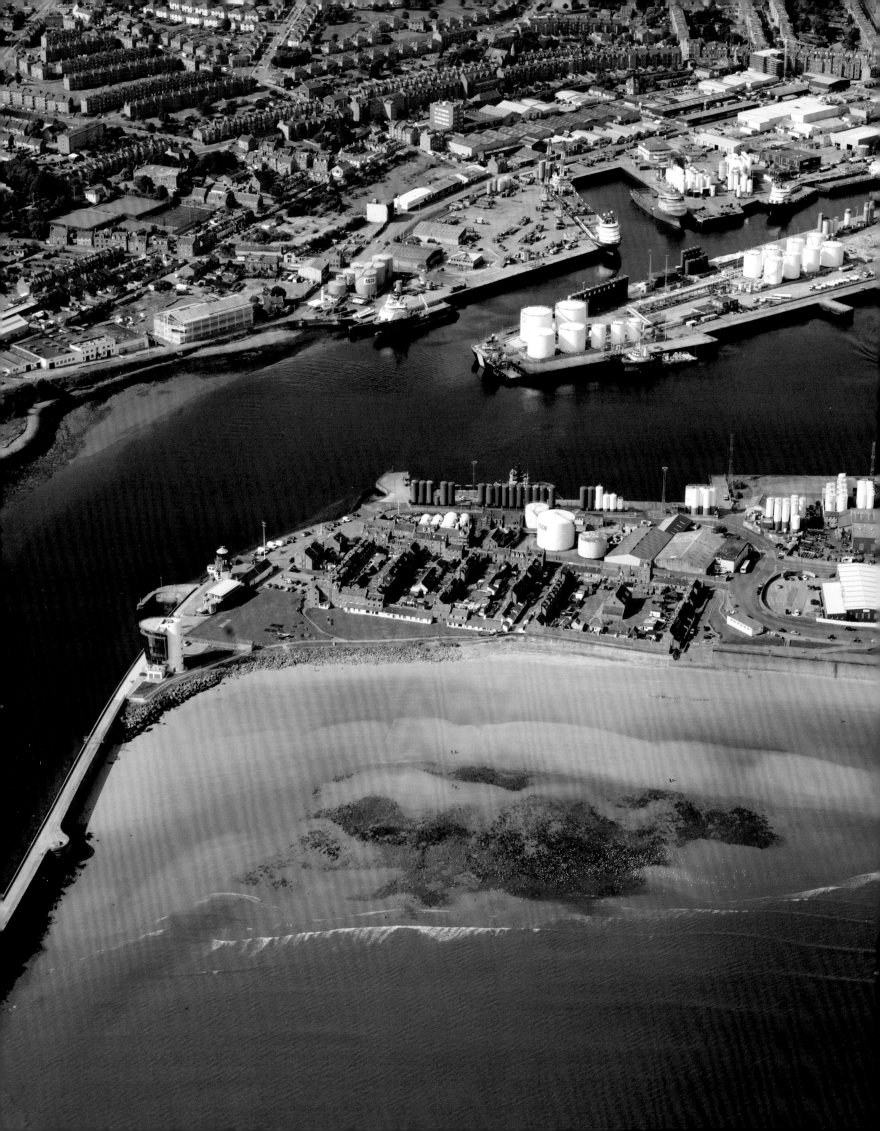

Aberdeen

It is the 100ft tall lighthouse standing on the Bell Rock, one of the North Sea's most notorious reefs. It is the last resting place of Prince Albert, a sarcophagus made from a single, flawless piece of grey rock, the largest of its kind to have ever been quarried. It is paving stones and ornamentation for streets and structures in cities across the world. It is the terraces of the Houses of Parliament and the fountains of Trafalgar Square, Liverpool's Titanic Memorial and Melbourne's Bank of Australia. It is white, grey, blue, pink, red; Rubislaw, Peterhead, Kemnay, Corrennie. It is north-east granite. And, in the great construction boom of the eighteenth and nineteenth centuries – the age of the modern city – it helped build an Empire.

The origins of the 'granite rush' date back to 1741 and the excavation by Aberdeen's Municipal Council of a site above the Hill of Rubislaw. Deciding that the rock would not make good building material, the Council sold the quarry to a local businessman in 1778 for just £13. The size of this misjudgement would soon become clear. Over the next 200 years, an estimated six million tonnes of granite were extracted from Rubislaw, creating what was described as the 'largest man-made hole in Europe'. 466ft deep – 180ft of which are below sea level – and 394ft wide, the astonishing scale of the works matched anything attempted by the Pharaohs of ancient Egypt or the Caesars of Imperial Rome. As the industrial revolution transformed the transport infrastructure, networks of canals, roads and railways opened the geology of the whole region to mineral prospectors. At its peak, around the turn of the twentieth century, the granite industry of Aberdeenshire could boast 127 working quarries, with the city's busy, long-established seaport the hub for exporting across the world.

For most of its history Aberdeen had been a compact city of jumbled streets centred on St Katherine's Hill. It extended west from the bustling market place of the Castlegate to St Nicholas Church, and north from the harbour – for a long time the most common entry point for any visitor to the city – to the medieval burgh of Old Aberdeen. In the early nineteenth century it broke free of these confines, and in spectacular fashion. While granite provided the raw material for a phenomenal period of expansion, it was a combination of the expert masonry of the local builders and the clean visions of the dominant architects of the day that created the monumental mould for modern Aberdeen.

Two men in particular determined the shape of the city – John Smith, Aberdeen's first City Architect, and Archibald Simpson. Both had trained in London, and Simpson had followed this with a scholarly tour of Italy, absorbing the glories of the renaissance from Florence to Rome. Although they returned to their home city to set up rival practices, there was no clash of styles or personalities. Instead, as a new Aberdeen emerged commission by commission, the work of the two competitors came to resemble a subtle collaboration. On King Street each new building by one man was presented almost as a variation on the preceding work of the other.

Smith's refined blocks of housing and his Greek-inspired North Church followed Simpson's designs for St Andrew's Episcopal Church and the Medical Hall. It was a conversation in buildings, the polite, agreeable discourse of the drawing room recast in the architecture of the city. The dialogue was to continue around Simpson's North of Scotland Bank – known as the 'hinge of the city' – and into Union Street. Here though, Simpson took the lead, his startling array of work dominating a mile of elegant granite buildings remarkable for their consistency of style and form.

Once considered suitable only for rough walling, granite had proven itself superior in strength and durability to any other stone, and advances in skills and technology had made it workable to an incredible smoothness, sharpness and even delicacy of appearance. This refinement in technique reached its pinnacle in Marshall Mackenzie's intricate new facade for the ancient Marischal College, which included the massive expansion of the Mitchell Tower into a 279ft-high monument of neo-gothic granite that still dominates the Aberdeen skyline. Over a period of a hundred years, a crystalline city had been created out of its own natural foundations, its buildings having, as nineteenth century master mason John Morgan describes in his memoirs, "a fine sparkle in the sunshine … and when the light is full upon the spires, they look as if they were built of white marble".

From the 1950s, a combination of cost and the modern enthusiasm for concrete prompted the rapid decline of Aberdeen's granite industry, both in civic construction and export. While trawl-fishing continued to thrive, the city's historical role as a trader port seemed under threat. Yet where granite had ruled Aberdeen's nineteenth century, it was a precious new commodity that would come to dominate its twentieth – oil. The 1970s saw the prospectors return, this time in the shape of giant multinationals, whose enormous investment in the local economy and infrastructure still resonates today. Far out in the North Sea, the many rigs and platforms of the oil industry look back at a city built, sustained and defined by its remarkable geology – a city of unyielding stone and prized bedrock, a city millions of years in the making.

PREVIOUS PAGES

The natural harbour of the sheltered Dee estuary has been in use for well over a thousand years, and was a seaport even before the infamous raid by the Norse Chieftain Eysteinn – who, according to the *Haraldsson Saga*, navigated the east coast of Scotland in the twelfth century and brought his ships to the town of 'Apardion', where he "killed many people and wasted the city". The first definitive recorded reference to Aberdeen's harbour comes in 1136, when King David I granted the Bishops of Aberdeen the right to levy a tithe on all ships trading at the port – a clear indication of royal favour, and also confirmation that the harbour was well-established and familiar to merchants. From earliest origins, the fortunes of Aberdeen have been tied irrevocably to the sea.

RCAHMS 2009 DP065235

RIGHT

Modern Aberdeen developed from the growth of two medieval burghs – Old Aberdeen, a small settlement beside the Don, dominated by St Machar's Cathedral, and New Aberdeen, a commercial burgh concentrated on the banks of the Dee. Today, behind the sweeping curve of the coastline, a dense urban fabric fills the space between the river mouths.

ASS 1988 006-002-003-370-C

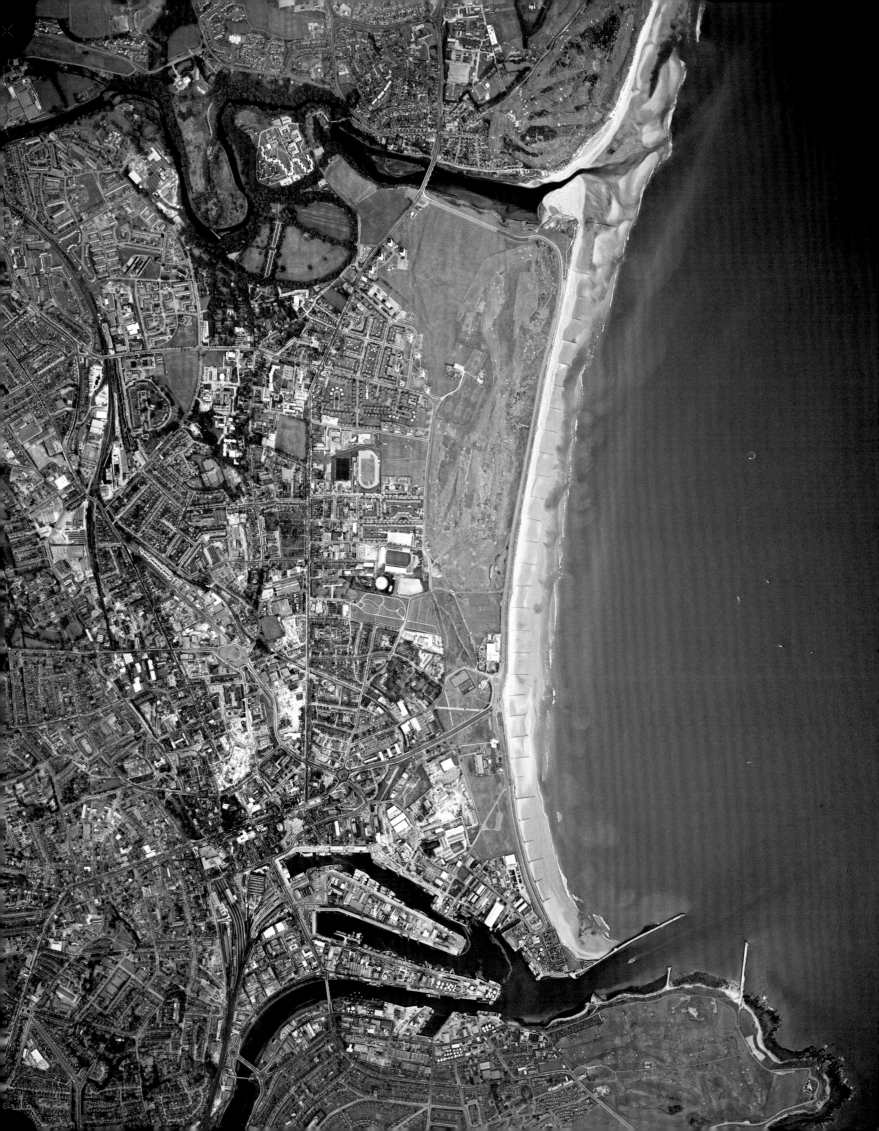

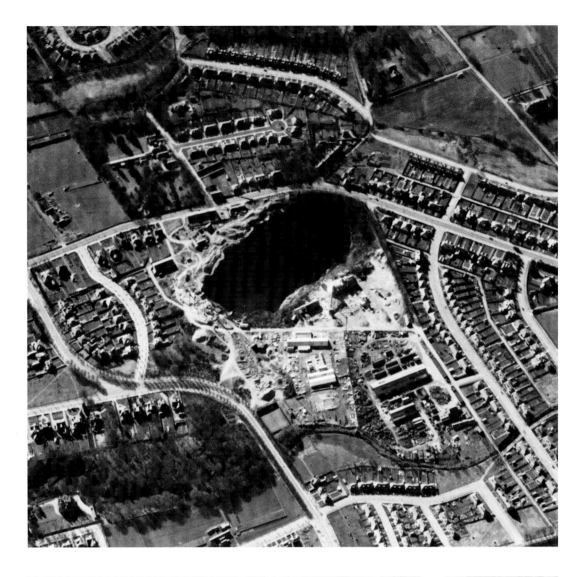

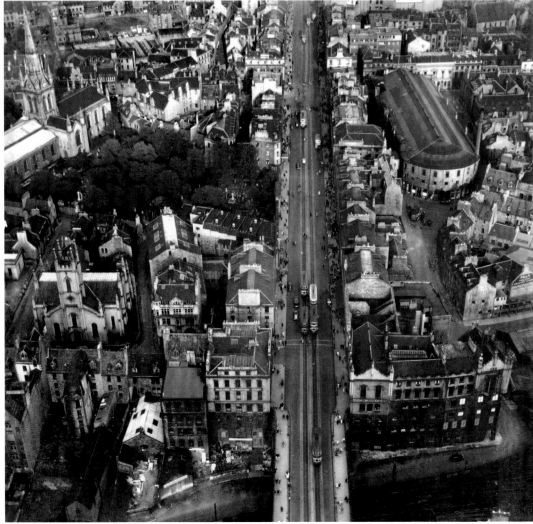

Even when viewed from directly above, Rubislaw Quarry is a startlingly black tear in the landscape. But then this was the 'deepest hole in Europe', a colossal open cavern, whose depths it was reputed the sun never penetrated. Established in the late eighteenth century, the quarry had six million tonnes of granite excavated out of the earth in the its lifetime, supporting a massive worldwide export business, and also providing local architects and planners with the iconic building blocks of modern Aberdeen – the sharp, hard, crystalline stone that keeps even the city's ageing structures looking brand new. Finally closed in 1971, Rubislaw soon filled with rainwater and was left derelict.

The granite mile of the granite city. Described in 1865 by the *Imperial Gazetteer* as "One of the finest streets in the Empire … straight, elegantly edificed, well-gemmed with public buildings", Union Street was conceived as Aberdeen's grand entrance boulevard – the centrepiece of engineer Charles Abercrombie's bold plan for developing the contained medieval burgh into a modern, expanding city. In order to connect the organic jumble of the old town to the surrounding countryside, Abercrombie proposed two dominant central streets setting off from the Castlegate – one running northwards, and the other west to the Den Burn. The former was King Street, the latter Union Street.

Although a simple plan, the construction of Union Street was an incredible engineering undertaking, requiring the creation of an elevated street carried by a series of road viaducts and causeways over the deep valleys of minor watercourses. First begun in 1801, the enormous costs involved effectively bankrupted the city in 1817, before the appointment of further trustees and a boom in local trade put the development back on an even keel. Over the next century and a half, the street developed into Aberdeen's iconic core, an elegant, unified architectural vision for a major urban thoroughfare.

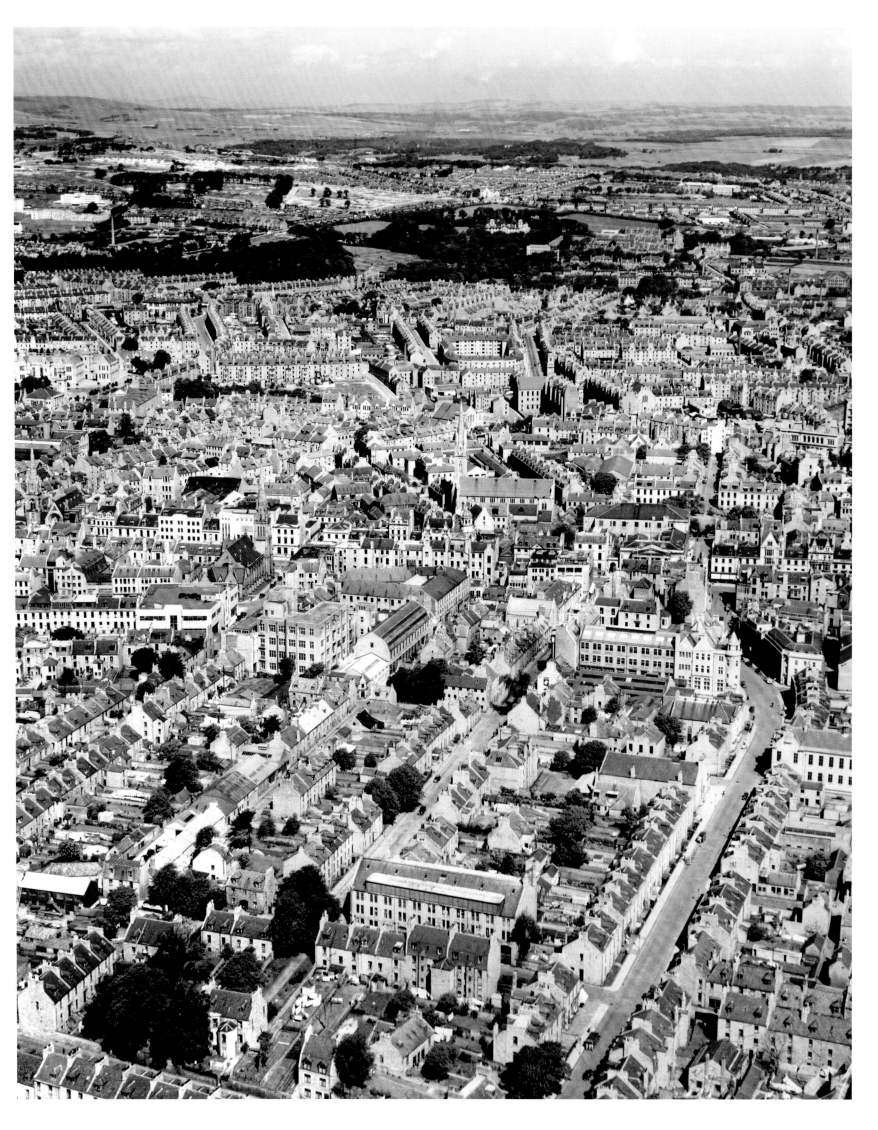

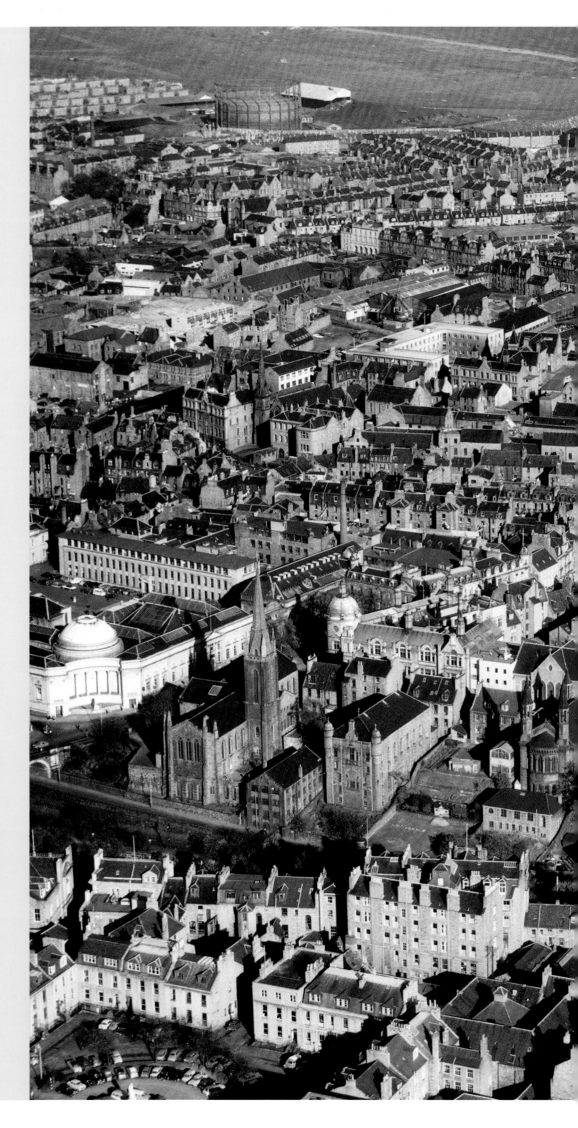

RIGHT

Looking over the shadowy route of
Union Street, the colossal granite facade
of Marischal College dominates the city.
Founded in 1593 by George Keith, Earl
Marischal, as a Protestant alternative to
Bishop William Elphinstone's 1495 King's
College, the two rival faculties eventu-
ally came together as the University of
Aberdeen in 1860. The College's original
medieval buildings formed a large court-
yard behind Broad Street, but, by the
early nineteenth century, their condition
had deteriorated considerably and in
1836 Archibald Simpson created a new
quadrangle of white granite. The develop-
ment was not finished, however, and
from 1891 Alexander Marshall Mackenzie
extended Simpson's structure spectacularly.
Proposing a wholly new facade and an
extension to the College's central tower,
Mackenize fashioned an extraordinary neo-
gothic temple – a granite masterpiece of
finely detailed stonework and monumental
ambition.

AEROFILMS 1962 A107597

FOLLOWING PAGES

Surrounded by the rapid expansion of the
nineteenth century city, St Nicholas Kirk
remains today as an isolated fragment of
New Aberdeen's original medieval burgh.
Founded in the twelfth century, the dedica-
tion of the grand ecclesiastical building to
St Nicholas – the patron saint of sailors – is
indicative of the importance of the church
to a trading community whose early liveli-
hood depended almost entirely on the sea.

RCAHMS 2007 DP036417

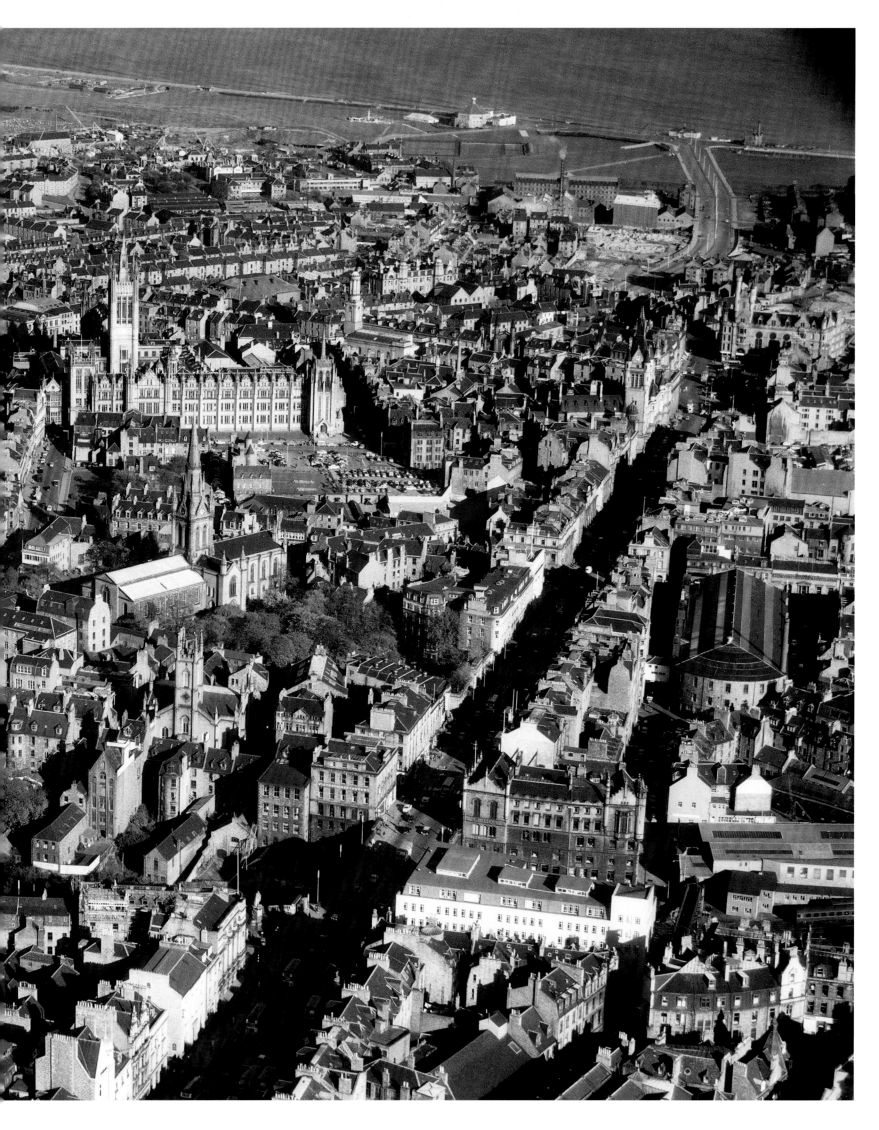

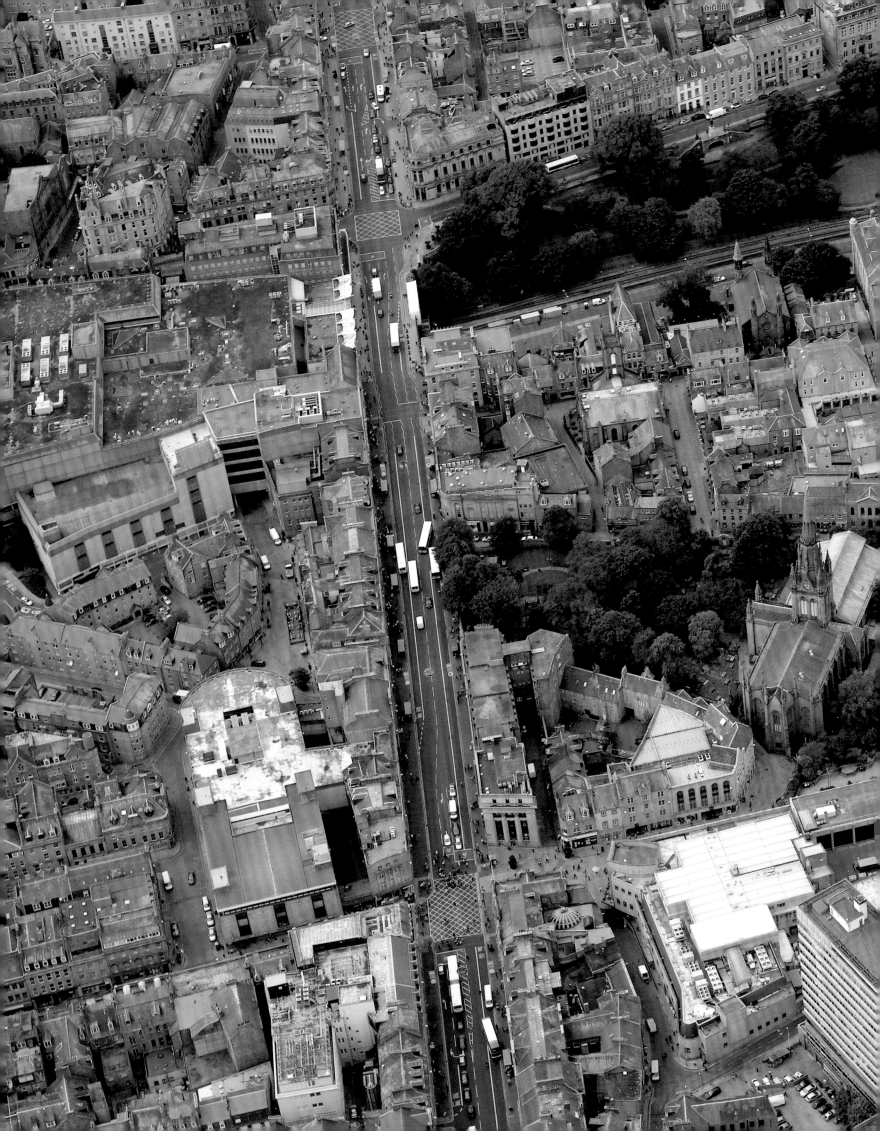

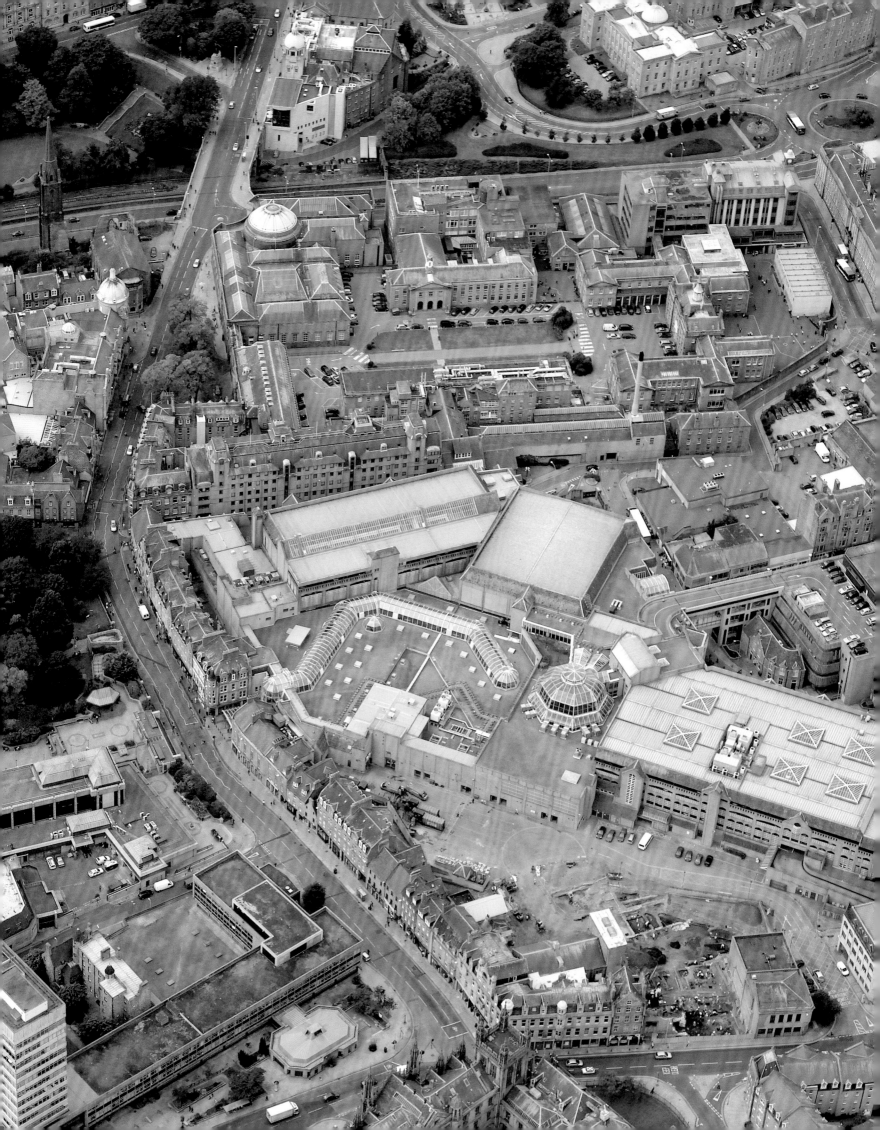

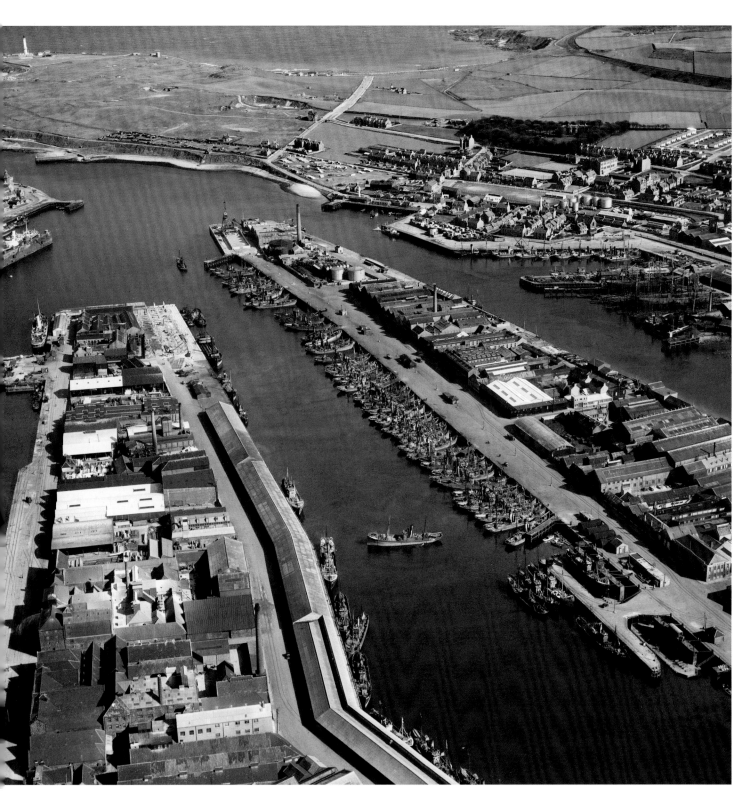

Although Aberdeen's harbour was long renowned for its safety and ease of access, by the sixteenth century the accumulating silt of the Dee had created substantial sandbanks, which threatened to block access to the port, particularly at low tide. The addition early in the seventeenth century of a bulwark at Torry helped to improve the scour of the outgoing tides, but it wasn't until 1781, with the construction of John Smeaton's North Pier – later extended by Thomas Telford – that the encroachment of the coastal sandbar was effectively contained. The distinctive, three-fingered layout was established in the nineteenth century, as further dredging and quay construction created Victoria Dock and the Albert Basin. Always a centre for trade, during the nineteenth century, the port came to be dominated by steam-powered trawl fishing, with the new rail connection providing a direct link from the quayside to the markets of London. This image shows the fleet in 1949 – on a Sunday, with many ships docked. Even here, almost all of the vessels are still steamers.

AEROFILMS 1949 A22571

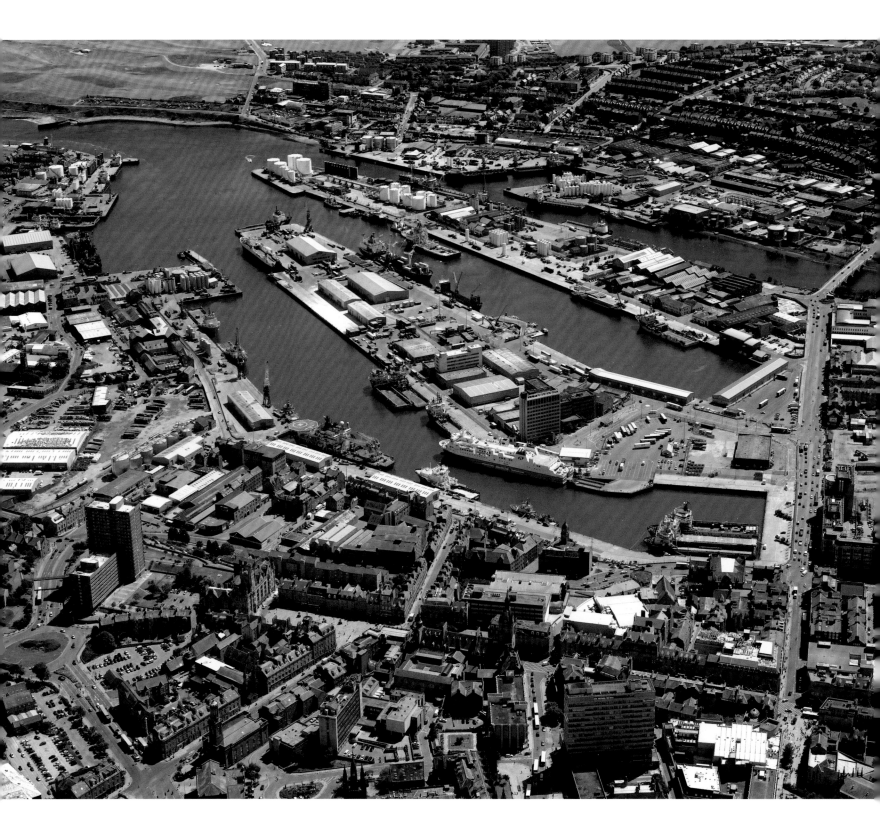

The arrival of the oil barons transformed the city harbour once again. Enormous investment in infrastructure created one of the most modern ports in Europe, with extensive facilities provided for deep-water berthing and ship repair. Aberdeen emerged as a state-of-the-art gateway to the North Sea – a staging post for the speculators in black gold, and a frontier boom-town for the twentieth century.

RCAHMS 2006 DP018192

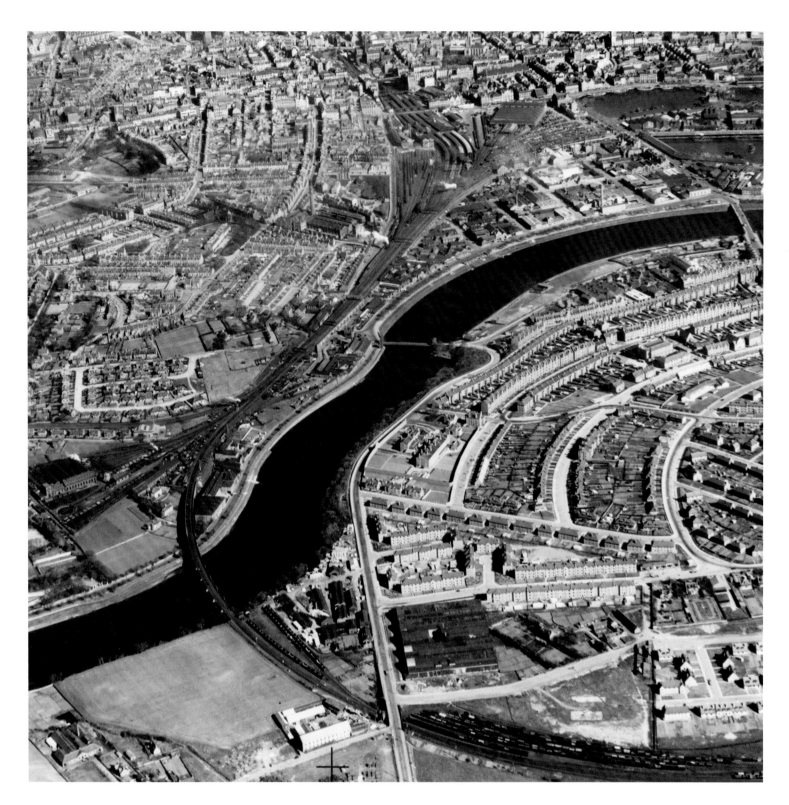

ABOVE AND RIGHT

Railtracks sweep around Torry to cross the Dee and head straight for the industrial heart of Aberdeen. Isolated for centuries on the far north-east coast of Scotland, the city suddenly had an easy connection with the rest of Britain and exceptional opportunities for trade. As the last major stop on the rail network, Aberdeen became a key strategic outpost during the great railway wars of the nineteenth century.

Desperate to establish their own, unbroken east-coast line and unlock the Caledonian Railway stranglehold over the route north, the North British Railway Company built the world's longest and largest rail bridges – over the Tay and Forth estuaries respectively. With these monumental engineering works complete and operational, in the summer of 1895 the two companies began a furious competition to provide the fastest

service between London and Aberdeen. Amid claims and counter claims of victory, the race was putatively settled on the morning of 23 August, as a Caledonian train reached Aberdeen in a time of eight hours and 32 minutes – eight clear minutes quicker that its North British rival.

RAF 1942 006-003-000-331-C
RAF 1947 006-003-004-087-C

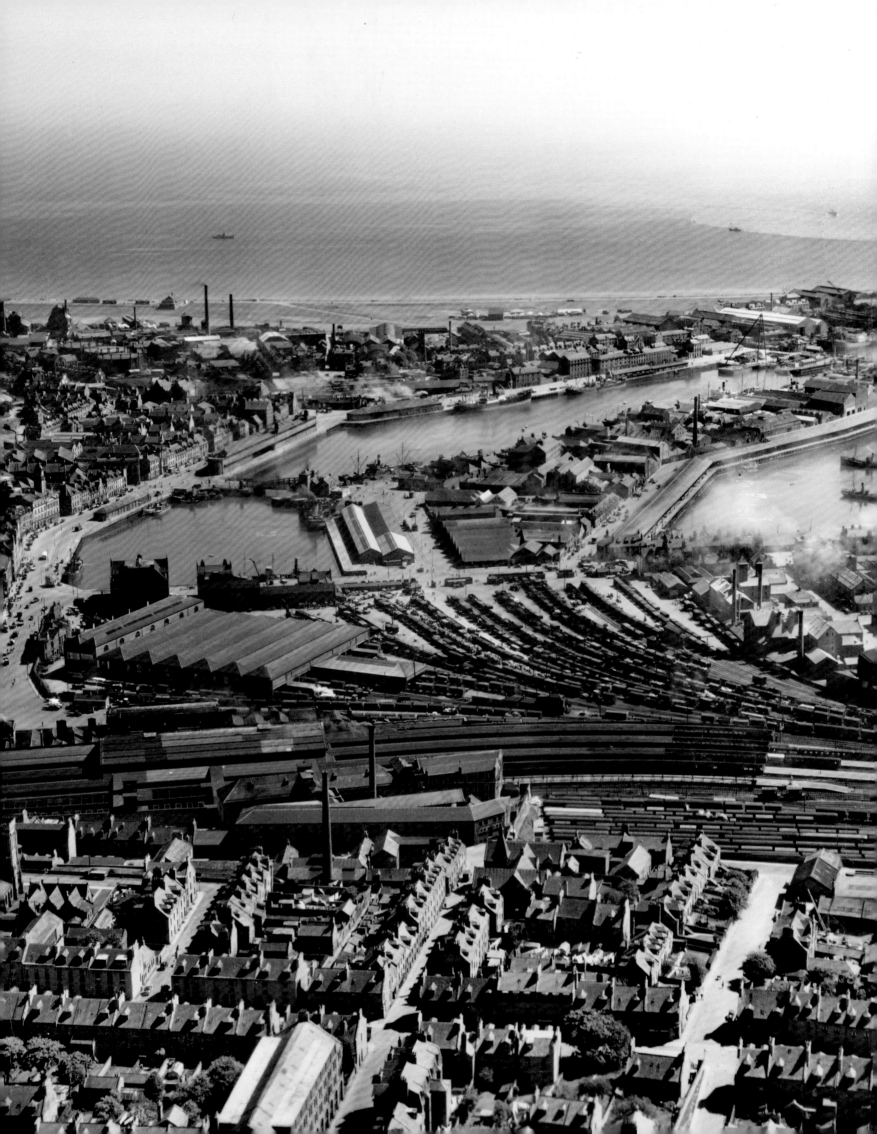

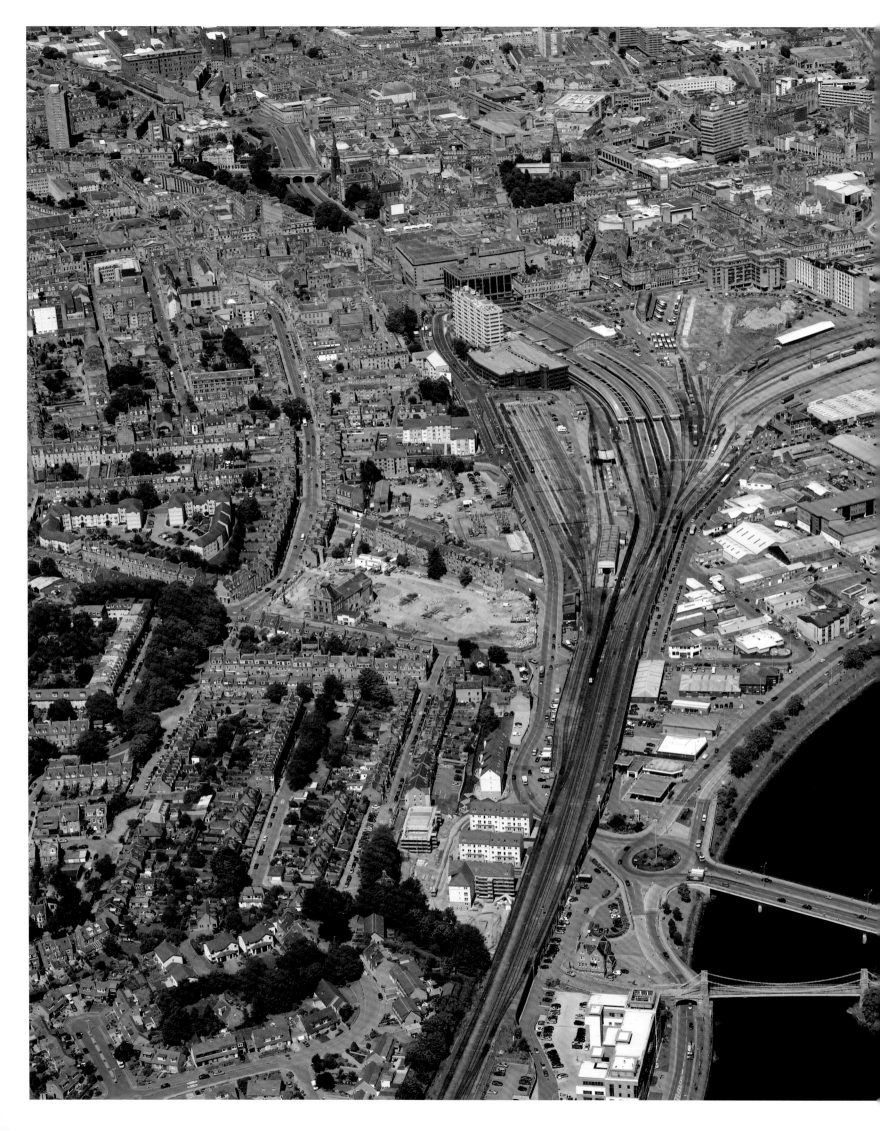

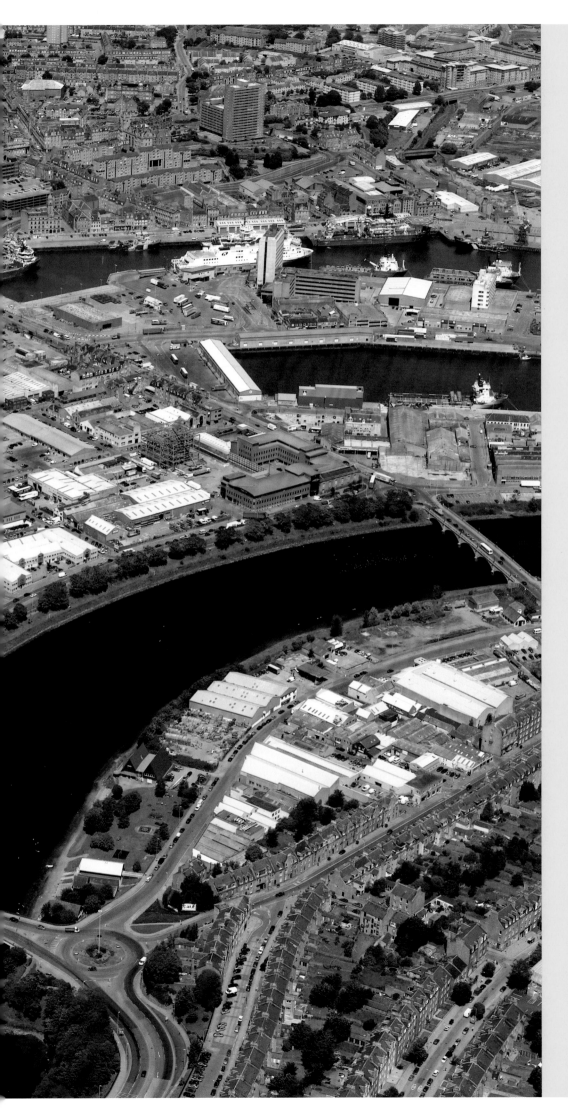

Throughout the twentieth century the railway – so crucial to Victorian Aberdeen's trade and infrastructure – steadily decreased in importance. Where, before, overflowing cargo sidings stretched directly to the harbour-side, today the industrial tracks are gone and have been replaced with residential flats and a shopping mall.

RCAHMS 2006 DP018200

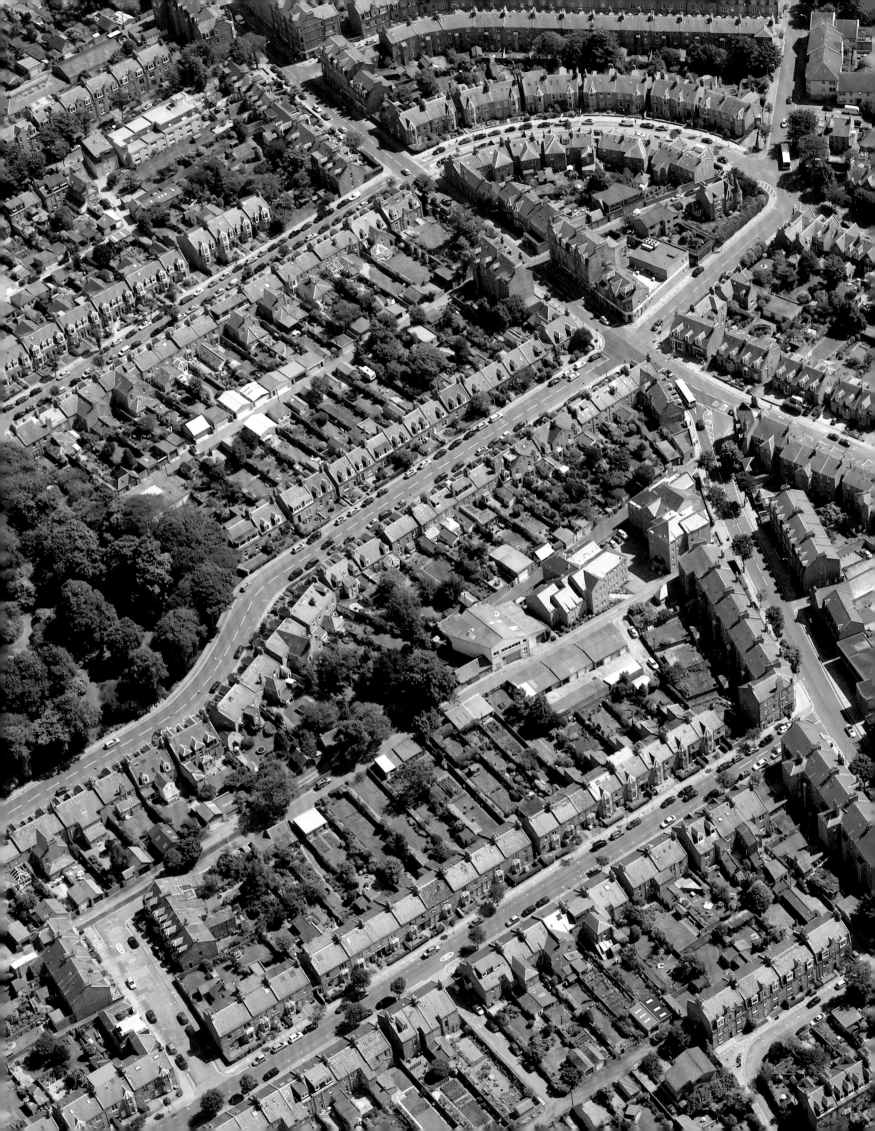

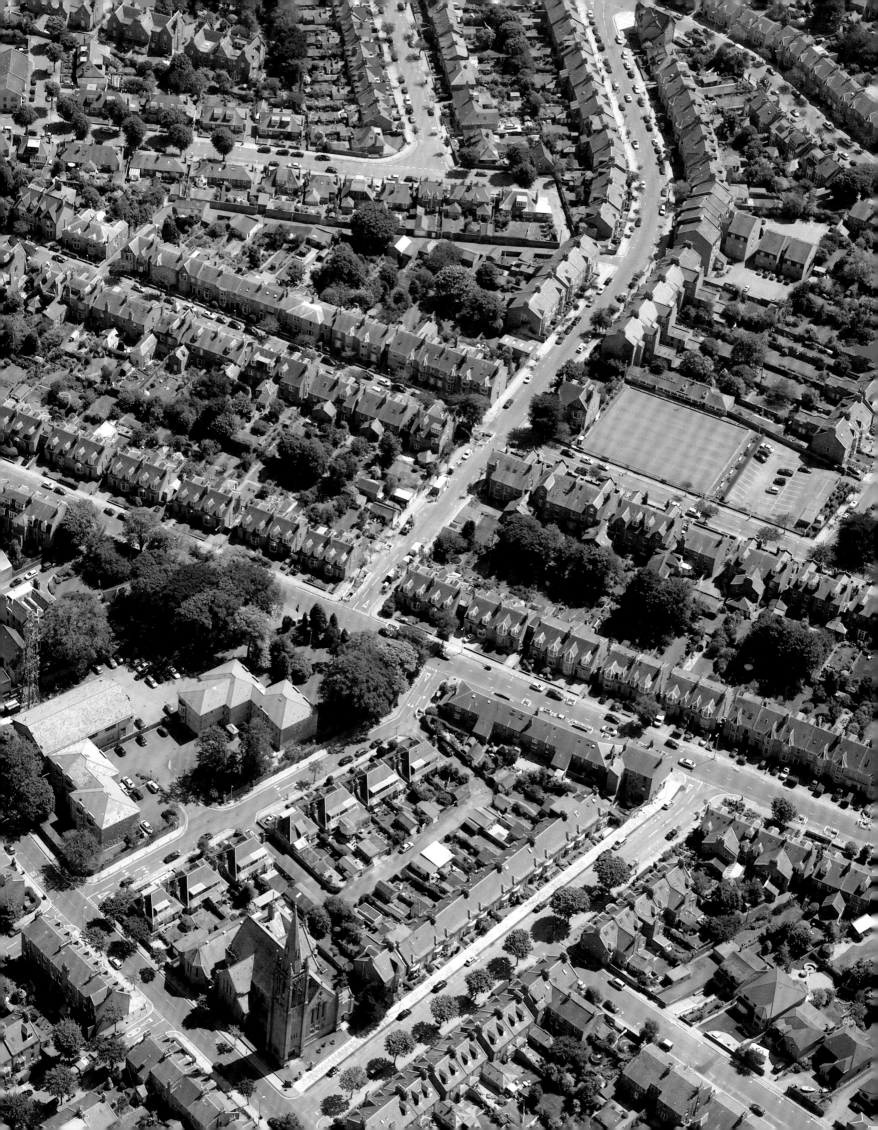

PREVIOUS PAGES

The villas and terraces of Aberdeen's West End – the product of the rapid population boom of the late nineteenth and early twentieth centuries – spread out in long, ordered lines of uniform granite. In the foreground the towering spire of Beechgrove Church – built in 1876 as a Free Church – acts as a community focal point among the regimented ranks of affluent suburbia.

RCAHMS 2006 DP018202

RIGHT

The Modernist vision – pictured here in 1971 – looks startlingly sharp and new, as the imposing, chunky slabs of the Tillydrone high-rises follow the sweeping curve of the multi-carriage Aberdeen ring road at Anderston Drive. In the low-rise city of Aberdeen, the arrival of the tower-block marked a stark intervention into the skyline of a city previously characterised by terraced urban sprawl.

AEROFILMS 1971 A214253

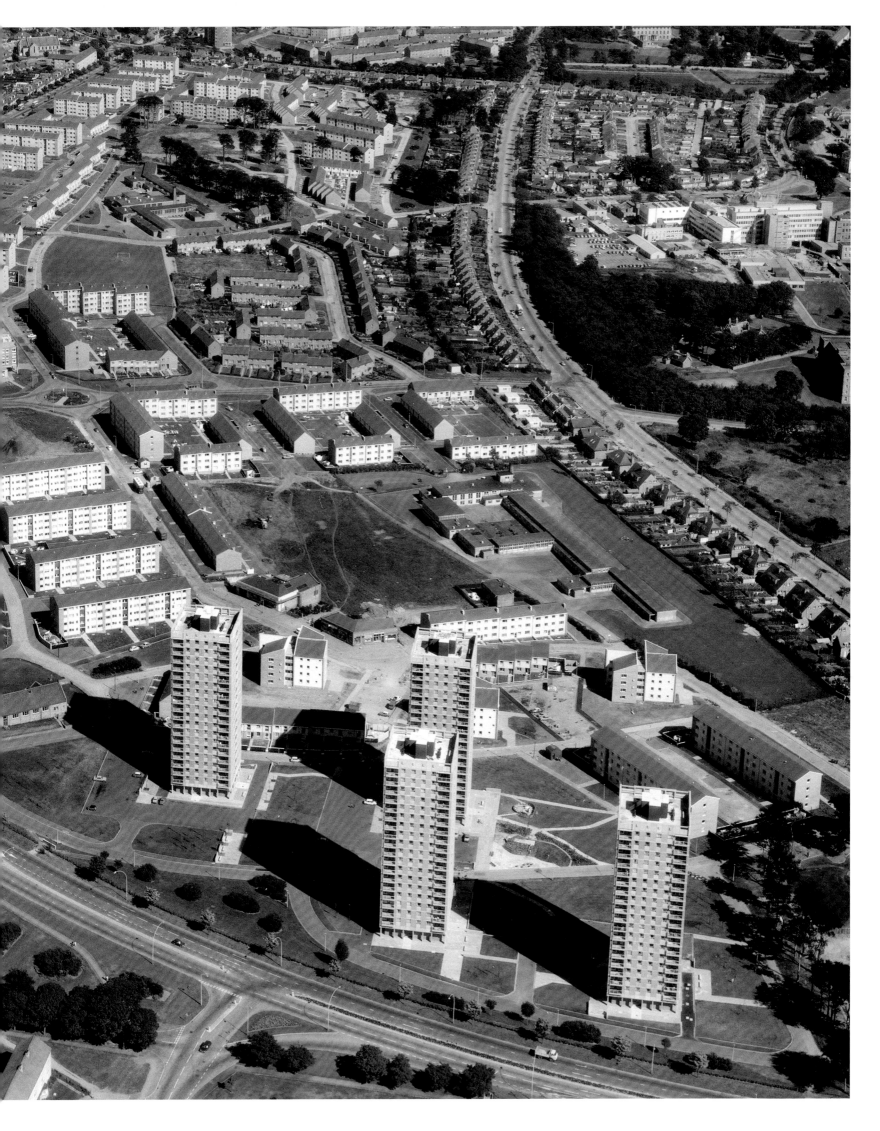

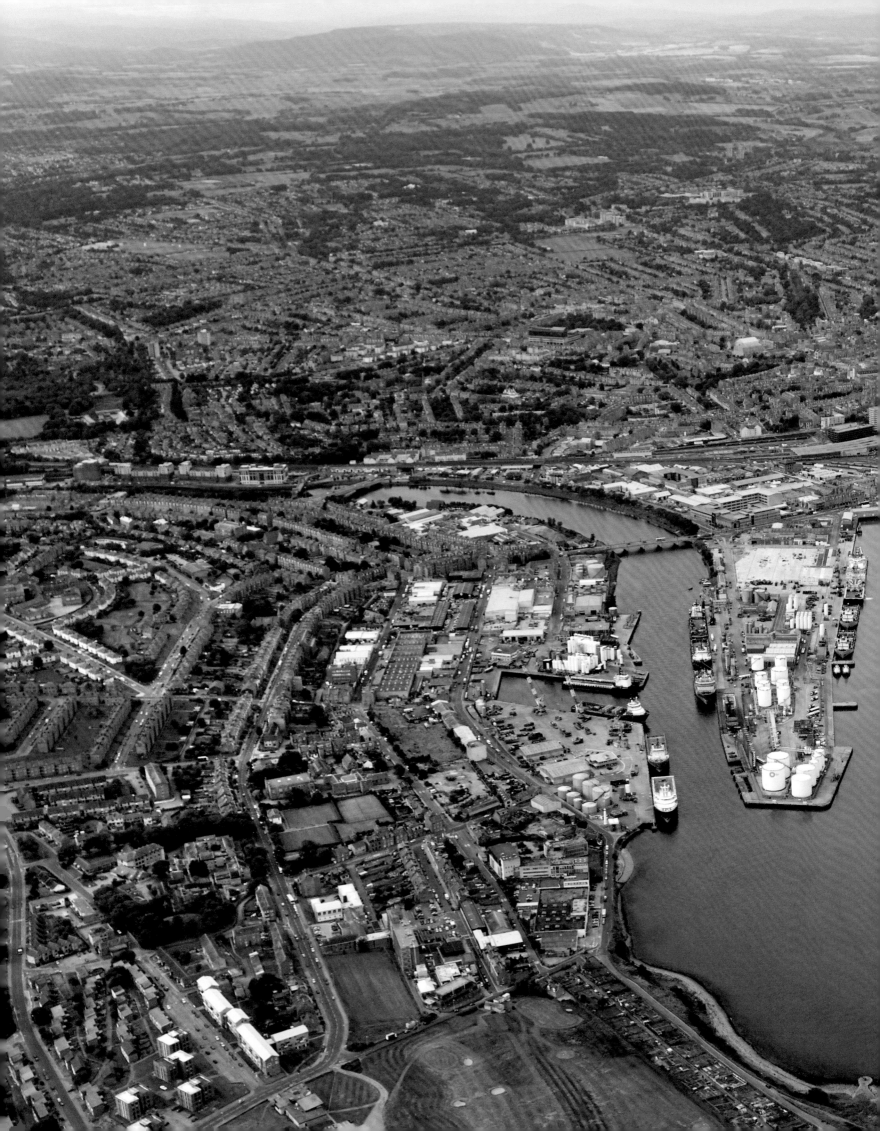

Stretching out across the countryside in swathes of pale-grey granite is a suburban city built during the boom times of Victoria and the Empire. Yet, unusually for a modern city, Aberdeen's ancient origin point – its harbour – remains its economic heart. From pre-history to the present day, the sheltered river mouth has sustained merchant traders, trawl-fishermen, tea clippers, granite exporters and, today, the massive infrastructure of the offshore oil and gas industries.

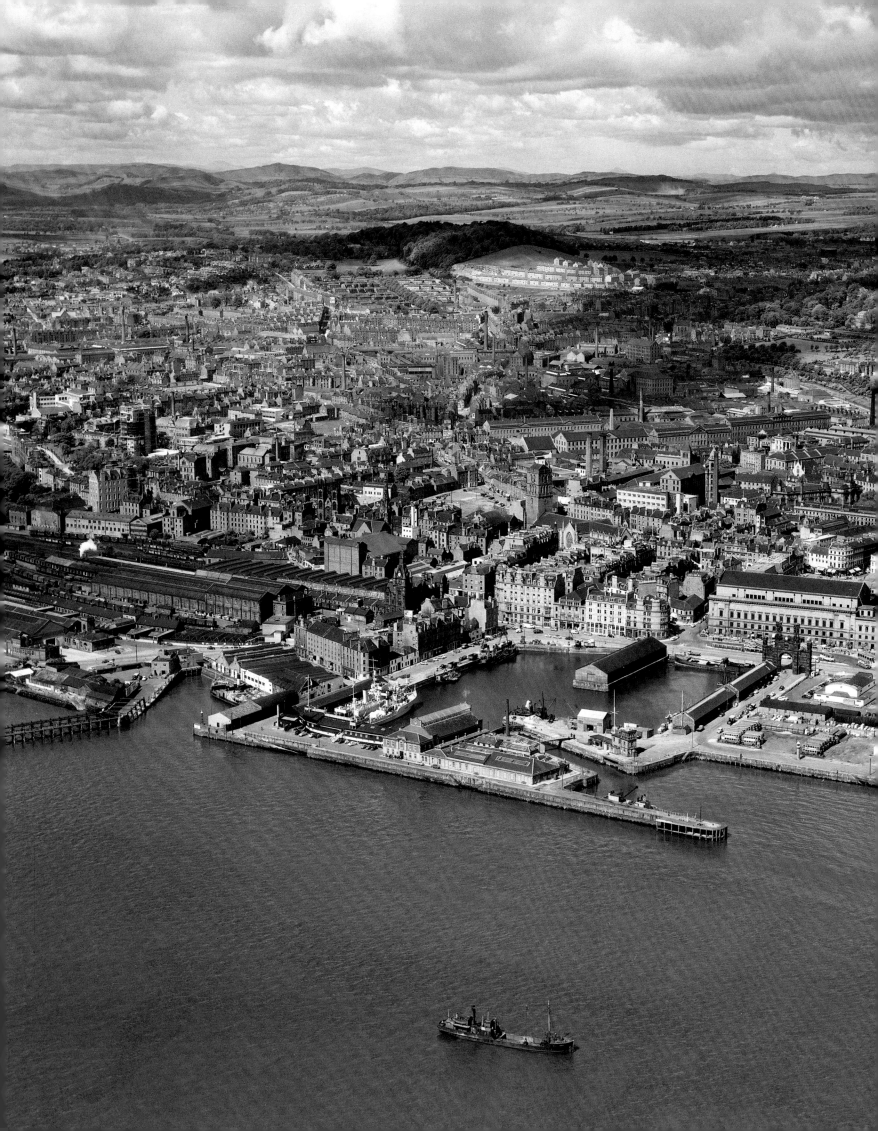

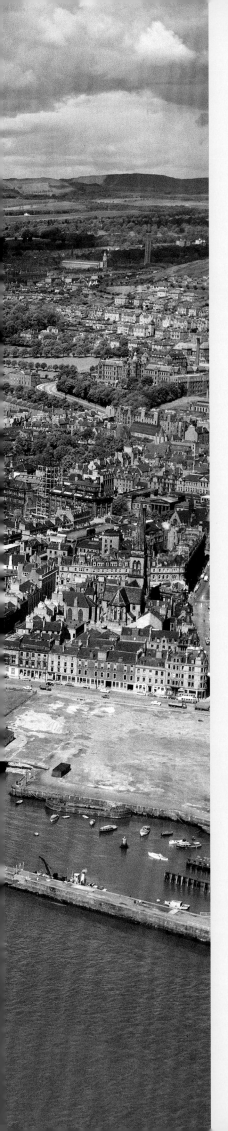

Dundee

On 8 January 1893, at the extreme tip of the Antarctic Peninsula, the whaling ship s s *Active* came upon an unknown landmass among the ice-floes of the Weddell Sea. The *Active* was one of four vessels sent to investigate and hunt the whale population of the largely uncharted waters of the world's last, unexplored, continent. In naming the new island, ship's Captain Thomas Robertson resolved to honour the ambitious port that had launched this hazardous mission to the ends of the earth – Dundee.

By the nineteenth century, the influence and reach of Dundee was astonishing. The city was a bustling trading centre with commercial links across the world. Goods like linen, flax, iron, tar, copper and timber arrived from Northern Europe, fleets of jute ships voyaged to and from India, and the whalers of the north and south Atlantic sold the oil and precious baleen of their catches for huge sums of money on the busy quaysides.

Entrepreneurial in spirit and international in outlook, Dundee, like many merchant cities, was shaped by the cosmopolitan influences of foreign trade and spliced to the fortunes of the economy. A boom-and-bust city created boom-and-bust architecture. In its first golden age, Dundee was Scotland's foremost renaissance port, the curved, crescent-like streets of its maritime quarter – designed to keep the biting offshore wind away from the town centre – echoing the layout of the trading guild sea-towns of Northern Europe, from Copenhagen in Denmark to Konigsberg in Poland. Merchants lived in style in grand townhouses adorned with painted galleries, and residential properties lined the Seagate, their garden walls washed by the Firth of Tay.

Over two hundred years later, it was the turn of the Victorians to make Dundee in their own image. At the start of the nineteenth century a major harbour development on reclaimed land – the work of the renowned civil engineer Thomas Telford – had increased the volume of mercantile traffic, but had removed Dundee from its original shoreline. As the 'Juteopolis' began its muscular expansion, brooding masses of mills and foundries encircled the medieval and renaissance core, and railways burst through the town to further separate it from the sea. This rapid industrial expansion transformed the fabric of Dundee, reducing the old centre to smoky, disease-ridden slums occupied only by the poorest citizens. With typically decisive Victorian vigour, the 'City Improvement Act' of 1871 saw this dilapidated core almost completely reconstructed. The civic body pursued an unflinching vision for a new Dundee: clear transport routes would be carved through the crammed city centre, and the likes of Commercial Crescent and Whitehall Street would be recast as elegant boulevards in the style of Milan and Paris. The trader ethos of the renaissance remained in spirit, but not in stone.

Such radical changes have characterised the history of urban Dundee. It is a cityscape that rises and falls like the tides. When called upon to act, the city fathers

have assumed the role of arch modernisers. After every crash – from the sacking by General Monk in 1651 to the post-war collapse of the great jute dynasties – a new version emerges, its buildings growing out of ashes, rubble or decay to reconstruct Dundee in defiance of adversity.

As the twentieth century progressed, it was a spirit of civic intervention that came to dominate urban development. A model 'Garden Suburb' was created at Craigiebank, its concentric layout of villa-styled flats landscaped in a pattern lifted directly from Ebenezer Howard's *Garden Cities of Tomorrow*. In the Modernist 1960s, the Tay Road Bridge brought the motorcar directly into the centre of Dundee. Just like the Victorian rail bridge a hundred years before, it arrived at a period of radical urban change. The bridge construction works laid a concrete blanket over many of the maritime quarter's once vital docks, while beyond, a new cityscape of low-and high-rise public housing grew from the derelict shells of old industry.

Whatever the social or economic climate, the merchant soul remains imprinted in Dundee. Over the latter part of the twentieth century and into the new millennium, the city has begun its latest transformation. Science parks and medical research facilities pioneer trade in new technologies. On the Nethergate, once the road from shore to market, a burgeoning cultural quarter is formed by the Dundee Contemporary Arts building – a bold public venue occupying the eroded shell of a former brick garage – and the internationally celebrated Rep Theatre. New university buildings and campuses continue to invigorate the old town centre, part of a drive to refocus as a city of thought and innovation. With a physical history that is repeatedly remodelled, the spirit of the city endures in its people. The architecture which lasts is found in the resilience of the Dundonian character – formed of enterprise, ideas and adventure, it stands undiminished across the centuries.

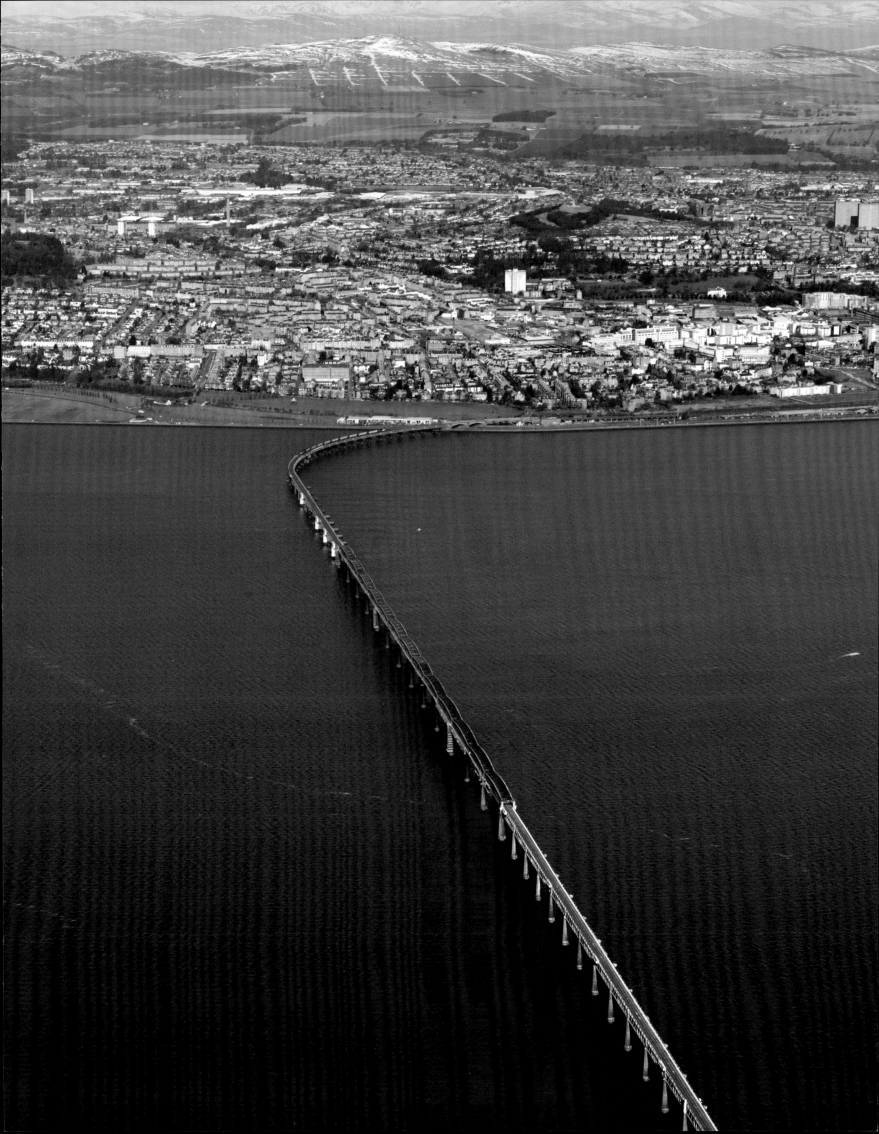

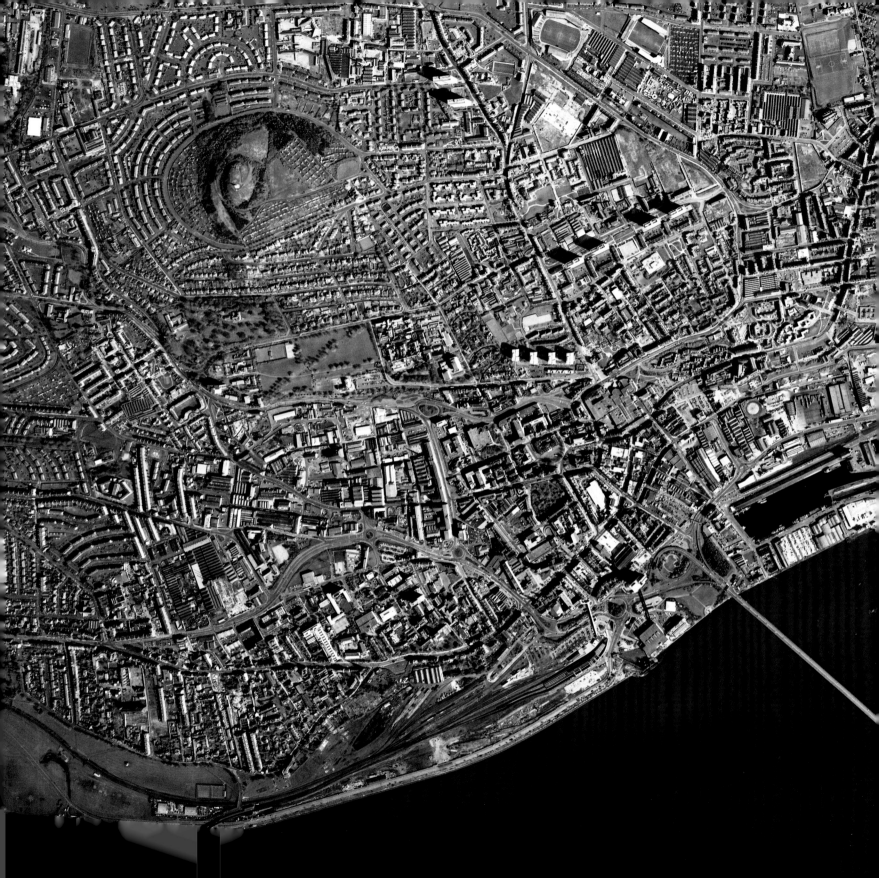

Trade and industry removed modern
Dundee from its original shoreline. Linked
across the estuary to the south first by rail
and then, in 1966, by road, the city front
is clearly dominated here by the massed
tracks of the railway and the dense sprawl
of a harbour built on reclaimed land.

ASS 1988 006-000-001-074-C

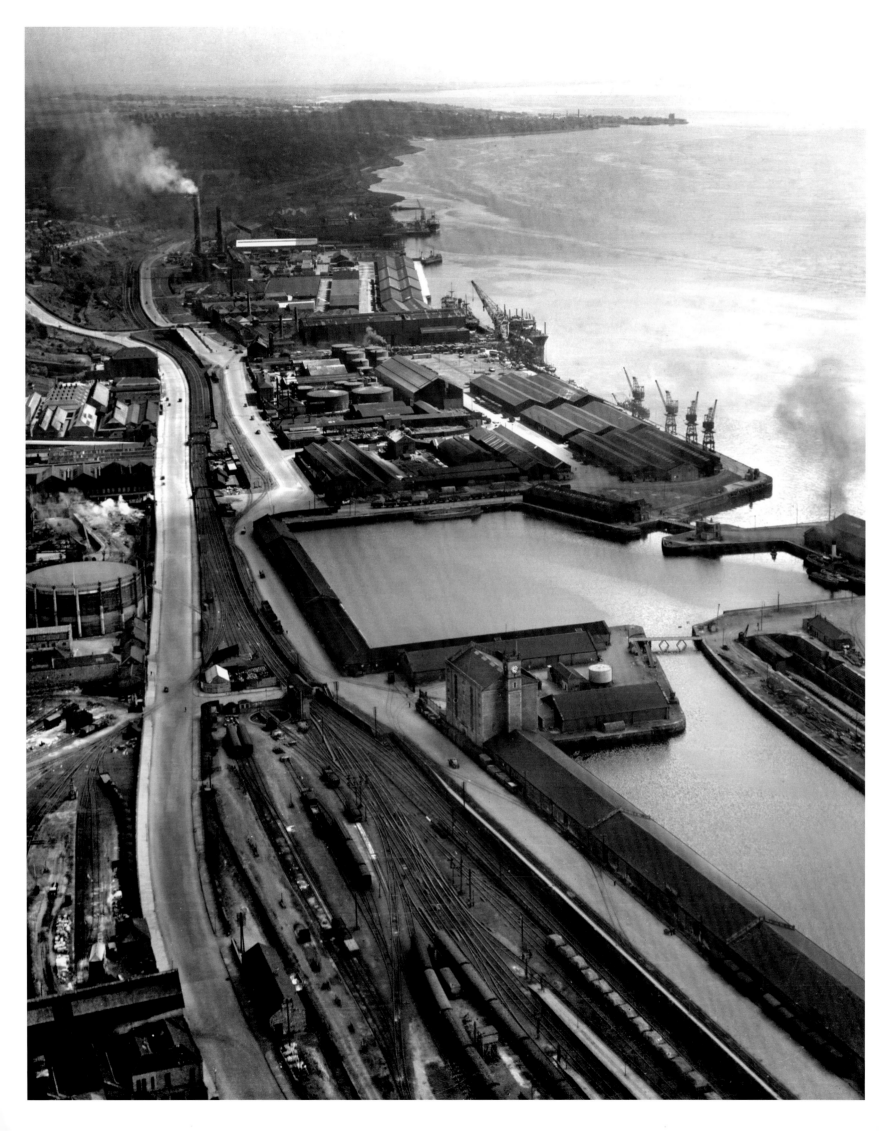

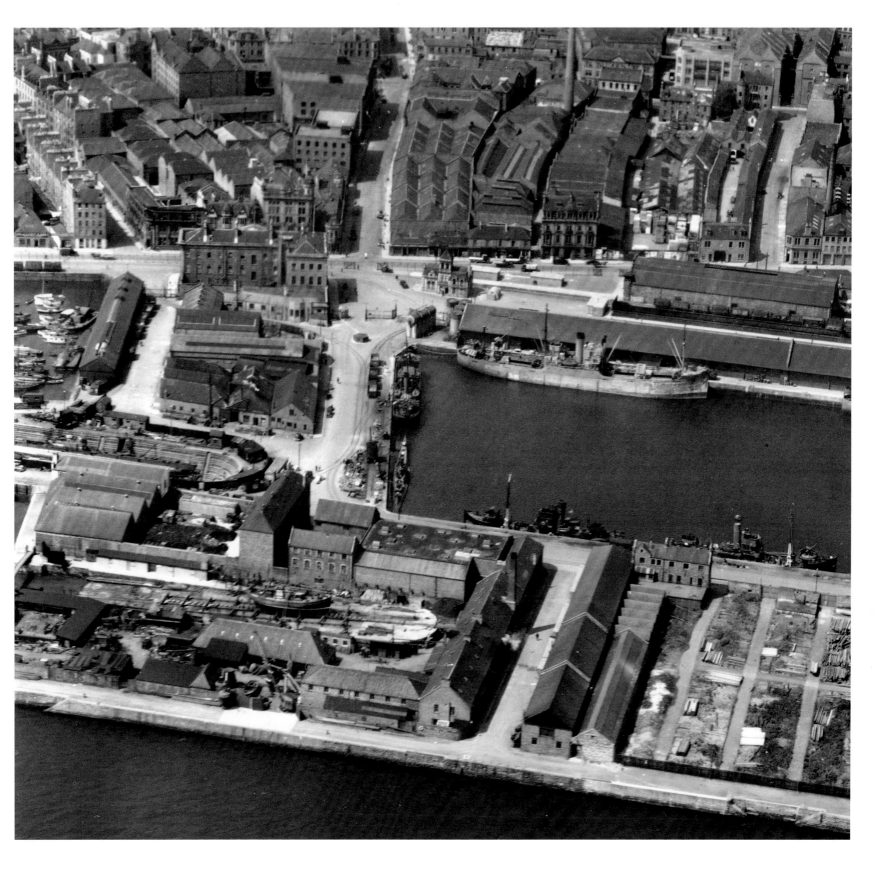

The growth, improvement and expansion of Dundee's merchant waterfront continued unabated for almost a century. The renowned civil engineer Thomas Telford began the process with the construction in the 1820s of floating and graving docks, and in 1843 he replaced the city's eastern tidal dock with the custom-built, enclosed harbour of the Earl Grey Dock.

The development continued westwards in the 1860s and 1870s with the addition of the Victoria and Camperdown Docks – pictured here – and by 1912, the harbour occupied 119 acres of land reclaimed entirely from the Tay, with three and a half miles of quayside linked by ten miles of railway allowing the port to handle over 800,000 tonnes of trade each year.

The renaissance shoreline of the sixteenth and seventeenth centuries – more Baltic Sea than North Sea – had been replaced by the powerhouse infrastructure of Victorian industry.

RAF 1947 006-001-000-225-C
RAF 1943 006-000-001-075-C

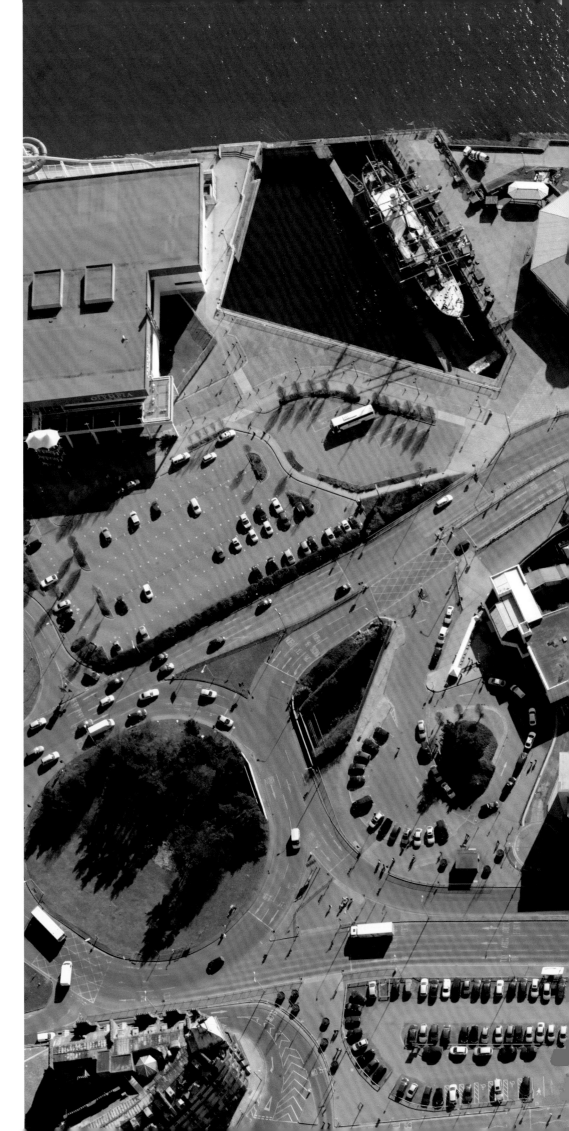

Once a massive hub servicing the rapidly expanding industrial and trader Dundee of the nineteenth century, today the city's Tay Bridge Station is reduced to a thin, functional sliver surrounded by Möbius Strips of road, concrete and carparks. An iconic symbol of a world-travelling past does, however, remain moored in the waters of Discovery Quay. The steam-assisted, wood-built Royal Research Ship *Discovery* was the first vessel to be designed and constructed specifically for scientific research. Dundee's whaling legacy had produced a generation of shipbuilders skilled in constructing boats capable of withstanding the ice of both the north and south Atlantic oceans. Sporting a unique double-hull, the *Discovery* was commissioned to take Robert Falcon Scott and Ernest Shackleton on their first mission to the Antarctic. The ship, which spent over two years from 1902 held fast by the ice of the McMurdo Sound, is now a visitor attraction encased by the concrete of a modern city.

RCAHMS 2010 DP075775

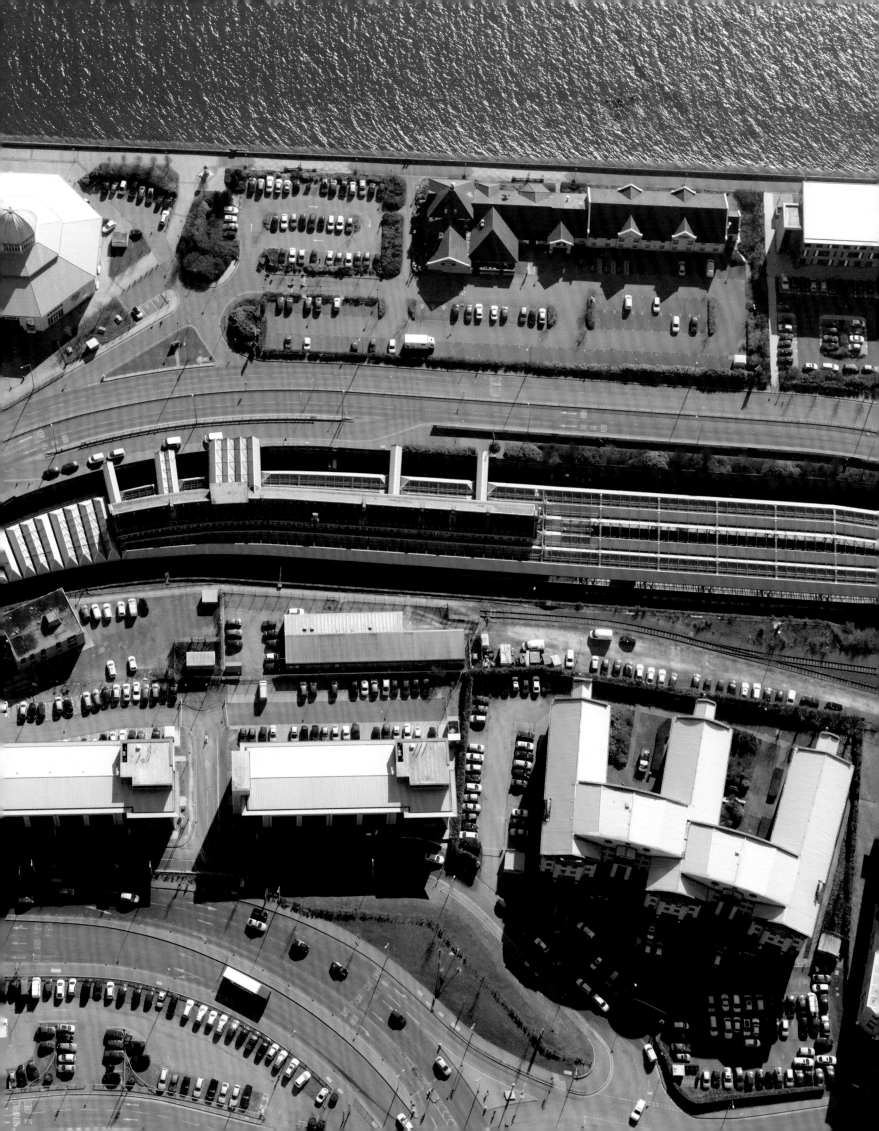

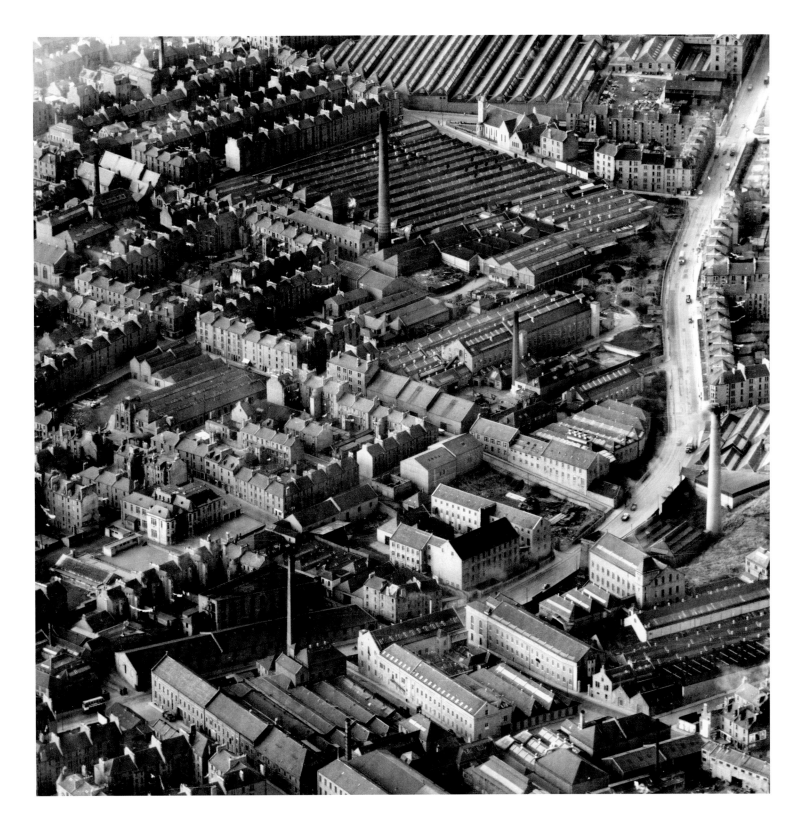

Arranged in a haphazard geometry, rows of tenement houses in Hawkhill line up against the vast corrugated roofs of the jute mills, each with their thin, towering chimneys soaring into the city skyline.

RAF 1958 006-000-001-077-C

Dundee Law, its lone monument flickering white in the background, looks down from the origin point of the city's first settlement at an urban fabric interwoven with fragments of centuries of competing developments. Hemmed in on all sides in the centre are the City Churches – a combination of St Mary's Church, the Mary Slessor Centre and the Steeple Church

– which date back to the fifteenth century and remain, despite various periods of reconstruction in the 1800s, as a tribute to the mercantile wealth of old Dundee. Surrounded by the housing, factories and railways of the industrial revolution, the Churches stand out here as fragments of the medieval age.

RAF 1947 006-001-000-227-C

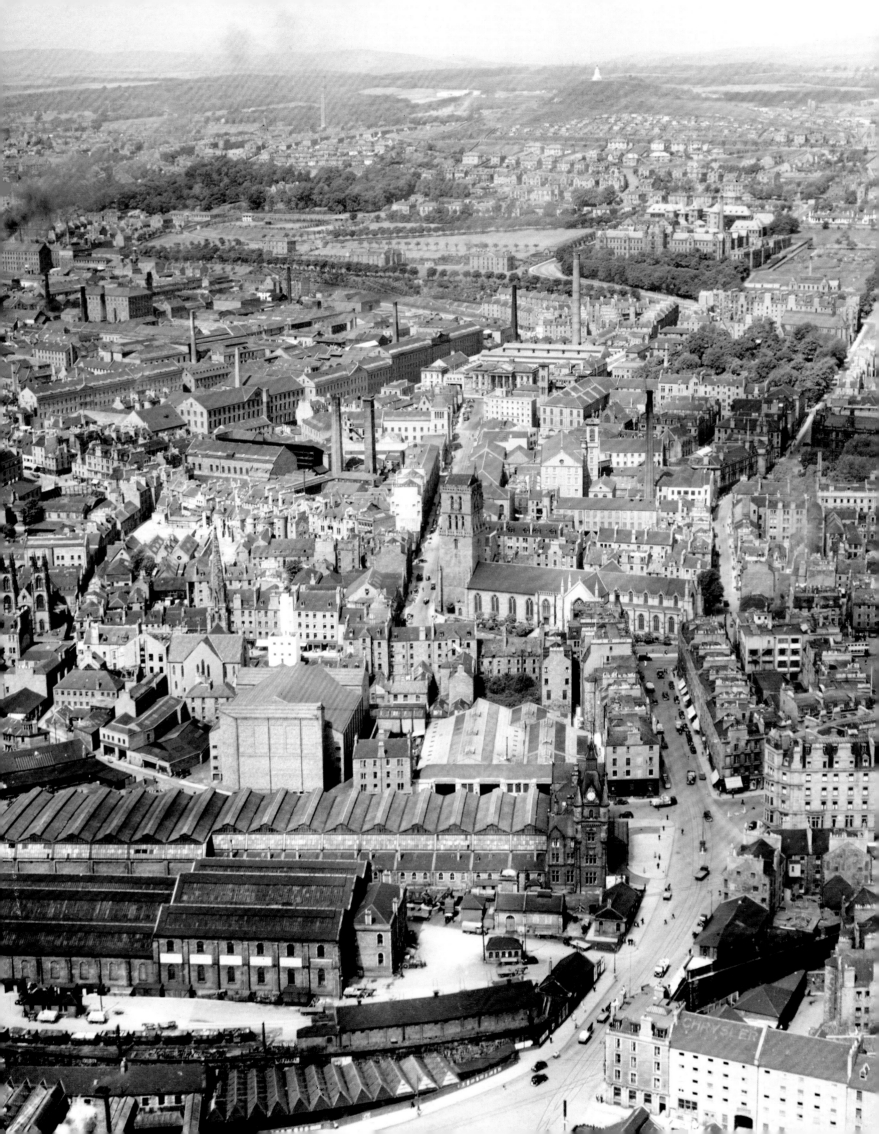

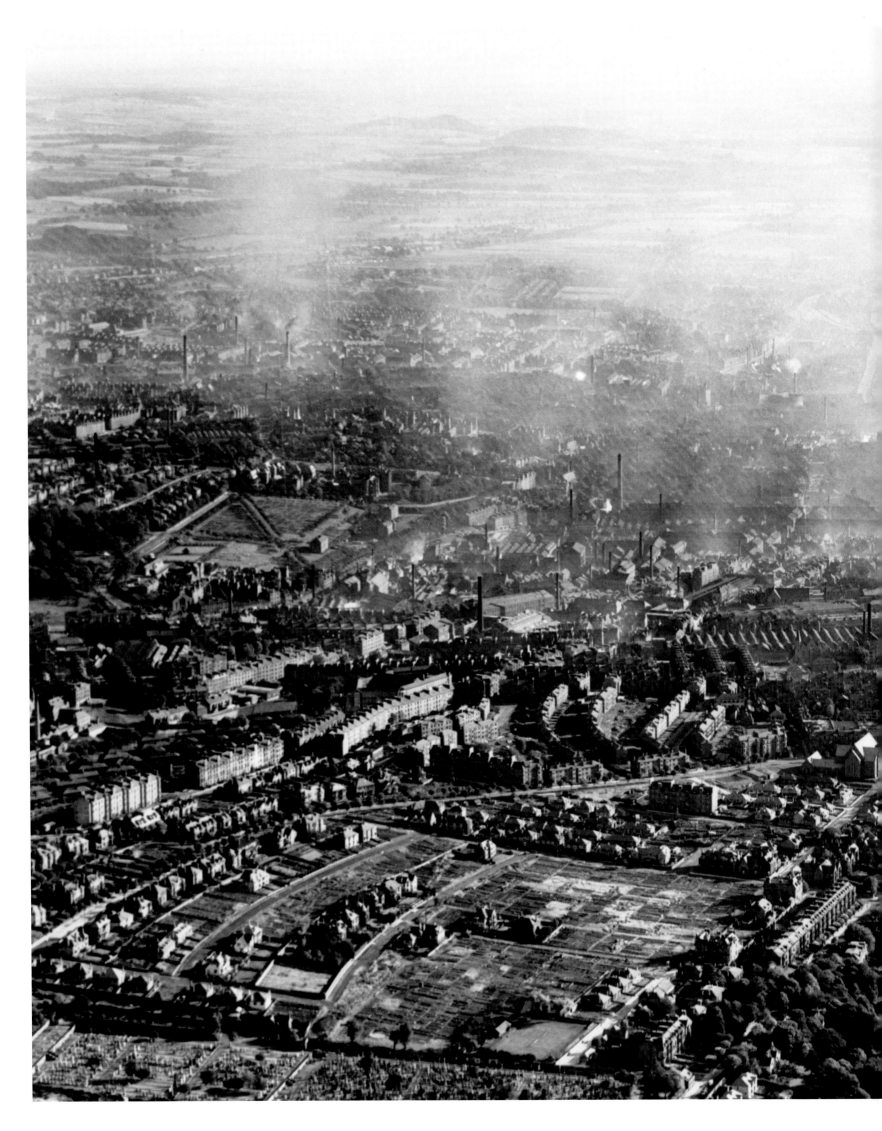

The steepled, smoky expanse of 'Juteopolis' Dundee is instantly recognisable here in 1942. The jute industry consumed the city in three successive phases of rapid development – the 1830s, 1850s and 1870s – before it entered a gradual but terminal decline after the First World War. Tanneries, ropeworks, linen mills, jute mills and factories clustered around the main water sources of the Scouring Burn and the Dens Burn, and by 1871 Dundee's three textile barons – the Baxters, the Grimonds and the Coxes – employed over 10,000 people between them. By 1912, 34,000 Dundonians worked in jute – over 60 per cent of them women – a peak that would never again be reached as the industry lost a slow war of attrition against the cheaper manufacturing costs of the rival Indian mills.

RAF 1942 006-003-000-398-C

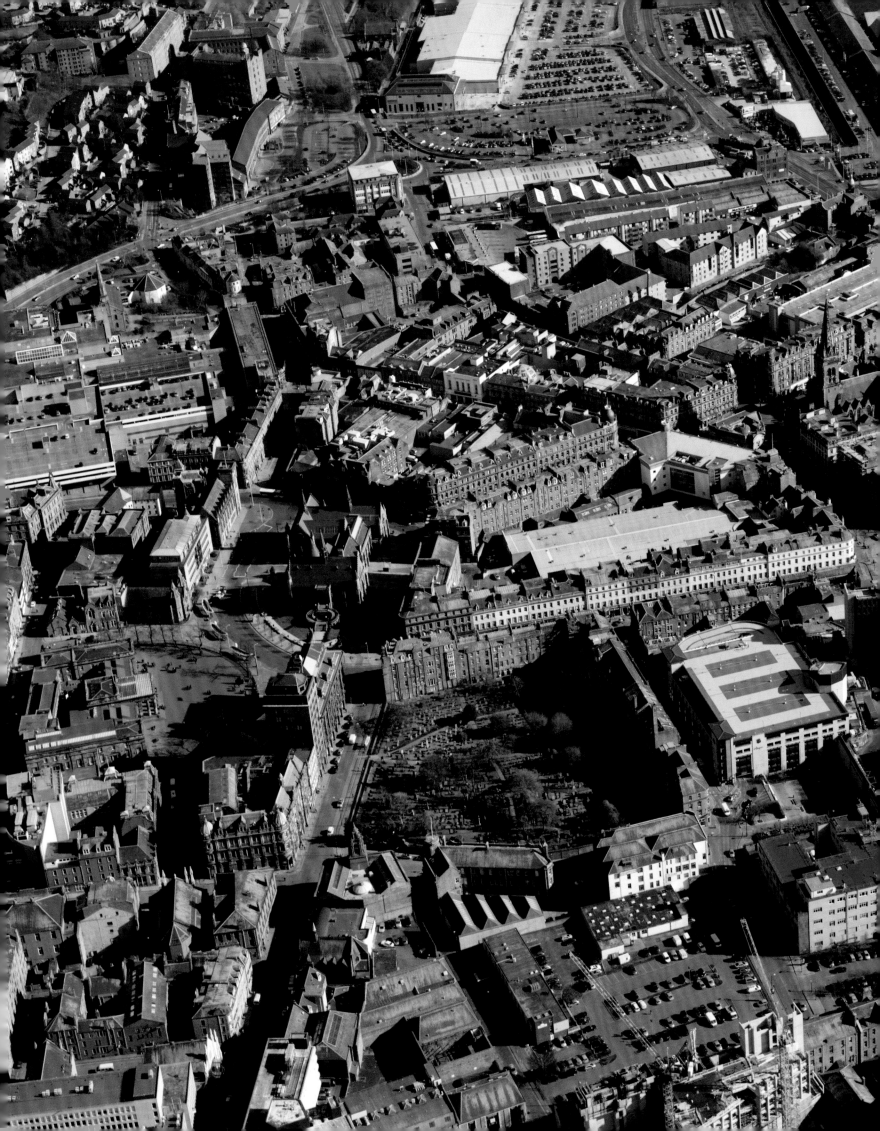

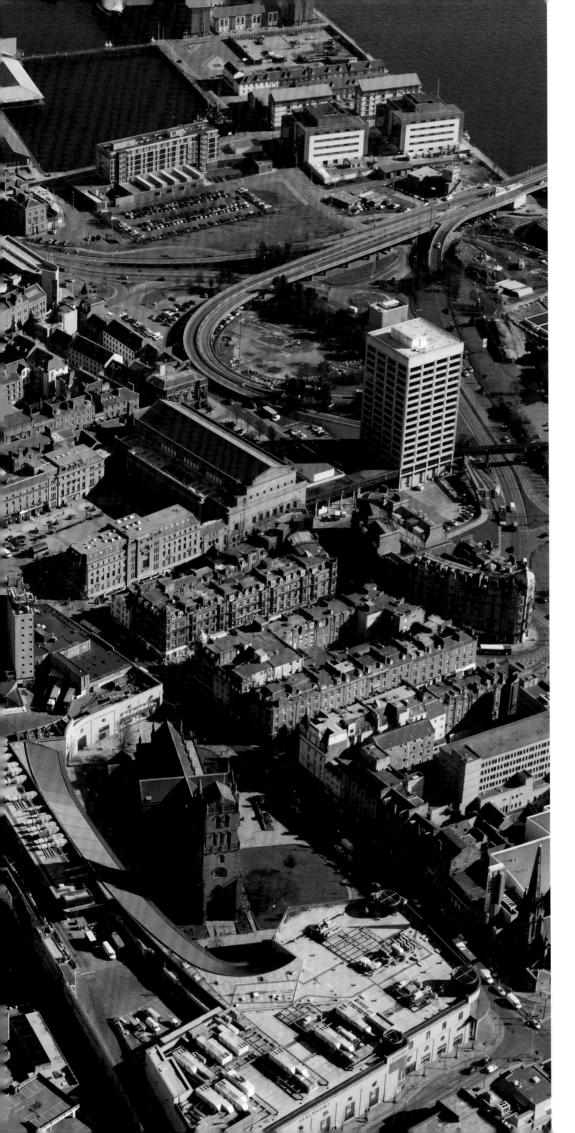

The decline of the jute works throughout the twentieth century saw the fragmentation of the industrial architecture of Victorian Dundee – and in its place came the first experiments in modernising the city. Between Albert Square and the High School, the Courier building – headquarters of Dundee's Thomson media dynasty, a journalism factory that still thrives today – rose in 1902 as an American-inspired, steel-framed office block of red stone, with a confident tower extension added in 1960. In 1967, the industrial slums that had once surrounded the City Churches on the Nethergate – inheritors of an overcrowded civic fabric dating back to the 1600s – were demolished to make way for another American invention: the great, stocky block of the Overgate shopping centre. After falling into disrepair, the first Overgate was replaced in 2001 by a sweeping curved glass structure designed by Keppie Architects.

RCAHMS 2010 DP075765

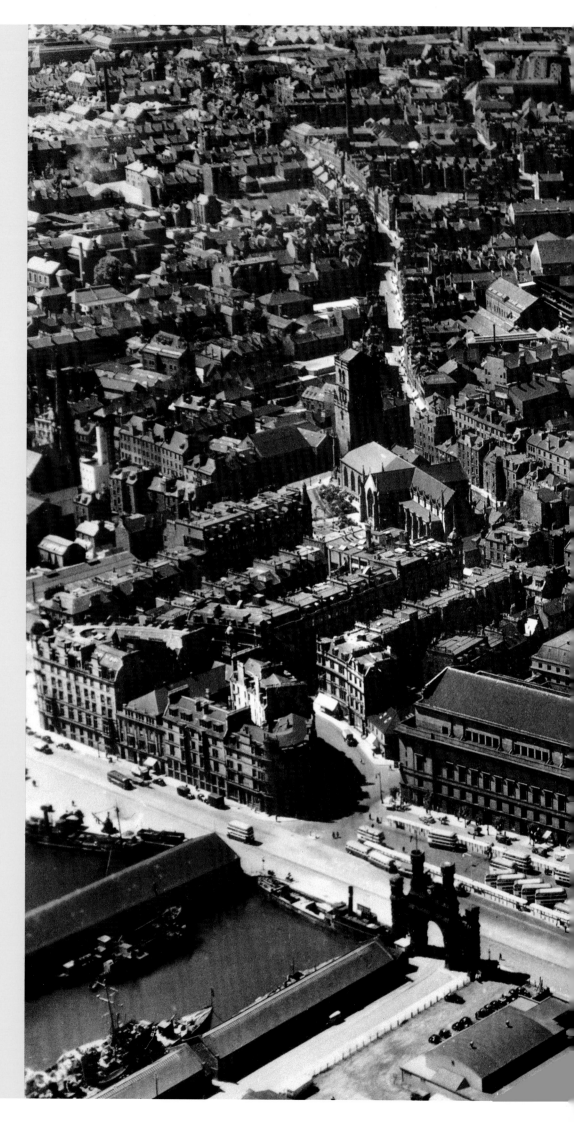

Two icons of an ambitious, wealthy Dundee face each other across the wide expanse of the harbour road. The giant Caird Hall was constructed between 1914 and 1922 after the wealthy jute manufacturer James Caird offered £100,000 to the city to build a new council chamber and concert space. A truly monumental civic structure, the Hall was built on the site of the Greenmarket and the Vault, a trading centre and warren of towering tenements and narrow wynds that had succumbed to overcrowded squalor. Opposite, the great, dark shadow of the Royal Arch was built in 1848 in honour of Queen Victoria's visit to the city four years earlier. Measuring 80ft across and straddling the pier entrance to the Earl Grey and King William IV Docks, the arch was demolished in 1964 to make way for the approaches to the Tay Road Bridge.

AEROFILMS 1950 C19255

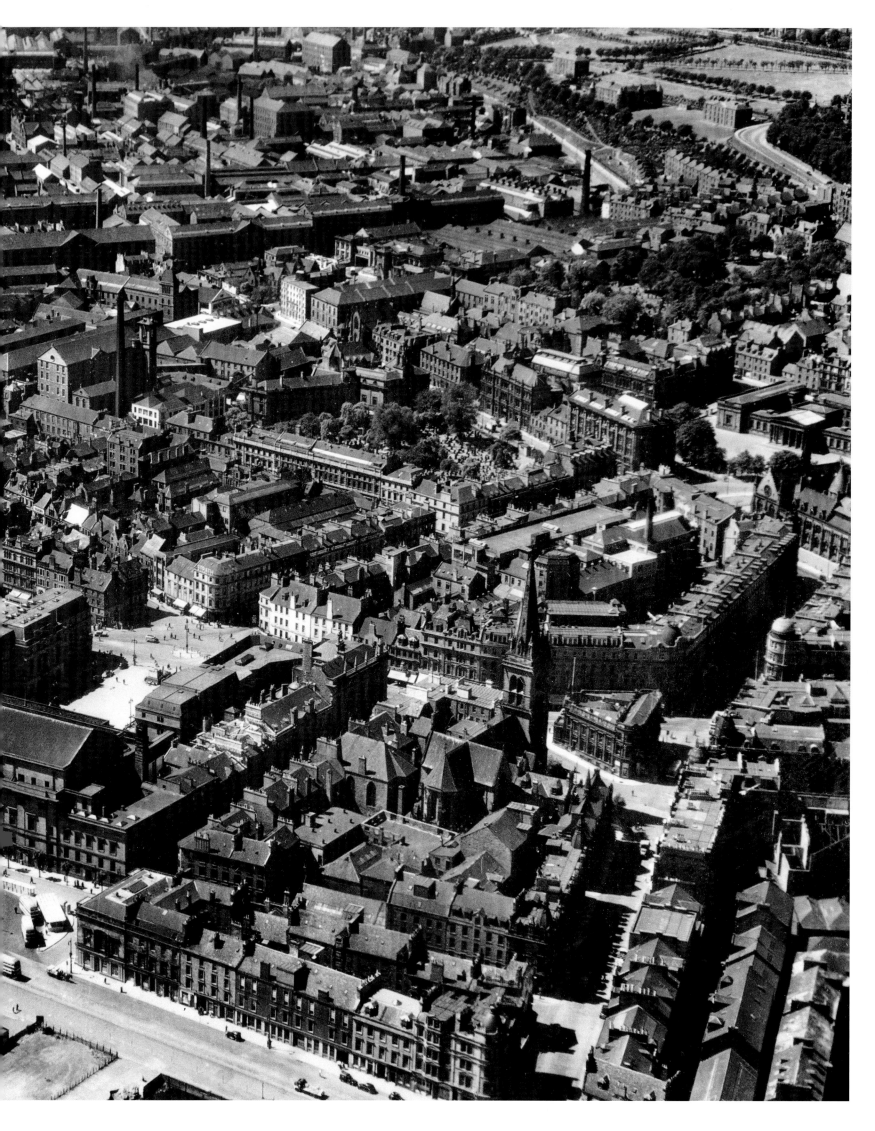

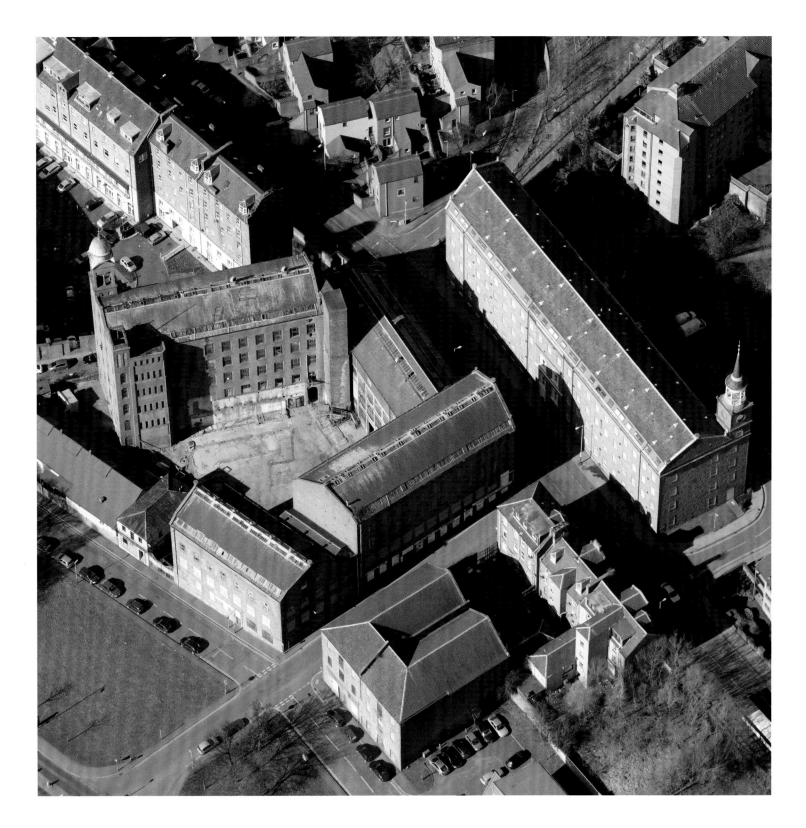

Monolithic monuments to Victorian industrial Dundee, the Dens Mills were at the heart of the Baxter brothers' great textile empire. Seen here on the left, the Lower Dens Mills – built on the site of the Baxters' original foundry – developed in stages over the mid nineteenth century, including the construction of its distinctive Italian bellcote in 1866, an architectural flourish modelled on the tower of the Santa Maria Della Salute in merchant Venice. Upper Dens, the largest of the buildings, comprised at its peak a mill, a wet spinning mill, a calender press, a power-loom factory, three warehouses, two foundries and two schools. The Baxters saw their workplaces as self-contained communities, taking a paternalistic approach to the management of their workforce including employing their own schoolmasters to educate employees' children. Abandoned by the collapse of the industry, the mills have now been repurposed as flats.

RCAHMS 2010 DP075735

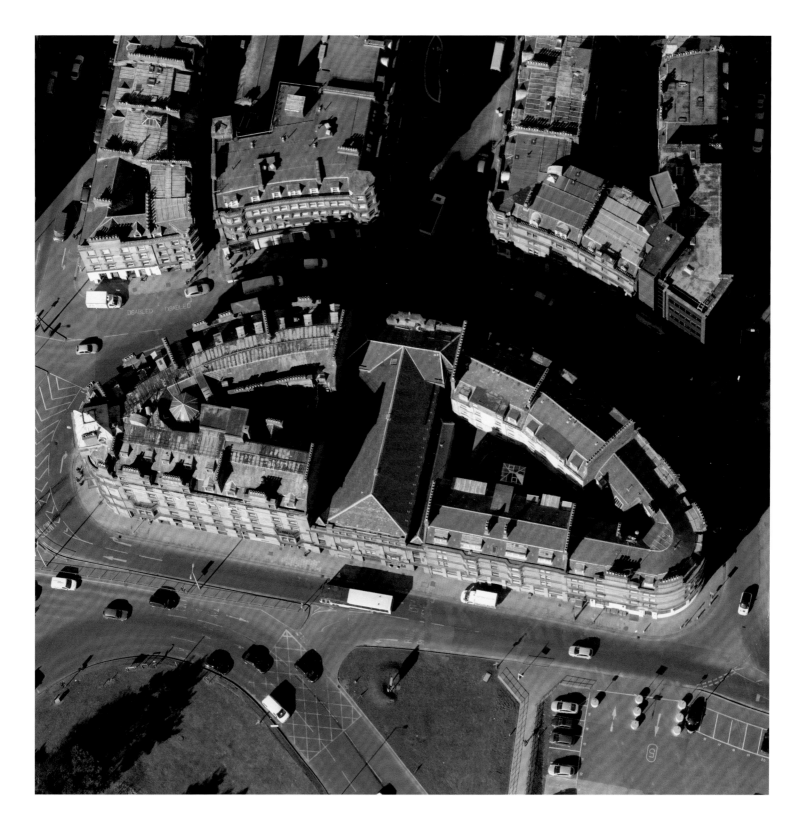

ABOVE

Taking inspiration from the wholesale civic restructuring carried out by Baron George Eugene Hausmann in mid nineteenth century Paris, the Dundee City Improvement Act of 1871 saw the city fathers embark on a programme to demolish the centre's disease-ridden medieval slums and create a continental civic core of grand, palace-fronted boulevards. Built between 1885 and 1889, Whitehall Crescent, with the Gilfillan Memorial Independent Church as its centerpiece, created a wide, sweeping thoroughfare behind its elegant harbour-facing facade.

RCAHMS 2010 DP075749

FOLLOWING PAGES

A great edifice of utilitarian splendour, the Tay Works formed the entire western edge of the Marketgait, the imposing frontage to the industrial heart of Victorian Dundee. Once the largest textile mill in Britain, it was completed in 1865 for the Gilroy brothers, another dynasty of manufacturing 'merchant princes'.

RCAHMS 2010 DP075752

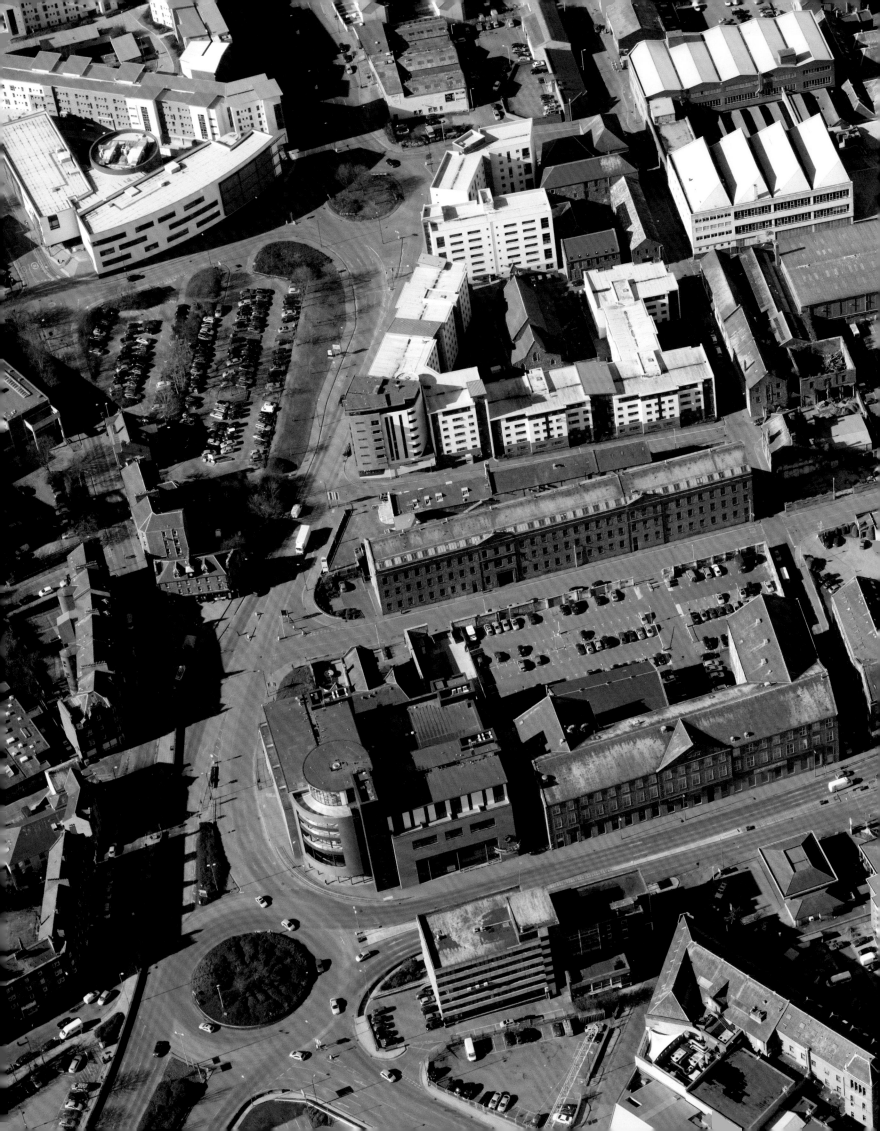

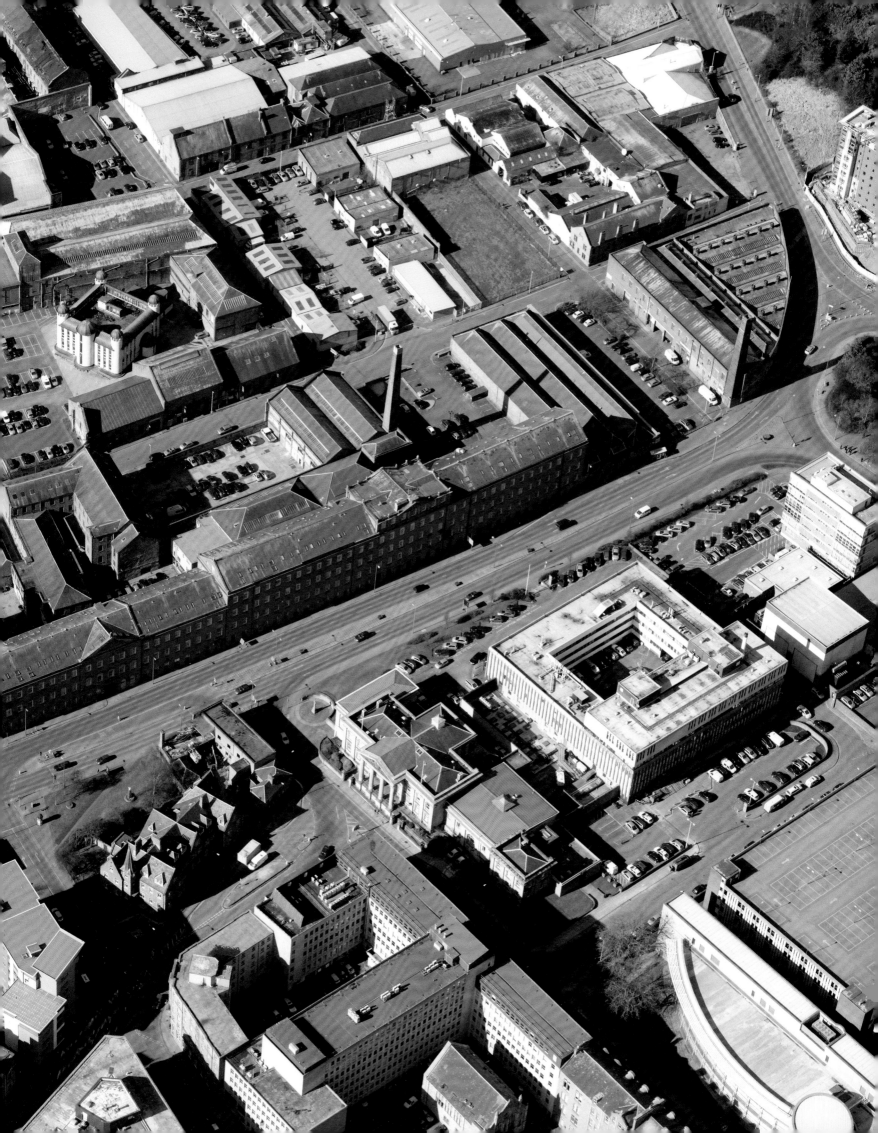

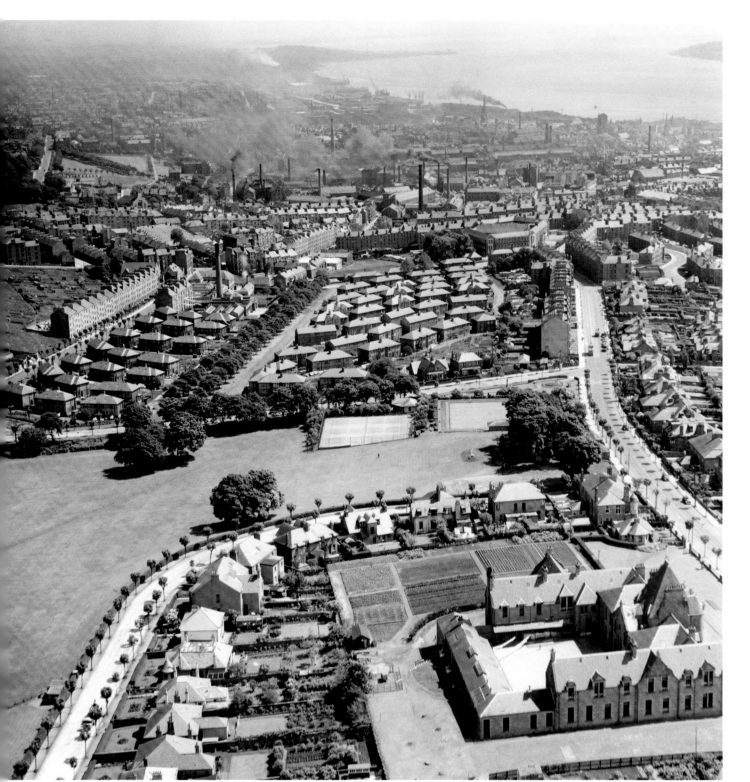

With the city centre behind cloaked in a
dark smear of industrial gloom, Dundee's
rapidly expanding suburbs are, by contrast,
a picture of neat, parkland perfection.
Regimented banks of trees line the sides of
Blackness Road, and large Victorian villas
curve around Parkview School.

RAF 1947 006-001-000-220-C

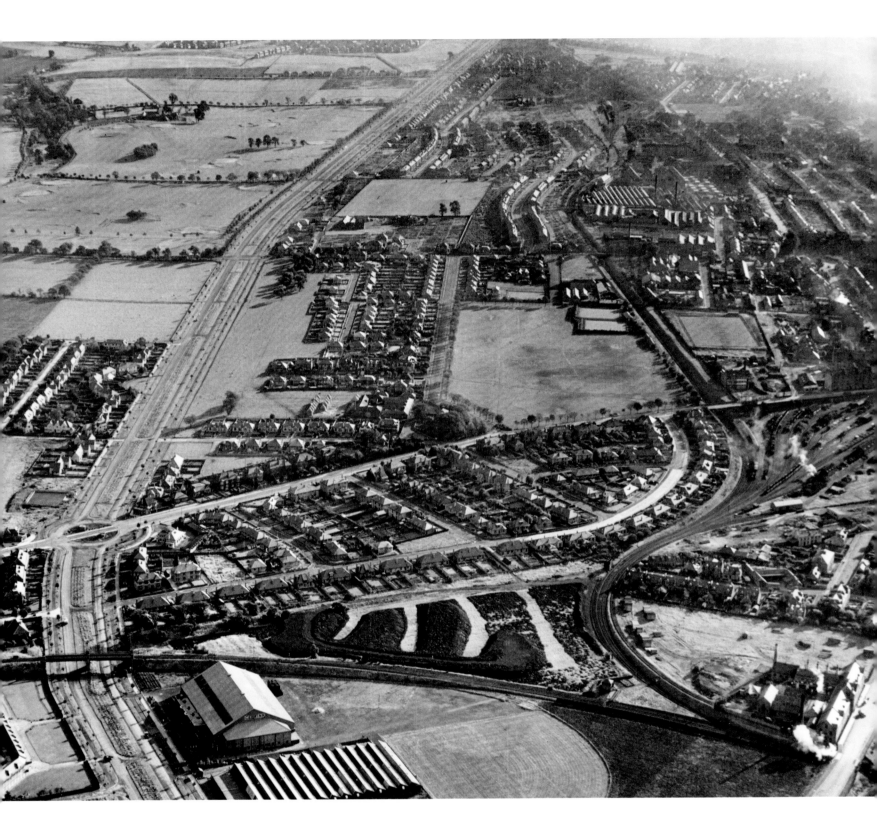

The construction of the Kingsway ring road in the 1930s was a first, symbolic, indicator of the huge impact that concrete and the motorcar would have on the urban fabric of twentieth century Dundee. A broad, tree-lined avenue broken regularly by junctions of cross-roads and roundabouts, this American-styled bypass created a sweeping road-border to the city centre and a transport artery that allowed planners to develop suburban estates in countryside far removed from the old core.

RAF 1942 006-003-000-397-C

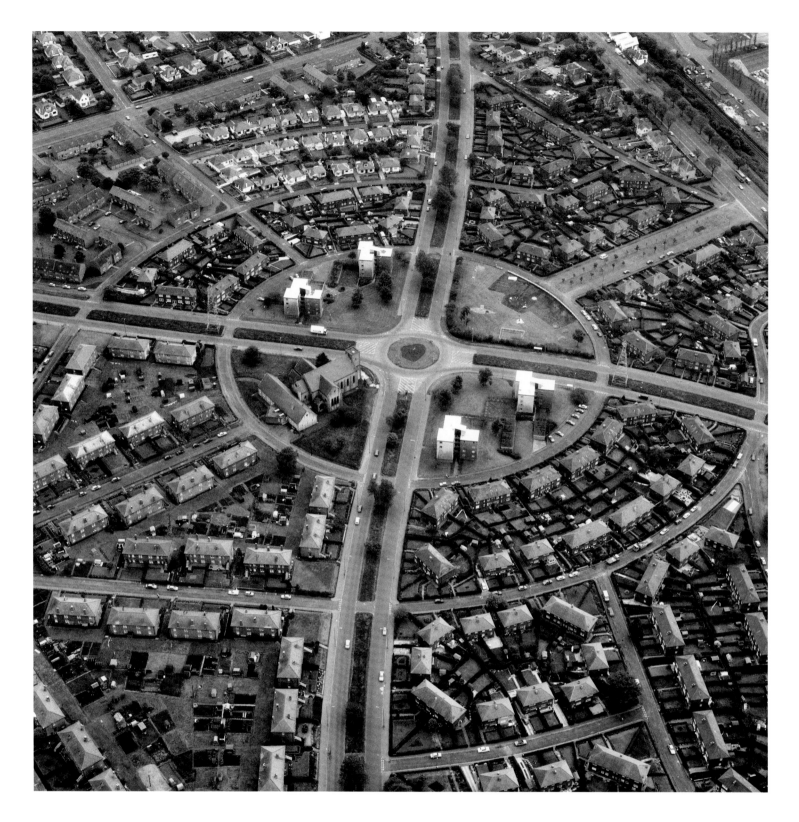

In 1898, Ebenezer Howard published *Garden Cities of Tomorrow*, a vision for transforming industrial civilisation that proffered a blueprint "in which all the advantages of the most energetic and active town life, with all the beauty and delight of the country, may be secured in perfect combination". These utopian theories for a new form of urban living had a major impact on father and son James and Harry Thomson, whose concentric design for Dundee's Craigiebank – built in 1919 – was lifted directly from the pages of Howard's seminal work.

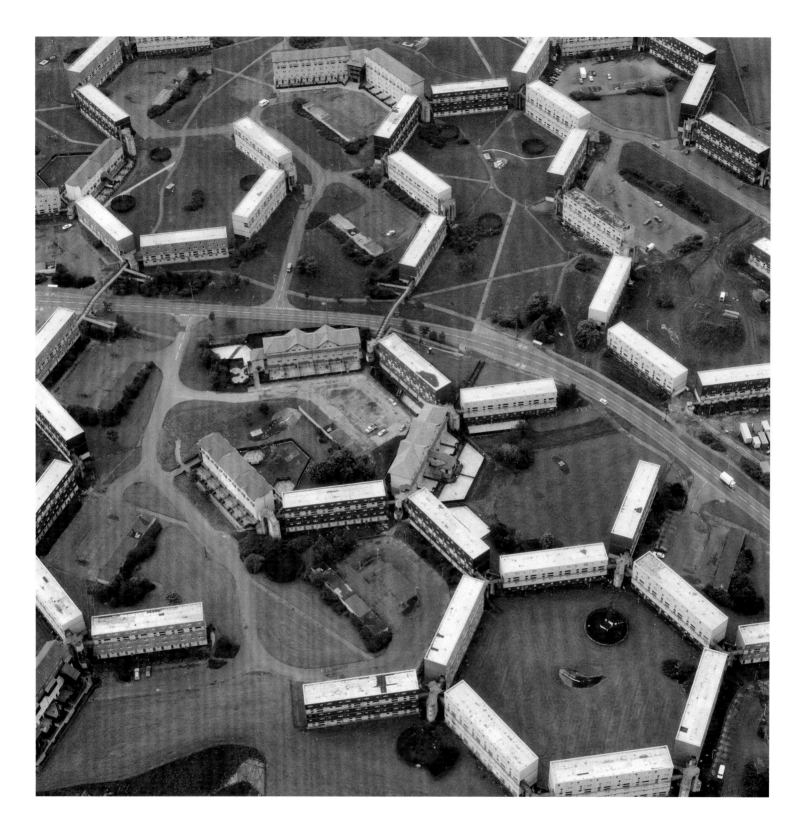

Laid out in a hexagonal pattern – like a
beehive's honeycomb – the Whitfield
Skarne estate was an ultimately unsuc-
cessful 1960s experiment in suburban
living. Made up of low-rise flats, the estate's
location, perhaps at too far a remove from
city centre services, saw it descend into
isolation and decay.

RCAHMS 1989 SC682572

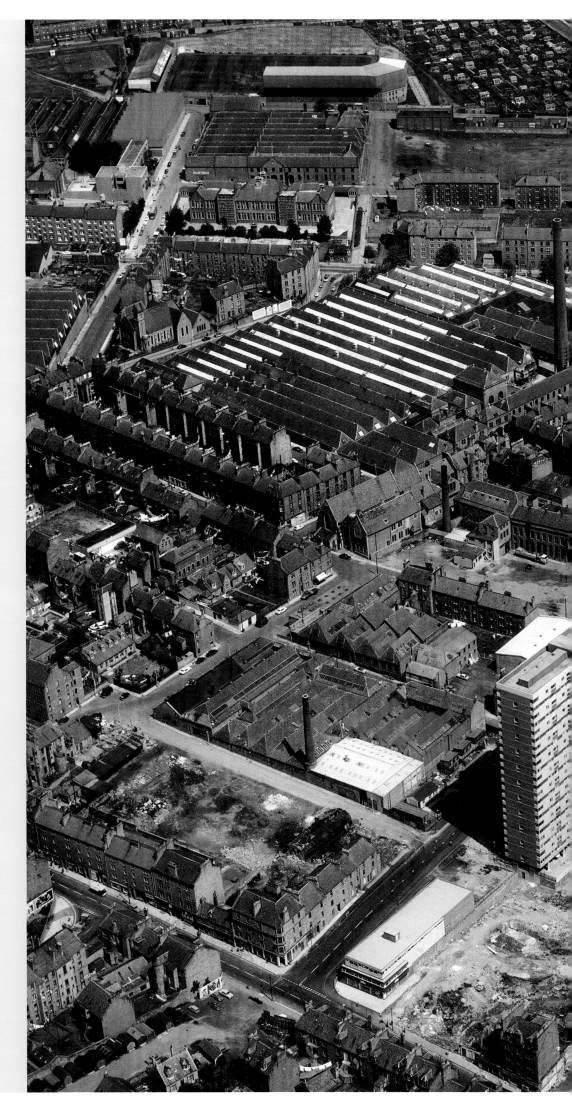

Surrounded by the Victorian fabric of giant jute factories and massed ranks of tenements, the startlingly alien figures of the four Modernist slabs of the Maxwelltown, Carnegie, Wellington and Jamaica Towers stand aloof amidst a century-old, declining industrial landscape. High-rise living had come to Dundee, the latest architectural answer to the challenges of managing city populations and providing municipal residential housing. First built on Alexander Street between 1965 and 1968, the tower-blocks were once part of the vanguard of a brave new urban planning world.

AEROFILMS 1969 A195405

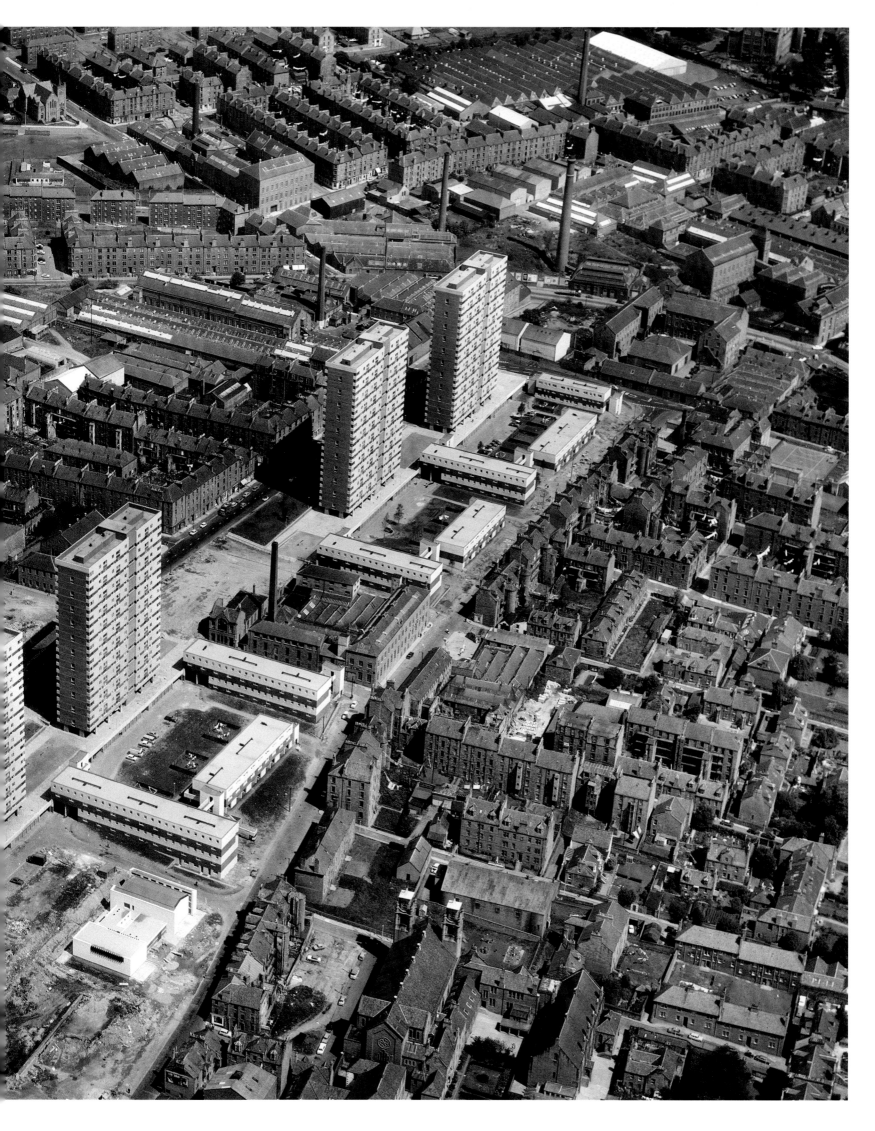

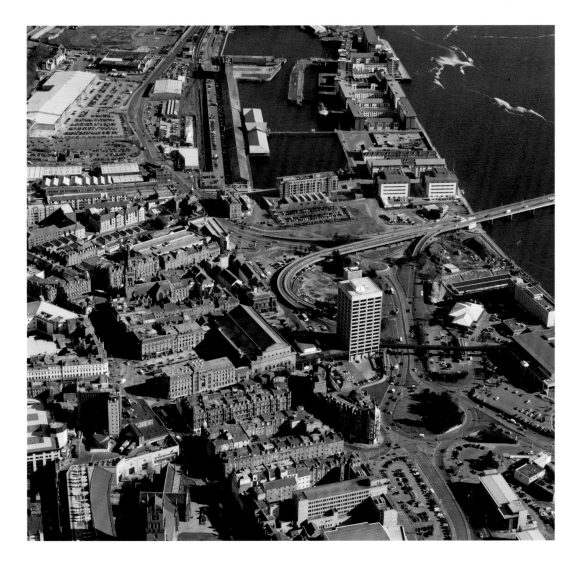

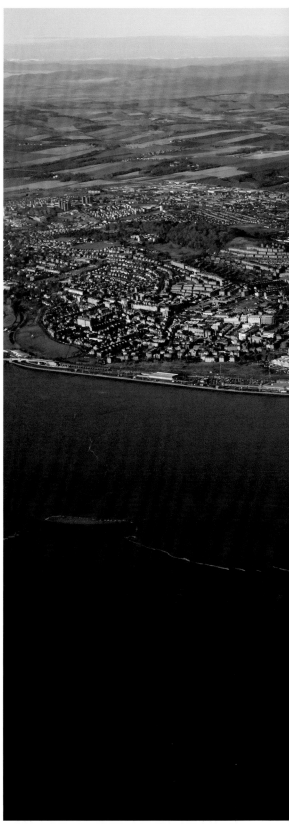

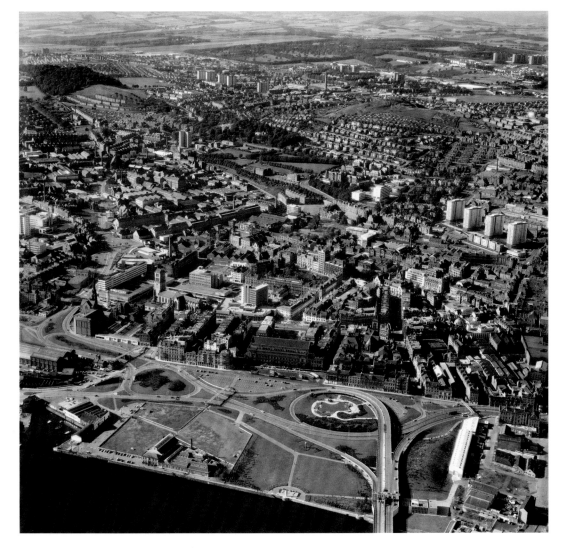

Where once the Caird Hall and Whitehall
Crescent had backed directly on to the Earl
Grey and King William IV Docks, the con-
struction of the Tay Road Bridge between 1963
and 1966 saw the old harbours buried beneath
a great expanse of concrete as the new crossing
powered its way into the old centre of Dundee.
RCAHMS 2010 DP075766
AEROFILMS 1970 A207509

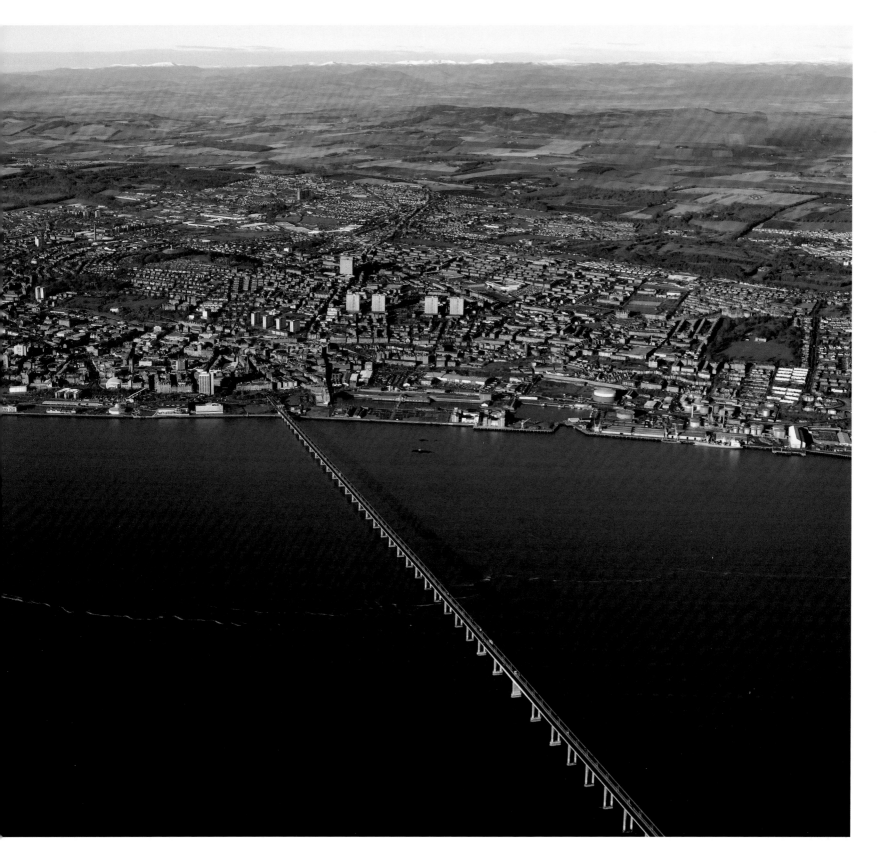

ABOVE
From a height of 38m at its Fife entry
point, the Tay Road Bridge descends on
a continuous gradient of 1 in 81 to enter
Dundee at just 9.7m above sea level.
A 2,250m-long stretch supported by
reinforced concrete columns, the bridge
was another symbol of the Modernist
revolution in urban planning.
RCAHMS 2004 DP007961

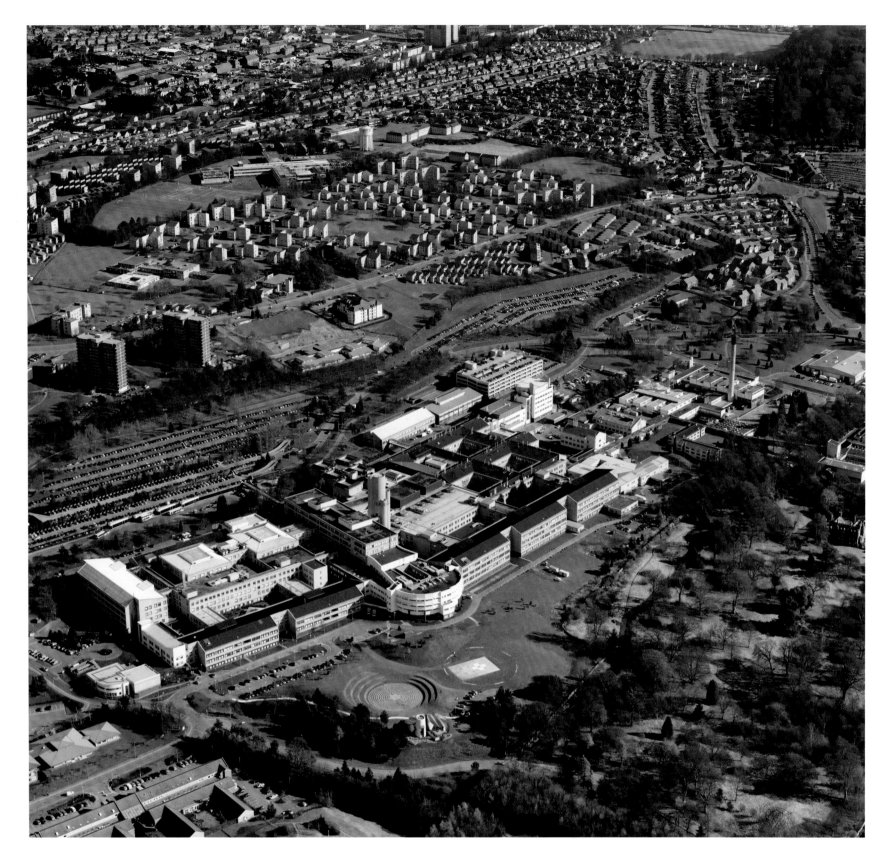

Completed in 1973, Ninewells Hospital was Britain's first twentieth century custom-built teaching hospital. In the foreground of this image is a twenty-first century architectural landmark – the award-winning Maggie's Cancer Care Centre – a small, lighthouse-like structure designed by world renowned architect Frank Gehry.

RCAHMS 2010 DP075691

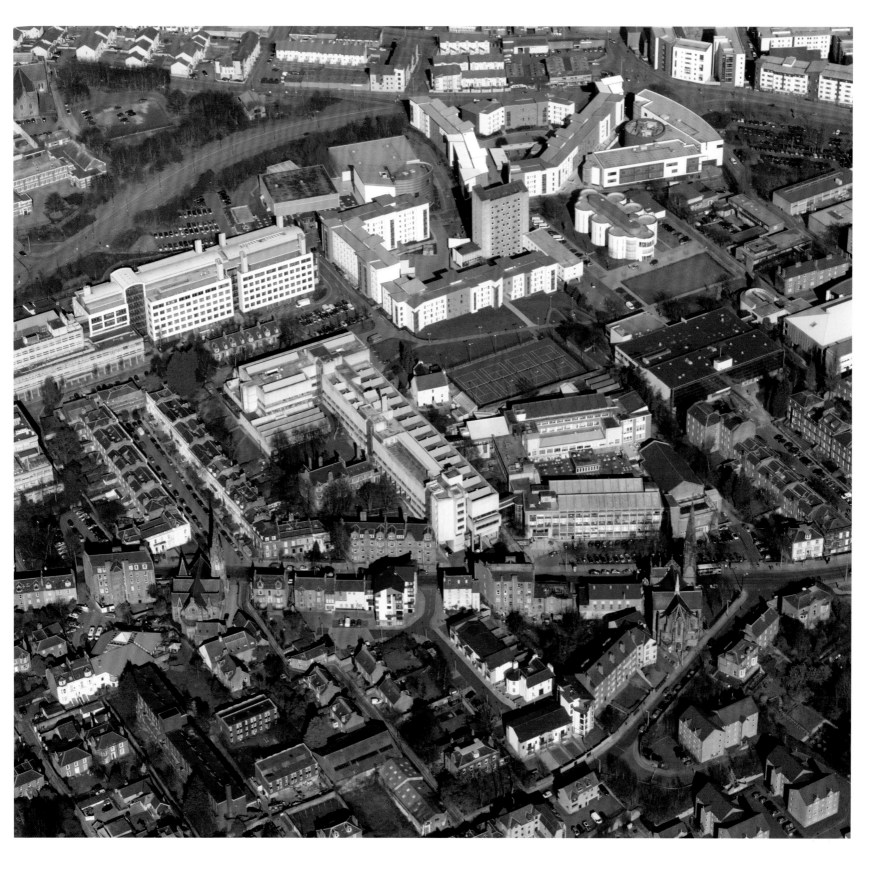

As modern Dundee refocuses as a city of education, innovation and design, it is a vibrant research and university community that is responsible for the reinvigoration of the old centre, creating a burgeoning cultural quarter among the rapidly disappearing fragments of the former jute heartland. Pictured here in the top left, the distinctive Dalhousie Building – designed by Campbell and Arnott in 2007 – marks the northern gateway to the campus, while the Duncan of Jordanstone College of Art and Design dominates the centre.

RCAHMS 2010 DP075807

Beyond the shorefront lies Dundee's
residential city, a sprawl of low-rise housing
and tower-block punctuations that reaches
out across a patchwork periphery towards
the distant, snow-capped Angus Hills.
Pictured here on the left, the volcanic
rise of Dundee Law – site of an Iron Age
hillfort and first incarnation of Dundee –
has seen the cityscape rise and fall across
the centuries, from renaissance port,
through manufacturing miasma, to
Modernist skyscapers. With the impend-
ing demolition of the Hilltown towers, yet
another new urban landscape will emerge
to define the city's coming century.

RCAHMS 2010 DP075786

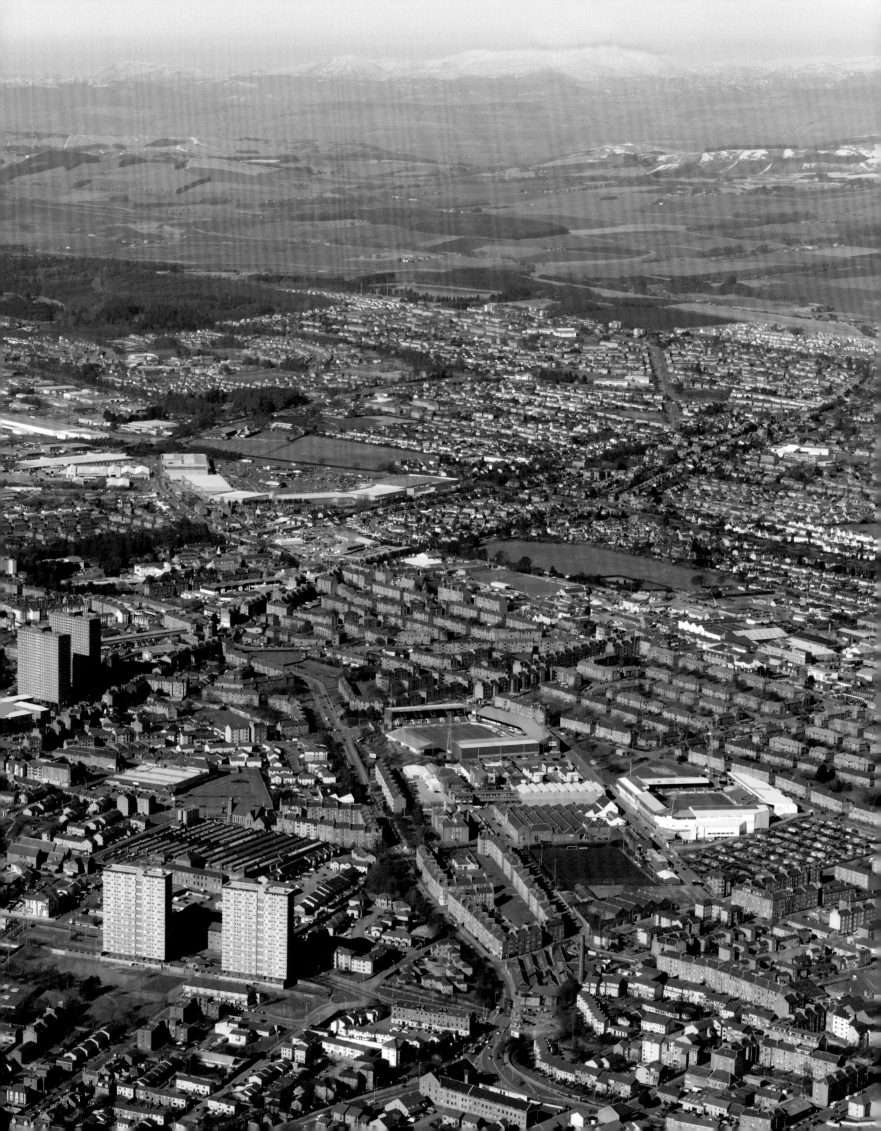

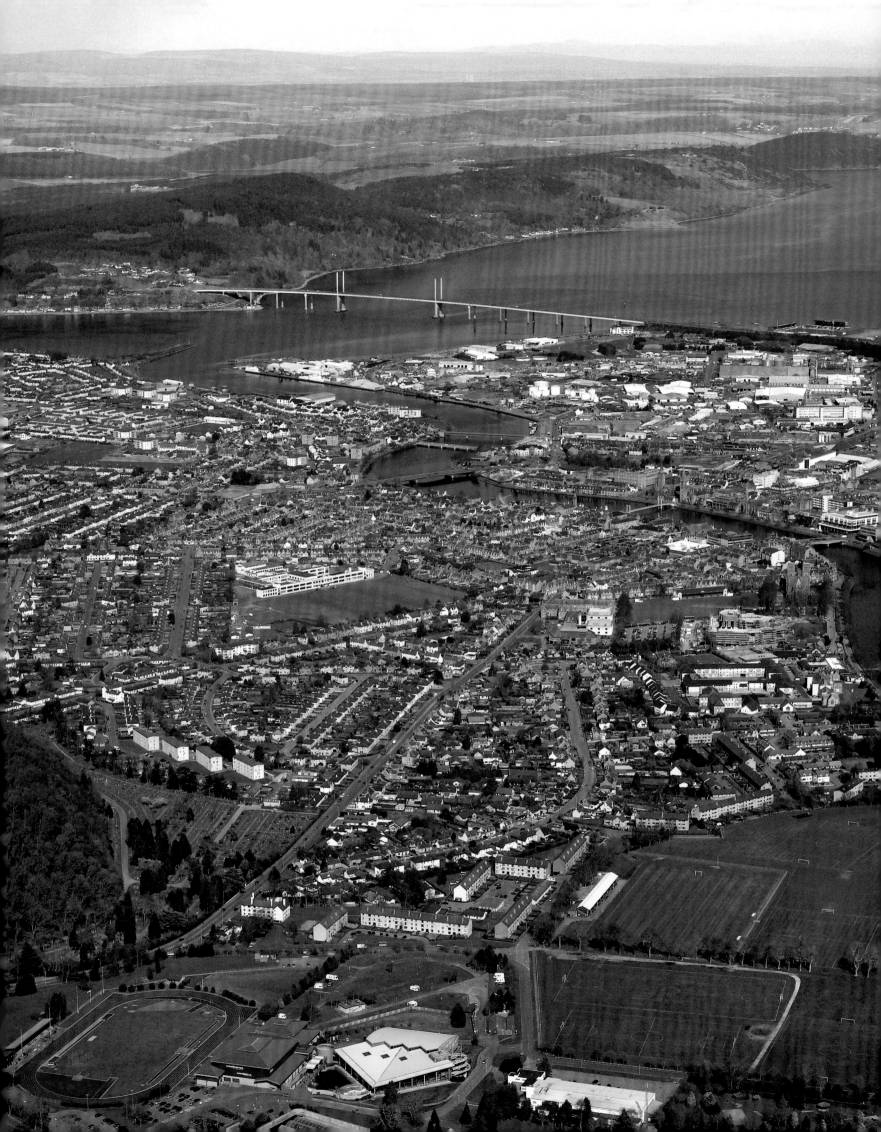

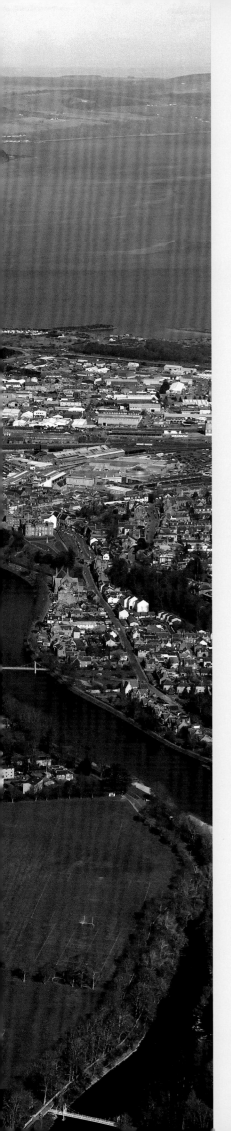

Inverness

A twin-engined Monospar, its propellers still wet with ceremonial whisky, rose from the grass of the Longman airstrip in Inverness, leaving behind a cheering crowd and the skirl of a bagpipe salute. Climbing into the foggy skies above the Moray Firth, Captain Ernest Fresson, an engineer and former pilot in the Royal Flying Corps, banked his aircraft northwards to Wick and Kirkwall. It was Tuesday 8 May 1933, and, two years after Fresson had toured his 'aerial circus' around the north of Scotland – combining stunt flying with five-minute joyrides for paying spectators – the first-ever scheduled passenger air service in the Highlands was embarking on its maiden flight. Fresson had discovered the region's best routes and landing sites while travelling in his airshow's Gypsy Moth and, with support from local motor engineers Macrae & Dick, and *The Scotsman* newspaper, who had agreed a contract for delivery of same-day editions to Orkney, he launched 'Highland Airways'.

The Lord Provost's wife smashed a whisky bottle on Fresson's four-passenger Monospar to christen it *Inverness*, and praised the airplane as "a mode of transport which brings the remotest parts of the country to our door". Aviation was revolutionising the communication networks of the Highlands. A year after this inaugural flight, Fresson established Britain's first domestic airmail delivery and followed this in 1935 with the north of Scotland's first air ambulance, insisting on piloting the most dangerous missions himself. After just four years, Highland Airways was flying to and from Inverness, Orkney, Wick, Shetland, Aberdeen, Perth and Glasgow, and had carried over 18,000 passengers.

Fresson, like many before him, had recognised the merits of Inverness as a transport hub and staging post for travelling to and from the distant reaches of northern Scotland. Enjoying sheltered anchorage at the mouth of the River Ness and commanding the north entrance to the Great Glen and the route from Moray to the fertile lands of the Aird, it had assumed major strategic significance since the Middle Ages. The hill now occupied by William Burn's sandstone Sheriff Court was the site of a royal castle from at least the eleventh century, with links to famous episodes in Scottish history from Macbeth's supposed murder of Duncan, to Cromwell's occupation and the Jacobite Rebellion. Made a royal burgh by David I in the twelfth century, the town first developed on the east bank of the Ness, stretching from the castle to the High Street and Church Street with today's Academy Street following the line of the old defensive wall.

A prosperous centre for local and foreign trade, Inverness was quick to take on the role of capital of the Highlands, laying down its first, faint urban footprints among the rural landscape. For a long time a stopping off point for Scotland's intricate network of drovers' roads, the markets of the town grew in size and importance as the industrial revolution brought increased commercialism to agricultural trade. Writing of his work in the Highlands in the early nineteenth century, the road

engineer Joseph Mitchell recalled the spectacle of the great sheep and wool market of Inverness, first held in 1817. "Here you see the portly figure of a wool-stapler of Huddersfield and Leeds; beside him the intelligent Liverpool merchant, or the shrewd woollen manufacturer of Aberdeen or Bannockburn. The burly south-country feeder stands at the street corner in deep conversation, about to strike a bargain with that sharp, lynx-eyed, red-haired little man who is the largest farmer in the North … There are small farmers, clad in homespun tweed of various colours, the real aborigines of the country, tall, stout, athletic fellows, some in kilts, with their plaids carelessly thrown over their shoulders … This market is perhaps the most singular in Great Britain."

By this time a major drive was underway to improve transport links across the often unforgiving Highland terrain. Thomas Telford's plan to connect east and west Scotland through Loch Lochy, Loch Oich and Loch Ness was a colossal undertaking, and brought civil engineering to the region on a heroic scale. The east end of Telford's great Caledonian Canal was built between the Beauly Firth and Loch Ness over a period of 15 years from 1803. To accommodate the engineers, large sandstone houses were constructed as a terrace – now known as Telford Street – near the canal's exit at Clachnaharry, with the area between the canal and Inverness gradually filling with housing over the next 100 years.

Expansion accelerated after the arrival of the railway in the mid nineteenth century, and estates of large villas grew behind the castle and outside the old burgh boundary. What it also brought was a new breed of traveller, the affluent visitor who would sustain the local economy for centuries to come – the tourist. Inspired by the works of Walter Scott, and encouraged by the ease of affordable transport, the Victorians reinvented the Highland landscape as a brooding, romantic canvas, and came to prize travelling through evocative scenery as an end in itself.

Far away from the smoky crush of the southern cities, Inverness understood its value to the world's newest industry of leisure. A century and a half on – and granted city status as part of the millennium celebrations – it remains a favourite of the tourist market, receiving over one million visitors each year. While housing continues its steady spread across the river plain, and the Kessock Bridge links the city to the Black Isle, developments like Eden Court Theatre create a focal point for the north of Scotland's art and culture. Modern Inverness thrives as an urban gateway, a city portal linking the past and the present. Step through its door and beyond awaits a landscape sculpted and refined by the relentless architecture of time – the Highlands of history and myth.

PREVIOUS PAGES
The urban gateway to a north Highland landscape, the city of Inverness spreads across the area where the River Ness, Beauly Firth and Moray Firth meet.
RCAHMS 2007 DP024623

RIGHT
Linking the ancient town centre to the west bank of the river, the Ness Bridge has existed in one incarnation or another since the eleventh century. The earliest structures were wooden-built and were regularly destroyed by flood or war, and it wasn't until 1685 that the first stone bridge appeared. Surviving for over a century and a half, the river claimed it in 1849, and in 1855 a 'flood-proof' suspension bridge was built as a replacement. Its large masonry archway created an impressive entrance point to the old town, but, as the motorcar developed and traffic increased, this decorative feature created a chronic bottleneck and planners were forced to re-imagine the crossing once again. Pictured here in 1947, a new bridge is under construction alongside the nineteenth century span, while, further down the river, a temporary structure has been erected to allow the flow of traffic to continue.
RAF 1947 006-001-007-250-C

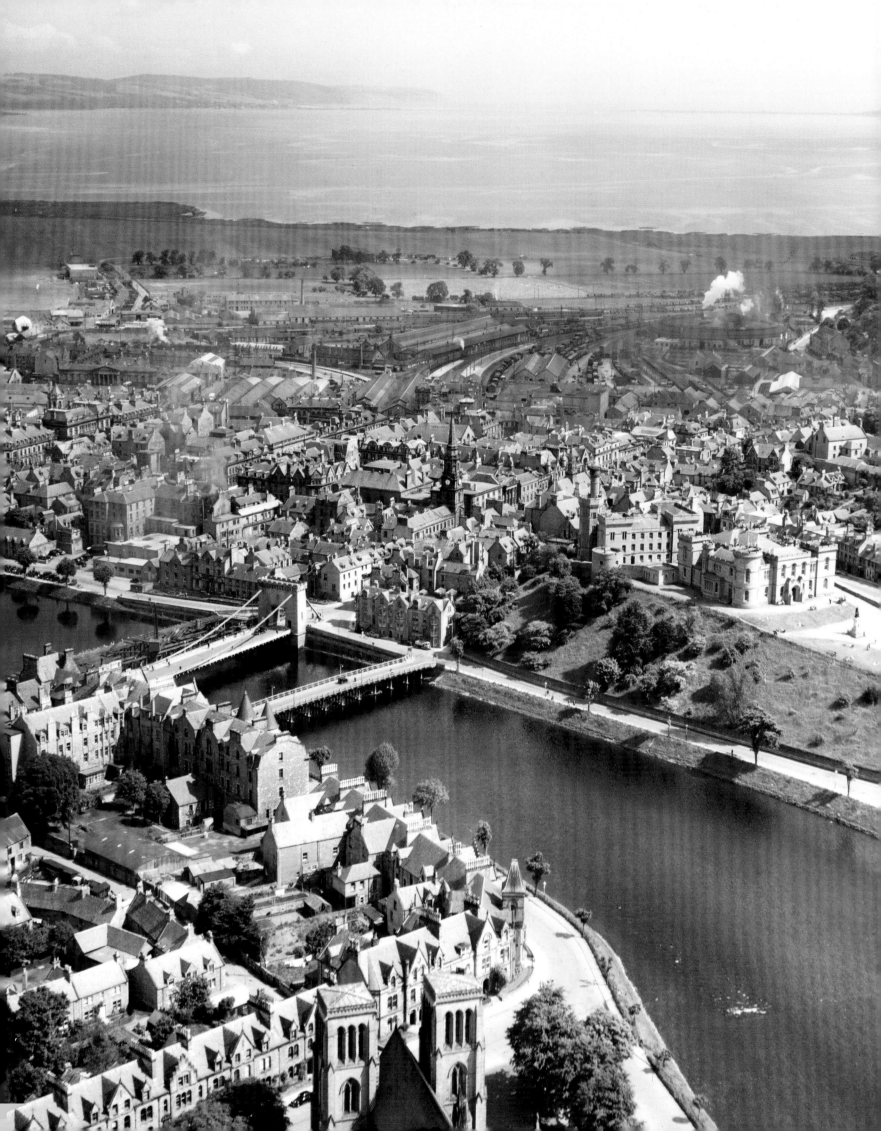

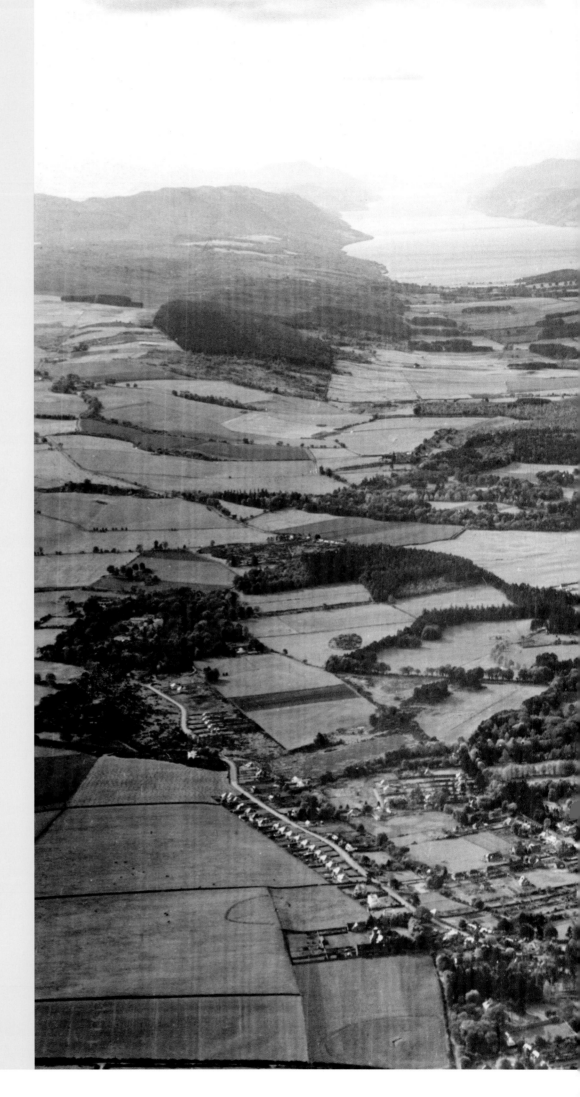

From the rugged funnel of the Great Glen, the river meanders out of the hazy expanse of Loch Ness and winds through fertile farmlands and the first, faint urban footprints of the town. Here Highland wilderness and human progress meet as, running alongside the natural bends of the river, the thin channel of the engineering marvel of the Caledonian Canal passes through the fringes of Inverness on the way to its eastern exit.

RAF 1942 006-003-000-447-C

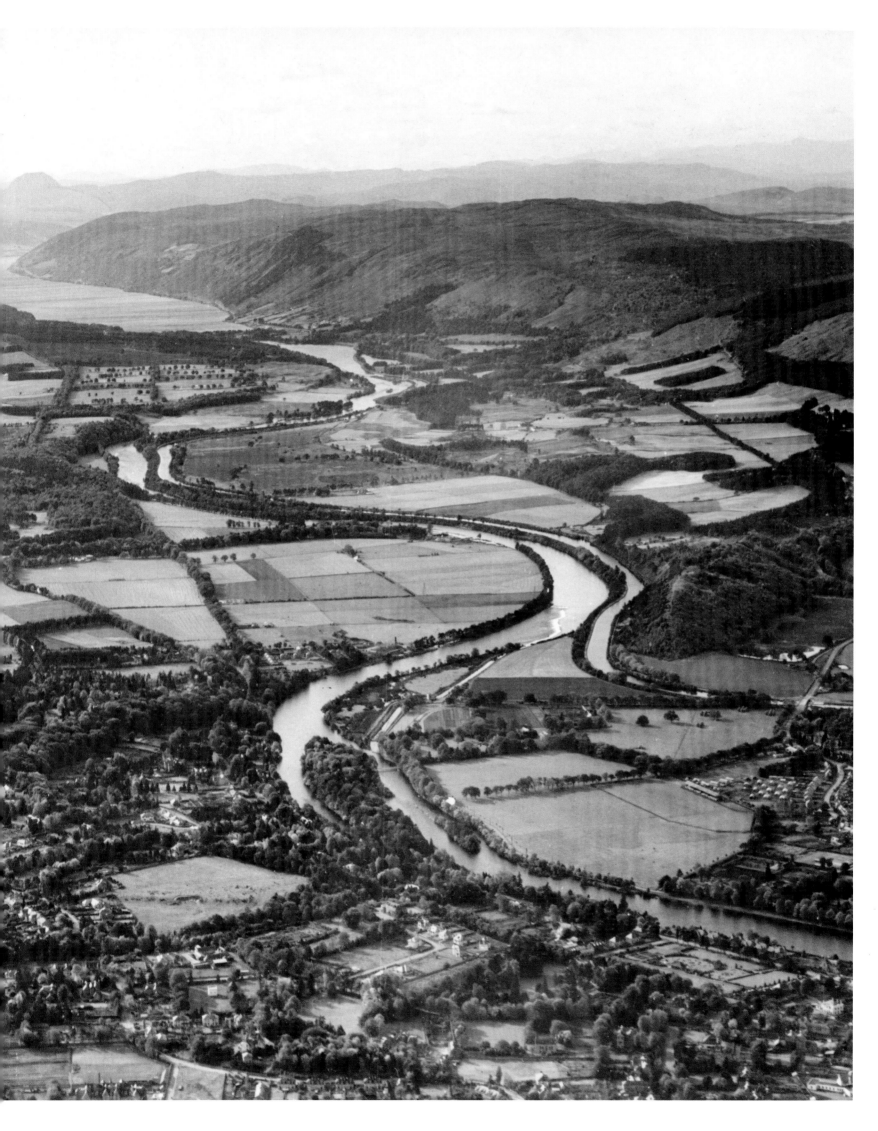

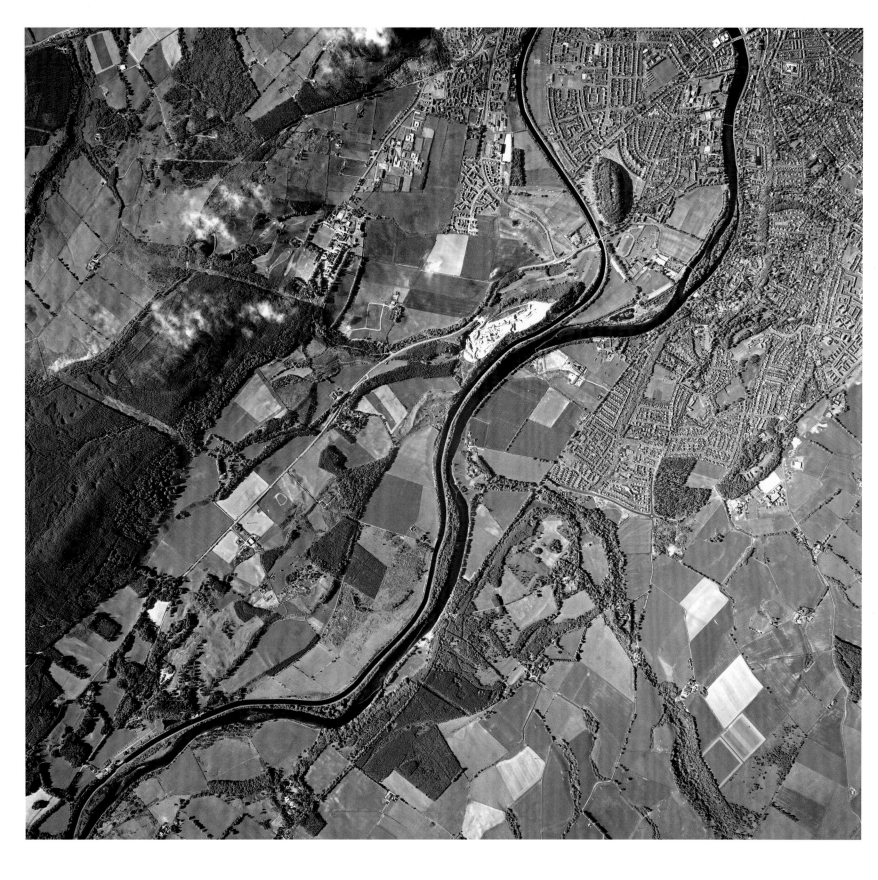

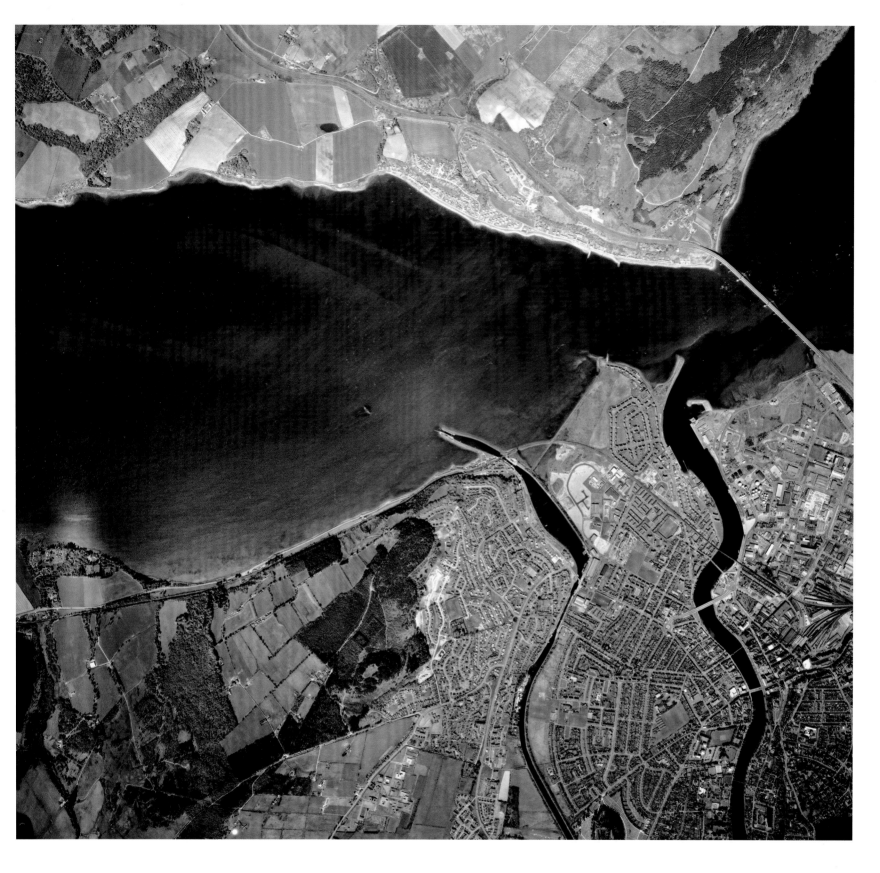

Two dark ribbons of water cut through the farmlands and floodplains of Inverness – one natural, the other man made. While the River Ness opens out into the Moray Firth, Thomas Telford's Caledonian Canal bends back to the Beauly Firth, its eastern exit marked by two thin pincers of man-made land. Along the banks of canal and river, housing has proliferated, and in the 'island' created where the two waterways diverge, urban development is total.

ASS 1988 006-002-007-293-C
ASS 1988 006-002-002-287-C

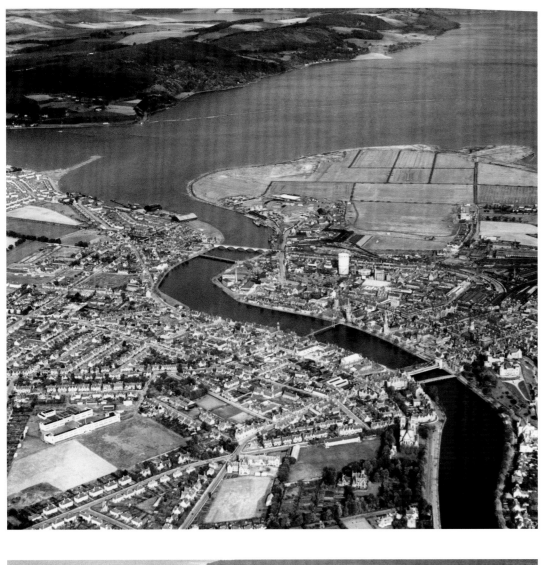

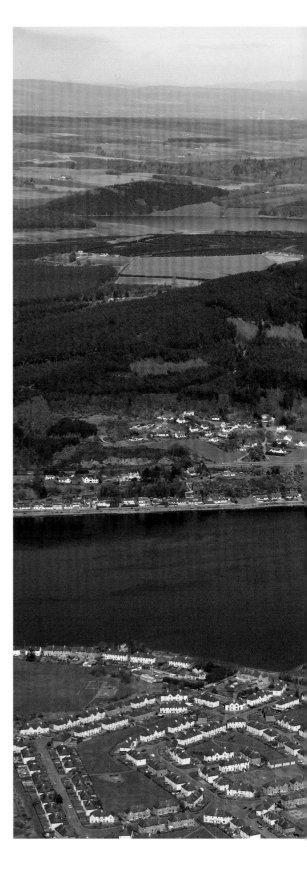

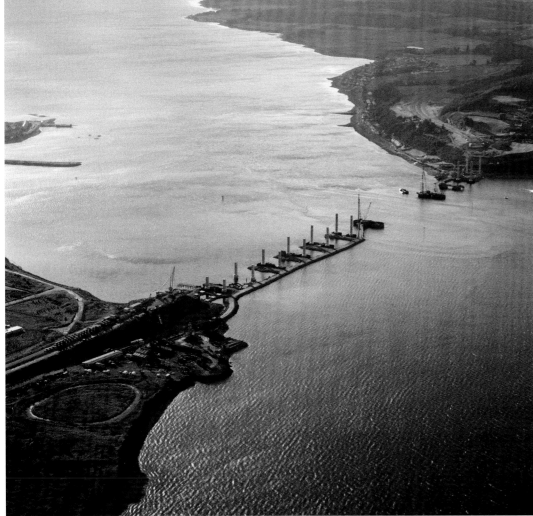

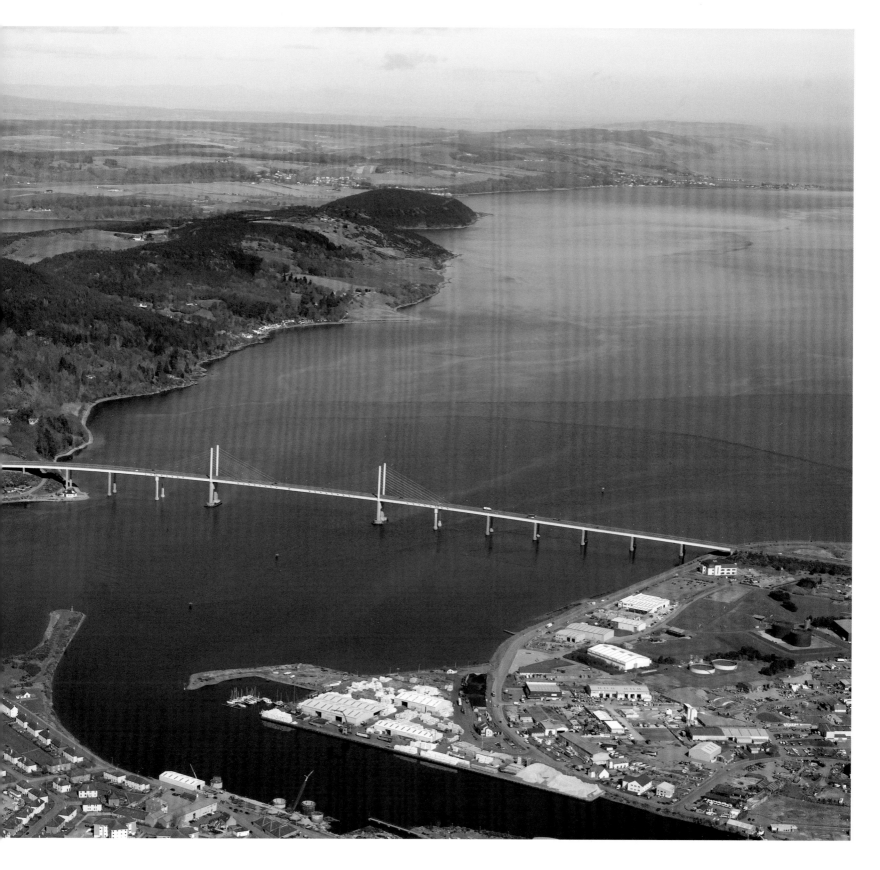

Seen here in 1942, a patchwork of fields covers the area where the Kessock Bridge now begins. At this time North Kessock and the Black Isle were accessible only by ferry – a crossing which had been on offer since the 1400s – or through a time-consuming round-trip of over 20 miles.

RAF 1942 006-003-000-448-C

BOTTOM LEFT

Work started on the Kessock Bridge in 1976 and was completed in 1982. The finished structure features spiral-strand steel cables strung like harp strings between the uprights of the 240m central span and the road deck below. Pictured here in 1979, the piers supporting the approaches are advancing towards the main span.

AEROFILMS 1979 387337

ABOVE

Stretching out across the wide mouth of the Moray Firth, from the air the Kessock Bridge appears as a thin, delicate strip. Yet its 1,052m of continuous steel superstructure have been one of the major factors in the growth of Inverness over the past 30 years.

RCAHMS 2007 DP024672

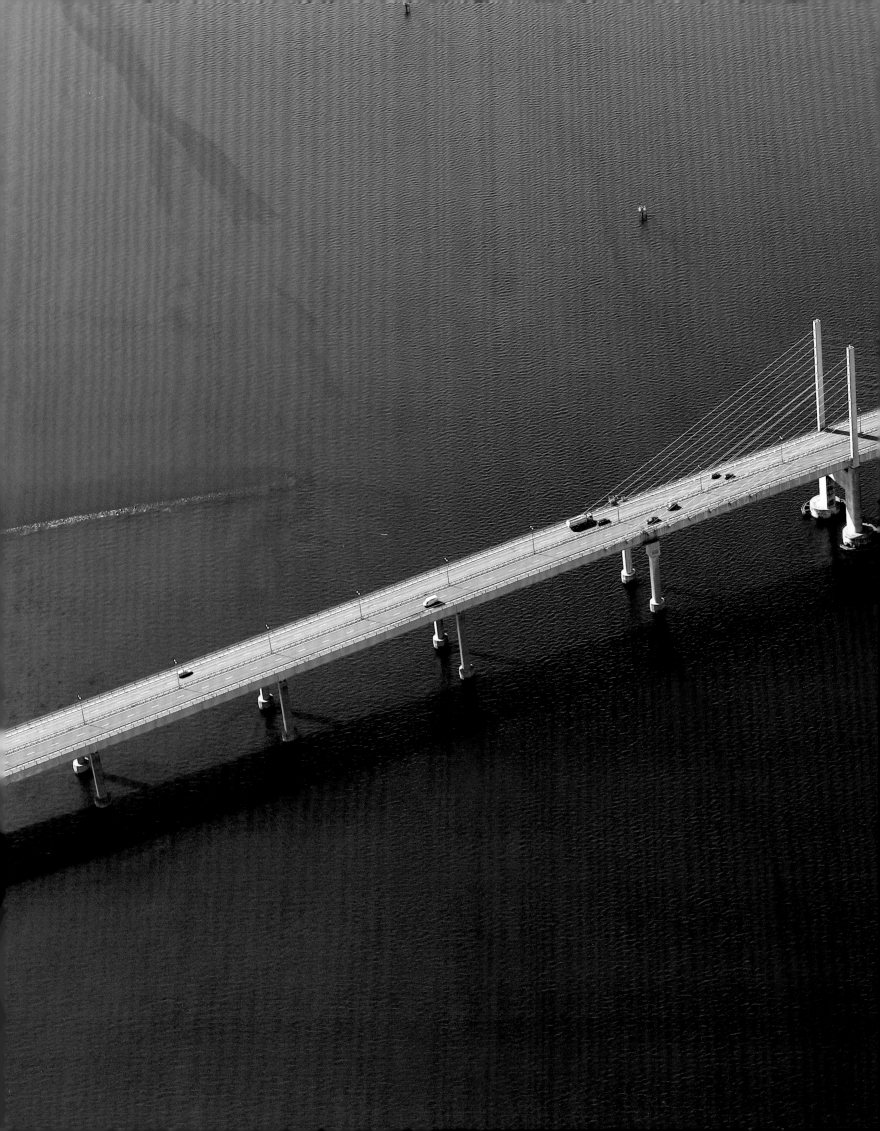

Modelled on the Rees Bridge – a crossing of the Rhine near Dusseldorf – at the time of construction the Kessock was the largest cable-stayed bridge in Europe and the only one of its kind in Britain. Carrying the A9 trunk road from the Lowlands and linking it for the first time to the northern Highlands, the bridge was essential to the long-term development of Inverness – a modern statement of the city's long established role as gateway and transport hub.

RCAHMS 2007 DP024653

LEFT

Following the geological fault line of the Great Glen almost directly south west to north east – from Fort William to Inverness – Thomas Telford's Caledonian Canal is a spectacular collaboration of natural landscape and engineering ingenuity. Linking the Highland lochs of Loch Lochy, Loch Oich and Loch Ness to each other and the sea, of the route's 62 miles, only around a third is man made. Yet over a period of 15 years from 1803 to 1818, an incredible scale of work was required to tame rugged and often remote landscapes. Here at Muirtown, four of the Canal's 29 locks control the waterway's descent through the Ness flood-plain to its eastern exit in the Beauly Firth.

RCAHMS 2007 DP024670

RIGHT

While the natural bend of the River Ness curves through the centre of the city, here at Clachnaharry the Caledonian Canal expands into the artificial bow of the Muirtown basin before exiting into the Firth through the twin spits of reclaimed land forming its most north easterly lock. From first residences built alongside the works to house engineering contractors and their families, to today's suburban sprawl, the Canal has been a catalyst for urban growth in Inverness.

RCAHMS 2007 DP024657

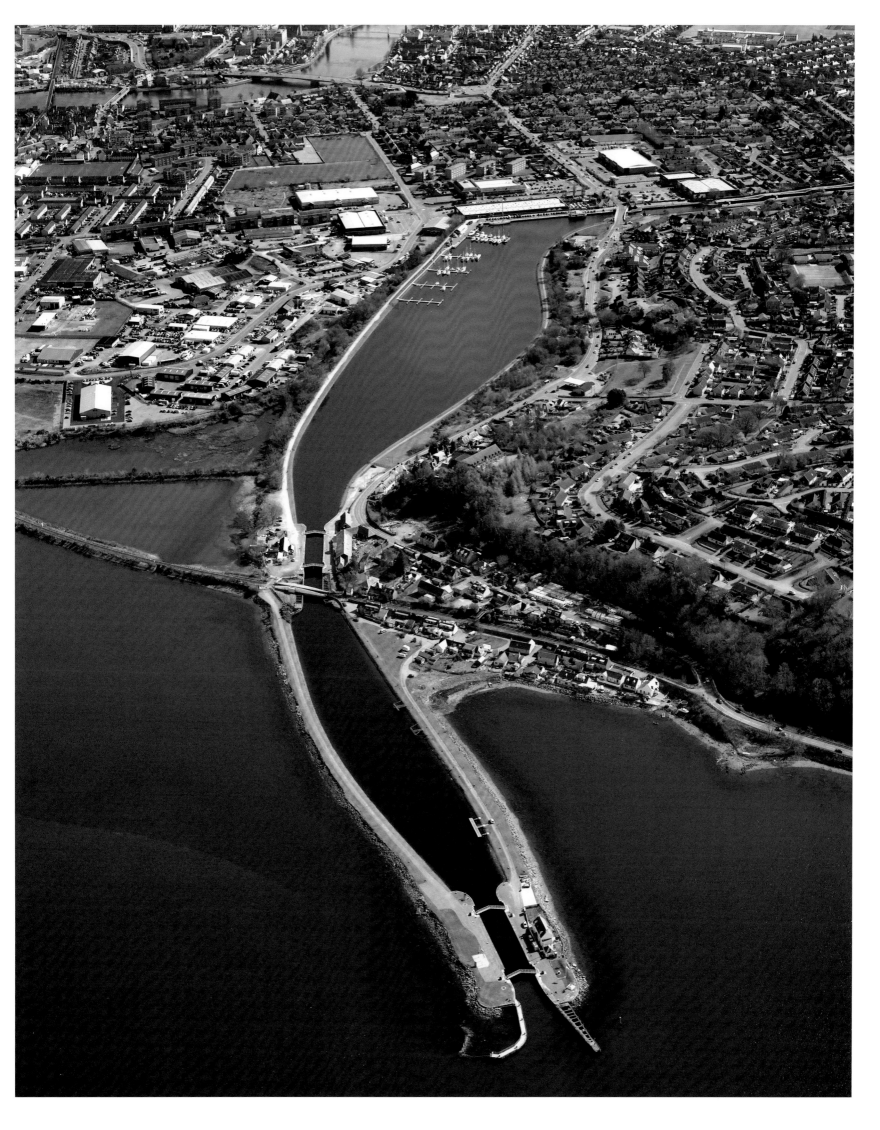

The pattern of old Inverness can be faintly traced here as a triangular wedge receding from the Castle to a point at the Old High Kirk. From the wide expanses of modern roofs, it is clear how little of the layout of the medieval city remains.

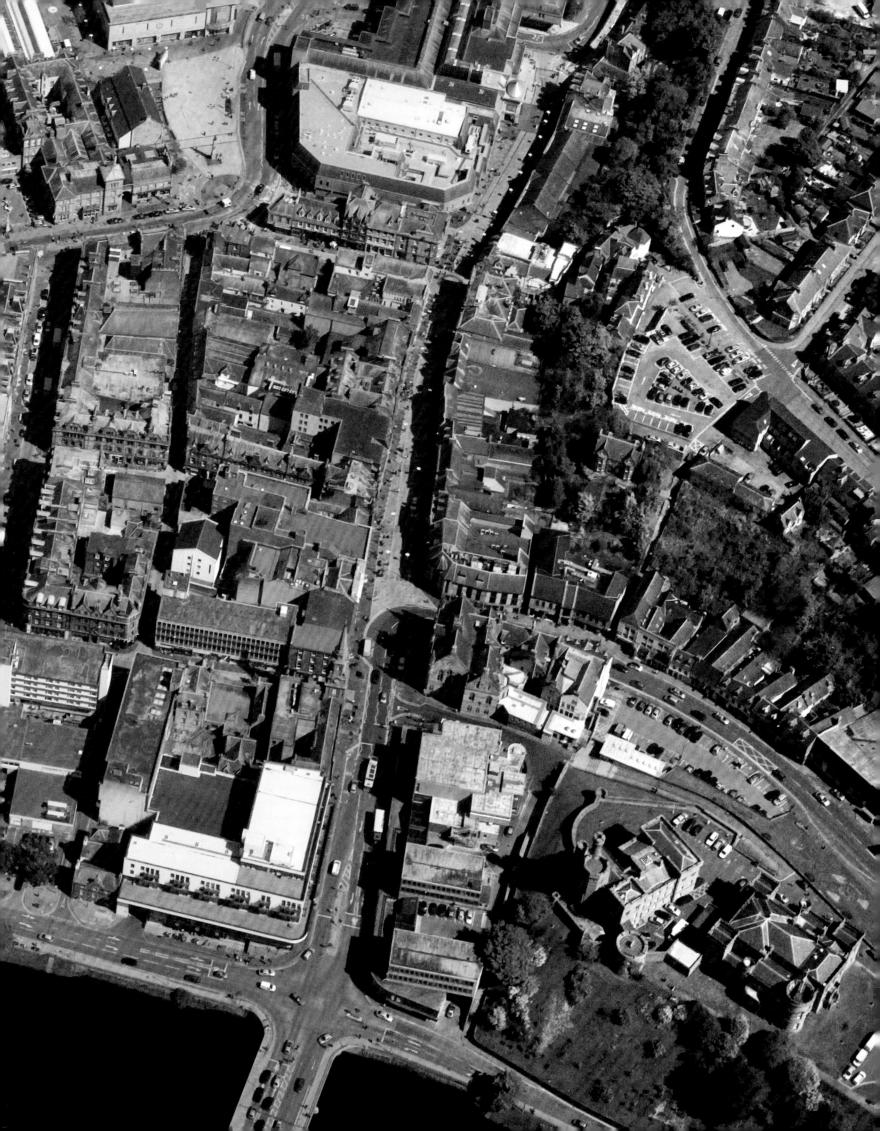

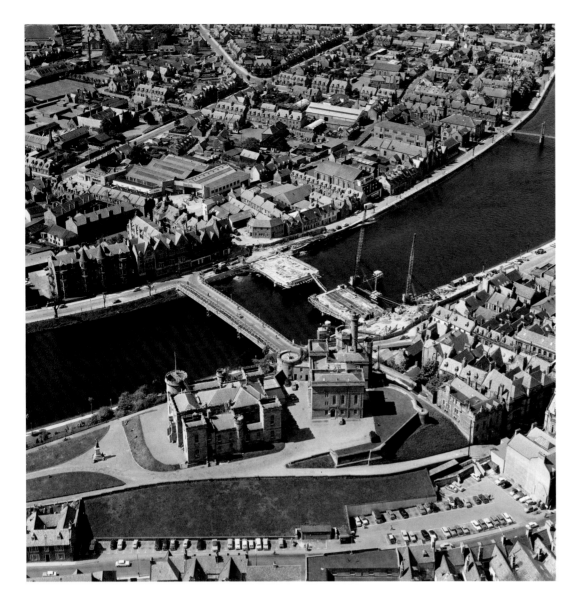

TOP LEFT

With the blocky appearance of a toy fort, David Bryce's ashlar-fronted, early nineteenth century Sheriff Court sits on a steep hill high above the east bank of the River Ness. Site of a castle in medieval times, this was the city's origin point, with the first settlement gradually expanding below the fortification to the north. In the background, the 1855 Ness Bridge has been demolished, and, with the new three-lane road bridge only just nearing completion, the temporary crossing remains in place.

AEROFILMS 1961 A88716

BOTTOM LEFT

Crossing the River Ness in the shadow of the Free North Church, the Greig Street suspension footbridge was built in 1881 by the Rose Street Foundry, the leading engineering firm in Inverness at the time. It was one of two built in the same year – the Infirmary footbridge was erected further downriver by Ness Ironworks.

AEROFILMS 1961 A88889

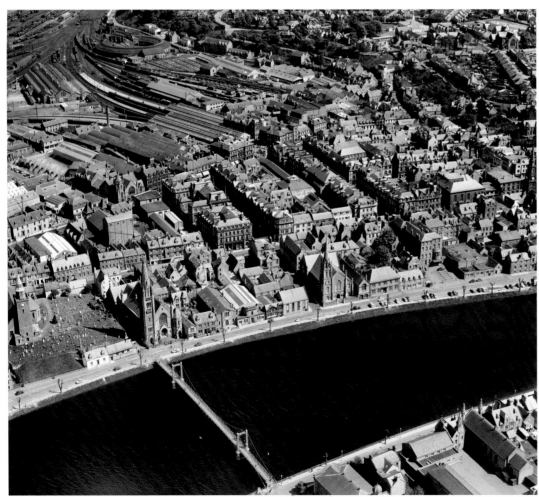

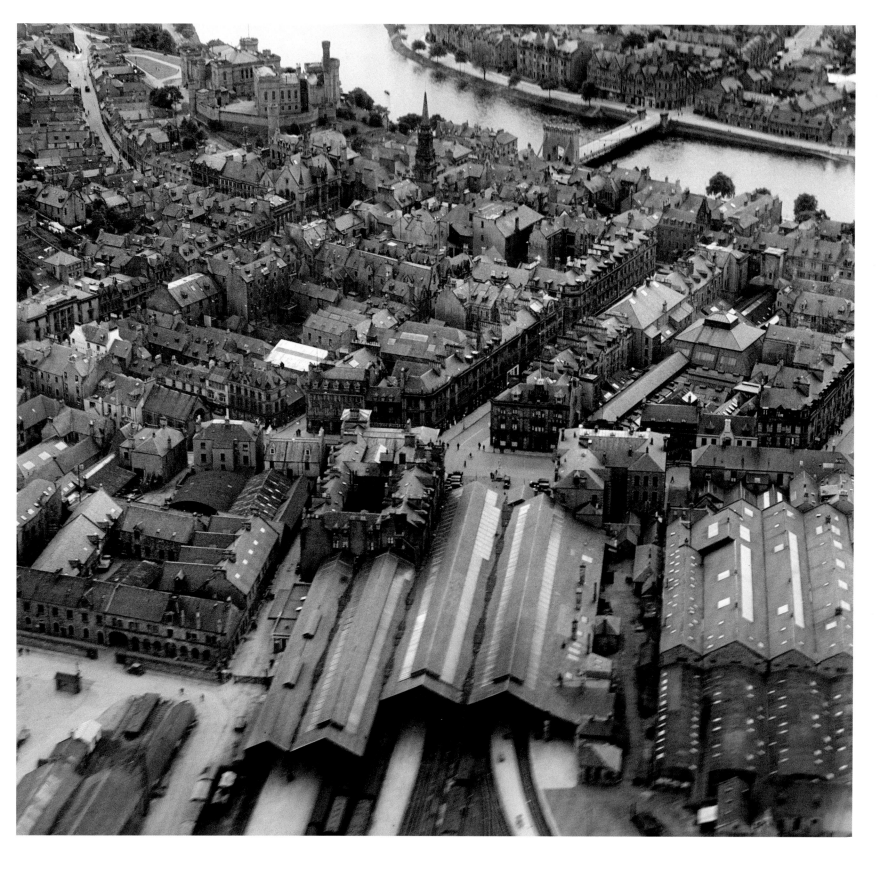

ABOVE

Pictured here in 1928, the roofs of Inverness railway station push against the tightly packed town centre. First opened in 1854 to service a route from Nairn, the station and the railway had – as with most towns and cities – a huge impact on the urban environment, driving iron lines through the landscape to meet in a sprawling, centrally located terminus. Almost directly opposite the station is the cast-iron and glass roof of the Market Hall, a large selling floor built in 1891 after the previous structure had been destroyed by fire.

AEROFILMS 1928 22140

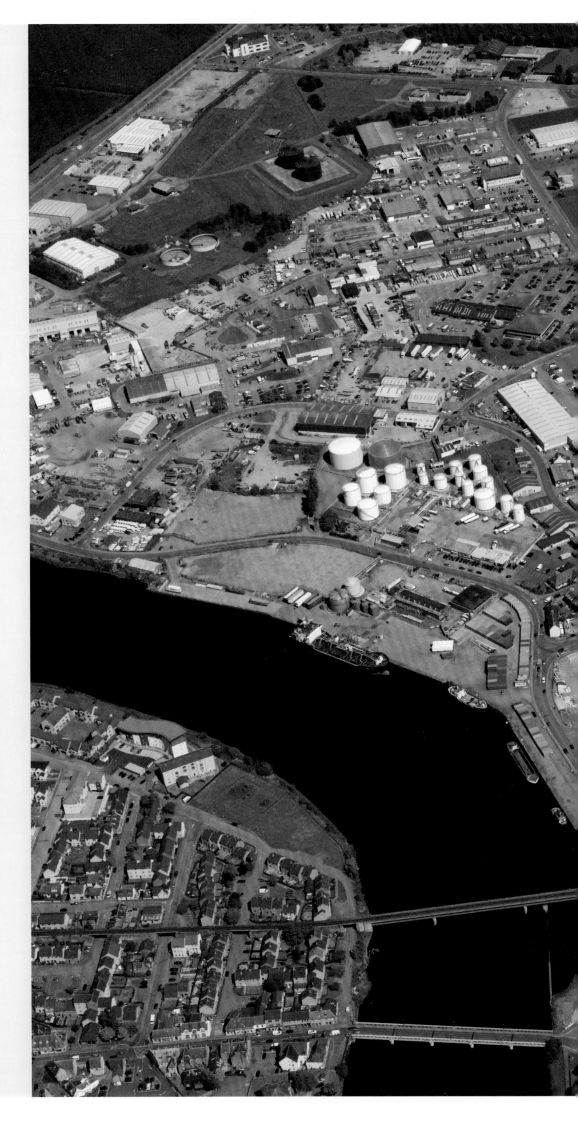

The open fields that once ran from the fringes of Inverness over the South Kessock peninsula are now completely subsumed by the jumbled, boxy units of a relentless industrial sprawl. Surrounded by the river on one side and a ring road on the other, the area is deliberately segregated from the residential districts of the city

RCAHMS 2009 DP074243

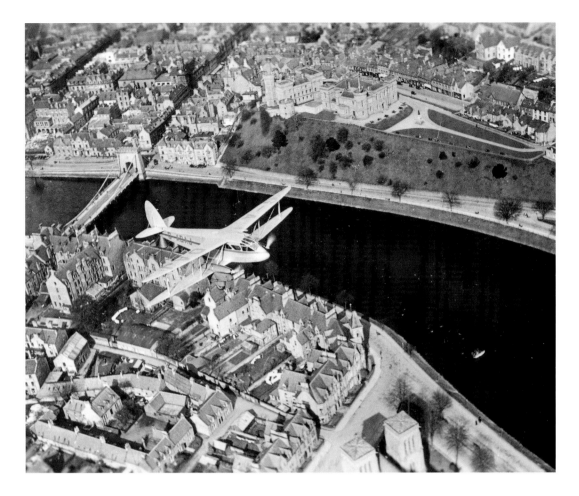

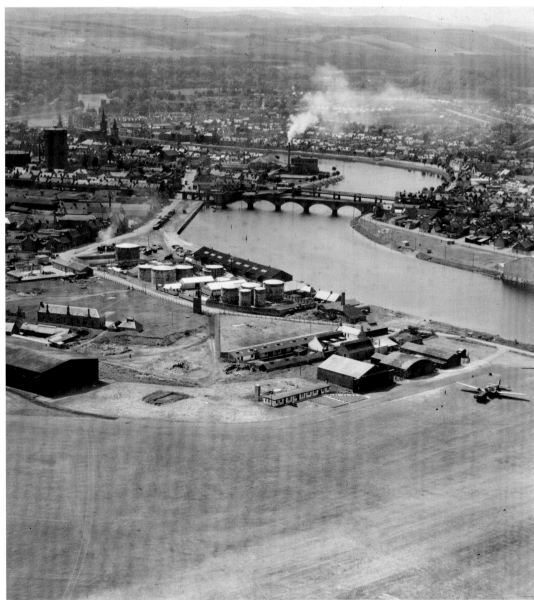

Captain Ernest Edmund Fresson – known as Ted – the 'Boys' Own' entrepreneur who set up and operated Highland Airways from Inverness from 1933, was also an enthusiastic amateur aerial photographer. Here, from his own plane, he captures his Highland airfleet's DH89 Dragon Rapide G-ADAJ mid-flight. Powered by two 200hp De Havilland Gipsy Queen air-cooled, in-line engines, the Dragon Rapide carried one pilot and six to eight passengers at a maximum speed of 157mph over a range of 570 miles.

The original Inverness Airport was situated on the grass runway of Longman airstrip on the immediate outskirts of the town centre. On 31 August 1947, only a month after this photograph was taken, the last civil flight operated out of Longman before the operational base of Inverness Airport moved to Dalcross. Although some of the original hangars still remain, the former airfield is now the site of a densely packed industrial estate.

Detached and semi-detached villas with long, thin strips of garden march out from the city centre. With such a small central core, in Inverness the transition from medieval old town to landscaped suburbia occurred over a very short distance.

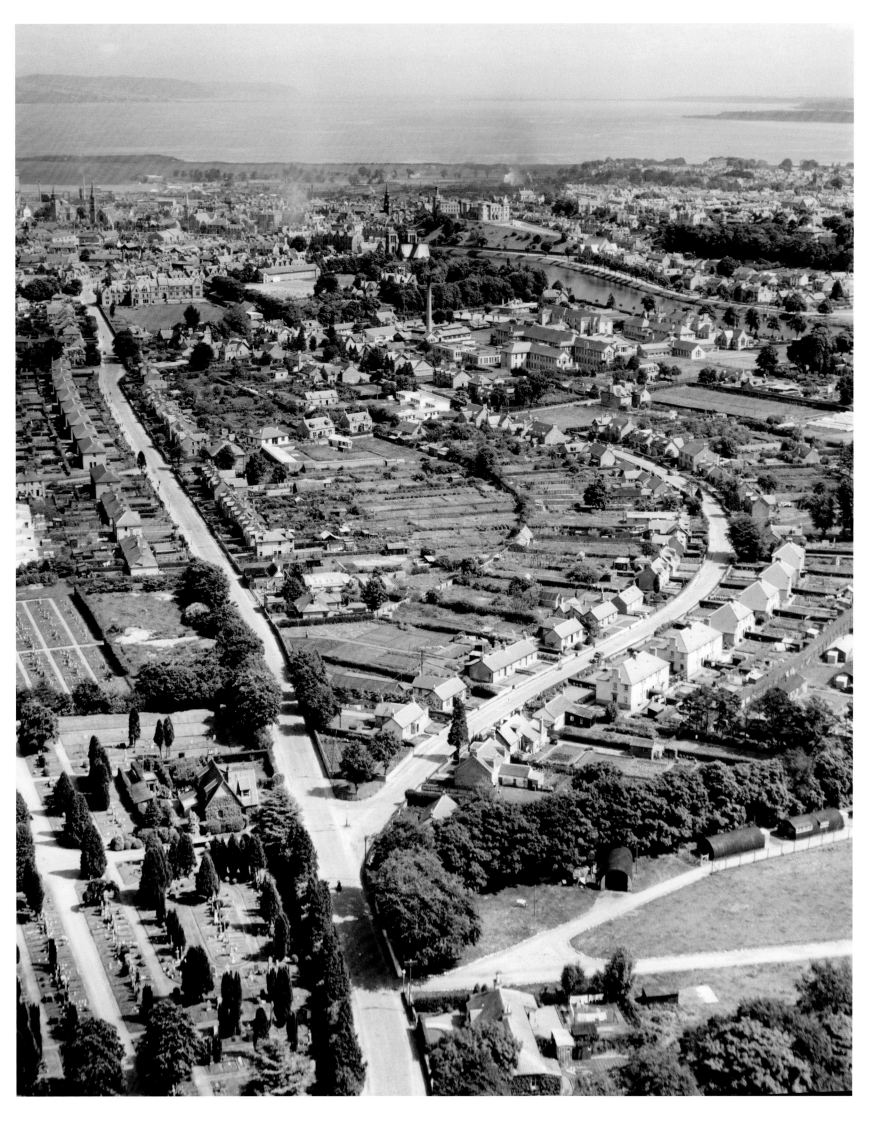

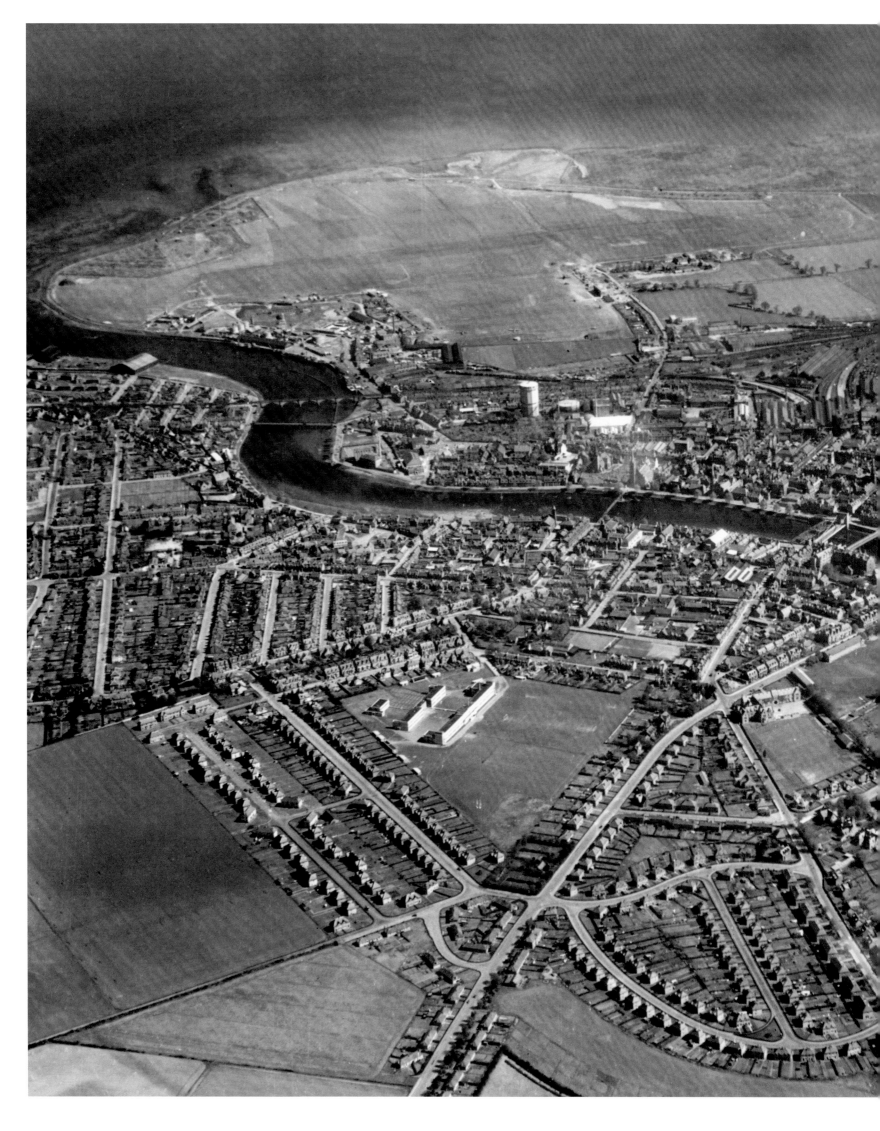

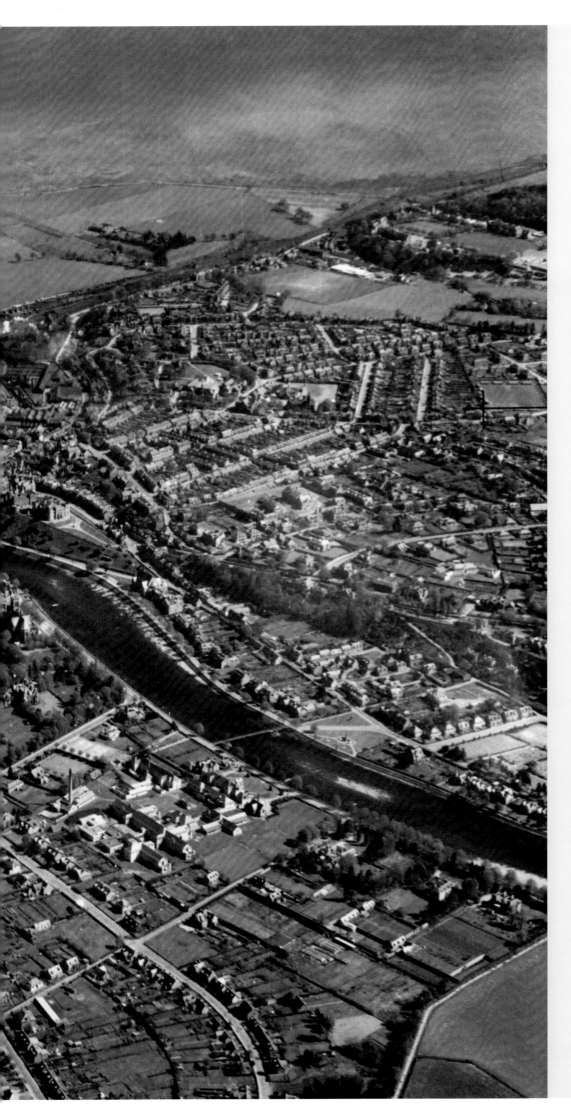

Although Inverness had grown and developed primarily on the eastern bank of the river, in the nineteenth century the construction near Clachnaharry of contractors' villas for Caledonian Canal engineers provided the impetus for the city to spread out across its western floodplain. Pictured here in 1942, brand-new rows of detached suburban housing arc out in planned patterns across the fields.

RAF 1942 006-003-000-338-C

Slowly but surely, modern Inverness reaches out into the surrounding landscape, its surburbs inching towards the wide mouth of Loch Ness. Here the city as gateway and borderland is most vivid, as the massed ranks of tiny houses fade out beneath the implacable, furrowed brow of the Great Glen's looming mountains.

RCAHMS 2007 DP024919

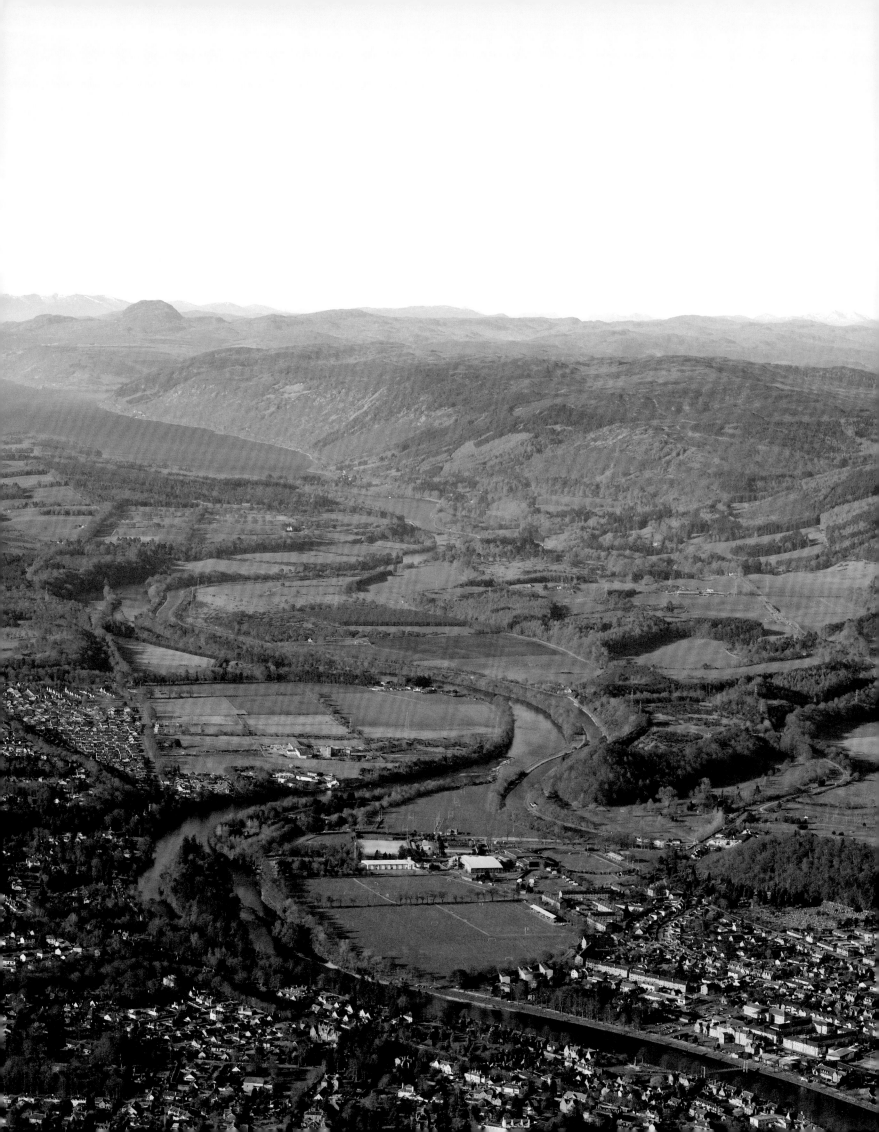

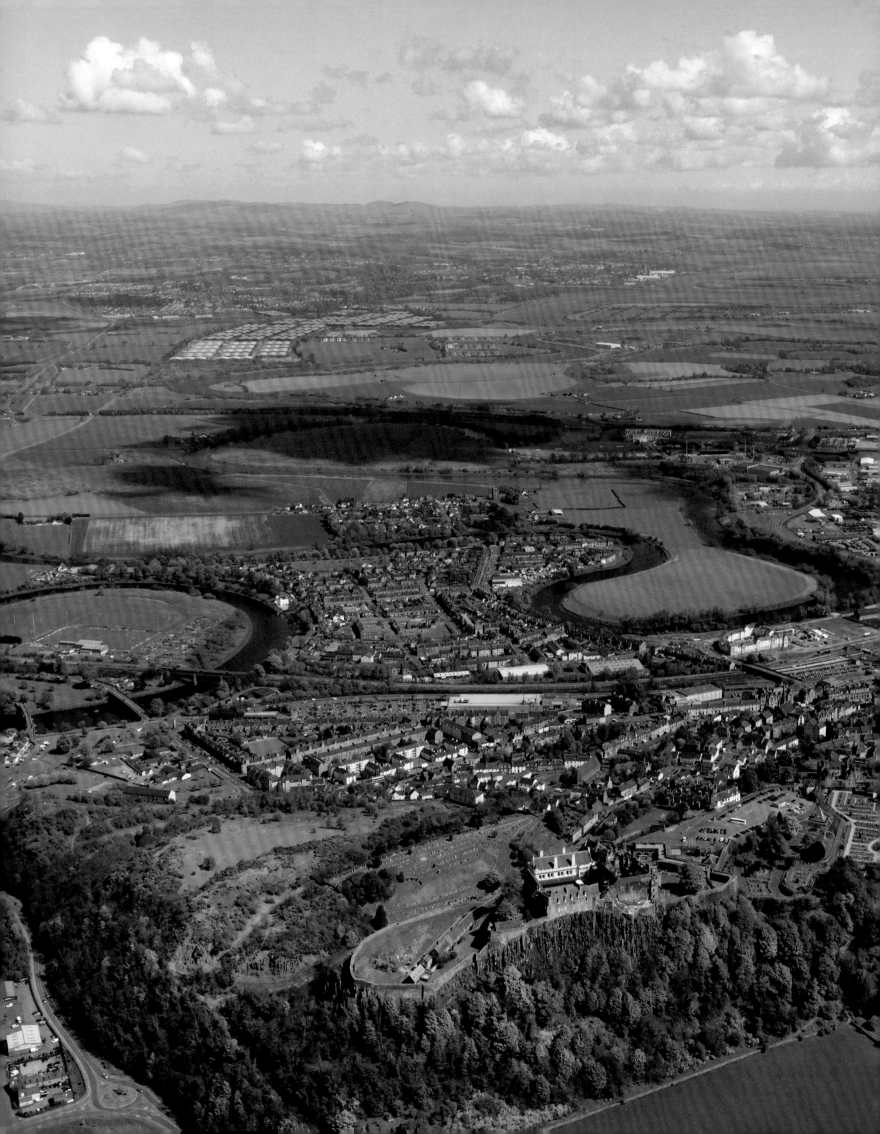

Stirling

In September 1507, beneath a leaden autumn sky, John Damian de Falcius stood high up on the west parapet of Stirling Castle, an elaborate, winged-contraption made of hen feathers strapped to his back. Damian was Scotland's Alchemist Royal, a French physician and inventor who had charmed James IV with promises of transforming base metals into gold. As a delegation of the court prepared to set out on a diplomatic mission to Paris, Damian revealed his remarkable construction to the King. The pair of artificial wings would, he claimed, allow him to soar from the castle walls southward to France and arrive long before the ambassadorial party. From a narrow rampart's edge, above a near 80ft cliff-drop, he launched himself into the skies. Although accounts of the flight differ, there is agreement on the final outcome – Damian landed in a nearby dung heap, breaking his leg. The fault, according to the alchemist, was in the feathers, because hens are birds that "covet the middens and not the skies". William Dunbar, court poet and Damian's biggest critic, gleefully recorded the episode in a long satirical verse. Yet today historians are not so sure that Damian was a failure. In reaching a midden which has been variously estimated as lying up to half a mile distant from the castle, the so called 'French leech' and court charlatan may well have been the first man in history to fly.

The renaissance revolution saw the passions and imaginations of men like Damian indulged on the grandest scale. Cultural refinement and intellectual advancement became a competition, a battle for status between the rival houses of royal Europe. No one wanted to be left behind, least of all the ambitious family that ruled Scotland – the Stewarts. In the mid sixteenth century James V – father of Mary Queen of Scots and grandfather of the 'cradle' King, James VI – built a glorious renaissance palace in the centre of Stirling Castle. The first of its kind in Britain, this sumptuous architectural statement was a key aspect of the Stewart blueprint for a community of cosmopolitan cultural excellence, an advert to the world of Scottish sophistication.

The choice of Stirling was an obvious one. Sitting on a volcanic outcrop rising over the near impassable moss and marshes of the Forth floodplain, the castle was a crucial gateway, controlling the only major route linking the Highlands and Lowlands of Scotland. Travellers, merchants, politicians and armies journeying north or south had to use the only main road – a partially paved track – and the only bridge, which left no option but to pass directly through Stirling itself. This accident of topography, over 350 million years in the making, turned the small fortress town into a focal point for intrigue and bloodshed. It was the backdrop for some of the most significant battles in the nation's history, from Bannockburn to the Jacobite Rebellion, and the stage for vicious scenes of internecine power struggle.

Stirling's development was dominated by this strategic significance. As with Edinburgh, the old town spread out in the lee of the castle, with the broad splendour

of the market place, once the trading centre for the entire burgh, leading into a network of narrow streets running down the crag's short, steep tail. After the Union of the Crowns in 1603, the Stuarts deserted their former favourite residence, and the glories of the renaissance were left to fade into disuse and disrepair. It would be over 250 years before a new vanguard of patrons arrived to make their self-confident, imperious mark on Stirling – and such was their impact that they began the process of transforming the castle town to a city. At an incredible pace, serried ranks of detached and semi-detached stone villas created the spacious streets of Victoria Square, Clarendon Place and Queen's Road. Dominating the fringes of the old medieval market town, these were the houses of Glasgow and Edinburgh industrialists and entrepreneurs, opulent Victorian suburbs that announced the arrival of the commuter haven, the sleeper city, to the late nineteenth century.

In a town dominated and defined by its ancient monuments and its position as a travel hub, the arrival in 1967 of a striking arrangement of Modernist architecture helped break the mould. 350 years after James VI had promised to found a 'free college' in Stirling, the Scottish practice of Robert Matthew and Stirrat Johnson-Marshall created a bold, custom-designed campus for a new university, a pocket-city of rectangular low-rise buildings constructed specifically to integrate with the contours of the surrounding landscape. The first university to be established in Scotland since Edinburgh in 1583, its location beneath the Victorian-gothic tower of the National Wallace Monument was rich in symbolism – two architectural visions together, one a grand homage to the past, the other a Modernist exercise in function and form.

The ambitious plan to bring the renaissance to Stirling, first set in motion by James IV, now seems complete. Granted city status as part of Queen Elizabeth II's Golden Jubilee celebrations, Stirling's civic culture of learning, art and enlightenment continues to flourish. At the same time, half a millennium on, the spotlight is returning to the court of the Stewart Kings. The lavish restoration of the Castle's Royal Palace will see one of Scotland's greatest architectural and cultural treasures unveiled to a modern world. The bold family that once chased fame and fortune so ardently would have expected nothing less.

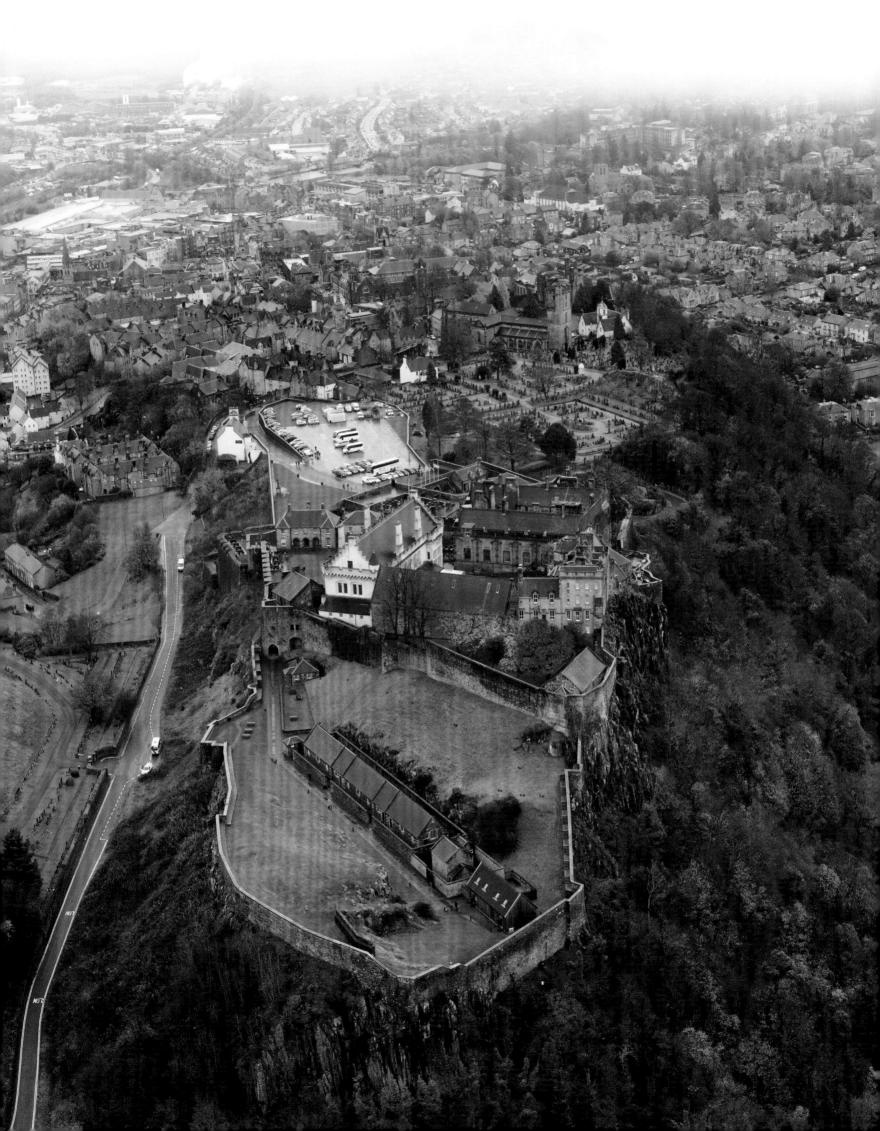

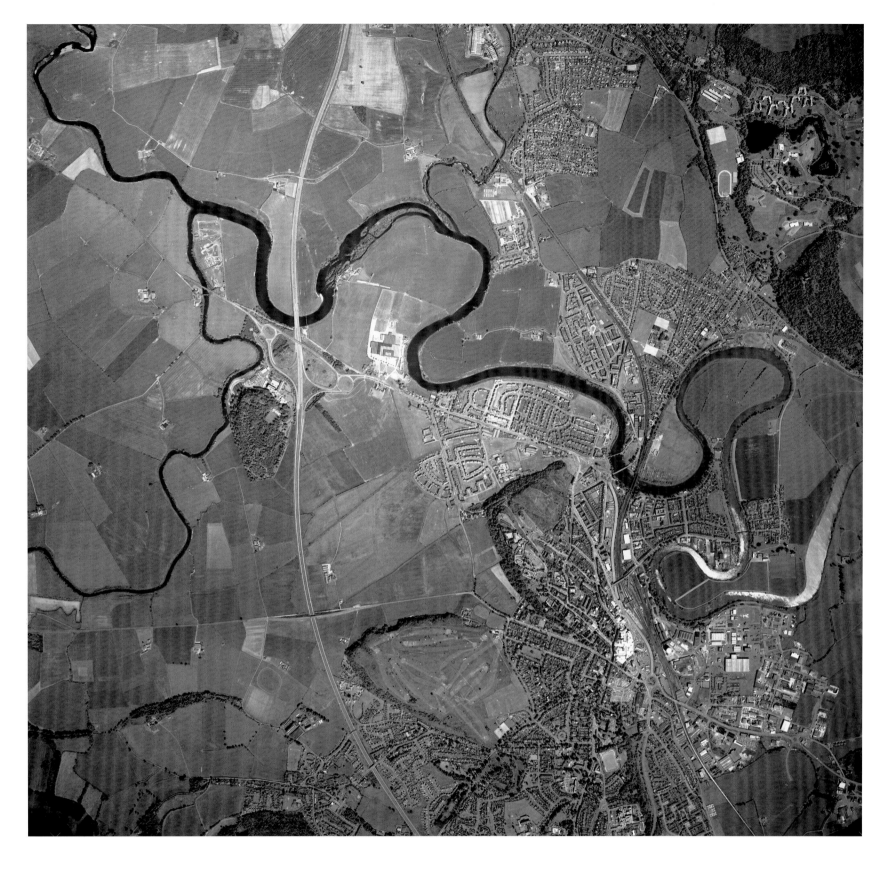

ABOVE

For a long time confined to the elevated wedge of the Castle Rock, the city of Stirling has gradually expanded over the once impassable marsh of the Forth floodplain. It was only 6,500 years ago that the Carse was first formed by the silting of the river estuary, and for millennia before that the area was beneath the waters of a sea that washed as far inland as modern day Aberfoyle. Remarkably, the remains of whales up to 25m long were found in the deep bogs and clays when the marsh was drained for agricultural use in the eighteenth and nineteenth centuries.

ASS 1988 006-002-001-192-C

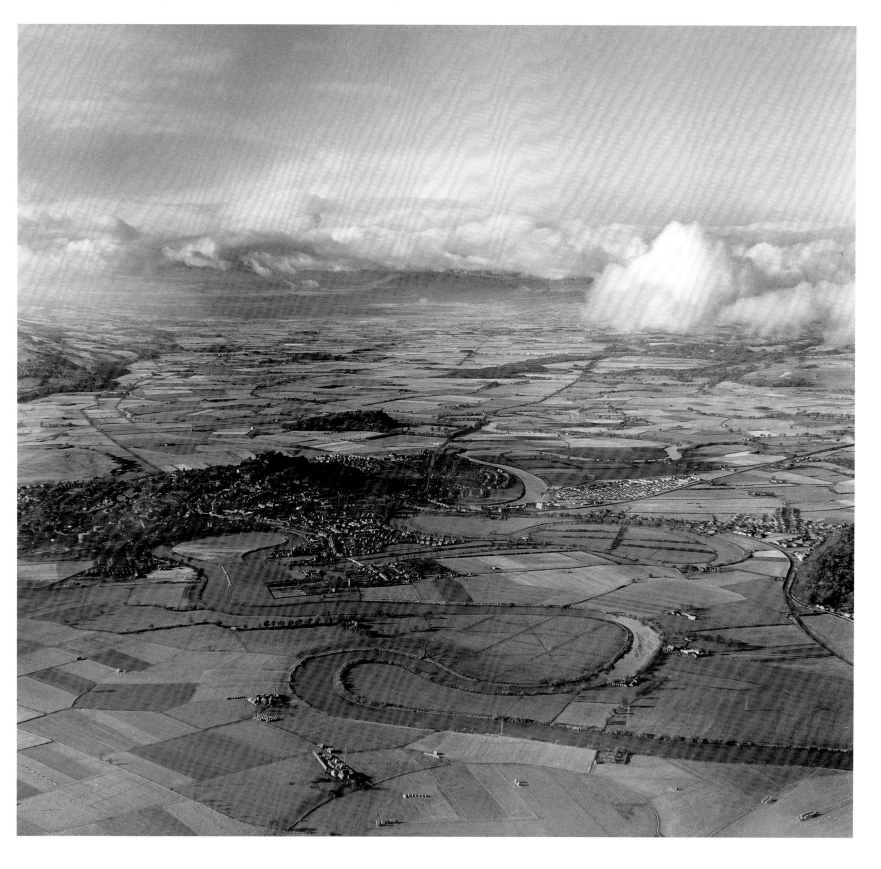

ABOVE

Although taken by Aerofilms in 1953, in this image there are clear echoes of the sight that would have greeted the north or southbound traveller in centuries past – an imposing fortress town rising above a flat expanse and reached by a single road, commanding a landscape famously washed red with the blood of Scotland's wars. Stirling was a frontier settlement and essential gateway between the Highlands and Lowlands – a place of refuge for some, a forbidding citadel of authority to others.
AEROFILMS 1953 R11988

FOLLOWING PAGES

The old core of Stirling is today criss-crossed with roads and enclosed by the Victorian railway lines. To the west, flanked by modern housing and a roundabout, are the raised earthworks of the King's Knot – a seventeenth century royal pleasure ground which once sported sculpted hedgerows, ornamental trees and an expansive orchard.
RCAHMS 2010 DP079020

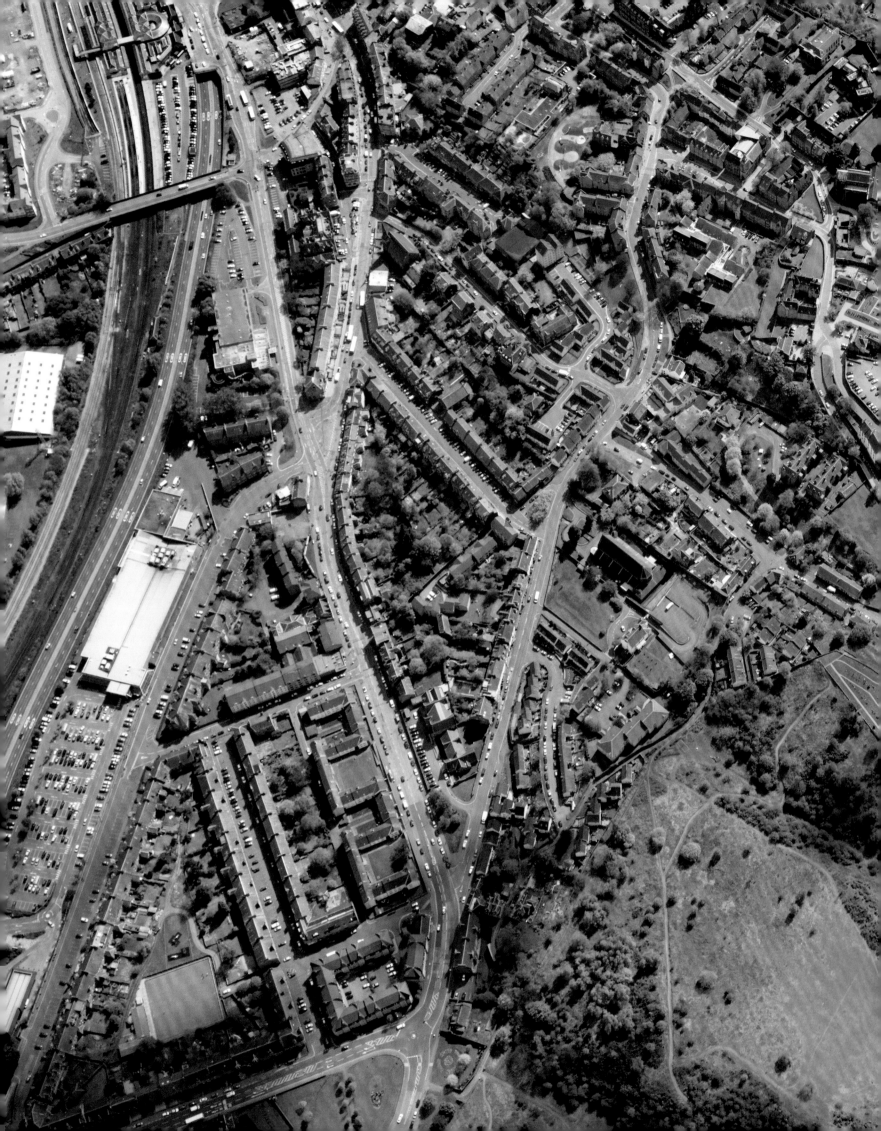

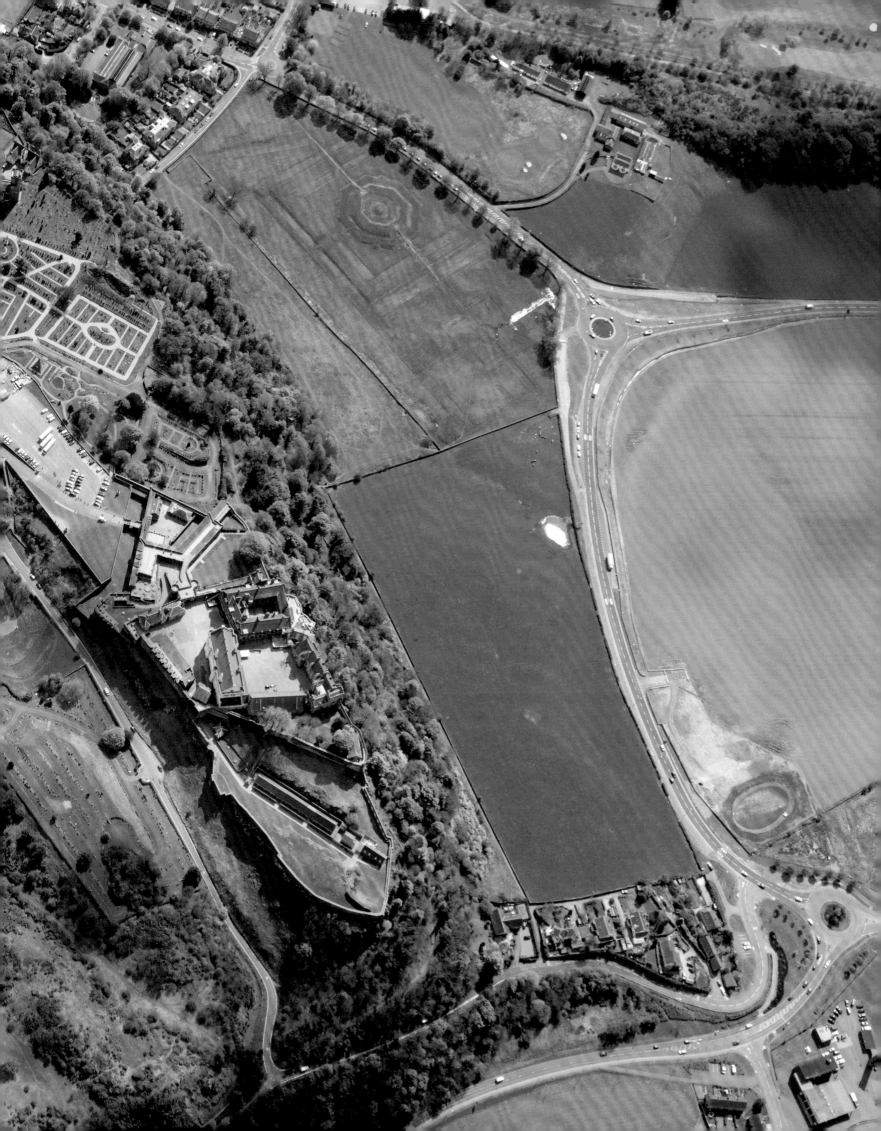

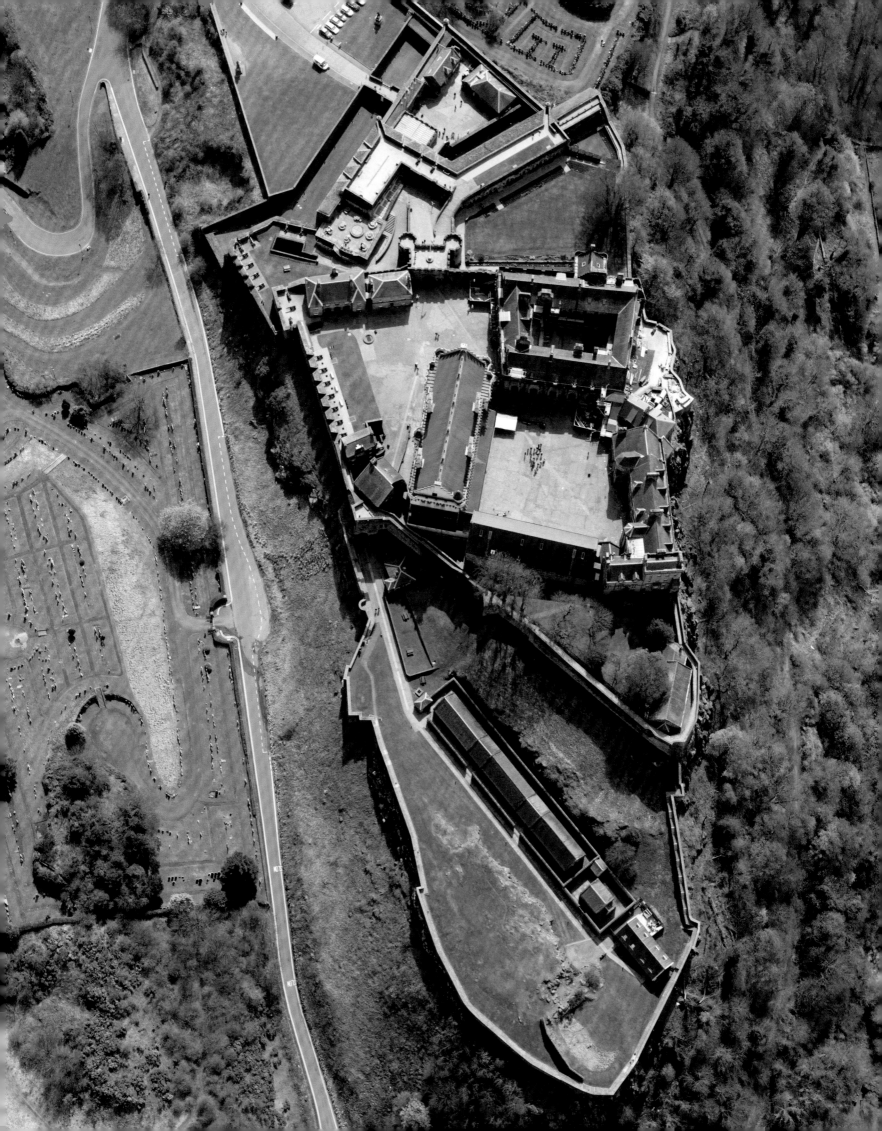

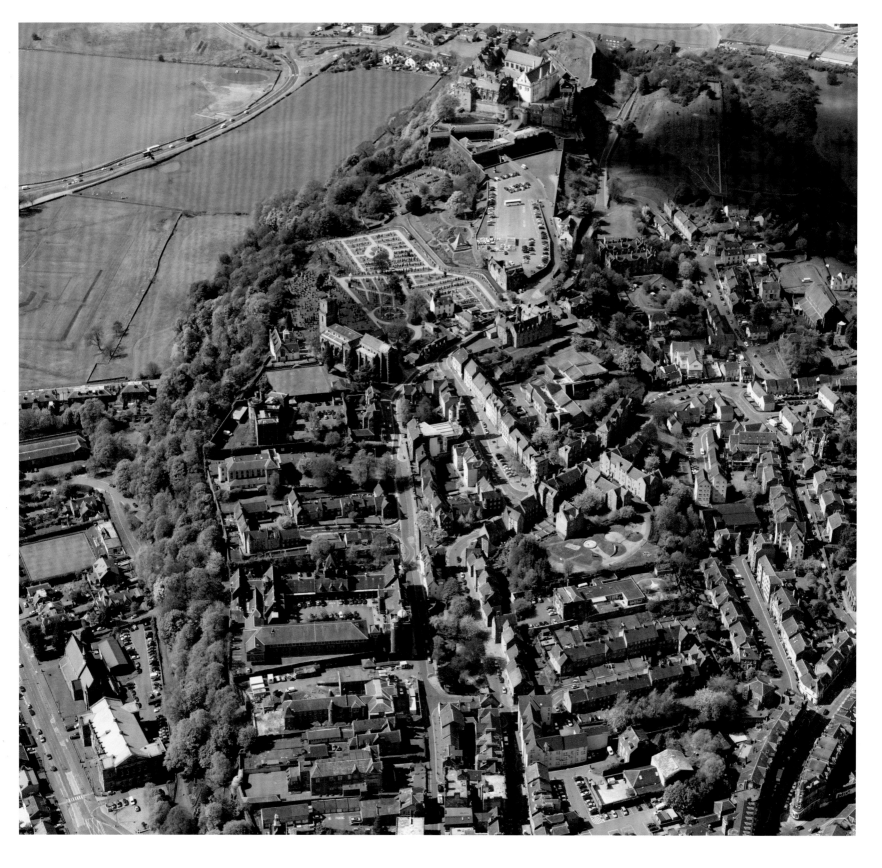

LEFT AND ABOVE

Thought to have been fortified from at least Pictish times, Stirling Castle's first recorded royal connection came with the death of King Alexander I in 1124, who also dedicated its original chapel. Beseiged, sacked and rebuilt numerous times, today it is a battle-scarred monument to a nation's turbulent history, a structure of fragmentary architecture ranging from Robert II's

imposing North Gate – dating from 1381 – to the extensive eighteenth century Outer Defences, created to withstand the threat of the Jacobite Rebellion. The Town Wall – seen here as a thick line of trees – was strengthened considerably amid the turbulence of the late sixteenth century, "for resisting our auld innimeis of Ingland" as the burgh fathers said in 1547. Built of

giant whinstone boulders, the Wall once continued its curve around the foot of the town, but over the centuries has been subsumed and replaced by modern growth.
RCAHMS 2010 DP079007
RCAHMS 2010 DP079040

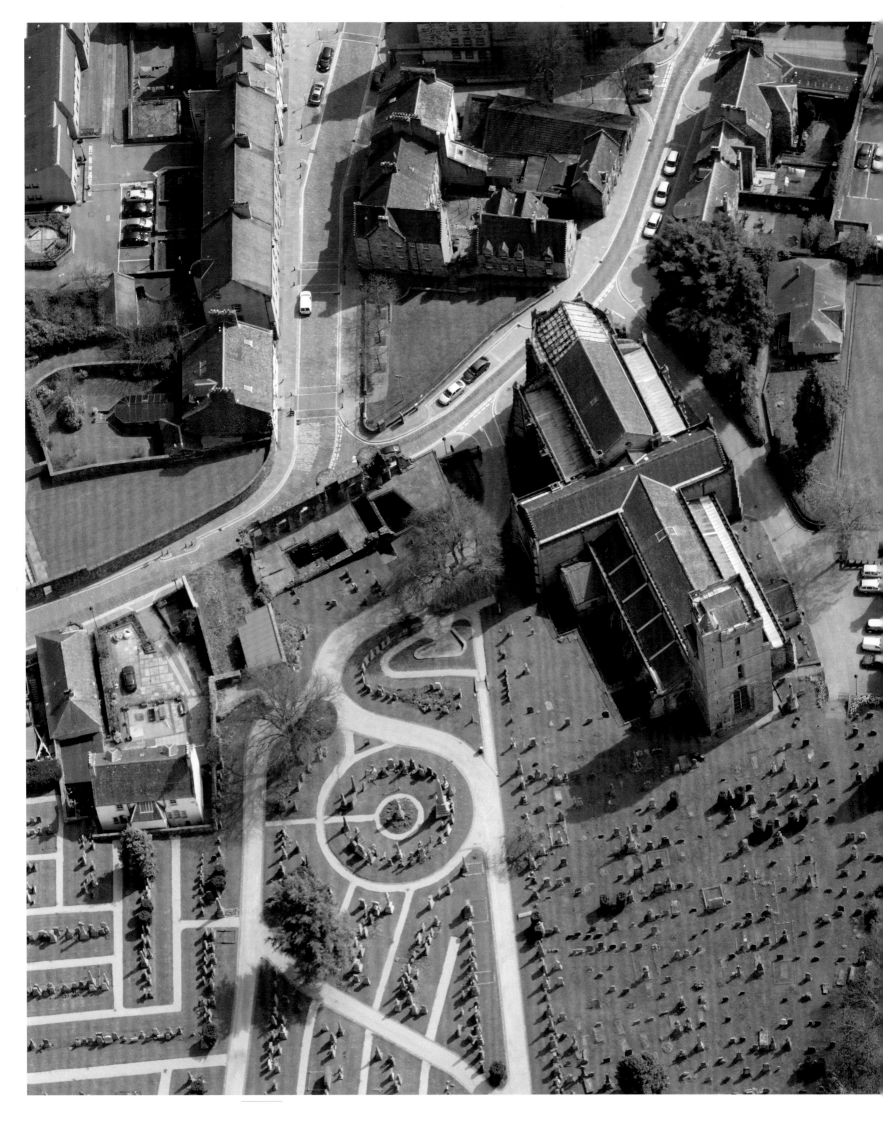

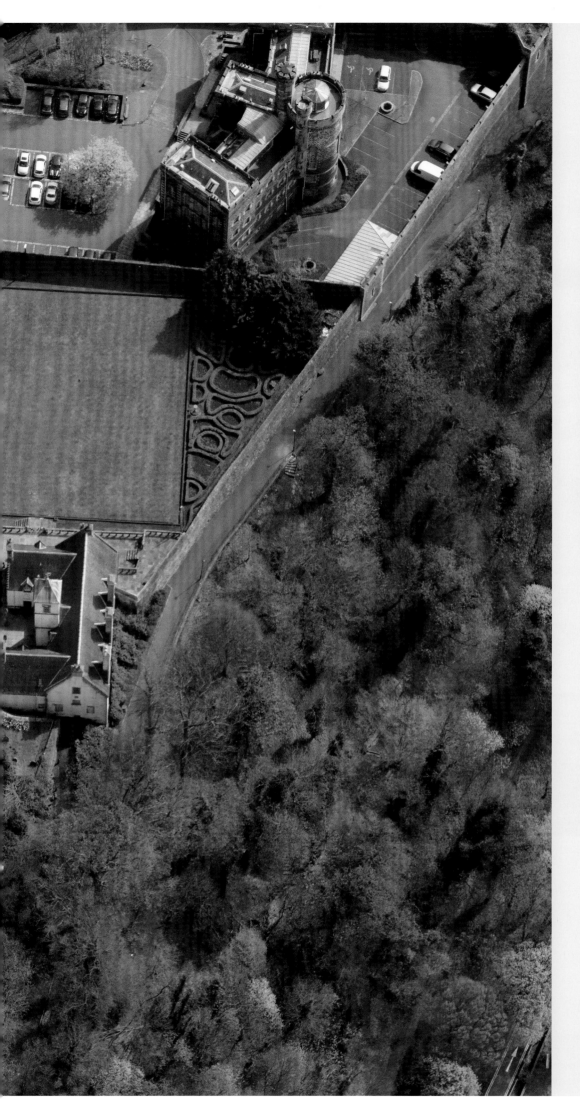

On 29 July 1567, with his mother Mary imprisoned in Lochleven Castle, the thirteen-month-old infant James VI was crowned King of Scotland in Stirling's Church of the Holy Rude. John Knox, the firebrand figurehead of the Reformation, preached the coronation sermon, symbolically recalling the Old Testament tale of the slaying of Queen Athaliah and the crowning in her place of young King Joash. Site of a church from the early twelfth century, Holy Rude – meaning Holy Cross – was rebuilt in its present form after fire devastated Stirling in 1405. Despite many alterations down the years, it remains one of Scotland's most splendid medieval parish churches, a stern structure of buttresses, pillars and gothic arches that remarkably still features an original, fifteenth century oak-beamed roof.

RCAHMS 2010 DP079012

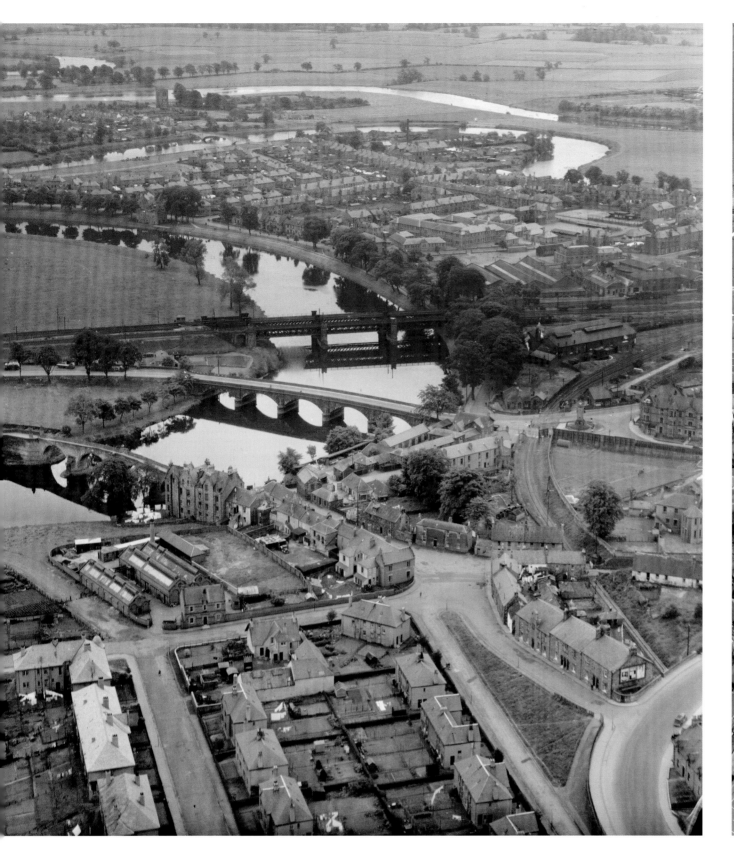

ABOVE

Hundreds of years of history, progress and development are preserved in four bridges meeting at a meandering bend of the Forth. Although not the actual bridge on which William Wallace fought and defeated the English in 1297 – it is believed to have been a timber structure around a half-mile west-wards at Kildean – the picturesque stone monument of Stirling's fifteenth century

Old Bridge remains one of the nation's finest surviving medieval crossings. For four centuries the lowest bridging point on the river, it also housed a booth for customs men in a recess on its central arch, who would levy duties on all goods entering the Burgh. Stirling's New Bridge was completed in 1832 by Robert Stevenson – grandfather of writer Robert Louis – and, less than

two decades later, came the transformative arrival of the railway, the unflinching tracks that carved up the landscapes of Scotland.

RAF 1947 006-001-007-283-C

ABOVE

For centuries before the railway, Stirling
had operated as a shipping port – although
from the 1600s navigating the bends of the
Forth necessitated the transfer of cargo
from larger to smaller vessels at Bo'ness.
Built just upriver from the harbour, the
bridges prevented passage further west for
all but the smallest vessels.

RCAHMS 2010 DP079005

FOLLOWING PAGES

The steam train – first connecting Stirling
to the south in 1848 – was the catalyst for
a major change in the town's urban fabric.
A fortified sentry-post during centuries of
civil struggle, in a more peaceful age, fast
transport links saw Stirling recast as a com-
muter haven away from the overcrowded
chaos of the Victorian cities.

RCAHMS 2010 DP079010

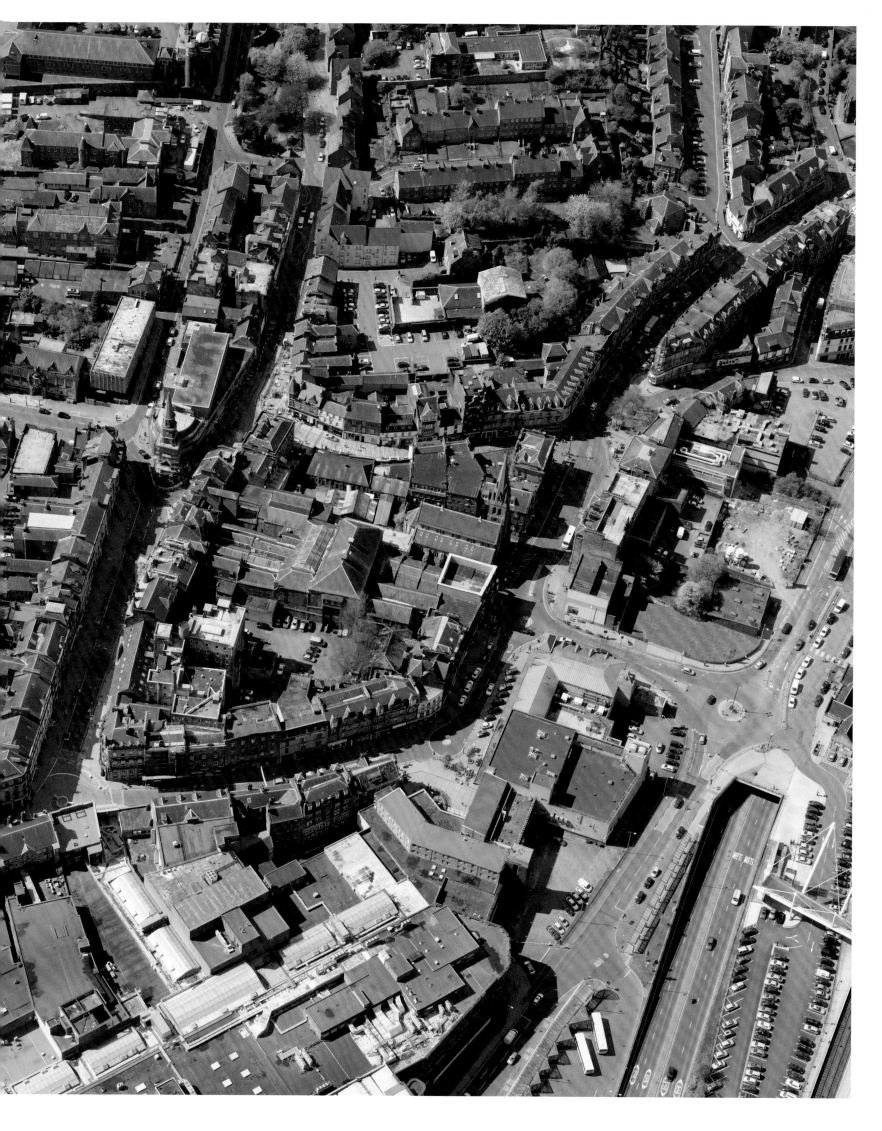

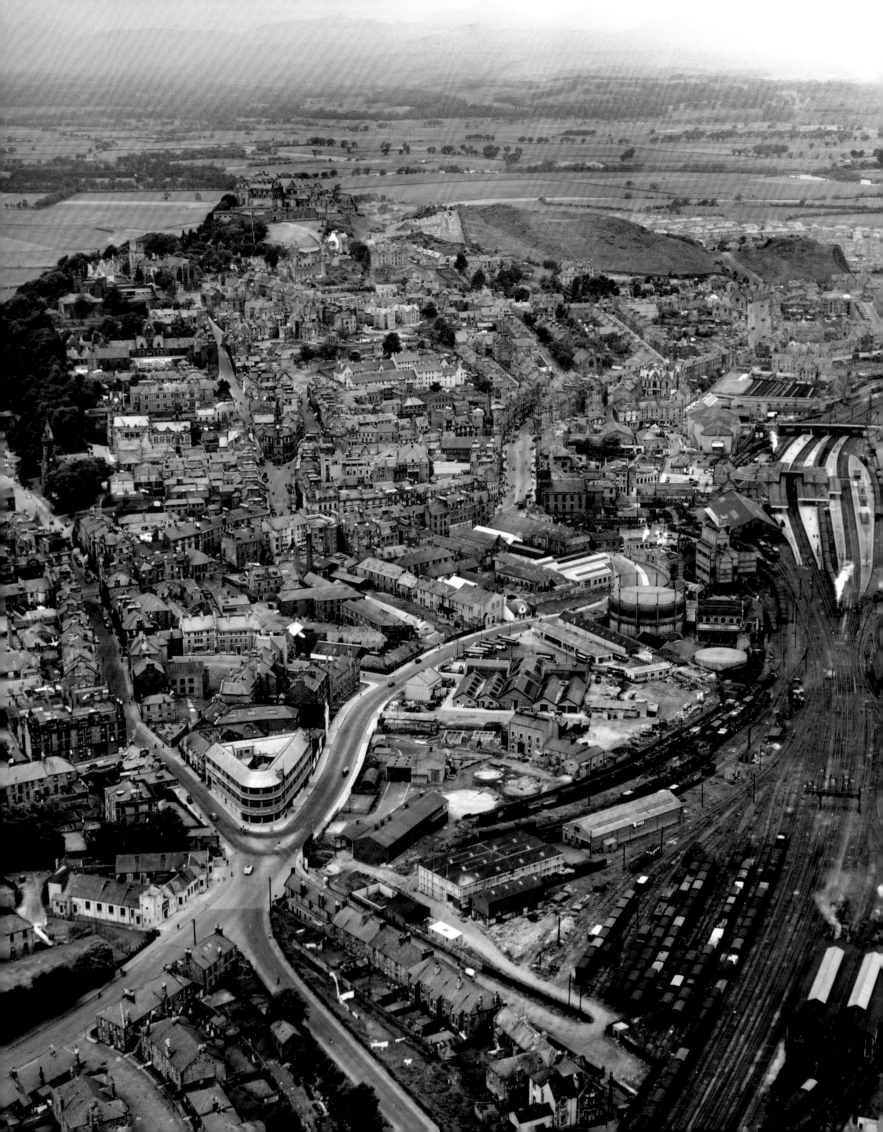

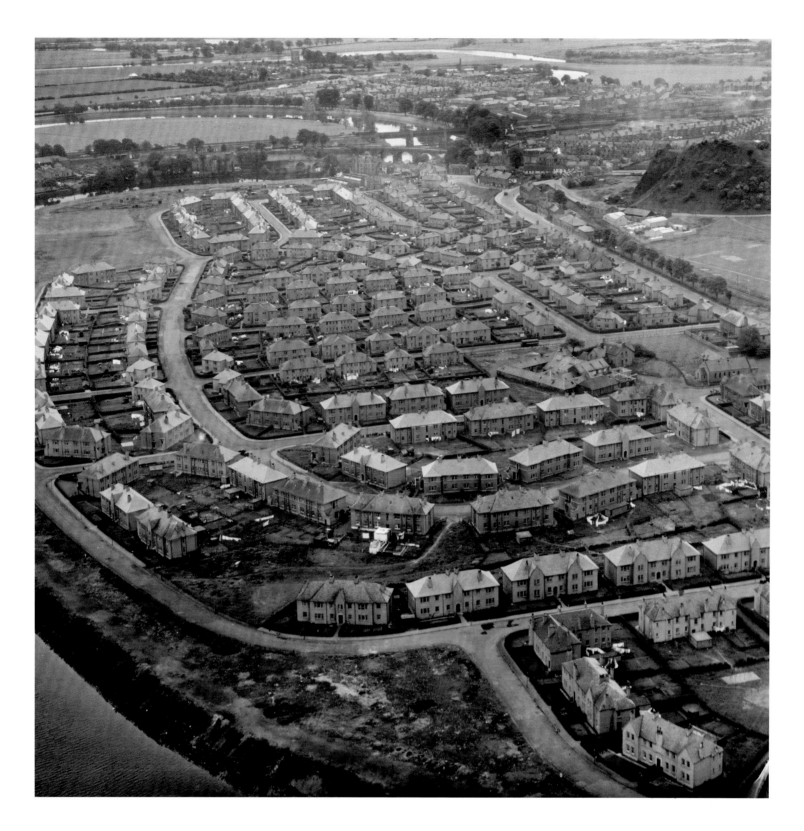

Constrained by the natural barrier of the crags on one side and – from the mid nineteenth century – by the artifical borderline of the railway on the other, the narrow plan of medieval Stirling is clear to see. Having expanded in a linear fashion down the lee of the Castle, the topography of the floodplain has forced Stirling to spread out across the ox-bow bends of the Forth. Pictured here in 1947, housing in the planned surburban estate of the Raploch curves against the banks of the river on open ground immediately to the north of the Castle Rock.

RAF 1947 006-001-007-288-C
RAF 1947 006-000-001-137-C

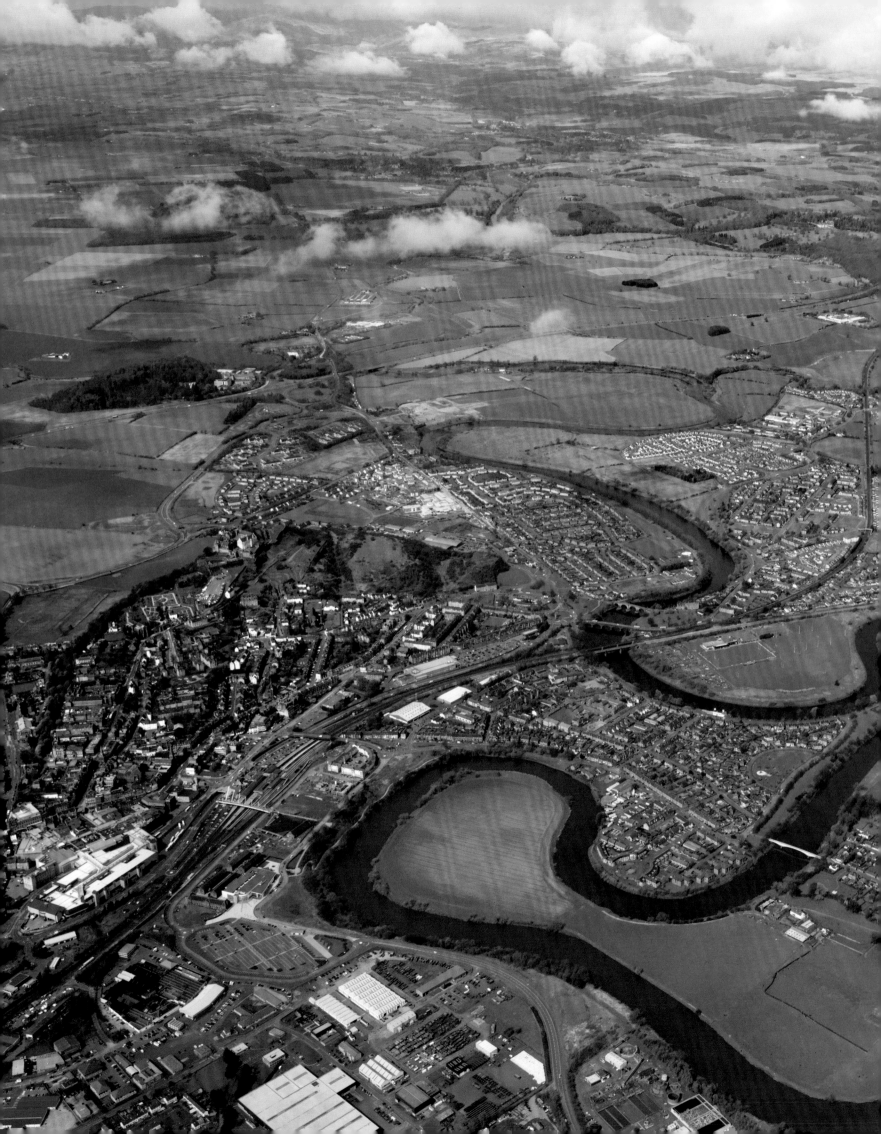

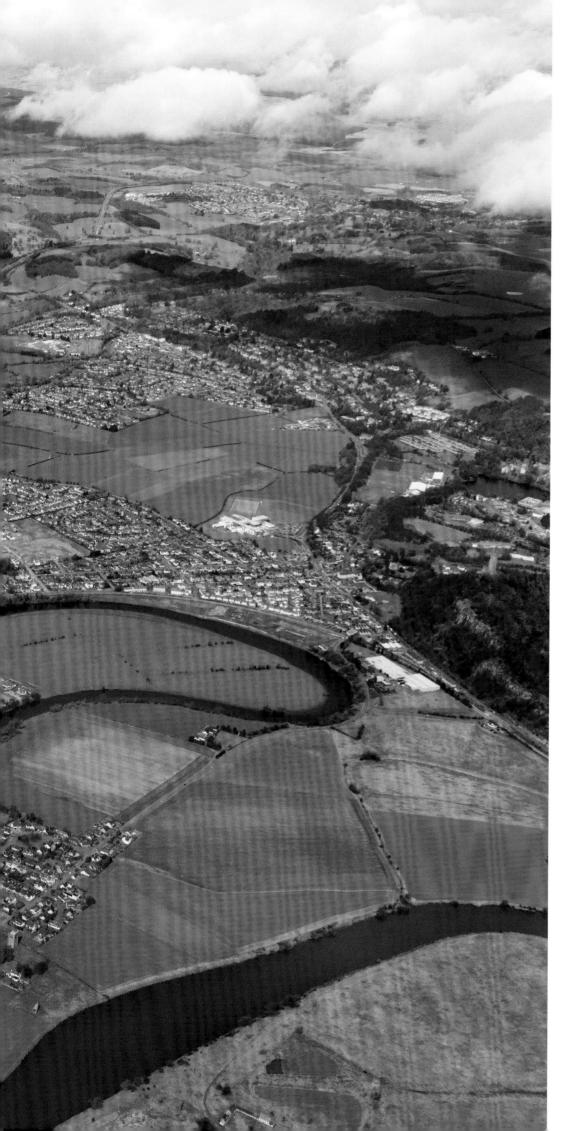

For the modern city of Stirling, the challenge is not just about managing expansion, but also stimulating urban regeneration. In the shadow of Castle Rock, the Raploch estate – formerly a sixteenth century service area for the Castle and village for the royal washerwomen – has experienced severe unemployment and social deprivation over the past 30 years. Now the subject of a £120 million investment, the intention is to refocus and reinvigorate the community, creating new homes, education and health facilities within an economically sustainable environment. The city's plan for a civic renaissance continues at 'Forthside' a major development beside the station on the post-industrial brownfields and Ministry of Defence land that occupied what was once Stirling's ancient harbour. This ambitious initiative proposes combining flats, hotels, conference centres and leisure facilities in a vibrant waterfront district.

RCAHMS 2010 DP078995

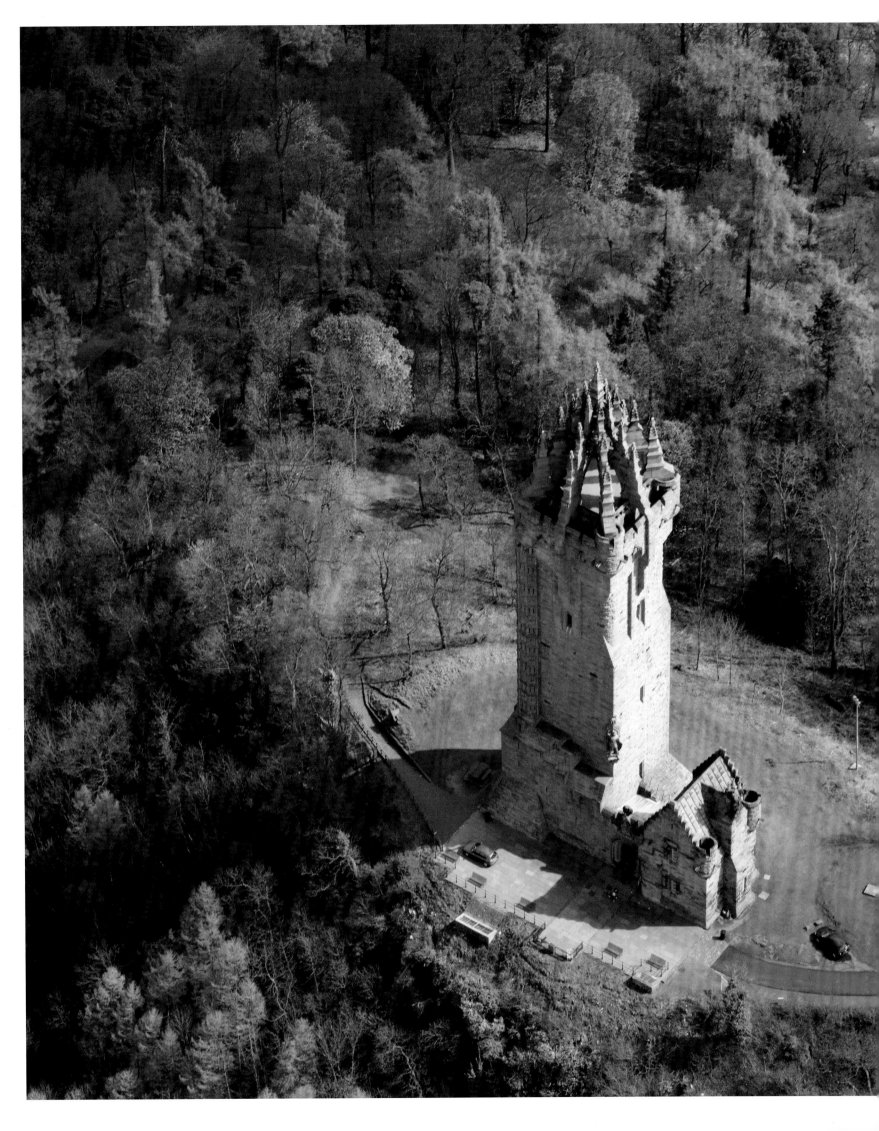

LEFT
Styled in the manner of an old Scots keep, the Wallace Monument was the dream of a Victorian society fashionably obsessed with the romantic exploits of ancient Scottish heroes, and eager to revive the architecture of gothic medievalism. A National Monument Committee had first been formed in the 1830s to decide on a suitable site and structure, but it was the influence 20 years later of the Reverend Doctor Charles Rogers, chaplain at Stirling Castle, that focused attention on the Abbey Craig. A volcanic mound rising above the Carse of Forth, it was also reputedly the spot where William Wallace had camped to watch the English army gather in the floodplain before the Battle of Stirling Bridge in 1297. Funded by philanthropic donations and public subscriptions, between 1859 and 1869 architect John Thomas Rochead's symbolic tower rose to its full 220ft height, the intricate stonework of its tiered spire intended as a representation of the Crown Royal of Scotland.

RCAHMS 2010 DP078991

FOLLOWING PAGES
Almost exactly a hundred years after the self-conscious confection of the Wallace Monument topped the Abbey Craig, the Modernist community of Stirling University emerged in its shadow, a bespoke, sculptured environment of rolling parkland and low-rise angular campus buildings.

RCAHMS 2007 DP026649

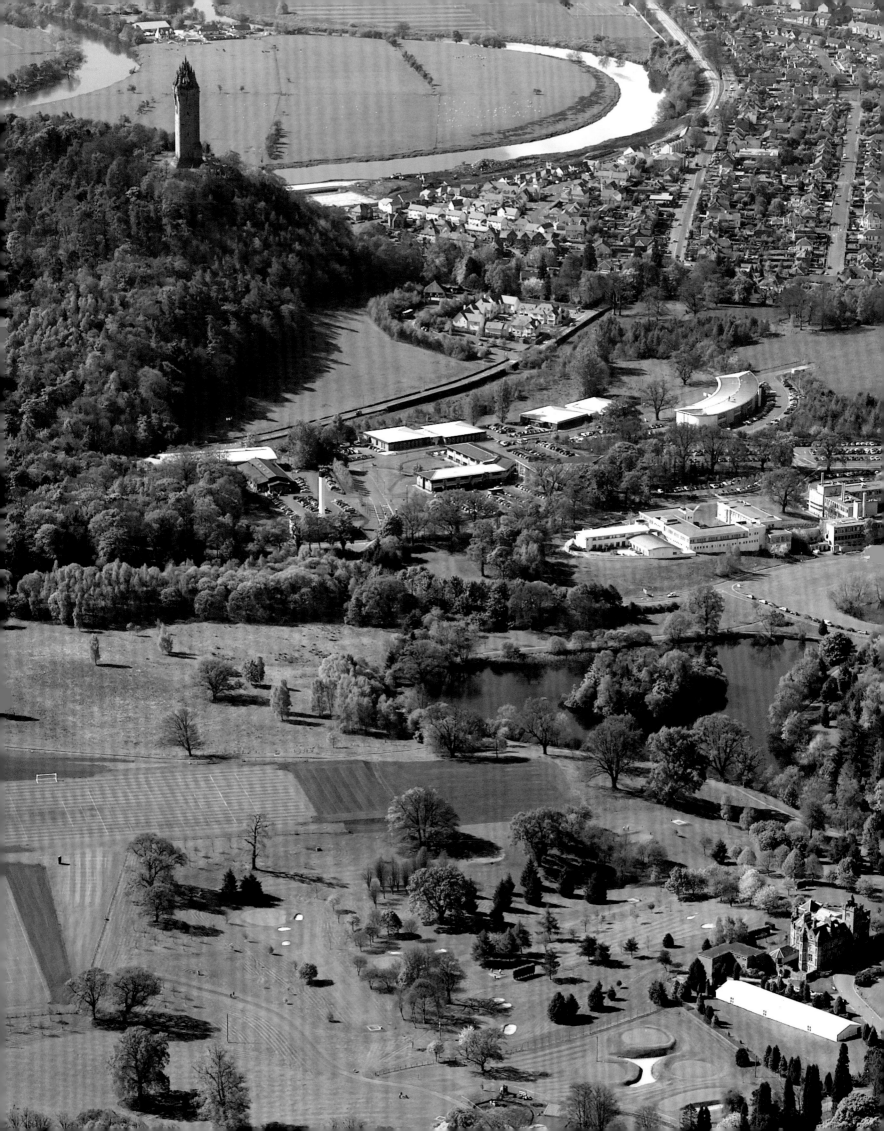

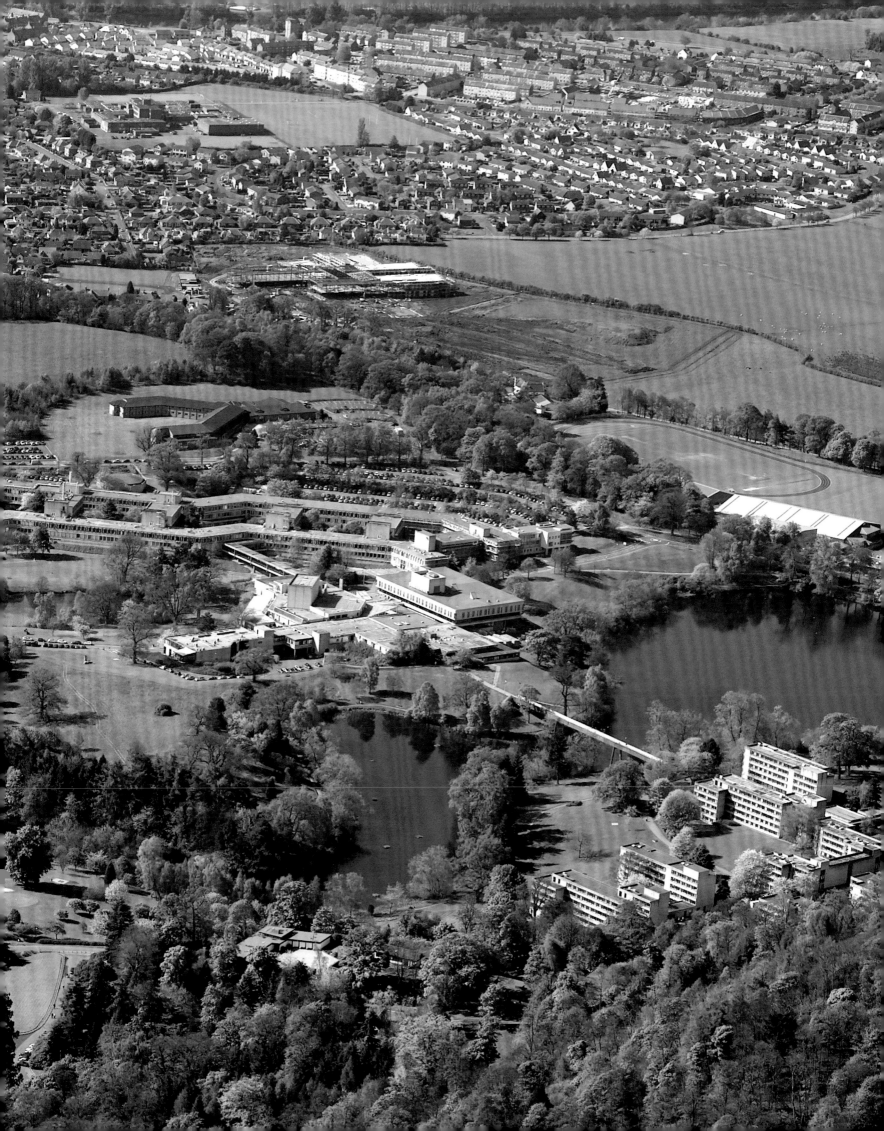

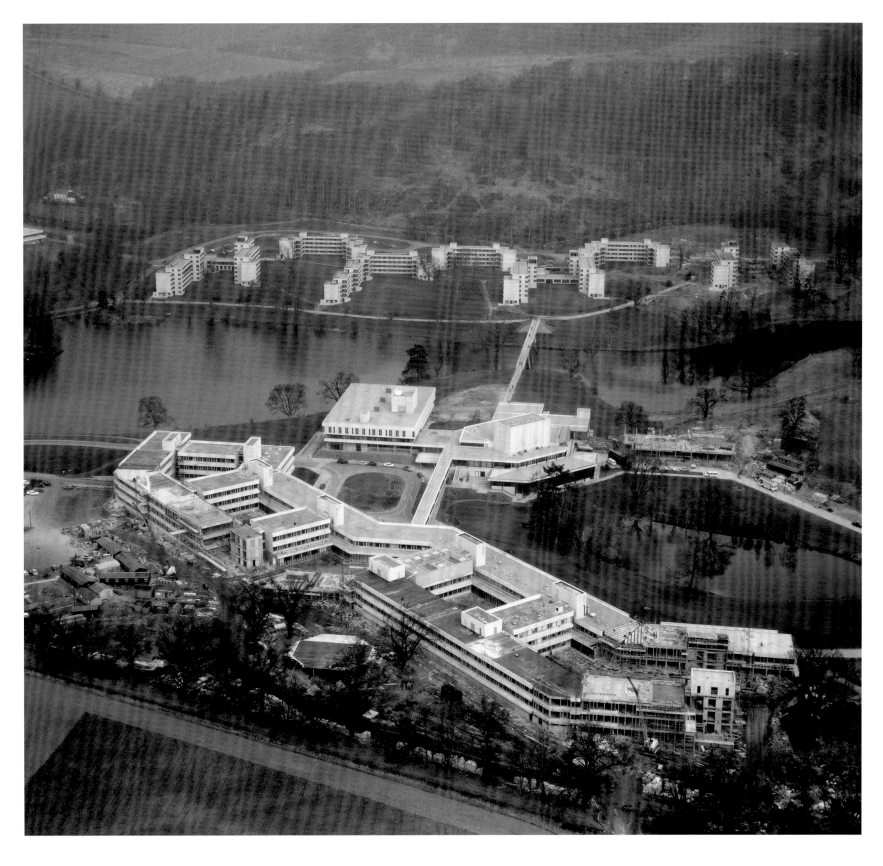

Pictured here in 1972 still partly under
construction, the campus of Stirling
University was an ambitious Modernist
vision. Conceived as a set of parallel blocks
stepping down a sloping hillside to the
shaped banks of an artificial loch, designers
Robert Matthew, Johnson Marshall and
Partners strived to create a unified environ-
ment of architecture and landscape.

AEROFILMS 1972 A223629

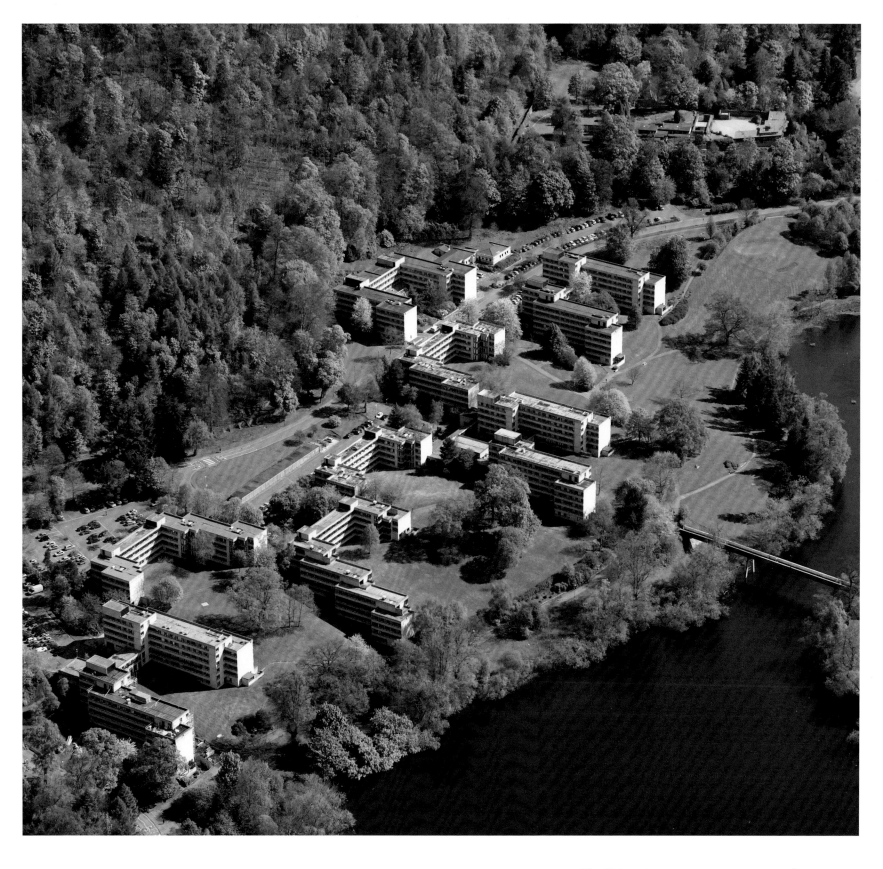

The University community was envisaged
– both geographically and philosophically –
as existing outside and independent of its city
of patronage, yet at the same time it attempted
to create a representative architectural model
for future suburban societies. Here a high-level
footpath runs from the teaching buildings
across Airthrey loch to the staggered terraces
of the residential accommodation.

RCAHMS 2007 DP026666

Although the last 200 years have marked the age of Scotland's cities – with the rapid transfer of population and influence away from the dominant rural communities of the previous centuries – they still exist only in the microcosm of human history. These urban footprints, which have grown for centuries along volcanic rises, glacial plains and silted river-mouths, remain dwarfed by the nation's great, ancient landscapes.

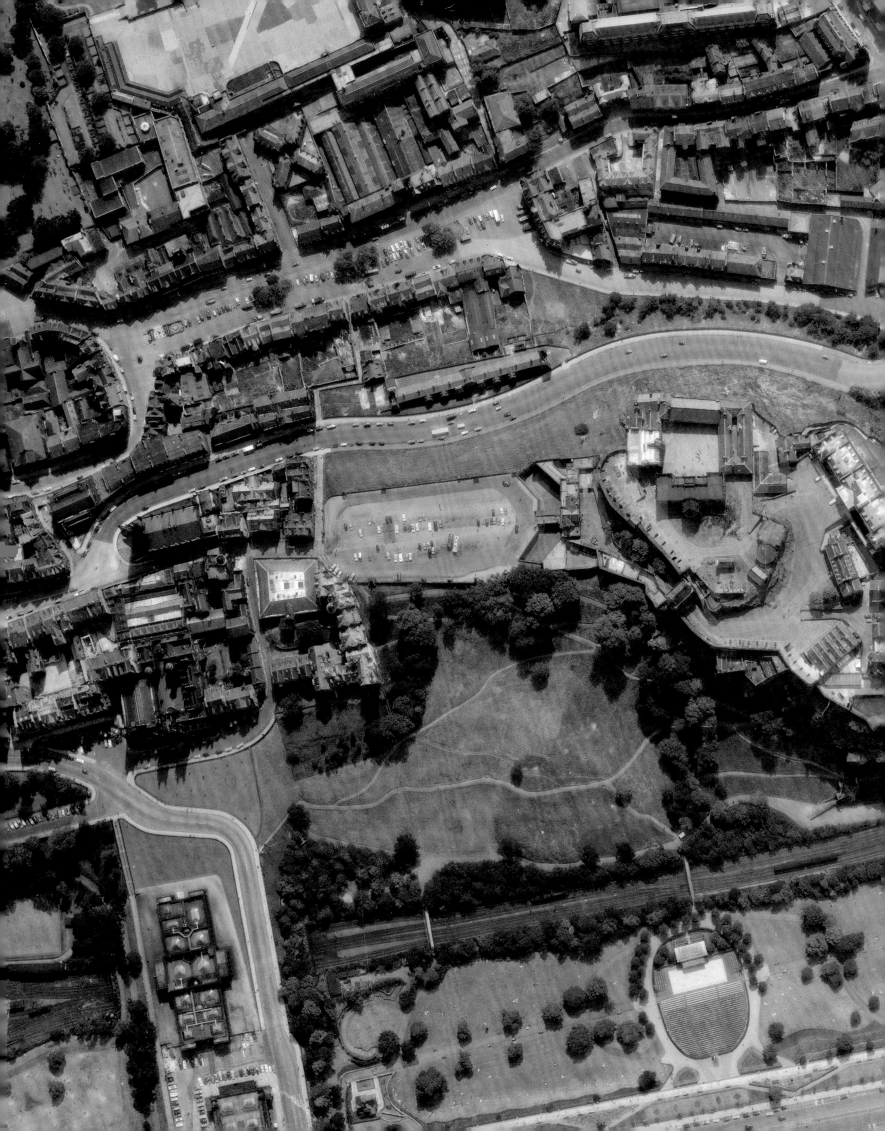

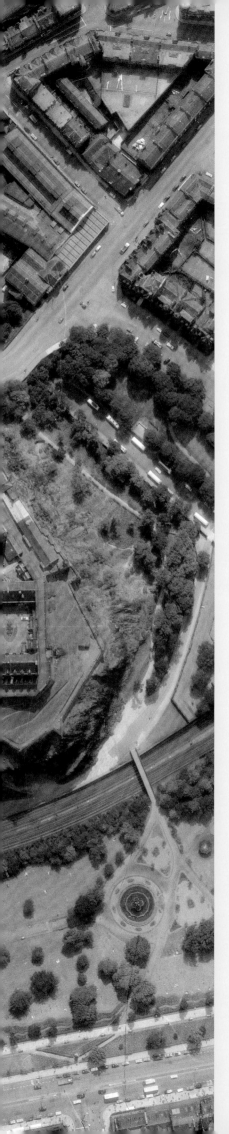

Three-dimensional Cities

For the better part of a century, the view from above has been guiding architects and planners, presenting a perspective of the city as a single organism, a living panorama. As urban environments have risen from hills, valleys and river plains, they have created new topographies, with artificial peaks and canyons formed by the spires, towers and facades of many hundreds of years of competing architectural visions. Anyone looking at the modern city is set a clear challenge by the complex variables of these hybrid landscapes, and a number of techniques have been devised to help make sense of our fragmentary urban histories. Perhaps most remarkable of all of these is the use of aerial photography to study the landscape in three dimensions.

By taking a series of vertical aerial images in quick succession – with each photograph overlapping by at least 60 per cent with the one before and the one after – it is possible to create an exceptionally detailed visual model. With the help of a binocular instrument called a stereoscope, the human brain is able to process the coinciding imagery to perceive depth, scale and elevation: the third dimension. This simple technology has been in use in one form or another since Victorian times – initially popularised in the 1850s for portraiture – but became a military specialism during the First World War. Stereoscopic interpretation of aerial imagery emerged as one of the most vital intelligence tools for strategists, allowing the detailed identification of enemy activity and enabling the planning of everything from surgical commando raids to landing entire armies on frontline beaches.

Following the Second World War – when the production of reconnaissance photography was taken to a near unimaginable scale – the technology was adapted for the reconstruction and re-imagining of the nation. RAF squadrons that had previously flown photographic reconnaissance missions across wartime Europe turned their unique skills towards the home front – including creating the Scottish Office Air Photograph Library. From the late 1940s, the men and women tasked with creating the blueprint for a new Scotland were able to draw on the resource of a library of aerial photographs that covered the country in its entirety. As the image collection grew, it increasingly allowed city planners to see the country in three dimensions. This library has continued developing and is now a publicly accessible part of The National Collection of Aerial Photography.

Today, the photographs provide a unique insight into the changing fabric of Scotland's cities. Archive aerial imagery digitised at high-resolution can be manipulated to create stunning three-dimensional representations – with exaggerated vertical scale – of both iconic urban landmarks and specific moments in the history of a city. By using the enclosed 3D viewer – with the red filter over the left eye and the cyan filter over the right – Scotland's cities rise up out of the page, from the imposing rocky heights of Edinburgh and Stirling to the Victorian street plans of Dundee and the geometric block-valleys of central Glasgow.

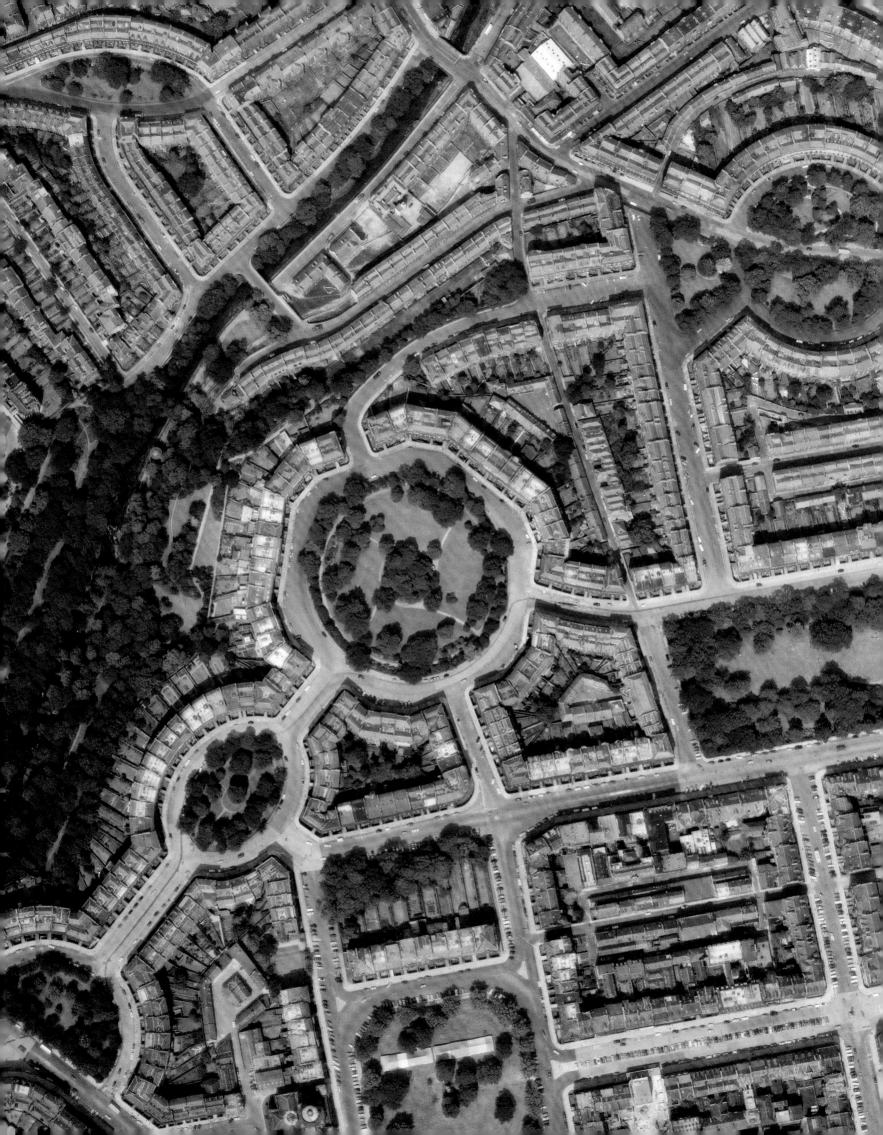

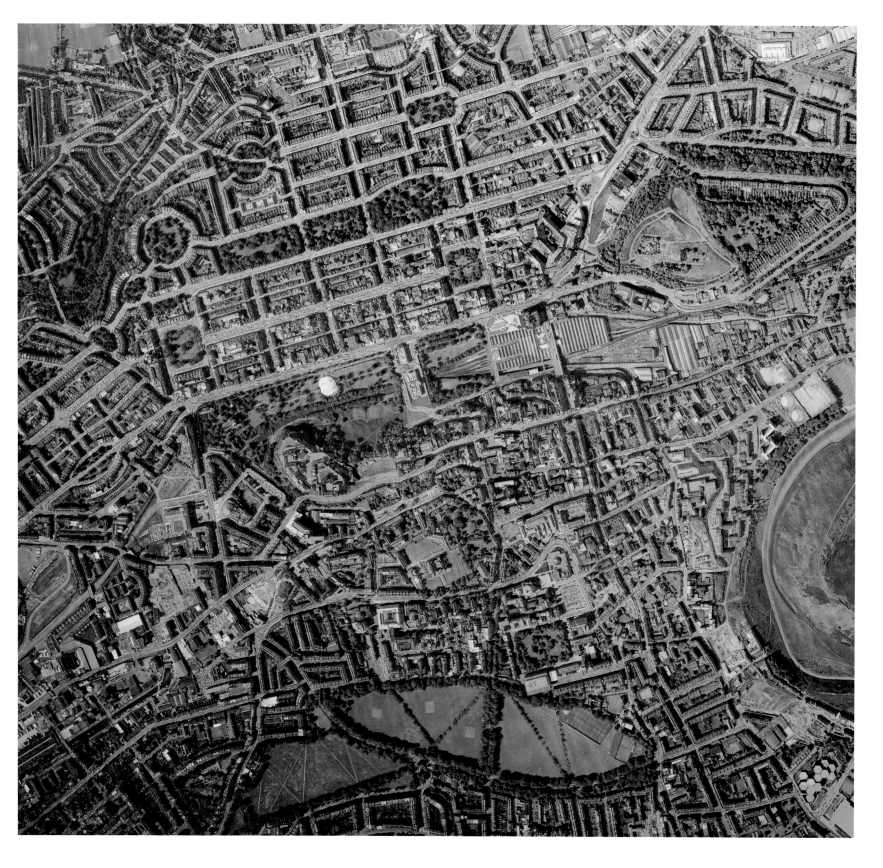

First fortified in Pictish times, the volcanic heights of Edinburgh Castle have been surrounded over the centuries by the growth of the modern city. From the tall, rocky crags, the steep-sided hill narrows to the starting point of the medieval Lawnmarket, marked by the turret of the Outlook Tower and the giant, dark spire of the Tolbooth Church.

RAF 1961 006-000-001-122-C

LEFT
The elegant patterns, crescents and circuses of the classical New Town sweep across Edinburgh's west end, above the valley of the Water of Leith.

RAF 1961 006-000-001-123-C

ABOVE
Edinburgh's unique topography – both barrier to growth and source of inspiration for dramatic town planning – is clearly demonstrated by the inter-relationship between the Old Town spine, Calton Hill, and the deep glacial valley of Princes Street Gardens.

ASS 006-000-001-124-C

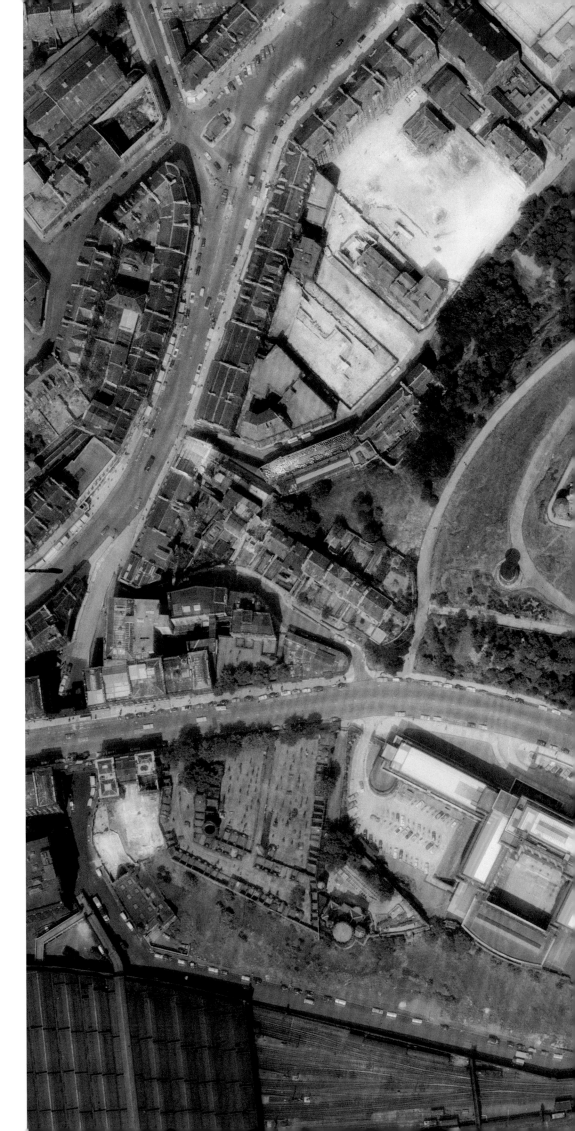

The many ages of Edinburgh come together at the city centre's east end. From the Enlightenment monuments on the peak of Calton Hill, the landscape runs down to the monolithic, Art-Deco St Andrew's House, before dropping into a valley filled with the Victorian railtracks of Waverley Station. Top left is the site of the St James Centre before its 1960s clearance and development.
RAF 1961 006-000-001-125-C

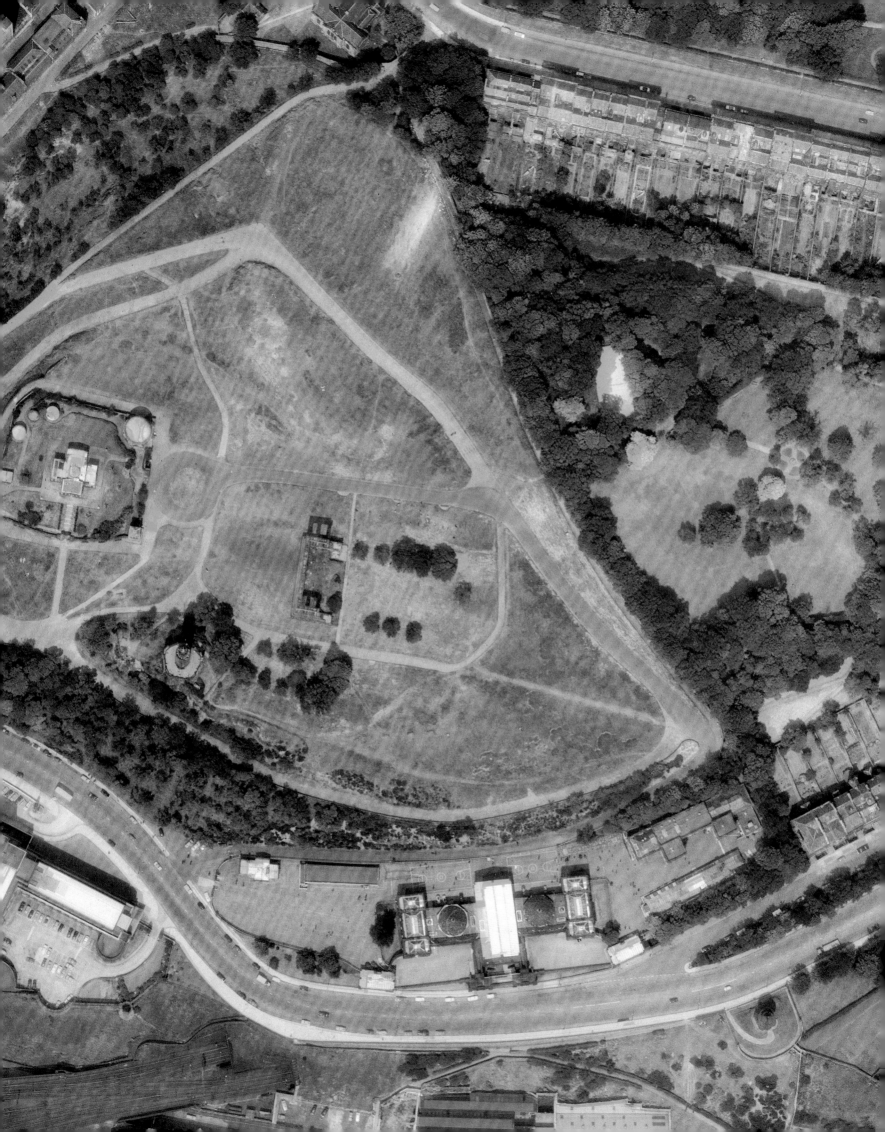

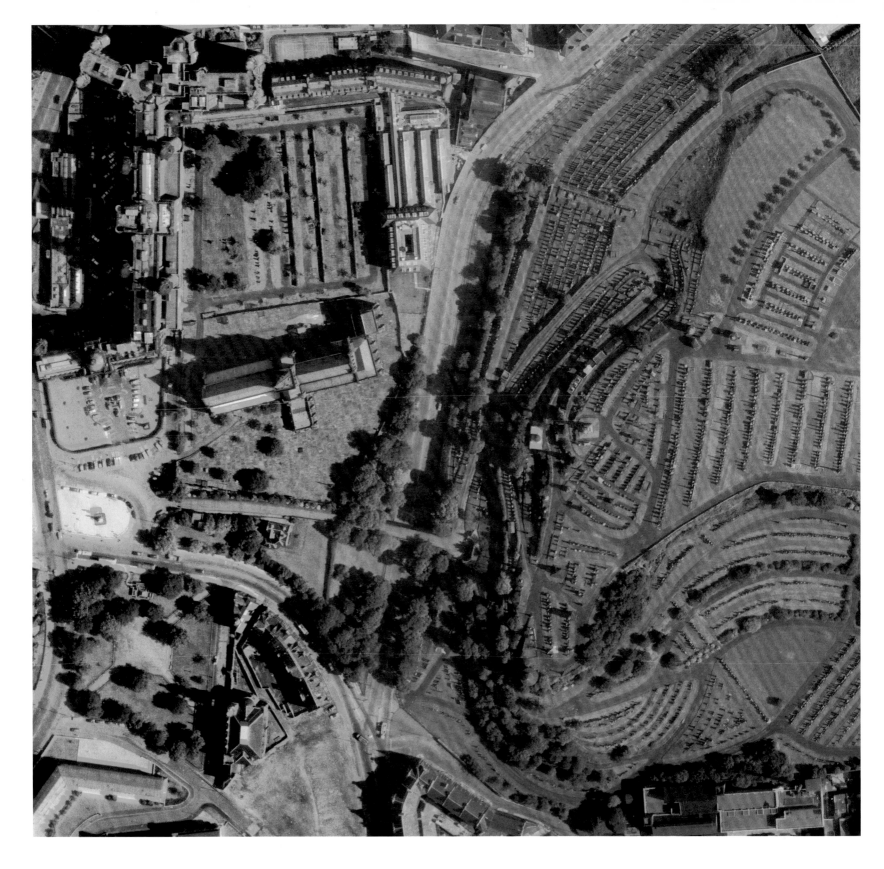

The origin point of Glasgow. The medieval Cathedral is surrounded on one side by the tall, blocky structure of the Royal Infirmary, and on the other by the extravagant mausoleums, crypts, headstones and obelisks of the Victorian Necropolis.

RAF 1968 006-000-001-126-C

RIGHT

The monumental urban sculpture of the motorway carves through Glasgow, creating two sides of a Modernist Inner Ring Road that was planned to encircle the city centre, but was never completed. In the block pattern, buildings continue to grow upwards, creating ever-deeper grid-iron canyons.

ASS 1988 006-000-001-127-C

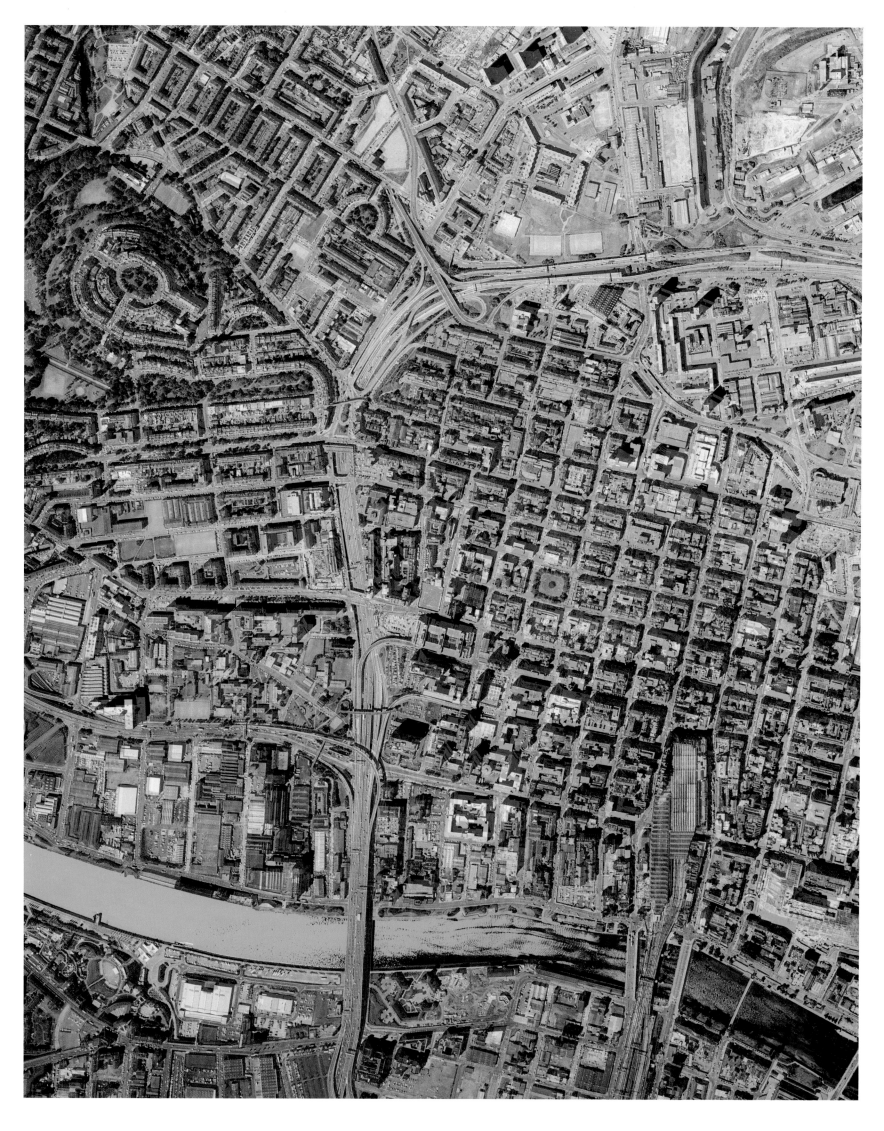

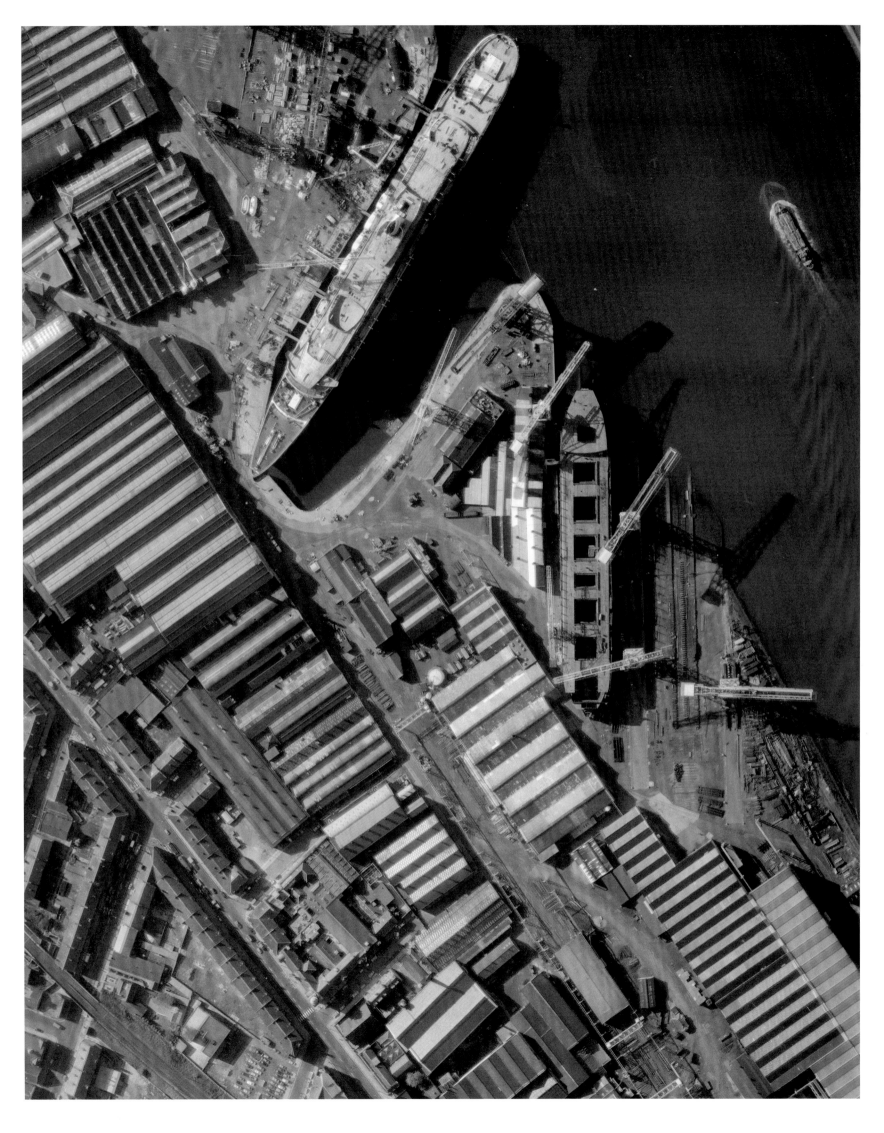

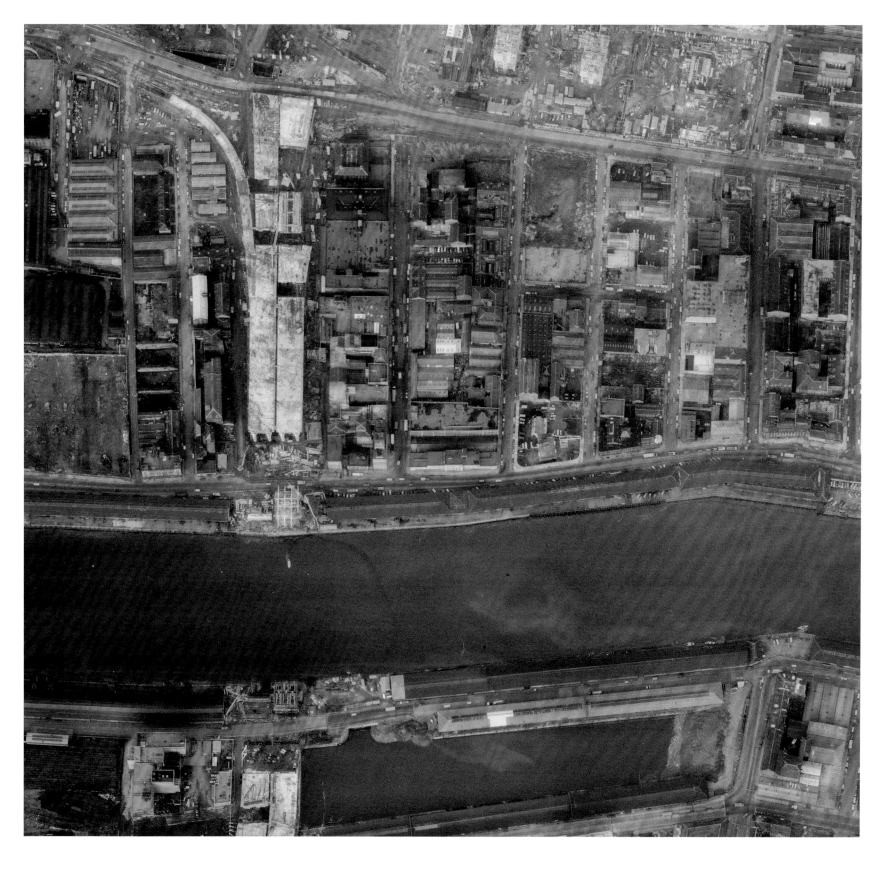

LEFT

On 7 July 1968, at John Brown's Shipyard, Clydebank, the *Queen Elizabeth 2* is under construction for the Cunard Line. Cranes twist busily above the deck, and just visible as a shadow at the top of the image is the iconic Titan cantilever crane – the only structure still surviving from the shipyard.

RAF 1968 006-000-001-128-C

ABOVE

Pictured in October 1968, the colossal concrete edifice of the Kingston Bridge rises into the Glasgow skyline. In this revealing image, the massive scale of the Inner Ring Road – and the devastating impact of its construction on the surrounding landscape – is strikingly clear.

RAF 1968 006-000-001-129-C

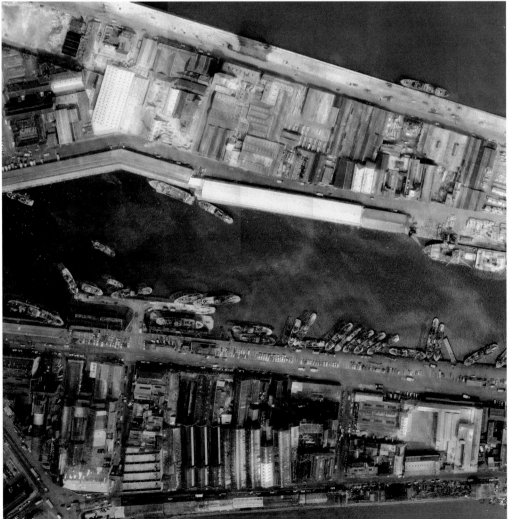

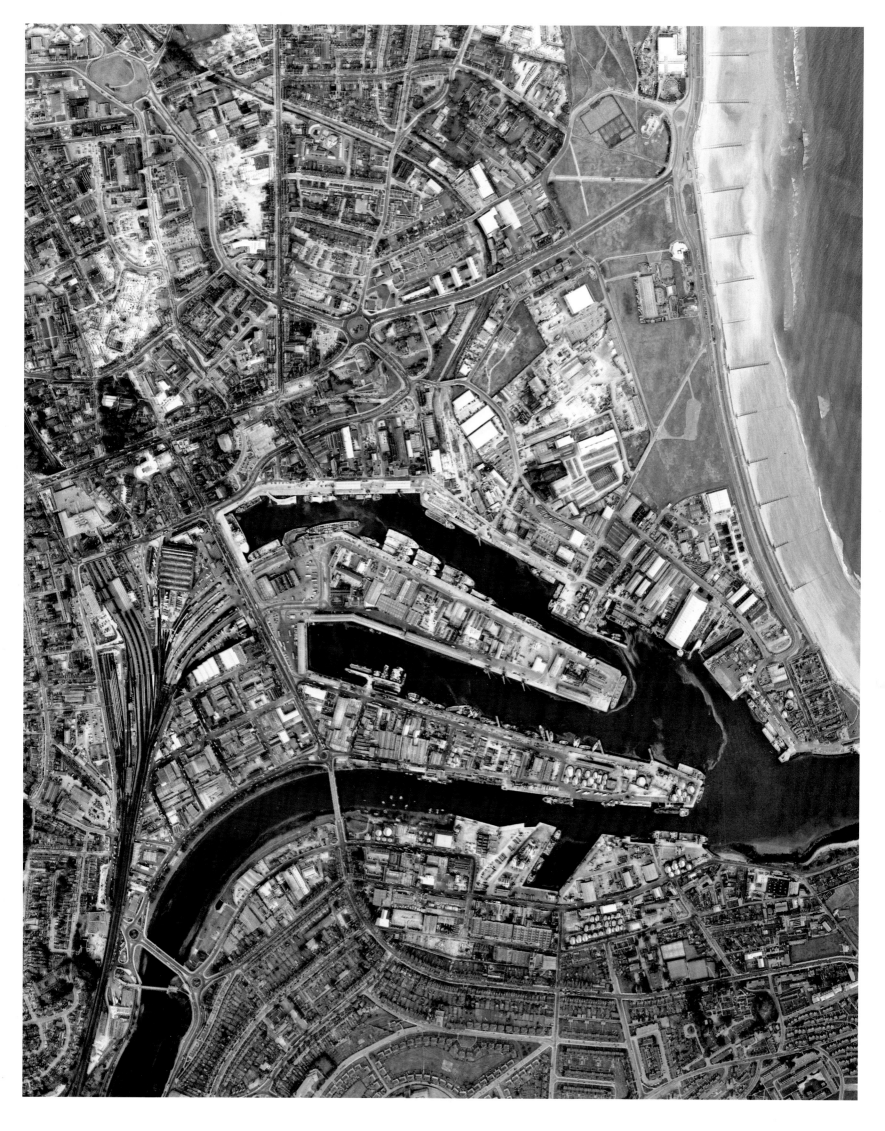

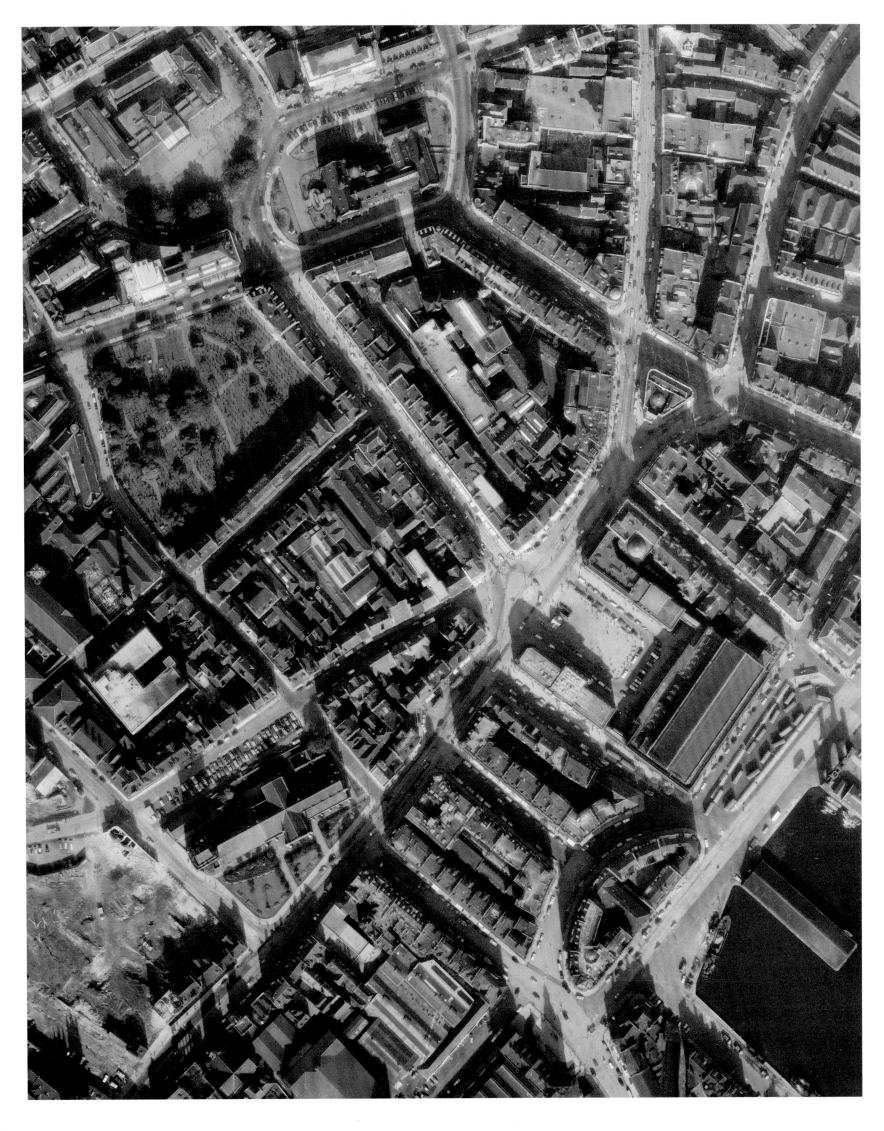

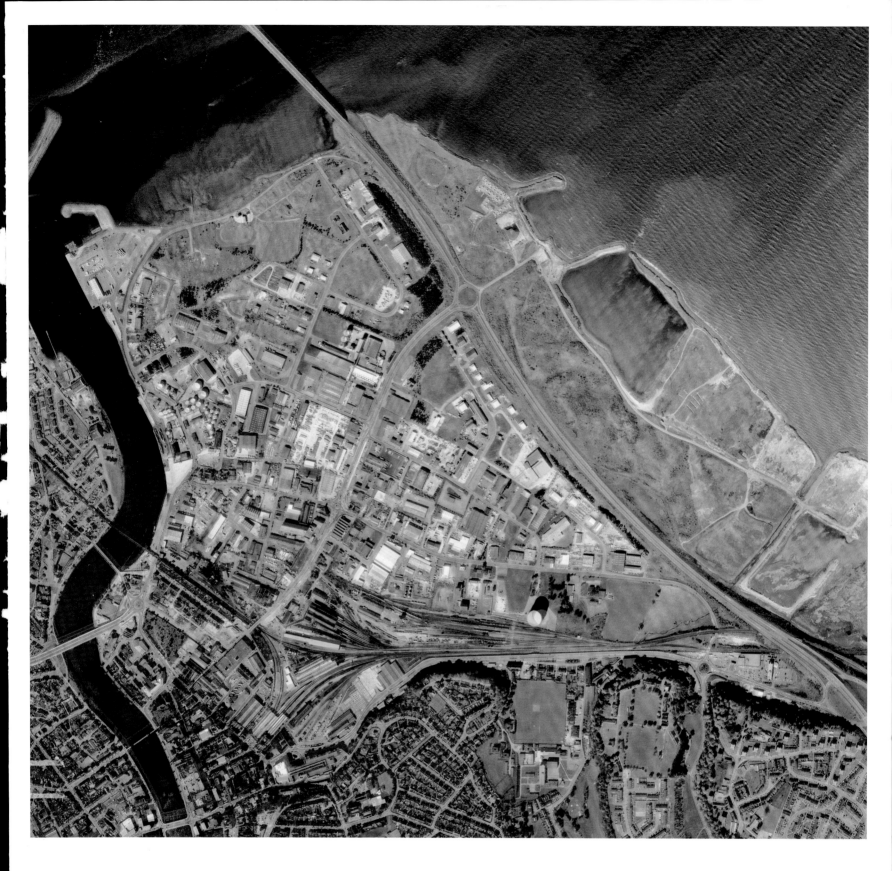

Through the harbour-front shadow of
the now demolished Royal Arch sits the
streetplan of Victorian Dundee. Whitehall
Crescent sits beside the civic square of the
Caird Hall, with Reform Street leading
past the Howff to meet the tall tower of the
Courier building, the Albert Institute and
the High School.

RAF 1961 006-000-001-133-C

ABOVE

As the River Ness winds past the wedge
of the ancient centre of the city, a vast
industrial park covers the flat plain below.
Skirting Inverness, the A9 trunk road rises
to the Kessock Bridge over the Moray Firth.

ASS 1988 006-000-001-134-C

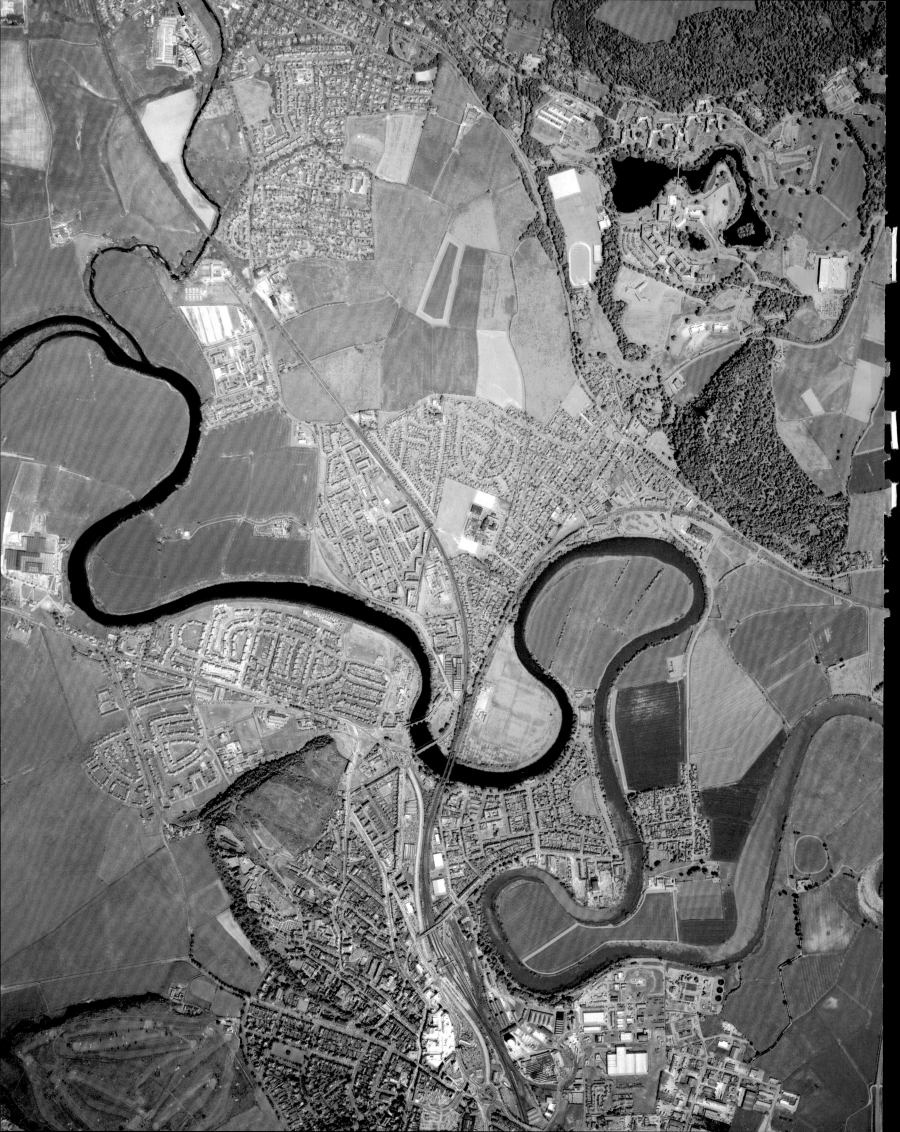

Scotland's National Collection of Aerial Photography

Held by the Royal Commission on the Ancient and Historical Monuments of Scotland (RCAHMS), the National Collection of Aerial Photography is one of the largest and most significant in the world. Often created for more immediate commercial or military purposes, these images have become an invaluable historical tool for everyone from archaeologists, geographers and conservationists to local and landscape historians. This unparalleled resource is made up of a number of distinct parts and is divided into two geographical areas – Scotland and worldwide.

IMAGERY OF SCOTLAND

RCAHMS has amassed 1.6 million images of Scotland from a number of different sources:

- The Aerofilms Collection contains some of the earliest aerial photographs ever taken of Scotland, and dates from the 1920s up to the 1990s – 80,000 images

- The Royal Air Force Collection dates from the 1940s through to the 1990s, with more imagery continually added as it becomes declassified – 750,000 images

- The Ordnance Survey Collection – produced to assist map making – features imagery dating from 1955 through to 2001 – 500,000 images

- Since 1976 RCAHMS has run an annual programme of aerial reconnaissance and photography to record the archaeology and buildings of Scotland, capturing changing urban and rural environments throughout the country, and leading to the discovery of thousands of new archaeological sites – 125,000 images

- The All Scotland Survey (ASS) dates from 1987–89 and was commissioned by the then Scottish Office to assess land use – 17,000 images

In addition to these, numerous smaller collections have also been added to the National Collection.

WORLDWIDE IMAGERY

In 2008, The Aerial Reconnaissance Archives (TARA) were entrusted to RCAHMS. Dating from 1938 onwards, the archives are made up of many millions of military intelligence photographs from around the world.

ACCESS

All images in this book, and a rapidly expanding selection of other photographs from the National Collection of Aerial Photography, are available to browse and buy online at aerial.rcahms.gov.uk. Full access to the Collection is available in the RCAHMS public search room in Edinburgh.

LEFT

The 350-million-year-old volcanic crags of the Castle Rock and the Abbey Craig dominate the flat, silted floodplain of Stirling's Carse of Forth and the meandering river.

ASS 1988 006-000-001-135-C

ACKNOWLEDGEMENTS

The preparation of this volume has benefited from the input
of many colleagues within RCAHMS. These include Robert
Adam, Oliver Brookes, Andreas Buchholz, Alasdair Burns,
Lesley Ferguson, Neil Gregory, Kevin McLaren, Anne Martin,
Sam Martin, Jessica Monsen, Alan Potts, Derek Smart
and Ruta Urneziute. Thanks are also due to Ronnie Cowan,
Robert Dalrymple, Nye Hughes, John Hume, Mairi
Sutherland, Wendy Toole, and English Heritage.